SPANISH GRAMMAR

2nd Edition

Ana Laura Tello Fairchild, MBA, MA
Colorado State University
Fort Collins, CO

Juan Mendez, MA, MBA

Contributing Editor
Dale F. Knickerbocker, Ph.D.
East Carolina University
Greenville, NC

Collins
An Imprint of HarperCollinsPublishers

An American BookWorks Corporation Production

HarperCollins books may be purchased for educational, business, or sales promotional use. For information please write: Special Markets Department, HarperCollins Publishers, 10 East 53rd Street, New York, NY 10022.

Library of Congress Cataloging-in-Publication has been applied for.

ISBN: 978-0-06-088157-3
ISBN-10: 0-06-088157-7

06 07 08 09 10 CW 10 9 8 7 6 5 4 3 2 1

Contents

Preface . v

Chapter 1 Articles and Nouns . 1

Chapter 2 Adjectives . 19

Chapter 3 Indicative Verbs . 41

Chapter 4 The Subjunctive Mood . 95

Chapter 5 The Imperative Mood . 119

Chapter 6 Passive Voice . 127

Chapter 7 Pronouns . 139

Chapter 8 Adverbs . 169

Chapter 9 Negatives . 175

Chapter 10 Prepositions . 183

Chapter 11 Idioms and Proverbs . 193

Chapter 12 Rules of Accentuation . 209

Appendix: Vocabulary . 213

Index . 245

Preface

Our goals in creating and editing this textbook have been to provide you with a clear and simple reference to some of the most difficult aspects of Spanish grammar. We have found that, in general, most language textbooks have segments of grammar points spread throughout the text according to themes. For example, the use of prepositions might be spread out through three or four chapters, or verb tenses might not always follow a logical sequence. This study guide, on the other hand, is meant to help you understand conceptual differences that are at times difficult to grasp in the more traditional language textbook.

This book contains explanations of grammatical rules as well as a series of opportunities to test yourself, with an answer key at the end of each chapter. We have also included a set of idioms and expressions that will facilitate your use and comprehension of Spanish, and have outlined the rules for using accent marks with Spanish words.

We would like to thank the reviewers for their attention to detail and their suggestions on how to improve this book. Although we were unable to implement *all* the suggestions, we are grateful for their comments.

We would like to offer special thanks to all the people who have shown us their support on this endeavor.

Articles and Nouns

Gender and number are aspects that are sometimes difficult for English speakers to learn. In this chapter we will look at how these function and also the use of the articles *the* and *a* in regards to these nouns.

ARTICLES

There are two types of articles in Spanish: definite and indefinite. The definite article *(the)* indicates a specific person or thing while the indefinite article *(a, an)* refers to a person or thing not known to the speaker. In a lot of cases they are used the same as in English. For example: *The* woman walked into the store. Or in the case of the indefinite article: *A* woman walked into the store. These articles in Spanish agree with the noun in gender, (feminine, masculine) and number (singular, plural). One must keep in mind that the articles used in Spanish are often omitted in English.

Definite Articles

There are four definite articles in Spanish: **el, la, los, las.** The plural of the masculine **el** is **los,** and the plural of the feminine **la** is **las.**

el autobús	*bus*	**la mesa**	*table*
los autobuses	*buses*	**las mesas**	*tables*
la blusa	*blouse*	**el papel**	*paper*
las blusas	*blouses*	**los papeles**	*papers*
el caballo	*horse*	**la yegua**	*mare*
los caballos	*horses*	**las yeguas**	*mares*

For phonetic purposes, feminine nouns that begin with an **a** or **ha** take the article **el** only when the first **a** is stressed.

el agua	*water*	**las hachas**	*axes*
las aguas	*waters*	But,	
el águila	*eagle*		
las águilas	*eagles*	**la acción**	*action*
el alma	*soul*	**la aceituna**	*olive*
las almas	*souls*	**la almohada**	*pillow*
el arma	*firearm*	**la altura**	*height*
las armas	*firearms*	**la amiga**	*friend*
el hacha	*ax*		

Please note that the stressed syllable in this last group of words is not the first **a.** For more detail, see Chapter 12.

With Nouns

The definite article in used in Spanish much more than in English. It is used with all general or abstract nouns:

La vida es dura.
Life is hard.

Con el dinero no se puede comprar la felicidad.
You can't buy happiness with money.

La paz es una idea valiosa.
Peace is a valuable idea.

When the Quantity is Vague

The article is omitted when the sentence implies *some, any, each,* or *many.*

Necesito dinero para comprar comida.
I need some money to buy some food.

However, if the noun is modified, the definite article is used:

Necesito el dinero que me dio mi abuelita para comprar libros.
I need the money my grandma gave me to buy books.

When Referring to a Person

The definite article is used with titles when referring to a person. It is omitted when addressing the individual or with the titles **don, doña, Santo, San** and **Santa.**

El rey Juan Carlos es un gran hombre.
King Juan Carlos is a great man.

El señor Ramírez es el dueño del apartamento.
Mr. Ramírez is the owner of the apartment.

La señorita María está estudiando la lección.
Miss María is studying the lesson.

But,

¿Cómo está usted, Señor Ramírez?
How are you, Mr. Ramírez?

Don Juan es un personaje famoso en la literatura.
Don Juan is a famous literary character.

Santo Domingo fundó la orden domínica.
Saint Dominic was the founder of the Dominican order.

When Referring to Languages

The definite article is used before all languages except when the name of the language follows the verb **hablar** or the prepositions **a, en,** and **de:**

El español es un idioma importante.
Spanish is an important language.

El inglés es el idioma internacional para el negocio.
English is the international language for business.

But,

Juan habla español muy bien.
John speaks Spanish very well.

La clase de español es interesante.
The Spanish class is interesting.

En inglés se dice, "Thank you."
In English you say, "Thank you."

With Verbs Related to Learning

The article is omitted with verbs related to learning, such as **aprender, escribir, enseñar, estudiar,** and **leer:**

Yo aprendo español.
I learn Spanish.

Ellos estudian francés.
They study French.

Tú lees alemán.
You read German.

In Place of the Possessive Adjective

The definite article is used in place of possessive adjectives when referring to parts of the body or articles of clothing, when the possessor is clear.

Me lavo la cabeza.
I wash my head.

Nosotros nos cepillamos el cabello.
We brush our hair.

Se quita la camisa.
He takes off his shirt.

Ella se pone el sombrero.
She puts her hat on.

With Names of Seasons

The definite article is used with the names of the seasons:

En el verano, nos vamos de vacaciones a España.
During the summer, we will go on vacation to Spain.

Me gusta ir a esquiar en el invierno.
I like to go to skiing during the winter.

With the Time of Day

The definite article is also used with the time of the day:

A las ocho empieza mi primera clase.
My first class begins at eight.

Te veré en la biblioteca a las tres.
I'll see you at the library at three.

With Days of the Week

In Spanish, unlike in English, the definite article is used with the days of the week, with the exception of when the day of the week is preceded by the verb **ser**:

Siempre vamos al cine los sábados.
We always go to the movies on Saturdays.

El lunes no hay clases.
On Monday, there is no school.

La tarea es para el lunes.
The homework is due on Monday.

But,

Mañana es lunes.
Tomorrow is Monday.

Hoy es domingo.
Today is Sunday.

With Countries, States, or Cities

The definite article is omitted with most countries, states, or cities. However, there are some occasions when it is used:

los Estados Unidos de América	*The United States of America*
la Argentina	*Argentina*
el Canadá	*Canada*
el Japón	*Japan*
el Perú	*Peru*
la India	*India*
la China	*China*
el Cairo	*Cairo*

The article is omitted with these countries *after* a preposition.

Los Estados Unidos es un país muy grande.
The United States is a big country.

But,

Salen de Perú y van para Canadá.
They are leaving Peru and going to Canada.

When Naming Mountains, Rivers, and Oceans

The definite article is used before names of mountains, rivers, and oceans:

Los Andes están en América del Sur.
The Andes are in South America.

El Ebro es el río más grande de España.
The Ebro is the biggest river in Spain.

El Pacífico es el océano más grande del mundo.
The Pacific Ocean is the biggest ocean in the world.

With Quantities, Weights, and Measures

The definite article is used instead of the indefinite article with quantities, weights, and measures.

La docena de huevos cuesta cien pesos.
A dozen eggs costs one hundred pesos.

El kilo de carne de res cuesta tres euros.
One kilogram of beef costs three euros.

Esta tela cuesta treinta mil pesos el metro.
This material costs thirty thousand pesos per meter.

With the Contractions a + el (al) and de + el (del)

The masculine singular definite article **el** is contracted with the preposition **de** to form the word **del,** and with the preposition **a** to become **al.** These contractions are not used with the masculine plural or with the feminine forms of the definite article.

Todos hablan bien del hombre.
Everyone speaks well about the man.

Necesito cambiarle las bujías al automóvil.
I need to change the spark plugs in the car.

Vamos a la casa de Juan.
We are going to John's house.

A las tres iremos a la biblioteca.
At three we will go to the library.

El profesor les da buenas notas a los estudiantes.
The professor gives good grades to the pupils.

Acabo de salir de la clase de física.
I just came out of the physics class.

Luis tiene las entradas de las chicas.
Louis has the girls' tickets.

De los zapatos que compré, solamente me gustan dos pares.
Of the shoes that I purchased, I like only two pairs.

Test Yourself: 1) Write the correct definite article for the following list of words.

1. autobús
2. papeles
3. avión
4. acción
5. agua
6. arma
7. aceituna
8. amiga
9. casa
10. cuaderno
11. águilas
12. hachas
13. blusas
14. almohada
15. yeguas
16. aguas
17. altura
18. muchachos
19. almas
20. caballo

Test Yourself: 2) Answer the following questions.

1. ¿Qué idioma hablas? (español)
2. ¿Qué usas cuando hace sol? (sombrero)
3. ¿Cuál es tu estación preferida? (invierno)
4. ¿A qué hora termina la escuela? (3:00)
5. ¿Para cuándo son las entradas de la ópera? (sábado)
6. ¿Qué día es mañana? (martes)
7. ¿A dónde vas? (Bolivia)
8. ¿Dónde está el Japón? (Asia)
9. ¿De qué color es el coche de tu padre? (azul)
10. ¿Cuál es el río más largo de España? (Ebro)

Indefinite Articles

The indefinite article *(a, an, some)* in Spanish refers to a person or thing not known to the subject who is speaking. It refers to any member of a class or group. There are four indefinite articles in Spanish: **un, una, unos,** and **unas.** The plural of the masculine **un** is **unos,** and the plural of the feminine **una** is **unas.**

una cuchara	a *spoon*	**un libro**	a *book*
unas cucharas	some *spoons*	**unos libros**	some *books*
un hombre	a *man*	**una pera**	a *pear*
unos hombres	some *men*	**unas peras**	some *pears*

Indefinite Articles and Feminine Words That Begin with a Stressed a

Like the feminine nouns that need the masculine article **el** when the first syllable is stressed, the same occurs when the indefinite article is used. These nouns take the indefinite article **un** instead of **una.**

un agua	*water*	**unas hachas**	*axes*
unas aguas	*waters*	But,	
un águila	*eagle*		
unas águilas	*eagles*	**una acción**	*action*
un alma	*soul*	**una aceituna**	*olive*
unas almas	*souls*	**una almohada**	*pillow*
un arma	*weapon*	**una altura**	*height*
unas armas	*weapons*	**una amiga**	*friend*
un hacha	*ax*		

With the Verb Ser

Unlike in English, in Spanish, the indefinite article is omitted after the verb **ser** when followed by a noun that is unmodified. However, the indefinite article is used when the noun is modified.

Ella es artista.
She is an artist.

Ella es una artista famosa.
She is a famous artist.

Unamuno es escritor.
Unamuno is a writer.

Unamuno es un escritor conocido.
Unamuno is a known artist.

With Non-Specific Entities

The indefinite article is used when referring to non-specific entities.

Hay un estudiante en su oficina.
There is a student in your office.

When Emphasizing a Number in Negative Expresssions

The indefinite article is also used in negative expressions when emphasizing the concept of a number.

No tenía ni un centavo.
I didn't have a single cent.

Ella no quería oir ni una palabra más.
She didn't want to hear one more word.

With Certain Words and Expressions

The indefinite article is omitted before any form of the words **otro, cierto, mil, cien, ciento, medio** and after the words **tal** and **que** in exclamations.

Ella necesita otra oportunidad.
She needs another opportunity.

Vinieron cien personas a la reunión
One hundred people came to the reunion.

¡Qué hombre!
What a man!

Test Yourself: 3) Write the appropriate indefinite article that corresponds to the words listed below.

1. mujer
2. libro
3. cuadernos
4. cuchara
5. zapato
6. arma
7. almas
8. almohada
9. amigo
10. casas
11. edificio
12. comedor
13. trenes
14. televisores
15. edificio
16. hachas
17. estudiante
18. persona
19. boleto
20. autobuses

Test Yourself: 4) Complete the following sentences with the correct indefinite article.

1. Jorge va a ___ café antes de ir al trabajo.
2. Yo fui a ___ tintorería a buscar mi ropa.
3. En ___ universidad se educan a los profesionales del futuro.
4. ___ jardín debe tener flores bellas.
5. Vamos a ___ plaza que está cerca del banco.
6. Juan tiene ___ cuenta en el banco.
7. Hay ___ examen el próximo lunes.
8. La familia Sánchez tiene ___ casa de veraneo preciosa.
9. Nueva York es ___ ciudad inmensa e interesante.
10. ___ obra maestra de la literatura mundial es *El ingenioso hidalgo Don Quijote de la Mancha.*

Test Yourself: 5) Complete the following sentences with the appropriate indefinite article when needed.

1. Gabriela Mistral es ___ escritora famosa.
2. Felipe tiene _____ talento enorme.
3. Quiero _____ otra galleta.
4. El es ___ pintor.
5. Carlos Miguel es ___ estudiante brillante.
6. La señorita tiene ___ educación extraordinaria.
7. Luisa desea ser ___ ingeniera.
8. En este restaurante hay ___ cocinero muy bueno.
9. Necesitamos _____ mil dólares para comprar eso.
10. El abogado es ___ alumno del profesor López.

TIME OF DAY, DATES, AND WEATHER EXPRESSIONS

In the following section you will learn about the expressions used for telling time, the date, and what the weather is like.

Time of Day

To be able to ask or to tell time is a very important factor in any language in order to attend a meeting; take a plane, a train, or a bus; or simply know whether you are on schedule. The following are ways to ask or tell time in Spanish, along with a typical response:

¿Qué hora es?
What time is it?

Es la una de la tarde.
It is one o'clock in the afternoon.

Notice that when asking for the time in Spanish, the singular form of the verb is always used. This is always the case even if a plural answer is expected.

¿Qué hora es?
What time is it?

Son las siete de la mañana.
It is seven o'clock in the morning.

Son las ocho y cinco.
It is five minutes after eight.

Son las ocho y quince.
It is fifteen minutes after eight.

Son las once y cuarenta y cinco.
It is forty five minutes after eleven.

Son las once menos diez.
It is ten minutes to eleven.

Son las once y cincuenta y cinco.
It is fifty five minutes after eleven.

Es la una.
It's one o'clock.

Son las dos.
It's two o'clock.

In Spanish, like in English, the words quarter and half are employed to tell time.

Son las ocho y cuarto.
It is a quarter past eight.

Son las nueve y media.
It is half past nine.

Son las diez menos cuarto.
It is a quarter to ten.

To tell time, the expression **faltar** + minutes + **para** + hour can be used:

Son las diez menos trece.
It is thirteen minutes to ten.

Or,

Faltan trece minutos para las diez.
It is thirteen minutes to ten.

¿A qué hora llega Juan?
At what time does Juan arrive?

¿A qué hora sales tú?
At what time do you leave?

Yo salgo por la mañana.
I leave in the morning.

Tú sales en la madrugada.
You leave at daybreak.

Él sale al mediodía.
He leaves at noon.

Nosotros salimos por la tarde.
We leave in the afternoon.

Vosotros salís por la noche.
You leave at night.

Ellos salen a las seis en punto.
They leave at six o'clock sharp.

Test Yourself: 6) Write the time corresponding to the numbers given. Do not repeat the same answer twice.

1. 07:00	6. 11:30
2. 08:10	7. 12:42
3. 09:15	8. 12:45
4. 09:15	9. 12:45
5. 11:30	10. 12:00

Dates

To be able to tell dates correctly is equally practical and important. Cardinal numbers, not ordinal numbers, are used to tell dates with the exception of **primero** *(first)*.

In Spanish, only the first letter of proper names and the first letter of a sentence are written in uppercase. All other letters are written in lowercase. This also applies to the months of the year and days of the week.

The years in Spanish are expressed in terms of thousands and hundreds. Also, keep in mind that when writing the date in Spanish, the day is written before the month, followed by the year.

¿Cuál es la fecha de hoy?
What date is today?

Hoy es el quince de septiembre.
Today is the fifteenth of September.

Hoy es el primero de octubre.
Today is the first of October.

Hoy es lunes, catorce de noviembre de mil novecientos noventa.
Today is Monday, November fourteenth, nineteen hundred and ninety.

¿En qué año estamos nosotros?
What year are we in?

Este año es el dos mil cinco.
This year is two thousand five.

¿En qué fecha llega el cargamento?
On what date does the shipment arrive?

Llega el tres de junio.
It arrives on June third.

Test Yourself: 7) Write the following dates in Spanish.

1. January 4
2. February 14
3. July 4
4. October 12
5. September 3

6. October 8
7. November 12
8. August 22
9. June 19
10. May 28

Weather Expressions

In the following section you will find ways of expressing what the weather is like. Notice that the verbs that are used the most are *hacer* and *estar*.

¿Qué tiempo hace hoy?
What is the weather like today?

¿Cómo está el día hoy?
How is the day today?

El día está claro.	*The day is clear.*	**agradable.**	*comfortable.*
soleado.	*sunny.*	**nublado.**	*cloudy.*
caluroso.	*warm.*	**lluvioso.**	*rainy.*
frío.	*cold.*	**húmedo.**	*humid.*
despejado.	*clear.*	**seco.**	*dry.*

Many weather expressions require the verb **hacer**:

Hace frío.	*It's cold.*
Hace calor.	*It's hot.*
Hace viento.	*It's windy.*

Hace mucho viento.
It's very windy.

Hace muy buen tiempo.
The weather is very nice.

Hay can also be used to speak about *observed* weather conditions:

Hay mucho sol hoy.
It is very sunny today.

Hay viento y llueve.
It is windy and raining.

Other verbs used with weather expressions are:

Llover.	*To rain*
Nevar.	*To snow*

Test Yourself: 8) Answer the following sentences according to the words given in parentheses.
María y Jorge fueron al parque. Al salir de la casa, ellos miraron el cielo y el día estaba _____(1) (sunny) y un poco _____(2) (warm). Al tomar el autobús, Maria notó que el cielo estaba _____(3) (clear). Era un día _____(4) (comfortable) aunque estaba un poco _____(5) (humid). Ellos llegaron al parque y pasaron un día maravilloso. De regreso a la casa por la tarde, el cielo se puso _____(6) (cloudy) y negro. Apenas ellos llegaron a casa empezó a _____(7) (to rain) fuertemente. ¡Qué suerte tenemos! exclamaron Jorge y María.

NOUNS

Nouns in Spanish have a gender and a number. The gender determines whether a noun is masculine or feminine. The number determines whether a noun is singular or plural.

Singular and Plural Nouns

Nouns that end in a vowel become plural when an –s is added to the end of the word. For nouns that end in a consonant, an –es is added to the end of the word to make them plural. When nouns end in –z, the –z changes to –c before making them plural. Also, certain nouns (such as days of the week) that end in –es remain unchanged when made plural.

singular	**muchacho**	**muchacha**
plural	**muchachos**	**muchachas**
singular	**automóvil**	**libertad**
plural	**automóviles**	**libertades**
singular	**lápiz**	**matriz**
plural	**lápices**	**matrices**
singular	**lunes**	
plural	**lunes**	

Masculine and Feminine Nouns

Nouns in Spanish are either masculine or feminine; most nouns ending in –o are masculine. Most nouns that end in –a are feminine.

Here are some examples of masculine nouns:

el muchacho	*boy*	**el tiempo**	*weather, time*
el libro	*book*	**el cuaderno**	*notebook*
el camino	*road, path*	**el zapato**	*shoe*
el pelo	*hair*	**el edificio**	*building*

Likewise, here are some feminine nouns:

la muchacha	*girl*	**la noticia**	*news*
la silla	*chair*	**la alfombra**	*rug*
la computadora	*computer*	**la ventana**	*window*
la tienda	*store*	**la puerta**	*door*
la lámpara	*lamp*	**la mesa**	*table*

Exceptions to this rule are some masculine words that end in –a, –ma, –pa, –ta:

el día	*day*	**el idioma**	*language*
el mapa	*map*	**el problema**	*problem*
el planeta	*planet*	**el poema**	*poem*
el programa	*program*	**el drama**	*drama*
el tema	*theme*		

There are a few nouns that end in –o that are feminine:

la mano	*hand*	**la moto**	*motorcycle*
la radio	*radio network*	**la foto**	*photograph*

Note that **la moto** and **la foto** are feminine because these words are derived from the words **la moto-cicleta** and **la fotografía.**

Nouns ending in **–dad, –tad, –tud, –umbre, –ie,** or **–ión** are normally feminine (except for avión and camión).

la igualdad	*equality*	**la muchedumbre**	*crowd*
la libertad	*liberty*	**la costumbre**	*custom*
la tempestad	*storm*	**la serie**	*series*
la altitud	*altitude*	**la canción**	*song*
la latitud	*latitude*	**la inversión**	*investment*

Nouns ending in **–e** tend to be masculine, especially when they refer to the human body or a person:

el jinete	*horseman*	**el aire**	*air*
el pie	*foot*	**el traje**	*suit*
el vientre	*womb*	**el cine**	*cinema*
el monje	*monk*	**el deporte**	*sport*
el hombre	*man*	**el puente**	*bridge*
el nombre	*name*	**el diente**	*tooth*

However, there are other nouns that end in **–e** that are feminine:

la frente	*forehead*	**la gente**	*people*
la calle	*street*	**la mente**	*mind*
la leche	*milk*	**la llave**	*key*
la noche	*night*	**la clase**	*class*
la nube	*cloud*		

Some nouns that allude to people do not change their form when the gender is inverted, including all nouns ending in **–ista:**

el dentista, la dentista	*dentist*	**el paciente, la paciente**	*patient*
el columnista, la columnista	*columnist*	**el joven, la joven**	*young*
el estudiante, la estudiante	*student*		*person*

Nouns that refer to days of the week, names of rivers, and names of oceans are masculine:

el jueves	*Thursday*	**el Atlántico**	*Atlantic*
el domingo	*Sunday*	**el Pacífico**	*Pacific*

Other nouns are masculine or feminine, depending on their meaning:

el capital	*capital investment*	**el orden**	*order, arrangement*
la capital	*capital city*	**la orden**	*command*
el policía	*policeman*	**el cura**	*priest*
la policía	*police department*	**la cura**	*cure*
el cometa	*comet*	**el Papa**	*pope*
la cometa	*kite*	**la papa**	*potato*
el cólera	*cholera*	**el corte**	*cut*
la cólera	*anger*	**la corte**	*court*
el frente	*firing line*	**el radio**	*radio*
la frente	*forehead*	**la radio**	*radio network*

Test Yourself: 9) Complete the following dialogue with the appropriate definite article.

Juan: Miguel, ¿Te gustan _____(1) deportes?

Miguel: Sí, me gusta _____(2) equitación.

Yo soy _____(3) mejor jinete en este club.

Juan: ¿Es un deporte peligroso?

Miguel: No, aunque _____(4) otro día me caí.

Juan: ¿Cómo está tu golpe en _____(5) frente?

Miguel: Mejor, gracias. Casi me rompo _____(6) dientes al caer.

Juan: ¿Cómo se llama tu equipo?

Miguel: _____(7) nombre del equipo es Monterrey.

Juan: ¿Tomas clases de equitación?

Miguel: _____(8) clase de equitación es a_____(9) tres.

¿Qué haces con tu tiempo libre?

Juan: Me gusta caminar. Me encanta_____(10) aire puro del parque.

Test Yourself: 10) Complete the following sentences by using the words provided. When writing the answer, use the correct form of the word with the definite article.

dentista	capital	orden
estudiante	frente	cura
paciente	policía	corte

1. _____ es una buena especialista de dientes.
2. _____ está muy preocupada por los crímelles.
3. _____ es el antídoto que el científico encontró.
4. _____ es una persona dedicada a Dios y a los hombres.
5. _____ es la ciudad principal de este país.
6. _____ acaba de ser admitido al hospital.
7. _____ que la compañía invirtió es mucha cantidad de dinero.
8. _____ es una parte importante del cuerpo humano.
9. _____ que el general recibió es un pedido del presidente.
10. _____ no ha decidido el veredicto.

Test Yourself: 11) Complete the following sentences with the appropriate definite article.

1. _____ casa está en la esquina.
2. _____ idioma oficial de México es el español.
3. _____ mapa es muy antiguo.
4. _____ igualdad de los hombres es un derecho inalienable.
5. _____ moto es un medio útil de transporte.
6. _____ universidad es una institución educativa.
7. _____ río Hudson pasa por la ciudad de Nueva York.
8. _____ Pacífico es el océano más grande del mundo.
9. _____ domingo es un día de descanso.
10. _____ joven francesa habla muy bien el español.
11. _____ llave de tu casa está en el escritorio.
12. _____ Amazonas es un río caudaloso.
13. _____ puente más largo del mundo está en California.
14. _____ presidenta del país es muy inteligente y justa.
15. _____ nube es inmensa.

Test Yourself: 12) Write the plural of the following nouns.

1. el muchacho
2. el estudiante
3. la paciente
4. la doctora
5. el automóvil
6. la opinión
7. el lápiz
8. el miércoles
9. el tema
10. la tarea

Test Yourself Answers

1)
1.	el	11.	las
2.	los	12.	las
3.	el	13.	las
4.	la	14.	la
5.	el	15.	las
6.	el	16.	las
7.	la	17.	la
8.	la	18.	los
9.	la	19.	las
10.	el	20.	el

2)
1. Yo hablo español.
2. Uso el sombrero.
3. Mi estación preferida es el invierno.
4. La escuela termina a las tres.
5. Las entradas son para el sábado.
6. Mañana es martes.
7. Voy a Bolivia.
8. El Japón está en Asia.
9. El coche de mi padre es azul.
10. El río más grande de España es el Ebro.

3)
1.	una	11.	un
2.	un	12.	un
3.	unos	13.	unos
4.	una	14.	unos
5.	un	15.	un
6.	un	16.	unas
7.	unas	17.	un/una
8.	una	18.	una
9.	un	19.	un
10.	unas	20.	unos

4)
1.	un	6.	una
2.	una	7.	un
3.	una	8.	una
4.	Un	9.	una
5.	una	10.	Una

5)
1.	una	6.	una
2.	un	7.	__
3.	__	8.	un
4.	__	9.	__
5.	un	10.	__

6)
1. Las siete.
2. Las ocho y diez.
3 y 4. Las nueve y quince.
3 y 4. Las nueve y cuarto.
5 y 6. Las once y treinta.
5 y 6. Las once y media.
7. Las doce y cuarenta y dos.
8 y 9. Las doce y cuarenta y cinco.
8 y 9. La una menos cuarto o la una menos quince.
10. Las doce.

7)
1. El cuatro de enero.
2. El catorce de febrero.
3. El cuatro de julio.
4. El doce de octubre.
5. El tres de septiembre.
6. El ocho de octubre.
7. El doce de noviembre.
8. El veinte y dos o veintidós de agosto.
9. El diez y nueve de junio o el diecinueve de junio.
10. El veinte y ocho de mayo o el veintiocho de mayo

8)
1.	soleado	5.	húmedo
2.	caluroso	6.	nublado
3.	claro	7.	llover
4.	agradable		

9)
1.	los	4.	el
2.	la	5.	la
3.	el	6.	los

7. El 9. las

8. La 10. el

10) 1. La dentista 6. El paciente

2. La policía 7. El capital

3. La cura 8. La frente

4. El cura 9. La orden

5. La capital 10. La corte

11) 1. La 4. La

2. El 5. La

3. El 6. La

7. El 12. El

8. El 13. El

9. El 14. La

10. La 15. La

11. La

12) 1. los muchachos 6. las opiniones

2. los estudiantes 7. los lápices

3. las pacientes 8. los miércoles

4. las doctoras 9. los temas

5. los automóviles 10. las tareas

Adjectives

An adjective is the part of the sentence that modifies a noun. They tell you what that noun is like—tall, short, good, bad, etc. In the following chapter we will look at the different types of adjectives and how they change in gender and number to agree with the noun they are modifying.

TYPES OF ADJECTIVES

Unlike English, adjectives in Spanish can change gender and number. They can be masculine, feminine, singular or plural.

Masculine Adjectives

Most adjectives in Spanish end in **–o,** and these adjectives are masculine. To form the plural of masculine singular adjectives, add an **–s** to the end of the word.

Adjectives must agree in gender and number with the nouns they modify. When an adjective modifies two or more nouns of different gender, the masculine plural is used. For example: **La cartera,** el **sombrero** y el **pañuelo** de esa chica son **rojos.**

Here are some examples of masculine adjectives:

Singular	Plural	
bueno	**buenos**	*good*
malo	**malos**	*bad*
alto	**altos**	*tall*
bajo	**bajos**	*short*
pequeño	**pequeños**	*small*
flaco	**flacos**	*skinny*
delgado	**delgados**	*slim*
esbelto	**esbeltos**	*slender*
gordo	**gordos**	*fat*
obeso	**obesos**	*obese*
guapo	**guapos**	*handsome*
feo	**feos**	*ugly*
atlético	**atléticos**	*athletic*
educado	**educados**	*educated*

El muchacho alto es mi amigo.
The tall boy is my friend.

Los muchachos altos son mis amigos.
The tall boys are my friends.

Feminine Adjectives

The feminine singular of adjectives ending in **–o** is formed by changing the **–o** to an **–a.** The feminine plural is formed by adding an **–s** to the feminine singular form.

Examples of feminine adjectives are as follows:

Singular	Plural	
bonita	**bonitas**	*pretty*
bella	**bellas**	*beautiful*
hermosa	**hermosas**	*beautiful*
magnífica	**magníficas**	*magnificent*
aplicada	**aplicadas**	*diligent*
extraordinaria	**extraordinarias**	*extraordinary*
carismática	**carismáticas**	*charismatic*
astuta	**astutas**	*astute*
perceptiva	**perceptivas**	*perceptive*
activa	**activas**	*active*

Test Yourself: 1) Complete the appropriate ending of the following adjectives.

María es una chica precios _____ (1). Tod _____ (2) las personas admiran su belleza. Darío dice que ella es una persona magnífic _____ (3). Según Rosario, María es una muchacha estudios _____ (4) y trabajador _____ (5). Ricardo, el hermano de María, es un chico atlétic _____ (6) y esbelto. Él juega en el equipo de fútbol de la universidad. Sus buen _____ (7) amigos son Andrés y Rosario. Andrés es gord _____ (8) pero muy educad _____ (9). Rosario es una muchacha aplicad _____ (10).

Test Yourself: 2) Write the feminine form of the following adjectives.

1. malo
2. alto
3. bajo
4. flaco
5. delgado
6. bonito
7. bello
8. hermoso
9. magnífico
10. educado

Test Yourself: 3) Write the plural of the following phrases.

1. un muchacho guapo
2. una chica astuta
3. el edificio alto
4. la bicicleta roja
5. el automóvil pequeño

Adjectives Ending in –e

Many adjectives end in the vowel **–e.** These adjectives use the same form for the masculine and feminine. To form the plural of these adjectives, add an **–s** to the ending.

Mario vive en un edificio grande.
Mario lives in a big building.

Mario vive en una casa grande.
Mario lives in a big house.

Mario tiene unas casas grandes.
Mario has several big houses.

Singular	Plural	
grande	**grandes**	*large*
enorme	**enormes**	*huge*
responsable	**responsables**	*responsible*
inteligente	**inteligentes**	*intelligent*
amable	**amables**	*kind*
humilde	**humildes**	*humble*
importante	**importantes**	*important*
excelente	**excelentes**	*excellent*
deseable	**deseables**	*desirable*
razonable	**razonables**	*reasonable*
admirable	**admirables**	*admirable*
paciente	**pacientes**	*patient*
distante	**distantes**	*distant*

Test Yourself: 4) Complete the following sentences with the appropriate form of the adjective given in parentheses.

1. Julio es un hombre _____ (grande).
2. María es una muchacha _____ (humilde).
3. Los profesores piden un aumento _____ (razonable).
4. Los estudiantes son muy _____ (inteligente).
5. Las ciudades están _____ (distante).
6. Mario es un muchacho _____ (excelente).
7. El juez es un hombre _____ (prudente).
8. Las casas están en una comunidad _____ (importante).
9. Los estudiantes están _____ (triste).
10. Las flores son _____ (verde).

Adjectives Ending in Consonants

Most adjectives that end in a consonant have the same form in the masculine and the feminine. To form the plural of these adjectives, add an **–es.**

Él es un muchacho joven.
He is a young man.

Ellos son unos muchachos jóvenes.
They are young men.

Ella es una muchacha joven.
She is a young woman.

Ellas son unas muchachas jóvenes.
They are young women.

Singular	Plural	
joven	**jóvenes**	*young*
popular	**populares**	*popular*
sentimental	**sentimentales**	*sentimental*
azul	**azules**	*blue*
gris	**grises**	*grey*
fácil	**fáciles**	*easy*
difícil	**difíciles**	*difficult*
normal	**normales**	*normal*
fenomenal	**fenomenales**	*phenomenal*

For adjectives with singular forms ending in **–z,** change the **–z** to a **–c** when making it the plural. Here are some examples:

El hombre feliz vive una vida larga.
A happy man lives a long life.

Las mujeres felices también viven una vida larga.
Happy women also live long lives.

Test Yourself: 5) Change the following adjectives from the singular to the plural.

1. azul
2. feliz
3. mortal
4. cortés
5. normal

6. difícil
7. gris
8. feroz
9. popular
10. veloz

Test Yourself: 6) Rewrite the following sentences in the plural.

1. El abogado es un hombre popular.
2. Esa flor es de color azul, verde y gris.
3. El hombre es un ser mortal.
4. Su carácter es gentil.
5. La profesora es fenomenal.

Adjectives of Nationality

Most adjectives of nationality, like many other masculine singular adjectives in Spanish, end in an **–o.** To form the plural, an **–s** is attached. The feminine singular is formed by changing the **–o** to an **–a.** To make the feminine plural form, add an **–s** to the feminine singular form.

Jorge es un ingeniero mexicano.
George is a Mexican engineer.

Marta es una doctora mexicana.
Martha is a Mexican doctor.

Jorge y Marta son mexicanos.
George and Martha are Mexican.

Marta y Luisa son mexicanas.
Martha and Luisa are Mexican.

Masculine	Feminine	
Singular, Plural	Singular, Plural	
norteamericano(s)	**norteamericana(s)**	*North American*
mexicano(s)	**mexicana(s)**	*Mexican*
guatemalteco(s)	**guatemalteca(s)**	*Guatemalan*
hondureño(s)	**hondureña(s)**	*Hondurian*
salvadoreño(s)	**salvadoreña(s)**	*Salvadorian*
panameño(s)	**panameña(s)**	*Panamanian*
colombiano(s)	**colombiana(s)**	*Colombian*
venezolano(s)	**venezolana(s)**	*Venezuelan*
ecuatoriano(s)	**ecuatoriana(s)**	*Ecuadorian*
peruano(s)	**peruana(s)**	*Peruvian*
chileno(s)	**chilena(s)**	*Chilean*
argentino(s)	**argentina(s)**	*Argentinian*
dominicano(s)	**dominicana(s)**	*Dominican*
cubano(s)	**cubana(s)**	*Cuban*
puertorriqueño(s)	**puertorriqueña(s)**	*Puerto Rican*
brasileño(s)	**brasileña(s)**	*Brasilian*
italiano(s)	**italiana(s)**	*Italian*
griego(s)	**griega(s)**	*Greek*
británico(s)	**británica(s)**	*British*
chino(s)	**china(s)**	*Chinese*
coreano(s)	**coreana(s)**	*Korean*
filipino(s)	**filipina(s)**	*Philippine*
indio(s)	**india(s)**	*Indian*

Adjectives of nationality that end in a consonant have four forms. The masculine singular is made into the plural by adding an **–es.** The masculine singular is changed into the feminine singular form by adding an **–a,** and an **–s** is added to the feminine singular form to make it plural.

Masculine	Feminine	
Singular,Plural	Singular, Plural	
español, españoles	**española, españolas**	*Spanish*
portugués, portugueses	**portuguesa, portuguesas**	*Portuguese*
francés, franceses	**francesa, francesas**	*French*
inglés, ingleses	**inglesa, inglesas**	*English*
irlandés, irlandeses	**irlandesa, irlandesas**	*Irish*
alemán, alemanes	**alemana, alemanas**	*German*
danés, daneses	**danesa, danesas**	*Danish*
japonés, japoneses	**japonesa, japonesas**	*Japanese*

Test Yourself: 7) Complete the following sentences with the appropriate form of the adjective in parentheses.

1. Este chico es (francés).
2. Esos señores son (norteamericano).
3. Ella es (español).
4. Sergio y Elena son (nicaragüense).
5. Este pasaporte es (chino).

6. Los estudiantes son (japonés).
7. La chica es (irlandés).
8. Este es un ejercicio (indio).
9. Los bailarines son (mexicano).
10. Las cantantes son (cubano).

Test Yourself: 8) Give the nationality of the people in the following countries according to context of the sentence.

Juan vive en Nueva York, él es un hombre (1) _____. Él es un administrador de empresas y viaja normalmente a muchos países. El año pasado él fue a México donde visitó a unos clientes (2) _____. Luego viajó a Puerto Rico a ver una fábrica de vidrios cuyos dueños son (3) _____. Después tomó un avión para Venezuela a dirigir un proyecto de agricultura (4) _____. Más tarde voló a Panamá a visitar a sus amigos (5) _____. Ellos lo invitaron a una fiesta en el Club de Banqueros donde conoció a personas de muchos países. Había un (6) _____ de Alemania; un (7) _____ de Italia; una (8) _____ de Dinamarca; unos (9) _____ de Grecia; unas ejecutivas (10) _____ de las Filipinas. Al día siguiente Juan regresó a los Estados Unidos porque extrañaba a su familia y deseaba estar con ellos.

Adjectives of Color

Adjectives of color like any other adjective agree in gender and number with the nouns they modify. However, do not confuse adjectives of color with Spanish nouns that refer to fruits, flowers, and minerals.

Mi automóvil azul está en el garage.
My blue car is in the garage.

Marta compró sus zapatos rojos en esa zapatería.
Martha bought her red shoes at that shoeshop.

La camisa amarilla está planchada.
The yellow shirt is ironed.

Las rosas blancas son mis preferidas.
White roses are my favorite.

Nouns	Adjectives	
rosa	*rose*	*pink*
café	*coffee*	*light brown*
naranja	*orange*	*orange*
violeta	*violet*	*purple*
vino	*wine*	*reddish purple*
castaño	*chestnut*	*chestnut*

When the above adjectives are used, the expression **de color** is normally used. Note that the adjectives that derive from these nouns do not agree in gender and number with the noun they modify. However, it is common to hear **los pantalones cafés.**

El sofá de color vino es muy elegante.
The reddish purple sofa is very elegant.

Los pantalones rosa son de algodón.
The pink pants are made of cotton.

Colors can be described further by naming the tone used. In this case, neither adjective agrees in gender and number with the noun it modifies.

Los pantalones azul marino.
The navy blue pants.

La casa verde oscuro.
The dark green house.

Las camisas de color azul claro.
The light blue shirts.

Test Yourself: 9) Complete the following sentences with the color given.
1. Esta camisa es _____. *(azul)*
2. Los pantalones de Luis son _____. *(negro)*
3. El edificio es _____. *(blanco)*
4. Las sillas son _____ *(amarillo)*
5. Los sombreros son _____. *(café)*
6. Los automóviles son de color _____. *(vino)*
7. Su cabello es _____. (castaño)
8. La pintura es de color _____ marino. *(azul)*
9. La tela es de color _____. *(naranja)*
10. Las hojas de estas plantas son _____. *(morado)*

POSITION OF ADJECTIVES

Adjectives in Spanish are normally placed after the noun. However, they can also be placed before the noun for stylistic purposes in order to emphasize the quality of the adjective.

Antonio es un estudiante bueno.
Anthony is a good student.

Antonio es un buen estudiante.
Anthony is a good student.

When some masculine singular adjectives are placed before a noun, the **–o** is dropped. Some of these adjectives are:

uno	**Un libro importante.**	*One important book.*
bueno	**Juan es un buen músico.**	*John is a good musician.*
malo	**Antonio es un mal escritor.**	*Anthony is a poor writer.*
primero	**El primer ministro está aquí.**	*The prime minister is here.*
tercero	**Éste es mi tercer libro.**	*This is my third book.*
alguno	**Algún día seré abogado.**	*Some day I will be a lawyer.*
ninguno	**José no tiene ningún interés en eso.**	*Joseph does not have any interest in that.*

The adjective **grande** becomes **gran** before a masculine or feminine singular noun. However, the meaning of the adjective changes in this case. When the adjective **grande** is placed after the noun, its meaning is big or large, but when the adjective **gran** is placed before the noun, its meaning is great or famous.

Un hombre grande
A big man.

Un gran hombre
A great man.

Una ciudad grande
A big city.

Una gran ciudad
A great city.

The adjective **santo** becomes **san** when placed before a masculine singular noun, except before names that begin with **to** and **do.**

San Juan de la Cruz
Saint John of the Cross

San Felipe Neri
Saint Philip Neri

Santo Domingo
Saint Dominic

Santo Tomás de Aquino
Saint Thomas Aquinas

Test Yourself: 10) Complete the following sentences with the appropriate form of the adjective given in parentheses.
1. En el garage hay _____ coche azul. (uno)
2. _____ persona pasó por aquí. (ninguno)
3. Éste es el _____ hombre que me pide dinero. (tercero)
4. Ella es una _____ administradora. (bueno)
5. Él es un _____ trabajador. (malo)
6. El _____ estudiante de la clase es Jorge. (primero)
7. La _____ cantante del concierto es Rocío. (primero)
8. Bolívar fue un _____ hombre. (grande)
9. _____ Domingo es la capital de la República Dominicana. (Santo)
10. _____ Francisco es una ciudad de California. (Santo)

ADJECTIVES THAT MAKE COMPARISONS

In using comparisons, adjectives continue to change in gender and number. There are different formats used depending on whether the comparison is between two or several things.

Regular Comparisons of Adjectives

To make a comparison between two items, the following formats used are:

más . . . que	*more . . . than*
menos . . . que	*less . . . than*

These formats can also be used with nouns and adverbs.

Isabel es más grande que José.
Elizabeth is bigger than Joseph.

José es más pequeño que Isabel.
Joseph is smaller than Elizabeth.

Esta casa es menos costosa que ésa.
This house is less expensive than that one.

Esa casa es más costosa que ésta.
That house is more expensive than this one.

El Océano Pacífico tiene más agua que el Océano Atlántico.
The Pacific Ocean has more water than the Atlantic Ocean.

The format **más de** and **menos de** is used to make comparisons with numbers when the sentence is affirmative.

Tengo más de tres mil dólares en el banco.
I have more than three thousand dollars in the bank.

Recibí menos de quinientos euros de paga.
I received less than five hundred euros as payment.

Test Yourself: 11) Make comparative sentences with the words given, using the comparative adjective **más . . . que** in the even-numbered sentences and **menos . . . que** in the odd-numbered sentences.
1. Este edificio / alto / el otro.
2. Isabel / inteligente / Raúl.
3. Esta silla / oscuro / ésa.
4. Esta ciudad / grande / Cali.
5. Antonio / fuerte / Luis.
6. El Museo Metropolitano / interesante / éste.
7. Las casas / lindo / los edificios.
8. El campo / verde / el parque.
9. El viaje por avión / largo / por autobús.
10. Esta temporada / lluvioso / la primavera.

Test Yourself: 12) Make comparative sentences according to the model.
modelo: **Luz es estudiosa. Marta no es estudiosa.**
Luz es más estudiosa que Marta.
1. Yo soy trabajador. Jorge no es trabajador.
2. José es alto. Miguel es pequeño.
3. Ester es fuerte. Julia no es fuerte.
4. Ellos son atentos. Él no es atento.
5. Ellas no son cómicas. Ellos son cómicos.

Adjectives Used in the Superlative

To form the superlative adjective in a sentence the following formats are used:

el . . .más . . . de *the most*
el . . . menos . . . de *the least*

The definite article agrees in gender and number with the noun that follows it. The superlative adjective is placed after **más** or **menos**. After the superlative adjective, the preposition **de** is translated as *in*.

Éste es **el** avión **más** rápido **del** mundo.
This is the fastest plane in the world.

Nueva York es **la** ciudad **más** grande del norte **de** los Estados Unidos.
New York is the biggest city in the north of the United States.

Juan es **el** chico menos alto **de** la escuela.
John is the shortest boy in the school.

Ellas son las estudiantes **más** inteligentes y guapas **de** la universidad.
They are the most intelligent and beautiful students in the university.

Juan es **el más** aplicado **de** la escuela.
John is the most diligent in the school.

Test Yourself: 13) Complete the following exercise using the superlative adjective **el . . . más . . . de** in odd-numbered sentences and the superlative adjective **el . . . menos . . . de** in even-numbered sentences.

1. Buenos Aires es _____ ciudad _____ grande _____ la Argentina.
2. Éstos son _____ estudiantes _____ estudiosos _____ la escuela.
3. El presidente es _____ hombre _____ importante _____ la clase.
4. Ellas son _____ asistentes _____ calificadas _____ el concurso.
5. El petróleo es _____ producto _____ útil _____ la industria.
6. Ésta es _____ fábrica _____ productiva _____ el área.
7. Lourdes es _____ empleada _____ trabajadora _____ la planta.
8. Ésa es _____ estación _____ limpia _____ la línea.
9. Nueva York es _____ ciudad _____ interesante _____ Norteamérica.
10. Éste es _____ automóvil _____ caro _____ la flota.

Test Yourself: 14) Make superlative sentences with the words given below, using the superlative adjective **el . . . más . . . de** in the even-numbered sentences and **el . . . menos . . . de** in the odd-numbered sentences.

1. Jorge / ser / muchacho / astuto / clase.
2. Granada / ser / ciudad / bella / Andalucia para Lorca.
3. Pablo / ser / pintor / conocido / Bogotá
4. Los Andes / ser / cordillera / alta / Sudamérica.
5. La educación / ser / prioridad / importante / la administración.
6. El petróleo / ser / producto / importante / Venezuela.
7. Ellos / ser / estudiante / aplicado / la universidad
8. Gloria / ser / cantante / buena / Puerto Rico
9. Este distrito / ser / demócrata / el país.
10. El Ebro / ser / río / largo / España.

Irregular Comparative Forms and the Superlative

The adjectives **bueno, malo, grande,** and **pequeño** have irregular forms for the comparative and superlative.

Este libro es mejor que aquél.
This book is better than that one.

El hemano menor de José es Víctor.
Joseph's youngest brother is Victor.

Positive	Comparative	Superlative
bueno	**mejor**	**el mejor**
buena	**mejor**	**la mejor**
buenos	**mejores**	**los mejores**
buenas	**mejores**	**las mejores**
good	*better*	*best*

Positive	Comparative	Superlative
malo	**peor**	**el peor**
mala	**peor**	**la peor**
malos	**peores**	**los peores**
malas	**peores**	**las peores**
bad	*worst*	*the worst*

Positive	Comparative	Superlative
grande mayor	**el mayor**	**la mayor**
grandes mayores	**los mayores**	**las mayores**
big (size)	*older (age)*	*the oldest (age)*
	más grande	**el más grande**
		la más grande
		los más grandes
		las más grandes
	larger	*the largest*
	menos grande	**el menos grande**
		la menos grande
		los menos grandes
		las menos grandes
	less large	*the least large*
	menor	**el menor**
	menor	**la menor**
	menores	**los menores**
	menores	**las menores**
	younger	*the youngest*
	más pequeño	**el más pequeño**
	más pequeña	**la más pequeña**
	más pequeños	**los más pequeños**
	más pequeñas	**las más pequeñas**
	smaller	*the smallest*
	menos pequeño	**el menos pequeño**
	menos pequeña	**la menos pequeña**
	menos pequeños	**los menos pequeños**
	menos pequeñas	**las menos pequeñas**
	less small	*the least small*

When the comparative adjectives are used, the word **que** is always needed. Notice that comparative adjectives do not require articles. Only definite articles are used in the superlative.

Ella es mejor jugadora que Alicia.
She is a better player than Alice.

Ella es la mejor jugadora de la liga.
She is the best player in the league.

The adjectives **mayor** and **menor** denote age rather than size.

Andrés es mayor que Luis.
Andrew is older than Louis.

Julio es el mayor de todos.
Julio is the oldest of all.

To express size, the adjectives **grande** and **pequeño** are used:

El edificio es más grande que la casa.
The building is bigger than the house.

Los niños son más pequeños que los adultos.
Children are smaller than adults.

The adjectives **mejor** and **peor** are normally placed before the noun:

Mi mejor asignatura es el español.
My best subject is Spanish.

Mis peores días son en el invierno.
My worst days are in the winter.

Test Yourself: 15) Complete the following sentences by using the appropriate comparative or superlative adjectives according to the sentences given.

1. Esta computadora es buena. Es _____ la otra, pero no es
 _____ de todas.
2. Esta comida es mala. Es _____ la de ayer, pero no es
 _____ de todas.
3. Este edificio es grande. Es _____ que el otro, pero no es
 _____ de todos.
4. Estas industrias son pequeñas. Son _____ las otras, pero no
 son _____ de todas.

Test Yourself: 16) Complete the following sentences with the appropriate comparative adjectives.

1. Luis es _____ su amigo Jorge. *(tiene más años)*
2. Este libro es _____ el otro. *(es más importante)*
3. El detergente es _____ este. *(es menos efectivo)*
4. Juan es _____ su hermano. *(tiene menos años)*
5. José es _____ que Raúl. *(tiene menos estatura)*
6. Este coche es _____ que aquél. *(tiene más tamaño)*
7. Esta casa es _____ que ésa. *(tiene menos área)*
8. El edificio es _____ que éste. *(tiene menos pisos)*
9. Carolina es _____ Luisa. *(tiene menos años)*
10. Ella es _____ él. *(Tiene más edad)*

Absolute Superlative Adjectives

When the suffix **–ísimo** is added to the adjective, the absolute superlative is formed. The equivalent translation in English is *most, very,* or *extremely.* When the adjective ends in a vowel in the singular, the vowel is substituted by the ending **–ísimo.** When the adjective ends in a consonant, the ending **–ísimo** is added to the adjective, except for words ending in **–z,** which change to **–c** before adding the ending. Like other adjectives, absolute superlative adjectives agree in gender and number with the nouns they modify.

Éste es un país lindísimo.
This is a very beautiful country.

Es una mujer inteligentísima.
She is a very intelligent woman.

Una señorita inteligentísima.
A very intelligent young lady.

Unas lanchas velocísimas.
Some very quick boats.

bueno	*good*	**buenísimo**	*very good*
malo	*bad*	**malísimo**	*very bad*
inteligente	*intelligent*	**inteligentísimo**	*most intelligent*
veloz	*quick*	**velocísimo**	*very quick*

Test Yourself: 17) Rewrite the following sentences by using the absolute superlative adjective required.

1. Este modelo es guapo.
2. Este coche es veloz.
3. María es inteligente
4. Ellos son personas buenas.
5. Esta verdura es mala.

Regular Comparisons of Equality

The comparative adjective is used to compare two items of the same characteristics or significance. In order to make this comparison, the words **tan . . . como** are used, which in English mean *as . . . as.*

El automóvil azul es tan cómodo como el blanco.
The blue automobile is as comfortable as the white.

Este estudiante es tan inteligente como aquél.
This student is as intelligent as that one.

Nouns can also be compared by using the expression **tanto . . . como,** which in English is translated *as much* or as *many . . . as.* Notice that the word **tanto** agrees with the noun it modifies within the expression.

Julio hace tanto trabajo como Juan.
Julio does as much work as John.

Elena y Josefina compran tantas cosas como María.
Helen and Josephine buy as many things as Mary.

This expression can be used as a pronoun in the following manner. In this case, the meaning *as much* or as *many . . . as* does not change.

Él gana tanto como José.
He makes as much as Joseph.

Estudiamos tanto como ellos.
We study as much as they do.

Test Yourself: 18) Using the model provided, write comparative sentences with the words given.
modelo: **Bajo: Roberto es tan bajo como Juan.**

1. amable:	6. trabajador:
2. serio:	7. cómico:
3. alegre:	8. perceptivo:
4. estudioso:	9. astuto:
5. guapo:	10. bueno:

Test Yourself: 19) Complete the following sentences with the correct form of the expression **tanto . . . como.**

1. Luis tiene _____ paciencia _____ Luisa.
2. Yo estudio _____ matemáticas _____ José.
3. Ellos trabajan _____ horas _____ ellas.
4. La fábrica produce _____ leche _____ queso.
5. Vosotros tenéis _____ tarea _____ yo.
6. Ellas caminan _____ kilómetros _____ nosotros.
7. Su madre prepara _____ comida _____ su tía.
8. Tú ves _____ ganado _____ él.
9. Esta exposición tiene _____ pinturas _____ aquélla.
10. A mí me gusta _____ el chocolate _____ la naranja.

CARDINAL NUMBERS

The use of numbers in any language is of great importance because with these you can communicate things like your age, address, phone numbers, etc. Numbers can be expressed in different ways, whether it's with the cardinal numbers (one, two, three) or with ordinal numbers (first, second, third). In the following section we will study numbers and how some of them change gender according to the noun they are modifying.

Tengo quince años de edad.
I am fifteen years old.

Ella vive en la calle Aragon número diez y ocho.
She lives at 18 Aragon Street.

Mi hermana tiene diez y seis años.
My sister is sixteen years old.

Mi hermano tiene dieciséis años también.
My brother is sixteen years old too.

The cardinal numbers from 0 to 20 in Spanish are:

0	**cero**	11	**once**
1	**uno**	12	**doce**
2	**dos**	13	**trece**
3	**tres**	14	**catorce**
4	**cuatro**	15	**quince**
5	**cinco**	16	**diez y seis**
6	**seis**	17	**diez y siete**
7	**siete**	18	**diez y ocho**
8	**ocho**	19	**diez y nueve**
9	**nueve**	20	**veinte**
10	**diez**		

The cardinal numbers from 21 to 1,000 in Spanish are:

21	**veinte y uno**	60	**sesenta**
22	**veinte y dos**	70	**setenta**
30	**treinta**	80	**ochenta**
40	**cuarenta**	90	**noventa**
50	**cincuenta**	100	**cien**

101	ciento uno	500	quinientos	
102	ciento dos	600	seiscientos	
110	ciento diez	700	setecientos	
200	doscientos	800	ochocientos	
300	trescientos	900	novecientos	
400	cuatrocientos	1,000	mil	

The cardinal numbers from 1,010 to 10,000,000 in Spanish are:

1,010	mil diez	200,000	doscientos mil
2,000	dos mil	500,000	quinientos mil
3,000	tres mil	1,000,000	un millón
10,000	diez mil	2,000,000	dos millones
100,000	cien mil	5,000,000	cinco millones
100,100	cien mil cien	10,000,000	diez millones

Correct Spelling

The conjunction **y** is used with numbers in Spanish only between multiples of ten and numbers less than ten:

36	treinta y seis	But,	
55	cincuenta y cinco	105	ciento cinco
89	ochenta y nueve	340	trescientos cuarenta

The numerals 16 to 19 and 21 to 29 are often written as one word. Notice that when this is done, the numbers 16, 22, 23, and 26 have a written accent mark on the last syllable:

16	dieciséis	24	veinticuatro
17	diecisiete	25	veinticinco
18	dieciocho	26	veintiséis
19	diecinueve	27	veintisiete
21	veintiuno	28	veintiocho
22	veintidós	29	veintinueve
23	veintitrés		

Feminine Numbers

The only numerals that agree with the feminine nouns that they modify are **uno,** as well as hundreds, starting with two hundred on up:

1 chica = **una chica**
200 casas = **doscientas casas**
215 puertas = **doscientas quince puertas**
520 millas = **quinientas veinte millas**
But, **103 sillas** = **ciento tres sillas**

Starting with one hundred and one and on up to two hundred, the only word used is **ciento,** whether the noun is feminine or masculine.

Sentence Agreement

Drop the **–o** in **uno** before masculine singular nouns:

un centavo
un estudiante

One hundred **cien** becomes **ciento** at 101:

ciento uno

cien mil habitautes

cien millones de dólares

cien hombres

cien mujeres

But,

ciento tres hombres

ciento cinco mil habitantes

ciento ocho mujeres

Un is not used before **cien, ciento,** or **mil:**

cien casas

mil barcos

However, we must say:

ciento un mil habitantes

a hundred and one thousand inhabitants

Un is used before the numeral **millón,** which requires **de** when a noun follows:

un millón de árboles

In Spanish, periods are used instead of commas to separate digits. For decimal places, commas are used instead:

US$1.500,00 instead of US$1,500.00

Test Yourself: 20) Write cardinal number in Spanish for the following numerals.

1. 10	6. 40	11. 200	16. 1.010
2. 15	7. 77	12. 203	17. 2.500
3. 50	8. 110	13. 325	18. 3.200
4. 25	9. 109	14. 415	19. 10.000
5. 27	10. 150	15. 1.000	20. 45.768

Test Yourself: 21) Complete the following sentences with the appropriate cardinal number.

1. Hay (300) _____ chicas en la escuela.
2. Sólo (1) _____ chica es mi amiga.
3. Lorenzo tiene (220) _____ libros.
4. Hay (400) _____ casas en mi barrio.
5. Hay más de (1000) _____ en este país.
6. Compré (51) _____ tarjetas de Navidad.
7. En esta comunidad viven (200) _____ familias.
8. En el corral caben (215) _____ llamas.
9. Yo ahorré (900) _____ dólares en el verano,
10. Encontré (103) _____ monedas de oro en el baúl.
11. Hay (1) _____ puerta en esta casa.
12. Hay (330) _____ reses en el corral.
13. Hoy vendí (500) _____ llantas de automóvil.
14. El año tiene (365) _____ días.
15. Un dólar tiene (100) _____ centavos.
16. Me duele (1) _____ pierna.

17. ¿Cuántas horas hay en diez días? (240) _____
18. Este libro tiene (435) _____ páginas.
19. Los habitantes de mi pueblo son (3.500) _____.
20. En mi clase hay (32). _____ estudiantes.

ORDINAL NUMBERS

The ordinal numbers in Spanish are:

primero	*first*	**sexto**	*sixth*
segundo	*second*	**séptimo**	*seventh*
tercero	*third*	**octavo**	*eighth*
cuarto	*fourth*	**noveno**	*ninth*
quinto	*fifth*	**décimo**	*tenth*

Like other masculine singular adjective, the ordinal numbers **primero** and **tercero** drop the final **–o** before a masculine singular noun.

Tú eres el segundo en la fila.
You are the second in line.

Llegué primero al aula.
I arrived first to the classroom.

El primer premio de la lotería es de 30 millones de dólares.
The first prize in the lottery is 30 million dollars.

En la Quinta Avenida hay muchas tiendas importantes.
There are many important stores on Fifth Avenue.

Test Yourself: 22) Write the correct ordinal numbers for the sentences given.
1. La (1) _____ en llegar fue Josefina.
2. El (4) _____ grado necesita repasar los verbos.
3. La (5) _____ Avenida es muy famosa en Nueva York.
4. El (7) _____ día de la semana es un día de descanso.
5. Yo estoy en el (8) _____ grado.
6. El (2) _____ lugar recibe una medalla de plata.
7. El (10) _____ número cardinal es el diez.
8. Necesitamos reparar el (3) _____ pupitre.
9. Los estudiantes del (6) _____ grado son estudiosos.
10. El (9) _____ estudiante es Julio Martel.

FORMATION OF NOUNS FROM ADJECTIVES

Adjectives can be transformed into nouns by placing a definite article before the adjective.

El viejo está hablando con el niño.
The old man is talking to the child.

El inteligente es Juan.
The intelligent one is John.

Las jóvenes son muy amables.
The young ladies are very kind.

POSSESSIVE ADJECTIVES

A possessive adjective denotes ownership of the noun it modifies; it agrees in gender and number with the person or thing possessed, not with the possessor.

Mi automóvil es nuevo.
My automobile is new.

Tu casa es hermosa.
Your house is beautiful.

¡Dios mío!
Oh, my God!

There are two forms of possessive adjectives: short form and long form. The short form *precedes* the noun. The long form of the possessive adjective *follows* the noun.

The short form possessive adjectives in Spanish are:

Masculine	Feminine	
Singular, Plural	Singular, Plural	
mi, mis	**mi, mis**	*my*
tu,tus	**tu,tus**	*your*
su, sus	**su, sus**	*your, his, her, their*
nuestro, nuestros	**nuestra, nuestras**	*our*
vuestro, vuestros	**vuestra, vuestras**	*your*

The long form

Masculine	Feminine	
Singular, Plural	Singular, Plural	
mío, míos	**mía, mías**	*mine*
tuyo, tuyos	**tuya, tuyas**	*yours*
suyo, suyos	**suya, suyas**	*yours, his, hers, theirs*
nuestro, nuestros	**nuestra, nuestras**	*ours*
vuestro, vuestros	**vuestra, vuestras**	*yours*

The use of the long form gives more emphasis to the possession.

Esos son mis guantes.
Those are my gloves

Esos guantes son mios.
Those gloves are mine

When refering to the parts of the body or to wearing personal items (when the possessor is clear), the definite article is used in place of the possessive adjective.

La bailarina levantó la pierna.
The dancer raised her leg.

Juan se lava la cara.
John washes his face.

When the meaning of the sentence is not clear, the definite article is used in place of the possessive adjective, and a prepositional phrase is used.

> **Andaba buscando su abrigo.**
> *He was looking for his (her, your, their) coat.*

> **Andaba buscando el abrigo de ella.**
> *He was looking for her coat.*

Test Yourself: 23) Complete the following paragraph using the correct possessive adjective.

¡Hola Diana, qué vestido más bonito!

Sí, ¿Te gusta? Es (1) _____ vestido favorito.

(2) _____ vestido es elegante, pero (3) _____ vestido es más elegante todavía.

Me alegro que te guste, pero espera a que veas el vestido de Josefina porque el (4) _____ es el más elegante de todos.

Ahi viene Josefina. Tienes razón (5) _____ vestido es impresionante.

¡Hola Josefina!

¡Hola Diana! ¡Qué elegante están ustedes!

Gracias, pero no tan elegantes como tú. (6) _____ vestido es sensacional. Te cambio el (7) _____ por el (8) _____ en cualquier momento.

No hagas bromas. (9) _____ vestido es elegantísimo.

Es cierto, Josefina, (10) _____ vestidos son elegantes. Nosotras luciremos espectaculares esta noche.

DEMONSTRATIVE ADJECTIVES

Demonstrative adjectives denote a location in relation to the speaker. These adjectives precede the noun they modify, and they agree in gender and number with this noun.

The demonstrative adjective **este** refers to that which is in the possession of or near to the speaker. **Ese** refers to that which is not in the possession of and is not so near to the speaker. **Aquel** refers to that which is remote from the speaker and the person addressed. Please notice that demonstrative pronouns take a written accent to differentiate them from demonstrative adjectives.

Masculine	Feminine	
Singular, Plural	Singular, Plural	
(When standing close to the speaker)		
este, estos	**esta, estas (aquí)**	*this, these (here)*
ese, esos	**esa, esas (allí, ahí)**	*that, those (there)*
(When standing farther from the speaker)		
aquel, aquellos	**aquella, aquellas (allá)**	*that, those (over there)*

Test Yourself: 24) Rewrite the following sentences.

1. These houses are big.
2. That assignment is difficult.
3. That teacher over there is excellent.
4. This book is important.
5. Those letters are from Luis.
6. Those girls over there are my friends.
7. That program is great.
8. These apartments are big.
9. Those men over there are strong.
10. This government is practical.

Test Yourself Answers

1)
1. preciosa
2. Todas
3. magnífica
4. estudiosa
5. trabajadora
6. atlético
7. buenos
8. gordo
9. educado
10. aplicada

2)
1. mala
2. alta
3. baja
4. flaca
5. delgada
6. bonita
7. bella
8. hermosa
9. magnífica
10. educada

3)
1. unos muchachos guapos
2. unas chicas astutas
3. los edificios altos
4. las bicicletas rojas
5. los automóviles pequeños

4)
1. grande
2. humilde
3. razonable
4. inteligentes
5. distantes
6. excelente
7. prudente
8. importante
9. tristes
10. verdes

5)
1. azules
2. felices
3. mortales
4. corteses
5. normales
6. difíciles
7. grises
8. feroces
9. populares
10. veloces

6)
1. Los abogados son hombres populares.
2. Esas flores son de color azul, verde y gris.
3. Los hombres son seres mortales.
4. Sus carácteres son gentiles.
5. Las profesoras son fenomenales.

7)
1. francés
2. norteamericanos
3. española
4. nicaragüenses
5. chino
6. japoneses
7. irlandesa
8. indio
9. mexicanos
10. cubanas

8)
1. norteamericano, estadounidense
2. mexicanos
3. puertorriqueños
4. venezolano
5. panameños
6. alemán
7. italiano
8. danesa
9. griegos
10. filipinas

9)
1. azul
2. negros
3. blanco
4. amarillas
5. café
6. vino
7. castaño
8. azul
9. naranja
10. moradas

10)
1. un
2. Ninguna
3. tercer
4. buena
5. mal
6. primer
7. primera
8. gran
9. Santo
10. San

11)
1. Este edificio es menos alto que el otro.
2. Isabel es más inteligente que Raúl.
3. Esta silla es menos oscura que ésa.
4. Esta ciudad es más grande que Cali.
5. Antonio es menos fuerte que Luis.
6. El Museo Metropolitano es más interesante que éste.
7. Las casas son menos lindas que los edificios.
8. El campo es más verde que el parque.
9. El viaje por avión es menos largo que por autobús.
10. Esta temporada es más lluviosa que la primavera.

12)
1. Yo soy más trabajador que Jorge.
2. José es más alto que Miguel.
3. Ester es más fuerte que Julia.
4. Ellos son más atentos que él.
5. Ellas no son más cómicas que ellos.

13)
1. la ciudad más grande de . . .
2. los estudiantes menos estudiosos de . . .

3. el hombre más importante de . . .

4. las asistentes menos calificadas de . . .

5. el producto más útil de . . .

6. la fábrica menos productiva de . . .

7. la empleada más trabajadora de . . .

8. la menos limpia de . . .

9. la ciudad más grande de . . .

10. el automóvil menos caro de . . .

14) 1. Jorge es el muchacho menos astuto de la clase.

2. Granada es la ciudad más bella de Andalucía para Lorca.

3. Pablo es el pintor menos conocido de Bogotá.

4. Los Andes es la cordillera más alta de Sudamérica.

5. La educación es la prioridad menos importante de la administración.

6. El petróleo es el producto más importante de Venezuela.

7. Ellos son los estudiantes menos aplicados de la universidad.

8. Gloria es la cantante más buena de Puerto Rico.

9. Este distrito es el menos demócrata del país

10. El Ebro es el río más largo de España.

15) 1. mejor que; la mejor

2. peor que; la peor

3. más grande; el más grande

4. más pequeñas que; las más pequeñas

16) 1. mayor que 6. más grande

2. mejor que 7. más pequeña

3. peor que 8. más pequeño

4. menor que 9. menor que

5. más pequeño 10. mayor que

17) 1. Este modelo es guapísimo.

2. Este coche es velocísimo

3. María es inteligentísima.

4. Ellos son personas buenísimas.

5. Esta verdura es malísima.

18) 1. Roberto es tan amable como Juan.

2. Roberto es tan serio como Juan.

3. Roberto es tan alegre como Juan.

4. Roberto es tan estudioso como Juan.

5. Roberto es tan guapo como Juan.

6. Roberto es tan trabajador como Juan.

7. Roberto es tan cómico como Juan.

8. Roberto es tan perceptivo como Juan.

9. Roberto es tan astuto como Juan.

10. Roberto es tan bueno como Juan.

19) 1. tanta . . . como

2. tantas . . . como

3. tantas . . . como

4. tanta . . . como

5. tanta . . . como

6. tantos . . . como

7. tanta . . . como

8. tanto . . . como

9. tantas . . . como

10. tanto . . . como

20) 1. diez

2. quince

3. cincuenta

4. veinte y cinco o veinticinco

5. veinte y siete o veintisiete

6. cuarenta

7. setenta y siete

8. ciento diez

9. ciento nueve

10. ciento cincuenta

11. doscientos

12. doscientos tres

13. trescientos veinte y cinco o trescientos veinticinco

14. cuatrocientos quince

15. mil

16. mil diez
17. dos mil quinientos
18. tres mil doscientos
19. diez mil
20. cuarenta y cinco mil setecientos sesenta y ocho.

21) 1. trescientas
2. una
3. doscientos veinte
4. cuatrocientas
5. mil
6. cincuenta y una
7. doscientas
8. doscientas quince
9. novecientos
10. ciento tres
11. una
12. trescientas treinta
13. quinientas
14. trescientos sesenta y cinco
15. cien
16. una
17. doscientas cuarenta
18. cuatrocientas treinta y cinco

19. tres mil quinientos
20. treinta y dos

22) 1. primera 6. segundo
2. cuarto 7. décimo
3. Quinta 8. tercer
4. séptimo 9. sexto
5. octavo 10. noveno

23) 1. mi 6. Tu
2. mi 7. mio
3. tu 8. tuyo
4. suyo 9. Tu
5. su 10. nuestros

24) 1. Estas casas son grandes.
2. Esa asignatura es difícil.
3. Aquel maestro es excelente.
4. Este libro es importante.
5. Esas cartas son de Luis.
6. Aquellas chicas son mis amigas.
7. Ese programa es magnífico.
8. Estos apartamentos son grandes.
9. Aquellos hombres son fuertes.
10. Este gobierno es práctico.

Indicative Verbs

At first glance, Spanish verbs look more complicated than those in English. Each conjugation is different whether in the first, second, or third person, singular or plural. In addition, in Spanish, personal pronouns (*I, you, he, she,* and so on) are also not used. Instead, the ending of the verb indicates who is doing the action.

Verbs in Spanish can be classified according to groups. The same group of verbs have the same conjugations or endings. Even the verbs that we call "irregular" have characteristics in common that make them easier to learn.

VERBS IN THE INFINITIVE

With Spanish infinitives, unlike English infinitives, the preposition *to* is already part of the meaning of the verb. Note that in the translation of the sentence **Jugar es importante** (to play is important), the preposition *to* does not appear by itself but is part of the meaning of the verb.

The infinitive is one of the guidelines used to successfully conjugate a verb in any of the different moods or tenses.

Vamos a jugar.
Let's play.

Quiero vivir, vivir y vivir.
I want to live, to live, and to live.

Every verb in Spanish can be divided into two parts: the stem and the ending. The stem of the verb changes according to the meaning of the verb. But verbs in the infinitive have only three possible endings –ar, –er, and –ir.

The following sections give you lists of commonly used verbs.

–ar Verbs

caminar	*to walk*	**jugar**	*to play (a game)*
cantar	*to sing*	**mandar**	*to send*
comprar	*to buy*	**mirar**	*to look, to watch*
estudiar	*to learn*	**tomar**	*to drink, to take*
hablar	*to talk*	**trabajar**	*to work*

–er Verbs

aprender	*to learn*	**poner**	*to place, to put*
beber	*to drink*	**saber**	*to know*
comer	*to eat*	**tener**	*to have*
correr	*to run*	**vender**	*to sell*
leer	*to read*	**ver**	*to look*

–ir Verbs

abrir	*to open*	**partir**	*to leave*
dirigir	*to direct*	**recibir**	*to receive*
escribir	*to write*	**reír**	*to laugh*
ir	*to go*	**venir**	*to come*
morir	*to die*	**vivir**	*to live*

Test Yourself: 1) Complete the following sentences with the appropriate infinitive.

1. Juan quiere _____ (to play) al béisbol.
2. _____ (to run) es importante para la salud.
3. Hoy vamos a _____ (to receive) nuestra correspondencia.
4. Ellos desean _____ (to sell) su casa.
5. ¿Quieres _____ (to eat) ahora?
6. _____ (to write) es mi pasatiempo favorito.
7. Necesito _____ (to know) la verdad.
8. Hay que _____ (to put) los libros correctamente.
9. ¿Deseas _____ (to look) la película?
10. Tengo que _____ (to go) a _____ (to work).

THE INDICATIVE MOOD

In Spanish, there are three moods: the indicative, the subjunctive, and the imperative. The indicative mood is used to express objective actions or events. The subjunctive mood (see Chapter 4) is used to express subjectivity, feelings, and emotions. The imperative mood (discussed in Chapter 5) is used to express commands.

Present Tense

Within the indicative mood there are several tenses which denote the time frame in which the speaker or the subject is referring. The present tense, as it's name denotes, is the time frame of the present.

Regular –ar Verbs

The present tense of regular –ar verbs is formed by dropping the –ar ending in the infinitive and adding the following endings:

yo	–o	**nosotros**	–amos
tú	–as	**vosotros**	–áis
***él**	–a	**ellos**	–an

Infinitive	**cantar**	**bailar**	**estudiar**
yo	**canto**	**bailo**	**estudio**
tú	**cantas**	**bailas**	**estudias**
***él**	**canta**	**baila**	**estudia**
nosotros	**cantamos**	**bailamos**	**estudiamos**
vosotros	**cantáis**	**bailáis**	**estudiáis**
ellos	**cantan**	**bailan**	**estudian**

El muchacho canta muy bien.
The boy sings very well.

Ellos trabajan mucho.
They work a lot.

María y Juan bailan salsa.
Mary and John dance salsa.

Because the ending of the verbs tells you the person to whom it refers, it is very common to omit the personal pronoun (**yo, tú, él, ella, usted, nosotros,** and so on) in Spanish.

¿Hablas español?
Do you speak Spanish?

Hacen la tarea.
They do the homework.

Camino muchos kilómetros.
I walk many kilometers.

Commonly used **–ar** verbs are:

abrazar	*to embrace*	**firmar**	*to sign*
actuar	*to act*	**ganar**	*to win*
alcanzar	*to reach*	**gastar**	*to spend*
arreglar	*to arrange/to fix*	**guardar**	*to keep*
bajar	*to lower*	**indicar**	*to indicate*
buscar	*to look for*	**lamentar**	*to regret*
calificar	*to grade*	**limpiar**	*to clean*
cambiar	*to change*	**llegar**	*to arrive*
cantar	*to sing*	**llenar**	*to fill*
charlar	*to chat*	**llevar**	*to take*
colocar	*to place*	**luchar**	*to fight*
cortar	*to cut*	**mandar**	*to send*
cruzar	*to cross*	**mejorar**	*to improve*
cuidar	*to take care of*	**nadar**	*to swim*
dejar	*to leave*	**necesitar**	*to need*
descansar	*to rest*	**nombrar**	*to name*
doblar	*to turn / to fold*	**pasar**	*to pass*
educar	*to educate*	**pesar**	*to weigh*
encontrar	*to find*	**prestar**	*to lend*
enojar	*to anger*	**regalar**	*to give*
enseñar	*to teach / to show*	**reparar**	*to repair*
escuchar	*to listen*	**sacar**	*to take out*
esperar	*to wait*	**saltar**	*to jump*
extrañar	*to miss*	**terminar**	*to finish*

*In all verb charts, **él** will be used to represent **ella** and **usted; ellos** will be used to represent **ellas** and **ustedes.**

Test Yourself: 2) Complete the following exercise with the appropriate form of the present indicative.

1. Yo _____ (charlar) con el director.
2. Juan _____ (descansar) en su cama.
3. Él _____ (doblar) las invitaciones.
4. Carmen y Julia _____ (buscar) un tesoro.
5. Usted _____ (llamar) por teléfono.
6. Tú _____ (cenar) con tu novio.
7. La secretaria _____ (copiar) la carta.
8. Yo _____ (esperar) a que tú llames.
9. Los jóvenes _____ (bajar) por la escalera.
10. Nosotros _____ (cantar) en el coro.
11. Yo _____ (viajar) por tren a la conferencia.
12. Vosotros _____ (esquiar) a las tres.
13. Usted _____ (ganar) la lotería.
14. Virginia y yo _____ (enseñar) francés.
15. Ellas _____ (comprar) un pasaje para viajar.

Test Yourself: 3) Complete the following paragraph using the present tense of the verbs in parentheses.
Yo _____ 1. (caminar) todos los días a la escuela. _____ 2. (tomar) la calle veinte y tres, y luego _____ 3. (doblar) a la derecha. Después _____ 4. (cruzar) una calle ancha y _____ 5. (llegar) a la escuela. _____ 6. (entrar) por la puerta principal porque así _____ 7. (hablar) con mis amigos antes de la clase. A las ocho, el profesor _____ 8. (enseñar) español. Yo _____ 9. (estudiar) mucho en esta clase porque _____ 10. (desear) aprender el idioma.

Irregular –ar Verbs

Some **–ar** verbs are irregular only in the first person singular (**yo**) of the present tense. Their conjugation is regular for the remaining declination of the verb. Note the accent marks on the forms of the verb **estar.**

Infinitive	dar	estar
yo	**doy**	**estoy**
tú	**das**	**estás**
él	**da**	**está**
nosotros	**damos**	**estamos**
vosotros	**dáis**	**estáis**
ellos	**dan**	**están**

Test Yourself: 4) Rewrite the following sentences in the first person singular form (**yo**).

1. Nosotros damos dinero al limosnero.
2. Ellos están estudiando en la biblioteca.
3. Tú estás en el cine todos los fines de semana.
4. Vosotros estáis en la calle doce.
5. Él da a la escuela una donación

Many verbs have regular endings in the present tense but have stem changes when conjugated. These verbs ending in **–ar**, which are called stem-changing verbs, change the stem vowel in the present tense from **e** to **ie** or **o** to **ue.** This occurs in all forms except in the **nosotros** and **vosotros** forms.

Infinitive	**pensar(ie)***to think*		
yo	**pienso**	**nosotros**	**pensamos**
tú	**piensas**	**vosotros**	**pensáis**
él	**piensa**	**ellos**	**piensan**

Like **pensar,** the following verbs have a vowel change from **e** to **ie:**

apretar(ie)	*to tighten*	**empezar(ie)**	*to begin*
cerrar(ie)	*to close*	**encerrar(ie)**	*to lock up*
comenzar(ie)	*to begin*	**gobernar(ie)**	*to govern*
confesar(ie)	*to confess*	**negar(ie)**	*to deny*
despertar(ie)	*to wake up*	**quebrar(ie)**	*to break*

Test Yourself: 5) Complete the following sentences with the correct form of the present indicative.

1. Yo _____ (apretar) el tornillo.
2. Usted _____ (confesar) la verdad.
3. Ella _____ (cerrar) la ventana.
4. Nosotros _____ (empezar) a cantar.
5. El presidente _____ (gobernar) el país.
6. Tú _____ (negar) la verdad.
7. Ustedes _____ (quebrar) el vidrio.
8. Todos nos _____ (despertar) temprano.
9. Yo _____ (comenzar) a trabajar.
10. Vosotros _____ (encerrar) los documentos bajo llave.

Infinitive	**mostrar(ue)** *to show*		
yo	**muestro**	**nosotros**	**mostramos**
tú	**muestras**	**vosotros**	**mostráis**
él	**muestra**	**ellos**	**muestran**

Like **mostrar,** the following verbs have a vowel change from **o** to **ue:**

acostar(se)(ue)	*to go to bed*	**encontrar(ue)**	*to find; to meet*
almorzar(ue)	*to have lunch*	**probar(ue)**	*to try*
contar(ue)	*to count; to tell*	**recordar(ue)**	*to remember*
costar(ue)	*to cost*		

Test Yourself: 6) Complete the following sentences with the appropriate form of the present indicative.

1. Yo _____ (mostrar) mi casa a Pablo.
2. Ustedes _____ (almorzar) juntos.
3. Margarita _____ (recordar) su niñez.
4. Nosotros _____ (probar) los dulces.
5. Vosotros _____ (contar) un cuento.
6. Tú _____ (encontrar) muchas personas en la fiesta.
7. Usted _____ (mostrar) el libro.
8. Ellas _____ (recordar) la lección.
9. Él _____ (almorzar) arroz con pollo.

Regular –er Verbs

The present tense of regular –er verbs is formed by dropping the –er ending in the infinitive and adding the following endings: –o, –es, –e, –emos, –éis, and –en.

Infinitive	aprender	comer	beber
yo	aprendo	como	bebo
tú	aprendes	comes	bebes
é1	aprende	come	bebe
nosotros	aprendemos	comemos	bebemos
vosotros	aprendéis	coméis	bebéis
ellos	aprenden	comen	beben

Tú aprendes español.
You learn Spanish.

Vosotros coméis temprano.
You (plural) eat early.

José bebe vino.
Joseph drinks wine.

Commonly used –er verbs are:

aprender	*to learn*	esconder	*to hide*
beber	*to drink*	leer	*to read*
comer	*to eat*	meter	*to put into*
comprender	*to understand*	prometer	*to promise*
correr	*to run*	vender	*to sell*
creer	*to believe*	ver	*to see*

Test Yourself: 7) Complete the following sentences with the appropriate form of the present indicative.
 1. María _____ (aprender) informática.
 2. Yo _____ (correr) en el parque por las mañanas.
 3. Alberto y Benito _____ (creer) que tú estás aquí.
 4. Nosotros _____ (comprender) la lección.
 5. Tú _____ (beber) vino con la cena.
 6. Él _____ (comer) arroz con pollo.
 7. Ustedes _____ (aprender) un nuevo idioma.
 8. Vosotros _____ (leer) un libro de Lope de Vega.
 9. Ellas _____ (ver) el ballet mexicano.
 10. Ella _____ (prometer) hacer el trabajo.

Test Yourself: 8) Complete the following exercise using the present indicative according to the example given.
 modelo: **Miguel / aprender la lección.**
 Miguel aprende la lección.
 1. Yo / comer paella.
 2. Eduardo / vender productos agrícolas.
 3. Nosotros / correr en las mañanas.
 4. Ellas / aprender nuevas palabras.
 5. Marta y yo / leer un libro interesante.

Some **–er** verbs are irregular only in the first person singular (**yo**) of the present tense. Their conjugation is regular for the remaining subjects (tú, él, ella, usted, nosotros, vosotros, ustedes, ellos)

Infinitive	**caber** *to fit*	**caer** *to fall*
yo	**quepo**	**caigo**
tú	**cabes**	**caes**
él	**cabe**	**cae**
nosotros	**cabemos**	**caemos**
vosotros	**cabéis**	**caéis**
ellos	**caben**	**caen**

Other irregular **–er** verbs in the first person singular of the present tense are:

componer	**compongo**	*to compose*
conocer	**conozco**	*to know*
disponer	**dispongo**	*to dispose*
hacer	**hago**	*to do*
oponer	**opongo**	*to oppose*
poner	**pongo**	*to put*
saber	**sé**	*to know*
satisfacer	**satisfago**	*to satisfy*
traer	**traigo**	*to bring*
valer	**valgo**	*to be worth*
ver	**veo**	*to see*

Like **conocer:**

aborrecer	**aborrezco**	*to hate*
agradecer	**agradezco**	*to thank*
aparecer	**aparezco**	*to appear*
carecer	**carezco**	*to lack*
crecer	**crezco**	*to grow*
desaparecer	**desaparezco**	*to disappear*
establecer	**establezco**	*to establish*
merecer	**merezco**	*to deserve*
obedecer	**obedezco**	*to obey*
ofrecer	**ofrezco**	*to offer*
parecer	**parezco**	*to seem*
permanecer	**permanezco**	*to remain*
pertenecer	**pertenezco**	*to belong*
reconocer	**reconozco**	*to recognize*

Test Yourself: 9) Rewrite the following sentences in the first person singular of the present indicative (**yo**).
1. Nosotros hacemos la tarea.
2. Tú sabes la verdad.
3. Ellos traen comida a la fiesta.
4. Pedro compone música clásica.
5. Miguelina y Rosario ven una película de misterio.

Test Yourself: 10) Complete the following sentences, using the appropriate form of the present indicative.

1. Yo _____ (ofrecer) un trabajo a Luis.
2. Yo _____ (poner) el libro sobre la mesa.
3. Yo _____ (saber) la verdad.
4. Yo _____ (disponer) de suficiente tiempo.
5. Yo _____ (carecer) destreza.
6. Yo _____ (reconocer) que su teoría es buena.
7. Yo _____ (establecer) mis prioridades.
8. Yo _____ (hacer) la faena.
9. Yo _____ (satisfacer) mi apetito.
10. Yo _____ (merecer) mejores notas.

Other **–er** verbs are completely irregular in the present tense.

Infinitive	**haber** *to have*		
yo	**he**	**nosotros**	**hemos**
tú	**has**	**vosotros**	**habéis**
él	**ha**	**ellos**	**han**

Test Yourself: 11) Complete the following sentence with the appropriate form of the verb haber.

1. Yo _____ visto a Juan.
2. Ella _____ tomado el examen.
3. Ustedes _____ caminado en el parque.
4. Marta _____ hecho el trabajo.
5. ¿Tú _____ visto al tío?
6. Nosotros _____ preparado todo.
7. Vosotros _____ terminado la tarea.
8. Él _____ comprendido el teorema.
9. Ellos _____ terminado el programa.
10. Julio _____ publicado su libro.

Infinitive	**ser** *to be*		
yo	**soy**	**nosotros**	**somos**
tú	**eres**	**vosotros**	**sois**
él	**es**	**ellos**	**son**

Test Yourself: 12) Complete the following exercise with the appropriate form of the verb **ser.**

1. Mi amigo _____ ingeniero.
2. Yo _____ estudiante.
3. Los alumnos _____ inteligentes.
4. Tú _____ alto.
5. Ellas _____ colombianas.
6. Él _____ un escritor famoso.
7. Vosotros _____ disciplinados.
8. García Márquez _____ un famoso novelista.
9. Federico García Lorca _____ un gran dramaturgo y poeta.
10. Ortega y Gasset y Julián Marías _____ filósofos.

Test Yourself: 13) Answer the following questions.
1. ¿Quién es tú mejor amigo?
2. ¿Cuál es tu profesión?
3. ¿Cuál es tu nacionalidad?
4. ¿Cuál es tu clase favorita?
5. ¿Cuál es la capital de Chile?

Infinitive	**tener** *to have*		
yo	**tengo**	**nosotros**	**tenemos**
tú	**tienes**	**vosotros**	**tenéis**
él	**tiene**	**ellos**	**tienen**

Test Yourself: 14) Write the following sentences according to the model, using the verb **tener.**
modelo: **Ramón / hambre**
Ramón tiene hambre.
1. Yo / sed.
2. Usted / una casa muy bonita.
3. Nosotras / un buen trabajo.
4. Ellos / que ir de compras.
5. Rafael / tarea de español.

Other irregular verbs that are conjugated like **tener** are:

contener	*to contain*	**mantener**	*to maintain*
detener	*to detain*	**sostener**	*to hold*
entretener	*to entertain*		

Test Yourself: 15) Complete the following sentences with the appropriate form of the present indicative.
1. Marta y yo _____ (entretener) a los invitados.
2. El policía _____ (detener) el automóvil.
3. Ellos _____ (sostener) la puerta.
4. Vosotros _____ (mantener) una buena postura.
5. Usted _____ (obtener) su título universitario.
6. Tú _____ (entretener) al grupo.
7. Ellos _____ (detener) el envío.
8. Yo _____ (sostener) la escalera.
9. Ella _____ (mantener) a sus hermanos.
10. Tú _____ (obtener) tu licencia de conducir.

Stem-changing verbs ending in **–er** change the stem vowel in the present tense from **e** to **ie** or **o** to **ue.** This occurs in all declinations except in the **nosotros** and **vosotros** forms.

Infinitive	**querer(ie)** *to want*		
yo	**quiero**	**nosotros**	**queremos**
tú	**quieres**	**vosotros**	**queréis**
él	**quiere**	**ellos**	**quieren**

Like **querer,** the following verbs have a vowel change from **e** to **ie:**

defender(ie)	*to defend*	**entender(ie)**	*to understand*
descender(ie)	*to descend*	**perder(ie)**	*to lose*

Test Yourself: 16) Complete the following sentences with the appropriate form of the present indicative.

1. Yo _____ (querer) ir al museo.
2. Ellas _____ (perder) sus llaves a menudo.
3. Tú _____ (defender) al acusado en la corte.
4. Nosotros _____ (querer) ver la ópera Carmen.
5. Ustedes _____ (perder) la esperanza de ganar.

Infinitive	**volver(ue)** *to return*		
yo	**vuelvo**	**nosotros**	**volvemos**
tú	**vuelves**	**vosotros**	**volvéis**
él	**vuelve**	**ellos**	**vuelven**

Like **volver,** the following verbs have a vowel change from **o** to **ue:**

devolver(ue)	*to give back*	**doler(ue)**	*to ache*
envolver(ue)	*to wrap*	**llover(ue)**	*to rain*
mover(ue)	*to move*	**poder(ue)**	*to be able to*
resolver(ue)	*to solve; to resolve*		

Test Yourself: 17) Complete the following sentences with the appropriate form of the present indicative.

1. Ellos _____ (volver) a casa temprano,
2. Tú _____ (mover) el automóvil de lugar.
3. Nosotros _____ (envolver) los regalos de la fiesta.
4. El ladrón _____ (devolver) lo que roba.
5. Yo _____ (resolver) los problemas del negocio.
6. Vosotros _____ (poder) ayudar a Miguel.
7. Nosotros _____ (devolver) las herramientas.
8. Me _____ (doler) la cabeza.
9. Hoy _____ (llover) muy fuerte.
10. Nosotros _____ (volver) a la clase mañana.

The verb **jugar** *(to play)* is also a stem-changing verb. The vowel **u** of the infinitive changes from **u** to **ue.** This is the only –**ar** verb in Spanish where this type of change occurs.

Infinitive	**jugar** *to play*		
yo	**juego**	**nosotros**	**jugamos**
tú	**juegas**	**vosotros**	**jugáis**
él	**juega**	**ellos**	**juegan**

Test Yourself: 18) Complete the following exercise according to the model.

modelo: **Yo / con mis amigos.**
Yo juego con mis amigos.

1. Tú / al ajedrez con tu padre.
2. Nosotros / al baloncesto.
3. Usted / con sus niños.
4. Vosotros / béisbol profesional.
5. Yo / al fútbol.
6. Ellos / fútbol americano.
7. Verónica / a las escondidas.
8. Él / a los vaqueros.
9. Juan y yo / juegos electrónicos.
10. Todos / un deporte u otro.

Regular –ir Verbs

The present tense of regular **–ir** verbs is formed by dropping the **–ir** ending in the infinitive and adding the following endings: **–o, –es, –e, –imos, –ís,** or **–en.**

Infinitive	escribir	subir	vivir
yo	escribo	subo	vivo
tú	escribes	subes	vives
él	escribe	sube	vive
nosotros	escribimos	subimos	vivimos
vosotros	escribís	subís	vivís
ellos	escriben	suben	viven

Commonly used **–ir** verbs are:

abrir	*to open*	**escribir**	*to write*
añadir	*to add*	**ocurrir**	*to happen*
cubrir	*to cover*	**partir**	*to break; to depart*
cumplir	*to fulfill*	**recibir**	*to receive*
decidir	*to decide*	**repartir**	to *distribute*
descubrir	*to discover*	**subir**	*to go up*
discutir	*to argue*	**vivir**	*to live*

Test Yourself: 19) Complete the following sentences with the appropriate form of the present indicative.
1. Ustedes _____ (abrir) la tienda en la mañana.
2. Miguel _____ (asistir) a la convención.
3. Él _____ (discutir) el problema con su jefe.
4. Nosotros _____ (subir) las escaleras.
5. Tú _____ (sufrir) mucho.
6. Javier y Antonio _____ (recibir) buenas noticias.
7. Yo _____ (admitir) mis errores.
8. Vosotros _____ (cubrir) el libro para protegerlo.
9. Para la receta Juan y yo _____ (añadir) dos tazas de harina.
10. Ella _____ (escribir) un poema surrealista.

Test Yourself: 20) Answer the following sentences by using the present indicative.
1. ¿Recibes tú cartas con frecuencia?
 Sí,
2. ¿Discutimos nosotros con el profesor?
 No,
3. ¿Escribimos una monografía sobre Calderón de la Barca?
 Sí,
4. ¿Asiste ella a la conferencia de Octavio Paz?
 Sí,
5. ¿Vives lejos de la universidad?
 No,

Irregular –ir Verbs

Some **–ir** verbs are irregular only in the first person singular (**yo**) of the present tense. Their conjugation is regular for the remaining forms of the verb.

Infinitive	salir	*to leave, to go out*	
yo	salgo	nosotros	salimos
tú	sales	vosotros	salís
él	sale	ellos	salen

Other irregular **–ir** verbs in the first person singular of the present tense are:

conducir	**conduzco**	*to conduct*
deducir	**deduzco**	*to deduct*
producir	**produzco**	*to produce*
traducir	**traduzco**	*to translate*

Test Yourself: 21) Complete the following sentences with the appropriate form of the present indicative.

1. Yo _____ (salir) para la escuela a las siete.
2. Tú _____ (producir) un buen producto.
3. Ellos _____ (traducir) del inglés al español.
4. Vosotros _____ (deducir) los gastos.
5. Marta _____ (conducir) cuidadosamente.

Other **–ir** verbs with irregular forms in the present tense are:

Infinitive	decir	*to say*	
yo	digo	nosotros	decimos
tú	dices	vosotros	decís
él	dice	ellos	dicen

Test Yourself: 22) Complete the following exercise according to the model.

modelo: **Juan / la verdad.**
Juan dice la verdad.

1. Julio / que no puede ir.
2. Ellos / que hacen la tarea.
3. Tú / que sí.
4. Nosotros / la respuesta correcta.
5. Yo / las letras del alfabeto.

Infinitive	ir	*to go*	
yo	voy	nosotros	vamos
tú	vas	vosotros	vais
él	va	ellos	van

Infinitive	oir	*to listen*	
yo	oigo	nosotros	oímos
tú	oyes	vosotros	oís
él	oye	ellos	oyen

Test Yourself: 23) Complete the following sentences with the appropriate conjugation of **oir** in the present indicative.

1. Yo _____ la radio.
2. Diego _____ música en su dormitorio.
3. Ellas _____ una cinta de cumbias.

4. María y José _____ los consejos de su hermano mayor.
5. Nosotros _____ tu llamada.
6. Ustedes _____ el ruido de la calle.
7. Ellos _____ el tren pasar.
8. Tú _____ el timbre de la puerta.
9. Yo _____ que mi madre me llama.
10. Nosotros _____ atentamente el sonido del radar.

Test Yourself: 24) Answer the following questions.

1. ¿Oyes la radio? Sí,
2. ¿Oímos el concierto? Sí,
3. ¿Oyen las noticias? No,
4. ¿Oís la conferencia? No,
5. ¿Oye él música clásica? Sí,

Infinitive	**venir** *to come*		
yo	**vengo**	**nosotros**	**venimos**
tú	**vienes**	**vosotros**	**venís**
él	**viene**	**ellos**	**vienen**

Test Yourself: 25) Answer the following questions, using the present indicative.

1. ¿De dónde vienes por las mañanas? (La universidad)
2. ¿Con quiénes vienes? (los abuelos)
3. ¿Quiénes vienen ahí? (amigos)
4. ¿Vienen a estudiar español esta noche? (sí,ellos)
5. ¿Vienes de prisa? (sí)

Stem-changing verbs ending in **–ir** change the stem vowel in the present tense from **e** to **ie, o** to **ue,** or **e** to **i.** This occurs in all forms except in the **nosotros** and **vosotros** forms.

Infinitive	**preferir (ie)** *to prefer*		
yo	**prefiero**	**nosotros**	**preferimos**
tú	**prefieres**	**vosotros**	**preferís**
él	**prefiere**	**ellos**	**prefieren**

Like **preferir,** the following verbs have a stem change from **e** to **ie:**

advertir (ie)	*to warn*	**mentir (ie)**	*to lie*
convertir (ie)	*to convert*	**sentir (ie)**	*to feel*
divertirse (ie)	*to enjoy oneself*	**sugerir (ie)**	*to suggest*
hervir (ie)	*to boil*		

Test Yourself: 26) Complete the following sentences with the appropriate verb in the present indicative.

1. Yo _____ (preferir) ir a la ópera.
2. Nosotros _____ (preferir) ir al concierto.
3. Ustedes _____ (sugerir) invitar a Juan a la fiesta.
4. Ellas _____ (hervir) los huevos para el desayuno.
5. Tú _____ (sentir) las vibraciones del tranvía.
6. Él se _____ (divertir) en el parque de diversiones.
7. Miguel le _____ (mentir) a su hermano.
8. Marta y Raquel se _____ (divertir) bailando.
9. Vosotros _____ (convertir) las millas en kilómetros.
10. Ellos _____ (hervir) el agua para bañarse.

The verb **dormir** has a stem change from **o** to **ue.**

Infinitive	**dormir(ue)** *to sleep*		
yo	**duermo**	**nosotros**	**dormimos**
tú	**duermes**	**vosotros**	**dormís**
él	**duerme**	**ellos**	**duermen**

Like **dormir,** the following verbs have a stem change from **o** to **ue:**

morir(ue) *to die*
dormirse(ue) *to fall asleep*

Test Yourself: 27) Complete the following exercise with the appropriate form of the present indicative of the verb **dormir.**
1. Tú / mucho los fines de semana.
2. Yo / cómodamente en el sofá.
3. Nosotros / en el autobús vía Madrid.
4. Ellos / parados.
5. Usted / en la sala.

Test Yourself: 28) Complete the following sentences with the appropriate form of the present indicative.
1. Yo _____ (dormir) temprano.
2. Tú _____ (dormir) en las noches.
3. Nosotros nos _____ (dormir) sin saberlo.
4. El bebé _____ (dormir) ya.
5. Ella _____ (dormir) muchas horas los sábados.
6. Marta y Mario _____ (morir) en el incendio.
7. Vosotros _____ (dormir).
8. Él se _____ (dormir).
9. El hombre _____ (morir) a los cien años.
10. Ellos _____ (morir) al final de la película.

The verb **pedir** has a stem change from **e** to **i:**

Infinitive	**pedir (i)**	*to ask for*		
yo	**pido**	**nosotros**		**pedimos**
tú	**pides**	**vosotros**		**pedís**
él	**pide**	**ellos**		**piden**

Like **pedir,** the following verbs have a stem change from **e** to **i:**

despedir (i)	*to dismiss, to fire*	**repetir (i)**	*to repeat*
freír (i)	*to fry*	**servir (i)**	*to serve*
impedir (i)	*to prevent*	**sonreír (i)**	*to smile*
medir (i)	*to measure*	**vestir (i)**	*to dress*
reír (i)	*to laugh*		

Test Yourself: 29) Complete the following verbs with the correct form of the present indicative.
1. El mendigo_____(pedir) una limosna.
2. Nosotros_____(pedir) información.
3. Ellos_____(pedir) ayuda.
4. Yo_____(freír) los huevos.
5. Nosotros_____(medir) el diámetro de la luna.
6. Geraldo_____(servir) las tapas.
7. La chica_____(sonreír).

8. Yo me_____(vestir) elegantemente para la fiesta.
9. Ustedes_____(impedir) un desorden.
10. Tú_____(despedir) a los trabajadores.

Verbs whose infinitive end in **–uir** (with the exception of **–guir**), a **–y** is added after the **–u,** in all forms except **nosotros** and **vosotros,** to make it two syllables.

Infinitive	**construir** *to construct, to build*	Infinitive	**influir** *to influence*
yo	**construyo**	**yo**	**influyo**
tú	**construyes**	**tú**	**influyes**
él	**construye**	**él**	**influye**
nosotros	**construímos**	**nosotros**	**influímos**
vosotros	**construís**	**vosotros**	**influís**
ellos	**construyen**	**ellos**	**influyen**

Other verbs are:

atribuir	*to attribute*	**distribuir**	*to distribute*
concluir	*to conclude*	**huir**	*to escape*
construir	*to build*	**incluir**	*to include*
contribuir	*to contribute*	**influir**	*to influence*
destruir	*to destroy*	**sustituir**	*to substitute*
disminuir	*to lessen*		

Test Yourself: 30) Complete the following sentences with the appropriate form of the indicative verb.
1. El hombre malo _____ (huir) de la policía.
2. Nosotros _____ (sustituir) al maestro.
3. Ellas _____ (influir) en sus acciones.
4. Usted _____ (incluir) el vocabulario en el examen.
5. Carolina _____ (construir) una hermosa casa.
6. Javier y Bernarda _____ (destruir) la hierba.
7. Vosotros _____ (disminuir) el problema.
8. Tú _____ (concluir) la función.
9. Ustedes _____ (distribuir) el anuncio.
10. La familia _____ (influir) en él.

Preterite Tense

The preterite tense is used to express an action that began and ended in the past.

Regular –ar Verbs

The preterite tense of regular **–ar** verbs is formed by dropping the **–ar** ending in the infinitive and adding the following endings: **–é, –aste, –ó, –amos, –asteis, –aron.**

Infinitive	**cantar**	**bailar**	**estudiar**
yo	**canté**	**bailé**	**estudié**
tú	**cantaste**	**bailaste**	**estudiaste**
él	**cantó**	**bailó**	**estudió**
***nosotros**	**cantamos**	**bailamos**	**estudiamos**
vosotros	**cantasteis**	**bailasteis**	**estudiasteis**
ellos	**cantaron**	**bailaron**	**estudiaron**

***Note:** In the **nosotros** form of **–ar** and **–ir** verbs, the present and the preterite tenses are conjugated exactly the same, but the tense is known through context.

El muchacho cantó muy bien.
The boy sang very well.

Ellos trabajaron mucho.
They worked a lot.

María y Juan bailaron salsa.
Mary and John danced salsa.

Test Yourself: 31) Complete the following sentences with the appropriate form of the preterite tense.
 1. Mi hermana _____ (cantar) en el festival.
 2. Ellos _____ (hablar) en la reunión.
 3. Vosotros _____ (mirar) la película de Almodóvar.
 4. Yo _____ (trabajar) todo el día.
 5. Él _____ (estudiar) para el examen.
 6. Usted _____ (caminar) por el jardín.
 7. Ellas _____ (bailar) en el espectáculo.
 8. Tú _____ (tomar) el autobús a las seis.
 9. Nosotros _____ (actuar) un drama.
 10. Ustedes _____ (comprar) un helado de vainilla.

Test Yourself: 32) Rewrite the following sentences in the preterite indicative.
 1. Ustedes trabajan en el supermercado.
 2. Yo gano ochenta dólares por día.
 3. Ellos compran una casa en el suburbio.
 4. Nosotros regresamos a la escuela.
 5. Tú corres todas las mañanas.

Test Yourself: 33) Complete the following paragraph in the preterite indicative by using the appropriate form of the verb in parentheses.

Ayer, yo me _____ 1. (levantar) a las ocho de la mañana. _____ 2. (caminar) hacia el baño pero _____ 3. (encontrar) que estaba cerrado. _____ 4. (regresar) a mi habitación y_____5. (esperar) a que se desocupara. Mi hermano me_____ 6. (llamar) para decirme que ya podía entrar. Al entrar en el aseo _____ 7. (tomar) una buena ducha. Después _____ 8. (desayunar), me _____ 9. (cambiar) y me _____ 10. (marchar) a la escuela. _____ 11. (caminar) hasta la estación del tren. _____ 12. (tomar) el tren de las nueve y _____ 13. (entrar) a mi clase de español a las diez en punto. El profesor _____ 14. (empezar) la clase dos minutos después y luego _____ 15. (pasar) la lista.

Test Yourself: 34) Answer the following sentences in the preterite indicative.
 1. ¿A qué hora llamaste a Miguel?
 2. ¿Cuántas millas caminaron en el estadio?
 3. ¿Qué regalos recibiste en las festividades?
 4. ¿Conociste a todas las personas?
 5. ¿Cuándo empezó la clase?

Irregular Verbs

Verbs ending in **–car, –gar,** and **–zar** have a change only in the first person singular of the preterite tense. The rest of their conjugation is regular. With verbs that end in **–car,** the **c** changes to **qu.** For verbs that end in **–gar,** the **g** changes to **gu.** With verbs that end in **–zar,** the **z** changes to **c.**

Infinitive	educar	llegó	almorzó
llegar	almorzar	nosotros	educamos
yo	eduqué	llegamos	almorzamos
llegué	almorcé	vosotros	educasteis
tú	educaste	llegasteis	almorzasteis
llegaste	almorzaste	ellos	educaron
él	educó	llegaron	almorzaron

Other verbs like **educar** *(to educate)* are:

atacar	*to attack*	marcar	*to mark*
buscar	*to look for*	masticar	*to chew*
calificar	*to grade*	pescar	*to fish*
colocar	*to place*	practicar	*to practice*
comunicar	*to communicate*	publicar	*to publish*
explicar	*to explain*	sacar	*to take out*
fabricar	*to manufacture*	tocar	*to play; to touch*

Other verbs like **llegar** *(to arrive)* are:

cargar	*to carry*	negar	*to negate*
colgar	*to hang*	pagar	*to pay*
encargar	*to order*	pegar	*to hit; to glue*
entregar	*to hand in*	rogar	*to beg*
jugar	*to play*	vengar	*to avenge*
madrugar	*to rise early*		

Other verbs like **almorzar** *(to have lunch)* are:

abrazar	*to embrace*	gozar	*to enjoy*
alcanzar	*to reach*	lanzar	*to throw*
comenzar	*to begin*	realizar	*to fulfill*
cruzar	*to cross*	rezar	*to pray*
empezar	*to begin*	trazar	*to plan*

Test Yourself: 35) Write the following sentences according to the model.

modelo: **Yo / educar a mis hermanos**
Yo eduqué a mis hermanos.

1. Yo / buscar un regalo para Pedro.
2. Ellos / colocar las flores en el florero.
3. Yo / dedicar este libro a mi amigo Ramón.
4. Nosotros / fabricar juguetes de niños.
5. Yo / sacar a mi amigo de un aprieto.
6. Tú / tocar la escultura de Minerva.
7. Yo / indicar la dirección correcta a los señores.
8. Usted / marcar los reportes.
9. Yo / embarcar la mercancía para Europa.
10. Vosotros / aplicar mucha presión a la superficie.

Test Yourself: 36) Form sentences in the preterite indicative with the following words.
1. Yo / pagar / cuenta.
2. Ellos / cargar / paquetes.
3. Tú / colgar / ropa / tendedero.
4. Ellas / llegar / tiempo.
5. Nosotros / arreglar/ flores.
6. Ustedes / encargar / mercancía.
7. Yo / jugar / ajedrez.
8. Ellos / rogar / paz.
9. Yo / entregar / trabajo.
10. Vosotros / apagar / luz.

Test Yourself: 37) Rewrite the following sentences in the first person singular **(yo),** using the preterite indicative.
1. Ellos almorzaron a las dos de la tarde.
2. Nosotros avanzamos rápidamente a la meta final.
3. Ustedes gozaron de los chistes de José.
4. Tú lanzaste el platillo unos cien metros.
5. Ellas abrazaron a su hermano.
6. Usted tropezó con esta piedra.
7. Vosotros os deslizasteis por la montaña.
8. Ellos comenzaron los ejercicios.
9. Él amenazó con despedir al empleado.
10. Ella gozó mucho el día de su cumpleaños.

The verbs **dar** and **estar** are irregular in the preterite. These verbs use the ending of regular **–er** and **–ir** verbs in the preterite.

Infinitive	**dar** *to give*		
yo	**di**	**nosotros**	**dimos**
tú	**diste**	**vosotros**	**disteis**
él	**dio**	**ellos**	**dieron**
Infinitive	**estar** *to be*		
yo	**estuve**	**nosotros**	**estuvimos**
tú	**estuviste**	**vosotros**	**estuvisteis**
él	**estuvo**	**ellos**	**estuvieron**

Test Yourself: 38) Rewrite the following sentences in the preterite indicative.
1. Yo doy una fiesta en mi casa.
2. Ellas están en la universidad hoy.
3. Tú das un examen de matemáticas.
4. Él está en la playa con sus amigos.
5. Nosotros damos una explicación a nuestro padre.

Test Yourself: 39) Complete the following sentences in the preterite indicative according to the verb in parentheses.
1. Ellos _____ (estar) aquí.
2. Tú le _____ (dar) el recado a Miguel.
3. Usted _____ (estar) ocupado.
4. Nosotros le _____ (dar) una limosna a este señor.
5. Ella _____ (estar) en Venezuela.
6. Él _____ (dar) una buena explicación.

7. Ustedes _____ (estar) en el seminario.

8. Yo _____ (dar) un discurso.

9. Vosotros _____ (estar) contentos.

10. Vosotros _____ (dar) un buen ejemplo.

Regular –er and –ir Verbs

The preterite tense of regular **–er** and **–ir** verbs is formed by dropping the **–er** or **–ir** endings and adding the following endings: **–í, –iste, –ió, –imos, –isteis,** and **–ieron.**

Infinitive	**comer** to eat	**vivir** to live
yo	**comí**	**viví**
tú	**comiste**	**viviste**
él	**comió**	**vivió**
nosotros	**comimos**	**vivimos**
vosotros	**comisteis**	**vivisteis**
ellos	**comieron**	**vivieron**

Test Yourself: 40) Complete the sentence with the appropriate verb in the preterite indicative.

1. Yo _____ (comer) hace dos horas.

2. Ellos _____ (vivir) en Nueva York.

3. Tú _____ (escribir) un cuento de niños.

4. Nosotros _____ (volver) de viaje ayer.

5. Miguel _____ (recibir) un premio.

6. Nélida _____ (abrir) sus regalos de cumpleaños.

7. Ustedes _____ (meter) la ropa en el equipaje.

8. Usted _____ (comer) muy a gusto.

9. Vosotros _____ (perder) en el concurso.

10. Ellas _____ (subir) en el elevador.

Test Yourself: 41) Complete the following paragraph in the preterite indicative by using the verbs in parentheses.

Juan _____ 1. (escribir) una carta a su amigo y luego _____ 2. (salir) a depositarla en el buzón de correos. Después _____ 3. (beber) un refresco en el restaurante, _____ 4. (volver) a su casa y _____ 5. (abrir) el refrigerador para preparar el almuerzo.

Note that verbs that end in **–er** or **–ir** that also have a vowel before the ending have a spelling change in the third person singular and plural forms, in which the **i** changes to **y.** This change occurs for phonetic purposes.

Infinitive	**creer** to believe	**oír** to hear
yo	**creí**	**oí**
tú	**creiste**	**oiste**
él	**creyó**	**oyó**
nosotros	**creímos**	**oímos**
vosotros	**creísteis**	**oísteis**
ellos	**creyeron**	**oyeron**

The verbs **ser** and **ir** are irregular in the preterite. These two verbs have the same conjugation in the preterite.

Infinitive	**ser** to be		ir to go	
yo	**fui**	**nosotros**	**fuimos**	
tú	**fuiste**	**vosotros**	**fuisteis**	
él	**fue**	**ellos**	**fueron**	

The following verbs have an irregular stem in the preterite tense.

caber, *to fit:*	**cupe, cupiste, cupo, cupimos, cupisteis, cupieron**
decir, *to say:*	**dije, dijiste, dijo, dijimos, dijisteis, dijeron**
haber, *to have:*	**hube, hubiste, hubo, hubimos, hubisteis, hubieron**
hacer, *to do:*	**hice, hiciste, hizo, hicimos, hicisteis, hicieron**
poder, *to be able to:*	**pude, pudiste, pudo, pudimos, pudisteis, pudieron**
poner, *to place:*	**puse, pusiste, puso, pusimos, pusisteis, pusieron**
producir, *to produce:*	**produje, produjiste, produjo, produjimos, produjisteis, produjeron**
querer, *to want:*	**quise, quisiste, quiso, quisimos, quisisteis, quisieron**
saber, *to know:*	**supe, supiste, supo, supimos, supisteis, supieron**
traer, *to bring:*	**traje, trajiste, trajo, trajimos, trajisteis, trajeron**
traducir, *to translate:*	**traduje, tradujiste, tradujo, tradujimos, tradujisteis, tradujeron**
venir, *to come:*	**vine, viniste, vino, vinimos, vinisteis, vinieron**

Test Yourself: 42) Make sentences with the following words in the preterite indicative.
1. Yo / estar / Zaragoza.
2. Ellos / hacer / composición.
3. Nosotros / poder / fabricar el equipo.
4. Ustedes / tener / apartamento elegante.
5. Vosotros / venir / viaje.
6. Tú / saber / respuesta.
7. Él / traer / las verduras.
8. Ellas / producir/ películas.
9. Usted / ser / profesional.
10. Todos / dar / contribución.

Uses of the Preterite Tense

The preterite tense expresses an action or event that began and was completed at a definite time in the past:

Eduardo compró una camisa elegante.
Edward purchased an elegant shirt.

Terminé de trabajar a las cuatro.
I stopped working at four.

El año pasado fui a México durante el verano.
Last year I went to Mexico during the summer.

Some verbs change their meaning in the preterite. These verbs are **conocer, saber, tener, querer,** and **poder.**

Yo conozco a Juan. Lo conocí en casa de unos amigos.
I know John. I met him at the house of some friends.

Yo sé la verdad. La supe al leer el periódico.
I know the truth. I learned it when I read the newspaper.

Ellos quieren trabajar, pero sus padres no quisieron permitirlo.
They want to work, but their parents refused to allow it.

Creo que puede hacer el proyecto. Ella pudo hacer uno mayor.
I believe she can do the project. She managed a bigger one.

Imperfect Tense

The imperfect tense is another past tense used in Spanish to express ongoing or habitual actions. It means *used to* or *was/were doing*. It is also used in any type of description, age, and time.

Regular –ar Verbs

The imperfect tense of regular **–ar** verbs is formed by dropping the **–ar** ending in the infinitive and adding the following endings: **–aba, –abas, –aba, –ábamos, –abais, –aban**.

Infinitive	cantar	bailar	estudiar
yo	cantaba	bailaba	estudiaba
tú	cantabas	bailabas	estudiabas
él	cantaba	bailaba	estudiaba
nosotros	cantábamos	bailábamos	estudiábamos
vosotros	cantabais	bailabais	estudiabais
ellos	cantaban	bailaban	estudiaban

Ellos trabajaban mucho.
They used to work very much.

María y Juan bailaban salsa.
Mary and John used to dance salsa.

There are no stem-changes in the imperfect. All **–ar** verbs are also regular verbs in the imperfect tense.

Test Yourself: 43) Complete the following sentences with the appropriate form of the imperfect indicative.
1. Margarita _____ (tomar) el té todas las tardes.
2. Juan y Silvia _____ (cantar) una canción.
3. Ellos _____ (bailar) en la pista de bailes.
4. Tú _____ (trabajar) en esa tienda.
5. Ella _____ (almorzar) a las doce.
6. Vosotros _____ (llegar) a la casa a las dos.
7. Usted _____ (comprar) comida en el supermercado.
8. Yo me _____ (bañar) por la mañana.
9. Él _____ (jugar) con sus amigos en el patio.
10. Ustedes _____ (caminar) después de la cena.
11. Nosotros _____ (nadar) en la piscina.
12. Ella _____ (hablar) con su amiga Gloria.
13. Nosotros _____ (estar) en la tienda.
14. Ellos _____ (reparar) el automóvil.
15. Vosotros _____ (comparar) el material.

Test Yourself: 44) Rewrite the following sentences in the imperfect.
1. Yo canto una aria de la ópera.
2. Tú compras un libro de Gustavo Adolfo Bécquer.
3. Ella llega a la cita a tiempo.
4. Nosotros estamos cansados.
5. Vosotros jugáis baloncesto.

Regular –er and –ir Verbs

The imperfect tense of regular **–er** and **–ir** verbs is formed by dropping the **–er** or **–ir** ending in the infinitive and adding the following declinations: **–ía, –ías, –ía, –íamos, –íais,** or **–ían.**

Infinitive	comer	vivir
yo	comía	vivía
tú	comías	vivías
él	comía	vivía
nosotros	comíamos	vivíamos
vosotros	comíais	vivíais
ellos	comían	vivían

Jorge comía muy bien en casa de su tío.
George used to eat well at his uncle's house.

Ellos vivían en la calle Ocho.
They used to live on Eighth Street.

El alumno hacía la tarea todas las noches.
The student used to do his homework every night.

There are no stem changes in the imperfect. All **–er** and **–ir** verbs have a regular stem in the imperfect tense.

Test Yourself: 45) Complete the following sentences with the appropriate form of the imperfect indicative.

1. Yo _____ (salir) de la universidad a las cuatro.
2. Ellas _____ (vivir) en el vecindario.
3. Tú _____ (comer) tacos y burritos mexicanos.
4. Nosotros _____ (hacer) la tarea.
5. Vosotros _____ (perder) la apuesta.
6. Él _____ (abrir) la puerta a los invitados.
7. Ellos _____ (traer) su almuerzo a la escuela.
8. Todos _____ (escribir) a estudiantes de Chile.
9. Ustedes se _____ (vestir) con el mismo uniforme.
10. María y Julia _____ (repetir) el poema.
11. Yo _____ (seguir) las noticias con interés.
12. Ella _____ (volver) a su casa.
13. Vosotros _____ (beber) unas limonadas.
14. Juan y yo _____ (tener) miedo.
15. Alberto _____ (seguir) estudiando.

Test Yourself: 46) Form sentences in the imperfect by using the following words.

1. Nosotros / comer / casa / abuelos / domingos.
2. Eduardo / hacer / tarea / diariamente.
3. Tú / vivir / gran / ciudad.
4. Vosotros / leer / periódico.
5. Ellos / salir / todos / días / misma / hora.

Irregular Verbs

There are only three irregular verbs in the imperfect tense. These are: **ir, ser,** and **ver.**

Infinitive	ir	ser	ver
yo	iba	era	veía
tú	ibas	eras	veías
él	iba	era	veía
nosotros	íbamos	éramos	veíamos
vosotros	ibais	erais	veíais
ellos	iban	eran	veían

Yo iba a bailar todos los viernes.
I used to go dancing every Friday.

¿Qué hora era? Eran las dos.
What time was it? It was two o'clock.

El joven no veía bien.
The young man did not see well.

Test Yourself: 47) Complete the following sentences with the verb in parentheses using the imperfect.
1. Eduardo _____ (ir) al cine los domingos.
2. Juan y Mario _____ (ser) muy buenos amigos.
3. Ellas _____ (ver) el espectáculo en la televisión.
4. Nosotros _____ (ir) a los museos.
5. Tú _____ (ser) un buen estudiante.
6. Andrés _____ (ver) a sus amigos con frecuencia.
7. Él _____ (ser) piloto.
8. Vosotros _____ (ir) de vacaciones a Europa.
9. Usted _____ (ver) con claridad.
10. Betina y yo _____ (ser) compañeros de clase.

Test Yourself: 48) Complete the following paragraph by using the appropriate verbs in the imperfect.
Cuando yo _____ 1. (ser) niño, me _____ 2. (gustar) ir al circo para ver los payasos. Cada vez que _____ 3. (haber) un circo en la ciudad, yo le _____ 4. (pedir) a mi padre que me llevara. Él siempre me _____ 5. (decir) que sí. Yo recuerdo como _____ 6. (reír) cuando _____ 7. (mirar) a los payasos saltar y hacer sus piruetas. Me _____ 8. (gustar) mucho el color de sus trajes. _____ 9. (ser) muy divertido y muchas veces recuerdo como me _____ 10. (hacer) feliz.

Uses of the Imperfect Tense

The imperfect is used to express repetitive or habitual actions, description, or a state of mind in the past. The imperfect is always used to tell age and time.

To express habitual actions:

Juan iba a la escuela en tren.
John used to go to school by train.

To express description:

El muchacho era alto y gordo.
The boy was tall and fat.

To express a state of mind (with the verbs **creer, pensar, querer,** and **saber**):

Creíamos que era cierto.
We believed it was true.

To tell time in the past:

Era la una de la tarde.
It was one o'clock in the afternoon.

With age:

Yo tenía 6 años en 1990.
I was 6 years old in 1990.

Test Yourself: 49) Rewrite the following sentences in the imperfect.
1. Juan viene a la escuela todos los días.
2. Alberto y Julio desayunan en el restaurante cada mañana.
3. Nosotros vamos a conciertos con frecuencia.
4. Ellos estudian todas las tardes.
5. Tú siempre dices la respuesta correcta en clase.
6. Yo veo a María en la ciudad de vez en cuando.
7. Vamos a la piscina todos los días.
8. Vosotros viajáis frecuentemente.
9. Él me llama a menudo.
10. Yo lo visito durante el verano.

The Preterite Tense Versus the Imperfect Tense

The use of the preterite and the imperfect tenses is somewhat difficult to master because these tenses share one thing in common: the past. Both of these tenses work from the framework of the past.

The difference between the preterite and the imperfect lies in the emphasis each verb places on an action or event. The preterite expresses a specific action or a definite event that was completed in the past; the emphasis is placed in that an action was started and completed in the past.

Ayer, fui a la fiesta de cumpleaños de Pepe.
Yesterday, I went to Joe's birthday party.

Ella hizo la tarea.
She did the homework.

Caminé una hora por el parque.
I walked for an hour in the park.

The preterite is used with a series of completed actions.

Hoy me levanté, me bañé, desayuné y fui al trabajo.
Today I got up, took a shower, had breakfast, and went to work.

The following words and expressions are often used to indicate the use of a preterite:

ayer	*yesterday*
anteayer	*the day before yesterday*
anoche	*last night*
anteanoche	*the night before last*
a la una, a las cinco	*(specific time) at one , at five o'clock*
el mes pasado, el año pasado	*last month, last year*
la semana pasada	*last week*
el sábado pasado	*last Saturday*
en el (año) 2003	*in the year 2003*
por fin	*at last*

de repente	*suddenly*
hace un rato	*a while ago*

The imperfect tense expresses a continuous action or event in the past; the emphasis is placed on how the action or event developed; it is used to describe a person, a thing, a state of mind, an action, or an event.

El semestre pasado, yo iba al trabajo después de mis clases.
Last semester, I used to go to work after my classes.

Luis siempre llegaba temprano a las fiestas.
Louis always arrived early to the parties.

La mujer era hermosa.
The woman was beautiful.

El día estaba nublado.
The day was cloudy.

Mi madre deseaba tomar un helado.
My mother wanted to have an ice cream.

When there is a descriptive action interrupted by another action, the description is an imperfect, whereas the verb that interrupts is a preterite.

Hablaba por teléfono cuando sonó el timbre.
I was talking on the phone when the door bell rang.

Some words and phrases that are often used with the imperfect are:

a veces	*sometimes*
muchas veces	*often*
frecuentemente	*frequently*
con frecuencia	*frequently*
a menudo	*often*
todos los días / meses / años	*every day / month / year*
los domingos	*on Sundays*

There are a few verbs that change their meaning when they are used in the preterite or the imperfect tense. These are:

Preterite		Imperfect	
conocí	*I met*	conocía	*I knew*
pude	*I could*	podía	*I was able to*
no pude	*I failed, couldn't*	no podía	*I wasn't able to*
quise	*I tried to*	quería	*I wanted to*
no quise	*I refused to*	no quería	*I didn't want to*
supe	*I found out*	sabía	*I knew*

Test Yourself: 50) Choose the verb that corresponds to the structure of the sentence.

Esta mañana 1. (me desperté, me despertaba) a las seis. 2. (Me levanté, Me levantaba) y 3. (fui, iba) al baño. Después 4. (tomé, tomaba) el desayuno y 5. (leí, leía) el periódico para enterarme de las noticias del día. Luego 6. (me vestí, me vestía) y 7. (salí, salía) hacia mi despacho. El día 8. (fue, era) hermoso. El cielo 9. (estuvo, estaba) claro y las nubes 10. (fueron, eran) blancas como la nieve. Los pájaros 11. (cantaron, cantaban) y 12. (hizo, hacía) una brisa fresca. 13. (Miré, Miraba) a mi alrededor y 14. (noté, notaba) que la gente 15. (estuvo, estaba) alegre. 16. (Tomé, Tomaba) el autobús y 17. (llegué, llegaba) a mi oficina media hora después.

Test Yourself: 51) Complete the following paragraph with the appropriate form of the preterite or imperfect of the verbs in parentheses.

Un día, yo _____ 1. (estar) en la sala leyendo un libro cuando _____ 2. (entrar) mi hermano corriendo para decirme que _____ 3. (haber) obtenido una beca para ir a la universidad. Él _____ 4. (estar) muy contento porque ahora _____ 5. (poder) continuar sus estudios y ser un programador de computadoras. Mis padres se _____ 6. (poner) muy contentos y nuestro perro que no _____ 7. (saber) lo que _____ 8. (pasar), _____ 9. (ladrar), y se _____ 10. (mover) alrededor de todos.

Test Yourself: 52) Rewrite the following sentences in the past changing **ayer** to **frecuentemente**.
1. Fui a la escuela ayer.
2. Caminé por el parque ayer en la tarde.
3. Trabajé duro aprendiendo español ayer.
4. Hice mi tarea de español ayer.
5. Busqué empleo en la ciudad ayer en la mañana.
6. Dormí una siesta ayer a las dos.
7. Pensé mucho acerca de este problema ayer.
8. Comí una cena deliciosa ayer en casa de mi amiga.
9. Ayer estudié mucho para mi examen de español.
10. Ayer caminé por la ciudad fotografiando los edificios.

Future Tense
The future tense is part of the indicative mood and indicates what will happen.

Regular –ar, –er, and –ir Verbs
The future tense is formed by adding the endings **–é, –ás, –á, –emos, –éis, –án** to the infinitive of these verbs.

Infinitive	hablar	comer	vivir
yo	hablaré	comeré	viviré
tú	hablarás	comerás	vivirás
él	hablará	comerá	vivirá
nosotros	hablaremos	comeremos	viviremos
vosotros	hablaréis	comeréis	viviréis
ellos	hablarán	comerán	vivirán

Pedro trabajará como director del hotel.
Peter will work as hotel director.

Los amigos de Miguel jugarán al tenis a las seis.
Michael's friends will play tennis at six.

Yo cenaré una buena paella esta noche.
I will eat a good paella tonight.

Ellos venderán su hacienda.
They will sell their plantation.

Mi madre irá de compras.
My mother will go shopping.

Viviré cerca de la casa de mis primos.
I will live near my cousins' house.

Test Yourself: 53) Complete the following sentences with the appropriate verb in the future indicative.

1. Mi hermano _____ (trabajar) para esta compañía.
2. Él _____ (vender) su automóvil.
3. Nosotros _____ (comer) sancocho dominicano.
4. Vosotros _____ (jugar) al tenis.
5. Tú _____ (aprender) español.
6. Ustedes _____ (visitar) mi casa pronto.
7. Los estudiantes _____ (tomar) un examen.
8. Los niños _____ (cantar) una canción.
9. Ricardo _____ (beber) cerveza con la cena.
10. Yo _____ (ir) a visitar a mi madre.

Test Yourself: 54) Complete the following sentences by using the future indicative.

1. Mañana yo (ir)
2. La próxima semana, ellos (esquiar)
3. Luego, vosotros (tomar)
4. Después, tú (comer)
5. El año que viene, Marta (viajar)
6. A las tres, nosotros (competir)
7. En dos meses, él (ser)
8. Luego, tú (escribir)
9. Mañana, ella (trabajar)
10. La semana próxima, yo (viajar)

Test Yourself: 55) Rewrite the following sentences in the future indicative.

1. Nadamos todos los días en la piscina del club atlético.
2. Terminamos la tarea después de la escuela.
3. Miramos un programa interesante de televisión.
4. Volvemos a casa por tren.
5. Vivimos en el Colegio Antonio de Nebrija en la universidad.
6. Conocemos al señor Fuentes.
7. Visito a mi amigo Felipe.
8. Tomo un café en el restaurante.
9. Admiro la belleza de ese museo.
10. Voy de viaje a México.

Irregular Verbs

Few verbs are irregular in the future tense. Those verbs are irregular, mainly because of their irregular stem. Notice, however, that their endings are regular.

caber, *to fit:*	**cabré, cabrás, cabrá, cabremos, cabréis, cabrán**
decir, *to say:*	**diré, dirás, dirá, diremos, diréis, dirán**
hacer, *to do:*	**haré, harás, hará, haremos, haréis, harán**
poder, *to be able:*	**podré, podrás, podrá, podremos, podréis, podrán**
poner, *to place:*	**pondré, pondrás, pondrá, pondremos, pondréis, pondrán**
querer, *to want:*	**querré, querrás, querrá, querremos, querréis, querrán**
saber, *to know:*	**sabré, sabrás, sabrá, sabremos, sabréis, sabrán**
salir, *to go out:*	**saldré, saldrás, saldrá, saldremos, saldréis, saldrán**

tener, *to have:*	**tendré, tendrás, tendrá, tendremos, tendréis, tendrán**
valer, *to be worth:*	**valdré, valdrás, valdrá, valdremos, valdréis, valdrán**
venir, *to come:*	**vendré, vendrás, vendrá, vendremos, vendréis, vendrán**

Compound verbs that are formed from other future irregular verbs are also irregular: **contradecir: contradiré: componer: compondré: convenir: convendré.**

Test Yourself: 56) Complete the following sentences with the appropriate form of the future indicative.

1. Nosotros _____ (decir) la verdad.
2. Tú _____ (hacer) la tarea.
3. Juanito _____ (querer) ir de compras.
4. Él _____ (poder) terminar el trabajo.
5. Vosotros _____ (saber) los resultados.
6. Ella _____ (caber) en el automóvil con nosotros.
7. Yo _____ (salir) de la biblioteca a las once.
8. Ellos _____ (tener) una fiesta para Luis.
9. Nosotros _____ (venir) juntos a la reunión.
10. Mis amigos _____ (saber) la información.

Test Yourself: 57) Rewrite the following sentences in the future indicative.

1. Yo pongo mi abrigo en el armario.
2. Tú dices la respuesta correcta.
3. Nosotros queremos ir al cine este fin de semana.
4. Él puede buscar la información.
5. Vosotros tenéis mucho trabajo en el colegio.
6. Jaime y Julia vienen a estudiar con nosotros.
7. Carmen sale para su trabajo a las cuatro.
8. Ellos ponen los libros sobre la mesa.
9. Yo quiero ir de vacaciones a Florida.
10. Ustedes pueden obtener mejores notas.

Uses of the Future Tense

The future tense is used in Spanish in the same manner as in English,

Miguel dice que irá a la escuela temprano mañana.
Michael says that he will go to school early tomorrow.

Ellos deciden que estudiarán más para el examen.
They decide that they will study more for the exam.

Mi madre dice que servirá la cena a las ocho.
My mother says that she will serve dinner at eight.

Another use of the future is to express an action that is probable.

¿Cuántos años tendrá?
I wonder how old he is.

Conditional Tense

Just like the future tense indicates what *will* happen, the conditional tense is used for what *would* happen.

Regular –ar, –er, –ir Verbs

The conditional of regular verbs is formed by adding the following endings to the infinitive: **–ía, –ías, –ía, –íamos, –íais, –ían.**

Infinitive	cantar	comer	vivir
yo	cantaría	comería	viviría
tú	cantarías	comerías	vivirías
él	cantaría	comería	viviría
nosotros	cantaríamos	comeríamos	viviríamos
vosotros	cantaríais	comeríais	viviríais
ellos	cantarían	comerían	vivirían

Yo iría contigo pero no puedo.
I would go with you, but I cannot.

Tú viajarías a Costa Rica.
You would go to Costa Rica.

Ellos encontrarían la dirección.
They would find the address.

Test Yourself: 58) Complete the following sentences with the appropriate form of the conditional tense of the indicative mood.

1. Yo _____ (escribir) pero no tengo tiempo.
2. Usted lo _____ (vender) pero no quiere.
3. Nosotros _____ (comer) pero no tenemos hambre.
4. Ustedes _____ (vivir) en Nueva York pero cuesta mucho.
5. Leoncio _____ (ir) contigo pero trabaja hoy.
6. Ellas _____ (estar) aquí pero no lo saben.
7. Tú _____ (comprar) el coche pero no puedes.
8. Ella _____ (conocer) a muchas personas.
9. Yo _____ (tomar) una cerveza pero tengo que conducir.
10. Él _____ (limpiar) su cuarto pero tiene un examen.

Test Yourself: 59) Make sentences in the conditional indicative with the following words.

1. Sofía / estar / casa.
2. Víctor y Luis / comprar / automóvil.
3. Nosotros / tomar / sopa.
4. Ellos / conocer / gobernador.
5. Ana y Luisa / comenzar / club cultural.

Irregular Verbs

The same verbs that are irregular in the future tense are irregular in the conditional tense.

decir, *to say:* **diría, dirías, diría, diríamos, diríais, dirían**
hacer, *to do:* **haría, harías, haría, haríamos, haríais, harían**
poder, *to be able to:* **podría, podrías, podría, podríamos, podríais, podrían**
poner, *to put:* **pondría, pondrías, pondría, pondríamos, pondríais, pondrían**

querer, *to want:* **querría, querrías, querría, querríamos, querríais, querrían**
saber, *to know:* **sabría, sabrías, sabría, sabríamos, sabríais, sabrían**
salir, *to go out, to exit:* **saldría, saldrías, saldría, saldríamos, saldríais, saldrían**
tener, *to have:* **tendría, tendrías, tendría, tendríamos, tendríais, tendrían**
valer, *to be worth:* **valdría, valdrías, valdría, valdríamos, valdríais, valdrían**
venir, *to come:* **vendría, vendrías, vendría, vendríamos, vendríais, vendrían**

Test Yourself: 60) Complete the following sentences with the correct form of the conditional tense of the indicative mood.

1. Ella _____ (decir) la verdad.
2. Tú _____ (hacer) el trabajo.
3. Nosotros _____ (poder) ir a la función.
4. Usted _____ (salir) a tiempo.
5. Margarita _____ (tener) un automóvil.
6. ¿_____ (valer) la pena ir allá?
7. ¿_____ (poner) ella la comida en el horno?
8. ¿_____ (venir) el correo a tiempo?
9. ¿_____ (caber) los libros en la caja?
10. ¿_____ (salir) el avión a tiempo?

Test Yourself: 61) Rewrite the following sentences in the conditional tense of the indicative mood.

1. Ellos harán el edificio.
2. Tú pondrás los instrumentos en el laboratorio.
3. Ustedes saldrán del cine a las once.
4. Las joyas valdrán mucho dinero.
5. La gente dirá su opinión.
6. Ellos vendrán a la fiesta.
7. Yo saldré de casa a las siete.
8. Nosotros pondremos el arbolito en el jardín.
9. Él sabrá qué hacer.
10. Marcos y Rolando podrán hacerlo.

Uses of the Conditional

The conditional is generally used in Spanish as in the English language. It is generally translated as *would, could, must have,* or *probably.* The conditional is used to convey a past probable action or event.

Nosotros dijimos que estudiaríamos una hora más.
We said that we would study one more hour.

Juan decía que los exámenes serían fáciles.
John used to say that examinations would be easy.

Dije que los muchachos deberían ser más amables.
I said that the young fellows should be more courteous.

Test Yourself: 62) Answer the following questions, using the conditional tense of the indicative mood.

1. ¿Te gustaría hablar español?
2. ¿Querrías ir con ellos al cine?
3. ¿Irías a España con nosotros este verano?
4. ¿Cuánto dinero necesitarías para el viaje?
5. ¿Vendrías a visitarnos a Caracas?
6. ¿Haríais bien el trabajo?
7. ¿Pensaríais en trabajar para esta compañía?

8. ¿Tendrías tú dinero para alquilar este apartamento?
9. ¿Iría él contigo a buscar los libros?
10. ¿Volverías tú a ver esa película?

Present Participle

In Spanish, the present participle, also called the gerund, is often used with the verbs **estar, seguir, continuar,** and **ir** and with verbs of motion to express that an action or event is (or was or will be) occurring at a particular moment.

Josefina está hablando con Margarita.
Josephine is talking to Margaret.

Estudiando, se aprende mucho.
By studying, one learns a lot.

Voy caminando a la escuela.
I am walking to school.

The gerund of **–ar** verbs is formed by dropping the **–ar** ending and adding **–ando.**

bailar	bailando	*dancing*
buscar	buscando	*looking for*
caminar	caminando	*walking*
escuchar	escuchando	*listening*
hablar	hablando	*speaking*
jugar	jugando	*playing*
limpiar	limpiando	*cleaning*
llamar	llamando	*calling*
nadar	nadando	*swimming*
trabajar	trabajando	*working*

The gerund of **–er** and **–ir** verbs is formed by dropping the infinitive endings and adding **–iendo.**

abrir	abriendo	*opening*
adquirir	adquiriendo	*acquiring*
añadir	añadiendo	*adding*
asistir	asistiendo	*assisting*
batir	batiendo	*beating*
beber	bebiendo	*drinking*
comer	comiendo	*eating*
componer	componiendo	*composing*
escribir	escribiendo	*writing*
hacer	haciendo	*making*
partir	partiendo	*leaving, breaking*
perder	perdiendo	*losing*
poner	poniendo	*placing*
recibir	recibiendo	*receiving*
saber	sabiendo	*knowing*
salir	saliendo	*leaving*
tener	teniendo	*having*
valer	valiendo	*costing*
vivir	viviendo	*living*
volver	volviendo	*returning*

Test Yourself: 63) Complete the following exercise with the appropriate present participle.

1. Yo estoy _____ (having) dificultad con la lección.
2. José está _____ (eating) en el comedor
3. Nosotros estamos _____ (drinking) cerveza.
4. Ellos están _____ (talking) español.
5. La clase está _____ (receiving) la tarea.
6. El euro está _____ (costing) cada día más dinero.
7. Estamos _____ (acquiring) mucha habilidad al hablar.
8. Rosa está _____ (calling) a Luisa.
9. Estamos _____ (opening) la puerta.
10. _____ (hearing) se aprenden muchas cosas.
11. _____ (living) en la ciudad, tú puedes visitar el museo.
12. Mi madre está _____ (beating) los huevos.
13. Estamos _____ (looking for) al profesor.
14. Vosotros vais _____ (walking) a la universidad.
15. Estoy _____ (receiving) muy buenas notas en español.

Many verbs ending in **–ir** have a stem change from the **e** to **i** and from the **o** to **u** in the gerund. The following are some of these verbs:

decir	**diciendo**	*saying*
dormir	**durmiendo**	*sleeping*
gemir	**gimiendo**	*groaning*
mentir	**mintiendo**	*lying*
morir	**muriendo**	*dying*
pedir	**pidiendo**	*asking for*
poder	**pudiendo**	*being able to*
reír	**riendo**	*laughing*
sentir	**sintiendo**	*feeling*
servir	**sirviendo**	*serving*
venir	**viniendo**	*coming*

Los estudiantes están pidiendo información.
The students are asking for information.

Ellos continúan riéndose.
They continue laughing.

Marta va durmiendo en el coche.
Martha goes sleeping in the car.

Test Yourself: 64) Complete the following sentences with the appropriate gerund.

1. _____ (serving) en este plato te ahorras tiempo.
2. Luis se está _____ (feeling) mejor ahora.
3. Me estoy _____ (sleeping) de cansancio.
4. _____ (asking for) las cosas se consigue mucho.
5. Mi perrito se está _____ (dying).
6. _____ (saying) la verdad se resuelven los problemas.
7. Es un chiste bueno. Me estoy _____ (laughing).

8. Josefa y María están _____ (serving) la comida.
9. El animal está _____ (groaning) de dolor.
10. Vosotros estáis _____ (sleeping).

Verbs ending in **–er** and **–ir** whose stems end in a vowel, form the gerund by adding **–yendo** to the stem.

caer	cayendo	*falling*
construir	construyendo	*constructing*
contribuir	contribuyendo	*contributing*
creer	creyendo	*believing*
distribuir	distribuyendo	*distributing*
huir	huyendo	*fleeing*
incluir	incluyendo	*including*
leer	leyendo	*reading*
oír	oyendo	*listening*
traer	trayendo	*bringing*

La noche está cayendo.
Night is falling.

Nosotros estamos oyendo la radio.
We are listening to the radio.

La compañía sigue distribuyendo los libros.
The company continues to distribute the books.

Nosotros estamos contribuyendo dinero.
We are contributing money.

Test Yourself: 65) Complete the following exercise with the correct form of the present progressive.
1. Este edificio se está _____ (falling).
2. La compañía está _____ (constructing) un edificio enorme en el centro de la ciudad.
3. Los ladrones se fueron _____ (fleeing).
4. Vosotros estáis _____ (contributing) a la clase.
5. Tú estás _____ (listening) una canción española.
6. Ricardo está _____ (reading) un libro de García Márquez.
7. Esta compañía está _____ (distributing) la mercancía.
8. Ustedes están _____ (bringing) demasiada comida.
9. Ellas están _____ (reading) el periódico.
10. Estamos _____ (listening) música cubana.

The verb **ir** is irregular in the gerund:

| **ir** | **yendo** | *going* |

Nosotros continuamos yendo a la ópera.
We continue to go to the opera.

Mario y Luisa siguen yendo al club.
Mario and Louise continue to go to the club.

The present participle is commonly used in the progressive tense. This tense is formed with the verbs **estar, seguir, ir** and with other verbs of motion to express that an action or event is (was or will be) in progress. In order to form the progressive tense, the appropriate tense of the auxiliary verb **estar, seguir, ir** or any other verb of motion is used, then the present participle of the main verb is formed.

Juan está corriendo en el parque.
John is running in the park.

Yo estoy haciendo la tarea.
I am doing my homework.

Miguel sigue buscando sus libros.
Michael continues to look for his books.

Ellos irán caminando mientras Jorge descansa.
They will be walking while George rests.

María estaba comiendo cuando sonó el teléfono.
Mary was eating when the telephone rang.

Present Progressive

This tense is used when the action or event is currently in progress

estoy hablando	**estoy comiendo**	**estoy viviendo**
estás hablando	**estás comiendo**	**estás viviendo**

Yo estoy hablando con mi mejor amigo.
I am talking with my best friend.

Maribel y Olga siguen comiendo tapas en el bar.
Maribel and Olga continue to eat tapas at the bar.

Vosotros estáis viviendo en la mejor ciudad del mundo.
You (plural) are living in the best city in the world.

Test Yourself: 66) Rewrite the following exercise with the correct form of the present participle.
1. I am talking on the phone.
2. He is looking for his book.
3. They go walking to the theater.
4. Joseph continues to eat paella.
5. You are talking to your friend.

Preterite Progressive

The preterite progressive tense is used when the action or event was taking place at a definite time in the past.

estuve hablando	**estuve comiendo**	**estuve viviendo**
estuviste hablando	**estuviste comiendo**	**estuviste viviendo**

Ayer, estuve hablando con Raúl.
Yesterday, I was talking to Raúl.

Ellos estuvieron divirtiéndose en la fiesta.
They were enjoying themselves at the party.

Carlos siguió estudiando en Harvard.
Charles continued to study at Harvard.

Test Yourself: 67) Rewrite the following sentences in the preterite progressive.

1. Yo estoy hablando.
2. Tú sigues comiendo.
3. Julio va vendiendo libros.
4. Nosotros estamos trabajando.
5. Ellos siguen estudiando.
6. María y Julio están riéndose.
7. Vosotros estáis aprendiendo.
8. Tú y yo vamos mirando.
9. Yo sigo escribiendo.
10. Marta va pensando.

Imperfect Progressive

The imperfect progressive tense is used when the event was ongoing or if it is a description.

estaba hablando **estaba comiendo** **estaba viviendo**
estabas hablando **estabas comiendo** **estabas viviendo**

Yo estaba hablando con Luis.
I was talking to Louis.

Roberto estaba bailando con Margarita.
Robert was dancing with Margaret.

Benito y yo continuábamos comiendo chorizos.
Benito and I continued to eat sausages.

Test Yourself: 68) Complete the following paragraph with the correct form of the imperfect progressive.
Un día, yo _____ 1. (to talk) con mi amigo cuando vimos un hombre que _____ 2. (to go out) por la ventana de una casa. Nosotros mirábamos como él _____ 3. (to go down) del segundo piso y como _____ 4. (to carry) un saco lleno de cosas. En ese momento vimos que otro señor _____ 5. (to run) detrás del primero. Yo le dije a mi amigo que algo malo _____ 6. (to happen) en aquel lugar y llamamos a la policía. Le describimos lo que _____ 7. (to see) y el sargento dijo que un coche de patrulla vendría a investigar el suceso.

Future Progressive

This tense is used when the event or action will be taking place at a particular time in the future.

estaré hablando **estaré comiendo** **estaré viviendo**
estarás hablando **estarás comiendo** **estarás viviendo**

Test Yourself: 69) Complete the exercise by using the future progressive tense.

1. María / mirar el televisor.
2. José / reírse de los chistes de Juan.
3. Nosotros / hacer la tarea.
4. Ellos / pensar.
5. Jorge y Yo / pintar.
6. Ramiro y Julio / correr en el estadio.
7. La señora Martínez / gritar.
8. Tú / caminar con Luisa en el parque.
9. Pepe / hacer la tarea de español.
10. Yo / bañarme a esa hora de la noche.

Conditional Progressive

The conditional progressive tense is used when the action or event would be taking place under certain conditions. It is usually used with *if* clauses.

estaría hablando	**estaría comiendo**	**estaría viviendo**
estarías hablando	**estarías comiendo**	**estarías viviendo**

Este estudiante estaría hablando español si tratara.
This student would be speaking Spanish if he tried.

Daniel seguiría trabajando si le pagaran más dinero.
Daniel would continue to work if they paid him more money.

José continuaría estudiando si tuviera dinero.
Joseph would continue to study if he had money.

Test Yourself: 70) Complete the following exercise by using the verbs **estar, seguir, ir** or **continuar** and the conditional progressive.

modelo: **La hermana de Juan estaría trabajando.**

1. Mi primo
2. Nuestros amigos
3. Yo
4. Ellos
5. Tú
6. Vosotros
7. Marta y Bélgica
8. Consuelo
9. Diana y tú
10. Él

Past Participle

The past participle is mainly used in conjunction with the verb "have". For example, have seen, have done, have gone, have worked, have practiced. The past participle in these cases is "seen, done, gone, worked, practiced". The conjunction of these verbs creates the "perfect tenses."

Hemos trabajado mucho hoy.
We have worked a lot today.

Javier ha comido lo suficiente.
Xavier has eaten enough.

Arturo ha vivido en San José.
Arthur has lived in San José.

The past participle of regular **–r** verbs is formed by adding the ending **–ado** to the stem of the verb.

estudiar	**estudiado**	*studied*
mirar	**mirado**	*looked*
tomar	**tomado**	*drunk*
trabajar	**trabajado**	*worked*
tratar	**tratado**	*tried*

The past participle of regular **–er** and **–ir** verbs is formed by adding the ending –ido to the stem of the verb.

comer	**comido**	*eaten*
ir	**ido**	*gone*
saber	**sabido**	*known*
vivir	**vivido**	*lived*

Test Yourself: 71) Complete the following letter, using the past participle of the verbs found in parentheses.

Mi querido amigo Miguel,

He _____ 1. (decidir) escribirte para saber como estás. Yo he _____ 2. (estar) un poco enfermo pero ahora me siento bien. ¿Has _____ 3. (recibir) las postales de mi viaje a México? Te he _____ 4. (mandar) tres tarjetas postales pero no he _____ 5. (saber) nada de ti. Mi hermano y yo hemos _____ 6. (viajar) por gran parte de México. Hemos _____ 7. (mirar) cosas muy interesantes como las pirámides de los aztecas y los mayas. Este viaje ha _____ 8. (ser) una experiencia inolvidable. Mis amigos mexicanos se han _____ 9. (comportar) maravillosamente con nosotros y nos han _____ 10. (llevar) a lugares exóticos donde los turistas raramente van.

When the stem of the verb that will be used as the past participle ends in a vowel, an accent mark is placed over the **–i** of **–ido.**

creer	**creído**	*believed*
oir	**oído**	*heard*
traer	**traído**	*brought*

He oído la explicación.
I have heard the explanation.

Eduardo ha traído estas cajas.
Edward has brought these boxes.

Los jueces han creído su cuento.
The judges have believed his story.

Some verbs have irregular past participles.

abrir	**abierto**	*opened*
cubrir	**cubierto**	*covered*
decir	**dicho**	*said*
descubrir	**descubierto**	*discovered*
escribir	**escrito**	*written*
hacer	**hecho**	*done*
imprimir	**impreso**	*printed*
morir	**muerto**	*died*
poner	**puesto**	*put*
resolver	**resuelto**	*solved*
romper	**roto**	*broken*
ver	**visto**	*seen*
volver	**vuelto**	*returned*

Fernando ha hecho la tarea.
Fernand has done his homework.

Ellos han abierto la puerta.
They have opened the door.

Ana ha descubierto el secret.
Ana has discovered the secret.

Test Yourself: 72) Write the past participle for the following verbs.

1. abrir
2. decir
3. descubrir
4. poner
5. romper
6. ver
7. hacer
8. resolver
9. imprimir
10. morir

Test Yourself: 73) Complete the following sentences with the correct form of the past participle.

1. Yo he _____ (ver) ese drama.
2. Ellos han _____ (hacer) la monografía.
3. El hombre ha _____ (cubrir) el sofá con una sábana.
4. El plato se ha _____ (romper).
5. Nosotros hemos _____ (escribir) un poema.

Present Perfect

The past participle is normally used with the present perfect tense. This tense is a compound tense that is formed by using the present indicative of **haber** + the past participle.

Yo he dicho la verdad.
I have told the truth.

Ellos han ido a la escuela.
They have gone to school.

Leoncio ha visto el anuncio.
Leoncio has seen the advertisement.

The present perfect is used to describe an action that began in the past and ended before the present moment.

Infinitive	hablar	comer	vivir
yo	he hablado	he comido	he vivido
tú	has hablado	has comido	has vivido
él	ha hablado	ha comido	ha vivido
nosotros	hemos hablado	hemos comido	hemos vivido
vosotros	habéis hablado	habéis comido	habéis vivido
ellos	han hablado	han comido	han vivido

Test Yourself: 74) Rewrite the following sentences by using the past participle according to the model.
modelo: **Julia / hablar sobre su libro.**
Julia ha hablado sobre su libro.

1. Juan / comer arroz con pollo.
2. Tú / traer un regalo.
3. Sara / cocinar un plato delicioso.
4. Beatriz y Ricardo / buscar un restaurante magnífico.
5. El fotógrafo / sacar unas fotografías estupendas.
6. Nosotros / ver la exposición.
7. Ellos / vivir en Madrid.
8. Vosotros / salir con María.
9. Ustedes / caminar por La Gran Vía.
10. Yo / visitar los Andes.

The past participle is also used with the pluperfect tense, the preterite perfect tense, the future perfect tense, the conditional perfect tense, the perfect infinitive, and the perfect participle.

Pluperfect

The past participle is also used with the past perfect tense also referred to as the pluperfect. This tense is a compound tense that is formed by using the imperfect indicative of **haber** + the past participle.

Andrés había comido en casa de Luz.
Andrew had eaten at Luz's house.

Yo había hablado con ella.
I had spoken with her.

Nosotros habíamos estudiado la lección.
We had studied the lesson.

Infinitive	hablar	comer	vivir
yo	había hablado	había comido	había vivido
tú	habías hablado	habías comido	habías vivido
él	había hablado	había comido	había vivido
nosotros	habíamos hablado	habíamos comido	habíamos vivido
vosotros	habíais hablado	habíais comido	habíais vivido
ellos	habían hablado	habían comido	habían vivido

The pluperfect is formed by using the imperfect tense of the auxiliary verbs **haber** with the past participle of the verb.

Test Yourself: 75) Complete the following sentences with the appropriate form of the pluperfect according to the verb in parentheses.

1. Yo _____ (hablar) con él.
2. Tú no _____ (comer) a las doce.
3. Carmen _____ (vender) toda la mercancía.
4. Nosotros _____ (ver) la película.
5. Vosotros _____ (decir) la verdad.
6. Mima y Rosa _____ (ir) de compras.
7. Él _____ (volver) a España dos veces antes.
8. Tú _____ (vivir) en Costa Rica con tus padres.
9. Ellos _____ (hacer) sus tareas.
10. Yo _____ (caminar) cinco kilómetros cuando lo vi.

Future Perfect

The past participle can also be used with the future perfect tense. This tense is a compound tense that is formed by using the future indicative of **haber** + the past participle.

Habremos hecho el trabajo para entonces.
We will have finished the work by then.

Para entonces, habréis terminado el trabajo.
By then, you will have finished the work.

Para esa hora, habrán llegado a esa ciudad.
By that hour, they will have arrived at that city.

Infinitive	hablar	comer	vivir
yo	habré hablado	habré comido	habré vivido
tú	habrás hablado	habrás comido	habrás vivido
él	habrá hablado	habrá comido	habrá vivido

nosotros	habremos hablado	habremos comido	habremos vivido
vosotros	habréis hablado	habréis comido	habréis vivido
ellos	habrán hablado	habrán comido	habrán vivido

The future perfect is used to express a future action that will be completed before another.

Test Yourself: 76) Rewrite the following sentences by using the future perfect.

modelo: **Yo voy a la escuela.**

Yo habré ido a la escuela.

1. Ellos van al cine.
2. Luis hace su proyecto.
3. Vosotros miráis la película.
4. Tú ves el edificio.
5. Yo camino por la ciudad.
6. Nélida busca su ropa en la tintorería.
7. Ellos oyen música.
8. Todos preparamos las maletas para el viaje.
9. Él no necesita trabajar en el verano.
10. Marta y Olga comen a las tres.

Conditional Perfect

As with the other tenses, the conditional perfect tense is a compound tense formed by using the conditional indicative of **haber** + the past participle.

Habrían sobrevivido en otro automóvil.
They would have survived in another car.

En un país hispano, habrían hablado más español.
In a Hispanic country, they would have spoken more Spanish.

Yo habría comido si tuviera dinero.
I would have eaten, if I had money.

Infinitive	hablar	comer	vivir
yo	habría hablado	habría comido	habría vivido
tú	habrías hablado	habrías comido	habrías vivido
él	habría hablado	habría comido	habría vivido
nosotros	habríamos hablado	habríamos comido	habríamos vivido
vosotros	habríais hablado	habríais comido	habríais vivido
ellos	habrían hablado	habrían comido	habrían vivido

The conditional perfect is used to describe an action or event that would have been completed in the past.

Test Yourself: 77) Complete the following exercise with the appropriate form of the conditional perfect.

1. Jorge _____ (hablar) pero no pudo.
2. Yo _____ (regresar) a tiempo.
3. Carlos me lo _____ (decir) pero no estaba en casa.
4. Papá _____ (terminar) este trabajo más pronto.
5. Tú _____ (hacer) esto mejor.
6. Ellos _____ (comer) mejor en este restaurante.

7. Ustedes _____ (beber) sangría.
8. Todas _____ (viajar) juntas en avión.
9. Juan _____ (contestar) correctamente esa pregunta.
10. Ella _____ (estudiar) mucho.

REFLEXIVE VERBS

A reflexive verb is one that makes the subject both the doer and the receiver of the action. Because the subject becomes the object of the action, reflexive pronouns are required; these pronouns normally precede the verb.

The following are all the conjugations of the verb **levantarse** in the indicative mood:

Present Tense

me levanto
te levantas
se levanta
nos levantamos
os levantáis
se levantan

Preterite Tense

me levanté
te levantaste
se levantó
nos levantamos
os levantasteis
se levantaron

Imperfect Tense

me levantaba
te levantabas
se levantaba
nos levantábamos
os levantabais
se levantaban

Future Tense

me levantaré
te levantarás
se levantará
nos levantaremos
os levantaréis
se levantarán

Conditional

me levantaría
te levantarías
se levantaría
nos levantaríamos
os levantaríais
se levantarían

Present Perfect

me he levantado
te has levantado
se ha levantado
nos hemos levantado
os habéis levantado
se han levantado

Pluperfect.

me había levantado
te habías levantado
se había levantado
nos habíamos levantado
os habíais levantado
se habían levantado

Future Perfect

me habré levantado
te habrás levantado
se habrá levantado
nos habremos levantado
os habréis levantado
se habrán levantado

Conditional Perfect

me habría levantado
te habrías levantado
se habría levantado
nos habríamos levantado
os habríais levantado
se habrían levantado

Test Yourself: 78) Complete the following sentences in the present tense with the appropriate form of the verb in parentheses.

1. Yo _____ (afeitarse) por la mañana.
2. Tú _____ (acostarse) temprano.
3. El _____ (despertarse).
4. Nosotros _____ (dormirse) a las tres.
5. Vosotros _____ (marcharse) para Barcelona.
6. Ellos _____ (vestirse) con su mejor ropa.
7. Yo _____ (sentarse) a esperar a Pablo.
8. Tú _____ (cepillarse) el cabello.
9. Julia _____ (quitarse) el sombrero.
10. Ellos _____ (despedirse) de nosotros.

Test Yourself: 79) Now change the above sentences into the preterite tense.

1. _____
2. _____
3. _____
4. _____
5. _____
6. _____
7. _____
8. _____
9. _____
10. _____

Test Yourself: 80) Write sentences in the imperfect tense by using the following words.

1. Mi hermano / vestirse / rápidamente
2. Mi madre / comprarse / vestido
3. Yo / bañarse / piscina.
4. Ellos / despedirse / amigos.
5. Tú / esconderse / cocina.

Test Yourself: 81) Write sentences in the future tense by using the following words.

1. Vosotros / irse / España.
2. Yo / ponerse / abrigo.
3. Ellos / negarse / ayudar / muchachos.
4. El consejero / levantarse / recibir / invitados.
5. Tú / vestirse / cuarto.

Test Yourself: 82) Complete the following sentences in the pluperfect tense.

1. Cuando Luis fue a su habitación, yo_____ (levantarse).
2. Cuando nosotros los vimos, ellos_____(tomarse) todo el vino.
3. Cuando ella llegó, tú_____(irse).
4. Cuando ustedes regresaron, Felipe_____(dormirse).
5. Cuando Daniel terminó, nosotros_____(acostarse)

Other commonly used reflexive verbs are:

Infinitive	Present Tense	
acostarse	**me acuesto**	*to go to bed*
bañarse	**me baño**	*to take a bath*
cambiarse	**me cambio**	*to change*

cepillarse	me cepillo	*to brush*
despedirse	me despido	*to take leave*
despertarse	me despierto	*to wake up*
dormirse	me duermo	*to fall asleep*
ducharse	me ducho	*to take a shower*
irse	me voy	*to leave*
marcharse	me marcho	*to leave*
peinarse	me peino	*to comb*
ponerse	me pongo	*to put on*
quedarse	me quedo	*to remain*
quitarse	me quito	*to take off (clothing)*
sentarse	me siento	*to sit down*
sentirse	me siento	*to feel*
vestirse	me visto	*to dress*

Notice that some of these verbs like **acostarse** and **despertarse** are stem-changing, and others are irregular like **irse** and **ponerse.** To study these stem-changing and irregular verbs in more detail, refer to the appropriate section in this chapter.

Infinitive

acostarse	despertarse	dormirse
me acuesto	me despierto	me duermo
te acuestas	te despiertas	te duermes
se acuesta	se despierta	se duerme
nos acostamos	nos despertamos	nos dormimos
os acostáis	os despertáis	os dormís
se acuestan	se despiertan	se duermen

Infinitive	irse	
me voy	te vas	se va
nos vamos	os váis	se van

Adjectives and Articles with Reflexive Verbs

When a reflexive verb is used in a sentence, possessive adjectives are omitted.

Me cepillo el pelo.
I comb my hair.

Pedro se lava la cara.
Peter washes his face.

Ellos se quitan el sombrero.
They take off their hats.

Notice that in all three sentences, the definite article is used instead of the possessive adjective. Due to the fact that the verbs are reflexive, it is undestood that the object belongs to the doer of the action. The predicate of the third sentence (**el sombrero**) remains singular in Spanish, although it is pluralized in English.

Reflexive pronouns also follow and are attached to the gerund and the infinitive.

Andrés estaba levantándose cuando oyó el teléfono.
Andrew was getting up when he heard the telephone.

Acabamos de levantarnos hace cinco minutos.
We just got up five minutes ago.

When a verb is conjugated, the reflexive pronoun precedes the conjugated form of the verb.

Me ducho a las seis de la mañana.
I take a shower at six o'clock in the morning.

Uses of Reflexive Verbs

Some verbs change their meaning when used reflexively. The following is a list of some of them:

Basic Meaning	Reflexive Meaning		
aburrir	*to bore*	**aburrirse**	*to become bored*
acostar	*to put to bed*	**acostarse**	*to go to bed*
apuntar	*to note; to point to*	**apuntarse**	*to enroll*
bañar	*to bathe*	**bañarse**	*to take a bath*
cansar	*to tire*	**cansarse**	*to become tired*
engañar	*to deceive*	**engañarse**	*to deceive oneself*
esconder	*to hide*	**esconderse**	*to hide (oneself)*
despedir	*to dismiss*	**despedirse**	*to take leave*
parar	*to stop*	**pararse**	*to stop oneself; to get up*
poner	*to put*	**ponerse**	*to put on; to become*
sentar	*to seat*	**sentarse**	*to sit down*

Other verbs can be used reflexively or nonreflexively. In this case, they are used reflexively only when the action of the verb refers to the subject.

Me lavo el pelo.
I wash my hair.

Yo lavo el automóvil.
I wash the car.

Me pongo el abrigo.
I put on my coat.

Yo pongo los libros en la mesa
I put the books on the table.

Test Yourself: 83) Complete the following sentences with the reflexive pronoun, when necessary.

1. Yo_____levanto a las seis.
2. Juan_____acuesta a sus hermanos.
3. Ellos_____duermen en el sofá.
4. Nosotros_____acostamos tarde.
5. Nosotros _____acostamos a los niños.
6. Ellos_____duermen al bebé.
7. Tú_____peinas el pelo.
8. Tú_____peinas el pelo de tu hermano.
9. Vosotros_____levantáis temprano.
10. Vosotros_____levantáis a vuestros vecinos.

Reciprocal verbs are verbs in which the subjects do actions to or for each other. In Spanish, these verbs function in the same manner as reflexive verbs. They are commonly translated as *each other* or *one another.*

Nos vemos en el parque a las tres.
We will see each other in the park at three.

Se escriben con frecuencia.
They frequently write to each other.

Ellas se saludaron al pasar.
They greeted one another when they passed by.

Test Yourself: 84) Write sentences in the preterite with the following words.
1. Juan / parar / taxi.
2. Juan / pararse / delante de / taxi.
3. Ellos / poner / arbolito / allí.
4. Nosotros / colocarse / compañía.
5. Tú / esconder / notas.
6. Tú / esconderse / detrás de / puerta.
7. Yo / cansarse / caminar
8. El /bañar /hijo.
9. El / ducharse / ducha.
10. Vosotros / sentarse / sillas.

Test Yourself Answers

1)
1. jugar
2. Correr
3. recibir
4. vender
5. comer
6. Escribir
7. saber
8. poner
9. ver; mirar
10. ir, trabajar

2)
1. charlo
2. descansa
3. dobla
4. buscan
5. llama
6. cenas
7. copia
8. espero
9. bajan
10. cantamos
11. viajo
12. esquiáis
13. gana
14. enseñamos
15. compran

3
1. camino
2. Tomo
3. doblo
4. cruzo
5. llego
6. Entro
7. hablo
8. enseña
9. estudio
10. deseo

4)
1. Yo doy dinero al limosnero.
2. Yo estoy estudiando en la bibliotieca.
3. Yo estoy en el cine todos los fines de semana.
4. Yo estoy en la calle doce.
5. Yo doy a la escuela una donación.

5)
1. aprieto
2. confiesa
3. cierra
4. empezamos
5. gobierna
6. niegas
7. quiebran
8. despertamos
9. comienzo
10. encerráis

6)
1. muestro
2. almuerzan
3. recuerda
4. probamos
5. contáis
6. encuentras
7. muestra
8. recuerdan
9. almuerza

7)
1. aprende
2. romete
3. creen
4. comprendemos
5. bebes
6. come
7. aprenden
8. leéis
9. ven
10. promete

8)
1. Yo como paella
2. Eduardo vende productos agrícolas
3. Nosotros corremos en las mañanas.
4. Ellas aprenden nuevas palabras.
5. Marta y yo leemos un libro interesante.

9)
1. Yo hago la tarea
2. Yo sé la verdad.
3. Yo traigo comida a la fiesta.
4. Yo compongo música clásica.
5. Yo veo una película de misterio.

10)
1. ofrezco
2. pongo
3. sé
4. dispongo
5. carezco
6. reconzco
7. establezco
8. hago
9. satisfago
10. merezco

11)
1. he
2. ha
3. han
4. ha
5. has
6. hemos
7. habéis
8. ha
9. han
10. ha

12)
1. es
2. soy
3. son
4. eres
5. son
6. es
7. sois
8. es
9. es
10. son

13)
1. Mi mejor amigo es Juan.
2. Yo soy estudiante.
3. Yo soy norteamericano.
4. Mi clase favorita de idiomas es el español.
5. La capital de Chile es Santiago de Chile.

14)
1. Yo tengo sed.
2. Usted tiene una casa muy bonita.
3. Nosotras tenemos un buen trabajo.
4. Ellos tienen que ir de compras.
5. Rafael tiene tarea de español.

15)
1. entretenemos
2. detiene
3. sostienen
4. mantenéis
5. obtiene
6. entretienes
7. detienen
8. sostengo
9. mantiene
10. obtienes

16)
1. quiero
2. pierden
3. defiendes
4. queremos
5. pierden

17)
1. vuelven
2. mueves
3. envolvemos
4. devuelve
5. resuelvo
6. podéis
7. devolvemos
8. duele
9. llueve
10. volvemos

18)
1. Tú juegas al ajedrez con tu padre.
2. Nosotros jugamos al baloncesto.
3. Usted juega con sus niños.
4. Vosotros jugáis al béisbol profesional.
5. Yo juego al fútbol.
6. Ellos juegan fútbol americano.
7. Verónica juega a las escondidas.
8. Él juega a los vaqueros.
9. Juan y yo jugamos juegos electrónicos.
10. Todos jugamos un deporte u otro.

19)
1. abren
2. asiste
3. discute
4. subimos
5. sufres
6. reciben
7. admito
8. cubrís
9. añadimos
10. escribe

20)
1. Sí, yo recibo cartas con frecuencia.
2. No, nosotros no discutimos con el profesor.
3. Sí, escribimos una monografía sobre Calderón de la Barca.
4. Sí, ella asiste a la conferencia sobre Octavio Paz.
5. No, no vivo lejos de la universidad.

21)
1. salgo
2. produces
3. traducen
4. deducís
5. conduce

22)
1. Julio dice que no puede ir.
2. Ellos dicen que hacen la tarea.
3. Tú dices que sí.
4. Nosotros decimos la respuesta correcta.
5. Yo digo las letras del alfabeto.

23)
1. oigo
2. oye
3. oyen
4. oyen
5. oímos
6. oyen
7. oyen
8. oyes
9. oigo
10. oímos

24)
1. Sí, oigo la radio.
2. Sí, oímos el concierto.
3. No, no oyen las noticias.
4. No, no oímos la conferencia.
5. Sí, oye música clásica.

25)
1. Yo vengo de la universidad.
2. Vengo con los abuelos.
3. Ahí vienen unos amigos.
4. Sí, vienen a estudiar español.
5. Sí, vengo de prisa.

26)
1. prefiero
2. preferimos
3. sugieren
4. hierven
5. sientes
6. divierte
7. miente
8. divierten
9. convertís
10. hierven

27)
1. Tú duermes mucho los fines de semana.
2. Yo duermo cómodamente en el sofa.

3. Nosotros dormimos en el autobus vía Madrid.

4. Ellos duermen parados.

5. Usted duerme en la sala.

28)
1. duermo
2. duermes
3. dormimos
4. duerme
5. duerme
6. mueren
7. dormís
8. duerme
9. muere
10. mueren

29)
1. pide
2. pedimos
3. piden
4. frío
5. medimos
6. sirve
7. sonríe
8. visto
9. impiden
10. despides

30)
1. huye
2. sustituimos
3. influyen
4. incluye
5. construye
6. destruyen
7. disminuís
8. concluyes
9. distribuyen
10. influye

31)
1. cantó
2. hablaron
3. mirasteis
4. trabajé
5. estudió
6. caminó
7. bailaron
8. tomaste
9. actuamos
10. compraron

32)
1. Ustedes trabajaron en el supermercado.
2. Yo gané ochenta dólares por día.
3. Ellos compraron una casa en el suburbio.
4. Nosotros regresamos a la escuela.
5. Tú corriste todas las mañanas.

33)
1. levanté
2. Caminé
3. encontré
4. Regresé
5. esperé
6. llamó
7. tomé
8. desayuné
9. cambié
10. marché

11. Caminé
12. Tomé
13. entré
14. empezó
15. pasó

34)
1. Llamé a Miguel a las ocho.
2. Caminamos cinco millas en el estadio.
3. Recibí unos discos.
4. Sí conocí a todas las personas.
5. Émpezó a las diez.

35)
1. Yo busqué un regalo para Pedro.
2. Ellos colocaron las flores en el florero.
3. Yo dediqué este libro a mi amigo Ramón.
4. Nosotros fabricamos juguetes de niños.
5. Yo saqué a mi hermano de aprieto.
6. Tú tocaste la escultura de Minerva.
7. Yo indiqué la dirección correcta a los señores.
8. Usted marcó los reportes.
9. Yo embarqué la mercancía para Europa.
10. Vosotros aplicasteis mucha presión a la superficie.

36)
1. Yo pagué la cuenta.
2. Ellos cargaron los paquetes.
3. Tú colgaste la ropa en el tendedero.
4. Ellas llegaron a tiempo.
5. Nosotros arreglamos las flores.
6. Ustedes encargaron la mercancia.
7. Yo jugué ajedrez.
8. Ellos rogaron por la paz.
9. Yo entregué el trabajo.
10. Vosotros apagasteis la luz.

37)
1. Yo almorcé a las dos de la tarde.
2. Yo avancé rápidamente a la meta final.
3. Yo gocé de los chistes de José.
4. Yo lancé el platillo unos cien metros.
5. Yo abracé a su hermano.
6. Yo tropecé con esta piedra.

7. Yo me deslicé por la montaña.

8. Yo comencé los ejercicios.

9. Yo amenacé con despedir al empleado.

10. Yo gocé mucho el día de mi cumpleaños

38) 1. Yo di una fiesta en mi casa.

2. Ellas estuvieron en la universidad hoy.

3. Tú diste un examen de matemáticas.

4. Él estuvo en la playa con sus amigos.

5. Nosotros dimos una explicación a nuestro padre.

39)
1. estuvieron
2. diste
3. estuvo
4. dimos
5. estuvo
6. dio
7. estuvieron
8. di
9. estuvisteis
10. disteis

40)
1. comí
2. vivieron
3. escribiste
4. volvimos
5. recibió
6. abrió
7. metieron
8. comió
9. perdisteis
10. subieron

41)
1. escribió
2. salió
3. bebió
4. volvió
5. abrió

42) 1. Yo estuve en Zaragoza.

2. Ellos hicieron la composición.

3. Nosotros pudimos fabricar el equipo.

4. Ustedes tuvieron un apartamento elegante.

5. Vosotros vinisteis de un viaje.

6. Tú supiste la respuesta.

7. Él trajo las verduras.

8. Ellas produjeron las películas.

9. Usted fue un profesional.

10. Todos dieron una contribución.

43)
1. tomaba
2. cantaban
3. bailaban
4. trabajabas
5. almorzaba
6. llegabais
7. compraba
8. bañaba
9. jugaba
10. caminaban
11. nadábamos
12. hablaba
13. estábamos
14. reparaban
15. comprabais

44) 1. Yo cantaba una aria de la ópera.

2. Tú comprabas un libro de Gustavo Adolfo Bécquer.

3. Ella llegaba a la cita a tiempo.

4. Nosotros estábamos cansados.

5. Vosotros jugabais baloncesto.

45)
1. salía
2. vivían
3. comías
4. hacíamos
5. perdíais
6. abría
7. traían
8. escribíamos; escribían
9. vestían
10. repetían
11. seguía
12. volvía
13. bebíais
14. teníamos
15. seguía

46) 1. Nosotros comíamos en casa de mis abuelos los domingos.

2. Eduardo hacía tarea diariamente.

3. Tú vivías en una gran ciudad.

4. Vosotros leíais el periódico.

5. Ellos salían todos los días a la misma hora.

47)
1. iba
2. eran
3. veían
4. íbamos
5. eras
6. veía
7. era
8. ibais
9. veía
10. éramos

48)
1. era
2. gustaba
3. había
4. pedía

5. decía 8. gustaba

6. reía 9. Era

7. miraba 10. hacía

49) 1. Juan venía a la escuela todos los días.

2. Alberto y Julio desayunaban en el restaurante cada mañana.

3. Nosotros íbamos a conciertos con frecuencia.

4. Ellos estudiaban todas las tardes.

5. Tú siempre decías la respuesta correcta en clase.

6. Yo veía a María en la ciudad de vez en cuando.

7. Íbamos a la piscina todos los días.

8. Vosotros viajabais frecuentemente.

9. Él me llamaba a menudo.

10. Yo lo visitaba durante el verano.

50) 1. me desperté 10. eran

2. Me levanté 11. cantaban

3. fui 12. hacía

4. tomé 13. Miré

5. leí 14. noté

6. me vestí 15. estaba

7. salí 16. Tomé

8. era 17. llegué

9. estaba

51) 1. estaba 6. pusieron

2. entró 7. sabía

3. había 8. pasaba

4. estaba 9. ladraba

5. podía 10. movía

52) 1. Iba frecuentemente a la escuela.

2. Caminaba frecuentemente por el parque en la tarde.

3. Trabajaba duro frecuentemente aprendiendo español.

4. Hacía frecuentemente mi tarea de español.

5. Buscaba frecuentemente empleo en la ciudad por la mañana.

6. Dormía frecuentemente una siesta a las dos.

7. Pensaba mucho frecuentemente acerca de este problema.

8. Comía frecuentemente una cena deliciosa en casa de mi amiga.

9. Frecuentemente estudiaba mucho para mi examen de español

10. Frecuentemente caminaba por la ciudad fotografiando los edificios.

53) 1. trabajará 6. visitarán

2. venderá 7. tomarán

3. comeremos 8. cantarán

4. jugaréis 9. beberá

5. aprenderás 10. iré

54) 1. iré al cine

2. esquiarán.

3. tomaréis café

4. comerás con nosotros.

5. viajará al Brasil.

6. competiremos en la corrida.

7. será presidente.

8. escribirás una carta.

9. trabajará todo el día.

10. viajaré a Paris.

55) 1. Nadaremos todos los días en la piscina del club atlético.

2. Terminaremos la tarea después de la escuela.

3. Miraremos un programa interesante de televisión.

4. Volveremos a casa por tren.

5. Viviremos en el colegio Antonio de Nebrija en la universidad.

6. Conoceremos al señor Fuentes.

7. Visitaré a mi amigo Felipe.

8. Tomaré un cafe en el restaurante.

9. Admiraré la belleza de ese museo.

10. Iré de viaje a México.

56)
1. diremos
2. harás
3. querrá
4. podrá
5. sabréis
6. cabrá
7. saldré
8. tendrán
9. vendremos
10. sabrán

57)
1. Yo pondré mi abrigo en el armario.
2. Tú dirás la respuesta correcta.
3. Nosotros querremos ir al cine este fin de semana.
4. Él podrá buscar la información.
5. Vosotros tendréis mucho trabajo en el colegio.
6. Jaime y Julia vendrán a estudiar con nosotros.
7. Carmen saldrá para su trabajo a las cuatro.
8. Ellos pondrán los libros sobre la mesa.
9. Yo querré ir de vacaciones a la Florida.
10. Ustedes podrán obtener mejores notas.

58)
1. escribiría
2. vendería
3. comeríamos
4. vivirían
5. iría
6. estarían
7. comprarías
8. conocería
9. tomaría
10. limpiaría

59)
1. Sofia estaría en casa.
2. Víctor y Luís comprarían un automóvil.
3. Nosotros tomaríamos una sopa.
4. Ellos conocerían al gobernador.
5. Ana y Luisa comenzarían un club cultural.

60)
1. diría
2. harías
3. podríamos
4. saldría
5. tendría
6. Valdría
7. Pondría
8. Vendría
9. Cabrían
10. Saldría

61)
1. Ellos harían el edificio.
2. Tú pondrías los instrumentos en el laboratorio.
3. Ustedes saldrían del cine a las once.
4. Las joyas valdrían mucho dinero.
5. La gente diría su opinión.
6. Ellos vendrían a la fiesta.
7. Yo saldría de casa a las seite.
8. Nosotros pondríamos el arbolito en el jardín.
9. Él sabría qué hacer.
10. Marcos y Rolando podrían hacerlo.

62)
1. Sí, me gustaría hablar español.
2. Sí, querría ir con ellos al cine.
3. Iría, pero no tengo suficiente dinero.
4. Necesitaría mil dólares para el viaje.
5. Sí, vendría a visitarlos a Caracas.
6. Sí, lo haríamos bien.
7. No, no pensaríamos trabajar para esta compañía.
8. No, no tendría dinero.
9. Sí, él iría conmigo a buscar los libros.
10. Sí, volvería a verla.

63)
1. teniendo
2. comiendo
3. bebiendo
4. hablando
5. recibiendo
6. costando
7. adquiriendo
8. llamando
9. abriendo
10. Oyendo
11. Viviendo
12. batiendo
13. buscando
14. caminando
15. recibiendo

64)
1. Sirviendo
2. sintiendo
3. durmiendo
4. Pidiendo
5. muriendo
6. Diciendo
7. riendo
8. sirviendo
9. gimiendo
10. durmiendo

65)
1. cayendo
2. construyendo
3. huyendo
4. contribuyendo

5. escuchando 8. trayendo
6. leyendo 9. leyendo
7. distribuyendo 10. escuchando

66) 1. Estoy hablando por teléfono.
 2. Él está buscando su libro.
 3. Ellos van caminando al teatro.
 4. José sigue comiendo paella.
 5. Tú estás hablando con tu amigo.

67) 1. Yo estuve hablando.
 2. Tú seguiste comiendo.
 3. Julio fue vendiendo libros.
 4. Nosotros estuvimos trabajando.
 5. Ellos siguieron estudiando.
 6. María y Julio estuvieron riéndose.
 7. Vosotros estuvisteis aprendiendo
 8. Tú y yo fuimos mirando
 9. Yo seguí escribiendo.
 10. María fue pensando

68) 1. estaba hablando
 2. estaba saliendo
 3. estaba bajando
 4. estaba cargando
 5. estaba corriendo
 6. estaba pasando
 7. estábamos viendo

69) 1. María estará mirando el televisor.
 2. José estará riéndose de los chiste de Juan.
 3. Nosotros estaremos haciendo la tarea.
 4. Ellos estarán pensando.
 5. Jorge y yo estaremos pintando.
 6. Ramiro y Julio estarán corriendo en el estadio
 7. La señora Martínez estará gritando.
 8. Tú estarás caminando con Luisa en el parquet.
 9. Pepe estará haciendo la tarea de español.
 10. Yo estaré bañándome a esa hora de la noche.

70) 1. Mi primo estaría estudiando.
 2. Nuestros amigos seguirían jugando.
 3. Yo iría buscando a Diego.
 4. Ellos continuarían comiendo.
 5. Tú seguirías trabajando.
 6. Vosotros estaríais mirando.
 7. Marta y Betina irían buscando la respuesta.
 8. Consuelo seguiría estudiando informática.
 9. Diana y tú estarían preocupados.
 10. Él iría caminando al trabajo.

71) 1. decidido 6. viajado
 2. estado 7. mirado
 3. recibido 8. sido
 4. mandado 9. comportado
 5. sabido 10. llevado

72) 1. abierto 6. visto
 2. dicho 7. hecho
 3. descubierto 8. resuelto
 4. puesto 9. impreso
 5. roto 10. muerto

73) 1. visto 4. roto
 2. hecho 5. escrito
 3. cubierto

74) 1. Juan ha comido arroz con pollo.
 2. Tú has traído un regalo.
 3. Sara ha cocinado un plato delicioso.
 4. Beatriz y Ricardo han buscado un restaurante magnífico.
 5. El fotógrafo ha sacado unas fotografías estupendas.
 6. Nosotros hemos visto la exposición.
 7. Ellos han vivido en Madrid.
 8. Vosotros habéis salido con María.
 9. Ustedes han caminado por la Gran Vía.
 10. Yo he visitado los Andes.

75)
1. había hablado
2. habías comido
3. había vendido
4. habíamos visto
5. habíais dicho
6. habían ido
7. había vuelto
8. habías vivido
9. habían hecho
10. había caminado

76)
1. Ellos habrán ido al cine.
2. Luis habrá hecho su proyecto.
3. Vosotros habréis mirado la película.
4. Tú habrás visto el edificio.
5. Yo habré caminado por la ciudad.
6. Nélida habrá buscado su ropa en la tintorería.
7. Ellos habrán oído música.
8. Todos habremos preparado las maletas para el viaje.
9. Él no habrá necesitado trabajar en el verano.
10. Marta y Olga habrán comido a las tres.

77)
1. habría hablado
2. habría regresado
3. habría dicho
4. habría terminado
5. habrías hecho
6. habrían comido
7. habrían bebido
8. habrían viajado
9. habría contestado
10. habría estudiado

78)
1. me afeito
2. te acuestas
3. se despierta
4. nos dormimos
5. os marcháis
6. se visten
7. me siento
8. te cepillas
9. se quita
10. se despiden

79)
1. me afeité
2. te acostaste
3. se despertó
4. nos dormimos
5. os marchasteis
6. se vistieron

7. me senté
8. te cepillaste
9. se quitó
10. se despidieron

80)
1. Mi hermano se vestía rápidamente.
2. Mi madre se compraba un vestido.
3. Yo me bañaba en una piscina.
4. Ellos se despedían de los amigos.
5. Tú te escondías en la cocina.

81)
1. Vosotros os iréis a España.
2. Yo me pondré el abrigo.
3. Ellos se negarán a ayudar a los muchachos.
4. El consejero se levantará a recibir a los invitados.
5. Tú te vestirás en el cuarto.

82)
1. me había levantado
2. se habían tomado
3. te habías ido
4. se había dormido
5. nos habíamos acostado.

83)
1. me
2. —
3. se
4. nos
5. —
6. —
7. te
8. —
9. os
10. —

84)
1. Juan paró un taxi.
2. Juan se paró delante de un taxi.
3. Ellos pusieron el arbolito allí.
4. Nosotros nos colocamos en la compañía.
5. Tú escondiste las notas.
6. Tú te escondiste detrás de la puerta.
7. Yo me cansé de caminar.
8. Él bañó a su hijo.
9. Él se duchó en la ducha.
10. Vosotros os sentasteis en las sillas.

The Subjunctive Mood

The subjunctive mood is a difficult subject to learn for English-speaking students. The difficulty lies in that you can not easily recognize this mood in the English language. The use of the subjunctive mood can be easily applied if the concept of the mood is first learned.

We must compare and contrast the indicative and the subjunctive moods. The indicative mood expresses facts and states objectivity. The actions or events stated or described by the indicative mood can be objectively proven or disproven.

Juan estudia mucho.
John studies a lot.

María y Josefina desean un millón de dólares.
Mary and Josephine want a million dollars.

Jorge va a la escuela.
George goes to school.

Ellos no fueron a la conferencia.
They did not go to the conference.

In all of these sentences, facts are stated about the different individuals. In the first sentence, it is stated that John studies. In the second sentence, Mary and Josephine want money. It is a fact that they feel this way. In the third sentence, a fact is also stated: *George goes to school.* In the fourth sentence, it is denied that they went to the conference.

Unlike the indicative mood, the subjunctive mood implies subjectivity. This mood expresses opinion, emotion, desire, feeling, doubt, necessity, request, uncertainty, wish, and other subjective desires that may or may not be true. Normally, the subjunctive mood appears in dependent clauses which are introduced by conjunctions or relative pronouns.

Juan desea que su hermano estudie.
John wants his brother to study.

El profesor quiere que sus alumnos obtengan buenas notas.
The professor wants his students to obtain good grades.

Yo dudo que José hable español.
I doubt that Joseph speaks Spanish.

In all these sentences, subjective opinions are expressed about different situations. In the first sentence, John wants his brother to study. In the main clause, the indicative mood is used because it is a fact that John feels this way. However, it is not John's task to see that his brother studies; it is up to his brother to do so. For this reason, the subjunctive mood is used in the dependent clause. The same occurs in the second and third sentences. It does not depend on the professor for the students to do well. The students have to do well themselves. The ability to speak a language rests on Joseph, not on the subject of the sentence.

The subjunctive mood is also used with impersonal expressions. An impersonal expression expresses something about someone which may or may not become a fact.

Es necesario que vayas a la tienda.
It is necessary that you go to the store.

Es importante que tenga un automóvil.
It is important that you have a car.

Es dudoso que lleguen a tiempo.
It is doubtful that they will arrive on time.

PRESENT SUBJUNCTIVE

The subjunctive mood, just as the indicative mood, has several time frames of which the first is the present. In this tense, the impersonal expressions, the doubts, the emotions are all expressed in the present.

Regular –ar Verbs

The present subjunctive of regular **–ar** verbs is formed by dropping the **–o** of the first person singular form (**yo**) of the present indicative mood, and adding the following endings: **–e, –es, –e, –emos, –éis,** or **–en.**

Infinitive	hablar	cantar	trabajar
yo (indicative)	**hablo**	**canto**	**trabajo**
yo (subjunctive)	**hable**	**cante**	**trabaje**
tú	**hables**	**cantes**	**trabajes**
él	**hable**	**cante**	**trabaje**
nosotros	**hablemos**	**cantemos**	**trabajemos**
vosotros	**habléis**	**cantéis**	**trabajéis**
ellos	**hablen**	**canten**	**trabajen**

Julio desea que yo hable.
Julius wants me to speak.

Betina quiere que Alicia cante una aria de la zarzuela.
Betina wants Alice to sing an aria of the zarzuela.

El jefe exige que trabajemos más.
The boss demands that we work more.

Mi madre espera que yo limpie mi habitación este sábado.
My mother hopes that I'll clean my bedroom this Saturday.

Test Yourself: 1) Complete the following sentences with the appropriate form of the present subjunctive.

1. Julio desea que yo _____ (hablar) con José.
2. Ellos quieren que vosotros _____ (trabajar).
3. Luis espera que tú _____ (cantar) bien.
4. El jefe quiere que ellos _____ (terminar) ahora.
5. Los niños sienten que él no _____ (bailar).
6. Nosotros preferimos que Marta _____ (estudiar).
7. Miguel desea que José _____ (pasar) la prueba.
8. Él teme que ellos _____ (caminar) en la lluvia.
9. María prohibe que ellos _____ (hablar) en clase.
10. Tú insistes en que él _____ (pintar) otro cuadro.

Test Yourself: 2) Form sentences with the words given below.

1. Yo / esperar / tú / hablar / Miguel.
2. Ella / desear / nosotros / trabajar / proyecto.
3. El profesor / insistir en / alumnos / cantar.
4. María / mandar / hijo / arreglar / alcoba.
5. Nosotros / preferir / ellos / estudiar / hoy.

Stem-Changing Verbs

Stem-changing **–ar** verbs have the same change in pattern in the present subjunctive as in the present indicative.

	(e, ie)	(o, ue)
Infinitive	cerrar	contar
yo (indicative)	cierro	cuento
yo (subjunctive)	cierre	cuente
tú	cierres	cuentes
él	cierre	cuente
nosotros	cerremos	contemos
vosotros	cerréis	contéis
ellos	cierren	cuenten

El jefe desea que yo cierre la puerta de la tienda.
The boss wants me to close the door of the store.

Marta quiere que tú cuentes un cuento.
Martha wants you to tell a story.

Yo espero que vosotros contéis correctamente.
I hope that you count correctly.

Que él cuente hasta diez, no significa que habla inglés.
That he can count to ten does not mean he speaks English.

Test Yourself: 3) Complete the following sentences by using the appropriate form of the present subjunctive.

1. Beatriz desea que yo me _____ (sentar) en el sofá.
2. Mi padre quiere que Pepe _____ (contar) el dinero.
3. Ellos mandan que vosotros _____ (contar).
4. Tú quieres que ella _____ (contar) un cuento.
5. Mi tío teme que Darío se _____ (sentar).
6. Marta prefiere que nosotros la _____ (cerrar).
7. Nosotros queremos que tú _____ (pensar) rápido.
8. Vosotros esperáis que nostros nos _____ (sentar)
9. Ella quiere que Luis no _____ (contar) la historia.
10. Felipe desea que yo me _____ (sentar).

Verbs ending in **–car, –gar,** and **–zar** have the same spelling change as in the preterite tense of the indicative where the **c** changes to **qu,** the **g** to **gu,** and the **z** to **c.** This occurs to keep the same phonetic sounds in the conjugation of the verb.

	(c, qu)	**(g, gu)**	**(z, c)**
Infinitive	buscar	pagar	alcanzar
yo (indicative)	busqué	pagué	alcancé
yo	busque	pague	alcance
tú	busques	pagues	alcances
él	busque	pague	alcance
nosotros	busquemos	paguemos	alcancemos
vosotros	busquéis	paguéis	alcancéis
ellos	busquen	paguen	alcancen

Ellos prefieren que tú busques la correspondencia.
They prefer that you (may) look for the correspondence.

Yo deseo que José pague su cuenta.
I want Joseph to pay his bill.

Rafael exige que ellos alcancen a Roberto.
Raphael demands that they catch up with Robert.

Mi madre desea que yo te pague el dinero.
My mother wishes that I pay you the money.

Test Yourself: 4) Complete the following exercise with the appropriate form of the present subjunctive.

1. Yo deseo que tú _____ (tocar) el piano.
2. Nosotros queremos que ella _____ (buscar) el té.
3. Tú quieres que yo _____ (alcanzar) las cosas.
4. Jorge siente que él _____ (buscar) las llaves.
5. Ellos temen que la policía _____ (llegar) aquí.
6. Nosotros deseamos que él _____ (pagar).
7. Tú deseas que yo _____ (entregar) la tarea.
8. Vosotros deseáis que nosotros _____ (comenzar).
9. Ella espera que vosotros _____ (pagar) por esto.
10. Ellos mandan que tú _____ (llegar) temprano.

Irregular –ar Verbs

The verbs **dar** and **estar** are irregular in the present subjunctive.

Infinitive	dar	estar
yo	dé	esté
tú	des	estés
él	dé	esté
nosotros	demos	estemos
vosotros	deis	estéis
ellos	den	estén

Espero que el profesor dé buenas notas.
I hope that the professor gives good grades.

Nosotros queremos que el jefe nos dé un aumento.
We want the boss to give us a raise.

Tú deseas que la tienda esté abierta.
You want the store to be opened.

Prefiero que Daniel esté en la clase de literatura.
I prefer Daniel to be in the literature class.

Test Yourself: 5) Complete the following sentences with the appropriate form of the present subjunctive.

1. Ella espera que yo _____ (dar) una limosna.
2. Mi madre desea que ellos _____ (estar) a tiempo.
3. Ellos esperan que el profesor _____ (dar) la lección.
4. Tú deseas que nosotros _____ (estar) en la fiesta.
5. Nosotros insistimos en que tú _____ (estar) presente.
6. Marta teme que ella no _____ (estar) allá.
7. Vosotros preferís que él _____ (dar) la charla.
8. Yo siento que ellos no _____ (dar) la conferencia.
9. Nosotras queremos que ellos _____ (estar) alerta.
10. Victoria espera que él le _____ (dar) un buen consejo.

Regular –er and –ir Verbs

The present subjunctive of regular **–er** and **–ir** verbs is formed by dropping the **–o** of the first person singular form (**yo**) of the present indicative mood, and adding the following endings: **–a, –as, –a, –amos, –áis,** or **–an.**

Infinitive	comer	vivir	salir
yo (indicative)	como	vivo	salgo
yo (subjunctive)	coma	viva	salga
tú	comas	vivas	salgas
él	coma	viva	salga
nosotros	comamos	vivamos	salgamos
vosotros	comáis	viváis	salgáis
ellos	coman	vivan	salga

Mi madre espera que yo coma bien.
My mother hopes I eat well.

Los padres quieren que sus hijos vivan cerca de ellos.
The parents want their children to live close to them.

Yo espero que tú salgas temprano del trabajo para ir al cine.
I hope you leave your work early to go to the movies.

Test Yourself: 6) Complete the following sentences with the appropriate form of the present subjunctive.

1. Esperamos que ellos _____ (comer) bien.
2. Deseas que yo _____ (comer) con ustedes.
3. Mi madre quiere que tú _____ (salir) con nosotros.
4. Natalia teme que ellos no _____ (comer) paella.
5. Tú prefieres que nosotros _____ (vivir) aquí.
6. Pedro está feliz que él _____ (salir) con nosotros.
7. Tú quieres que ellas _____ (escribir) a menudo.
8. Pablo insiste que vosotros _____ (leer) el libro.
9. Marcos desea que ella _____ (coger) la propina.
10. Yo prefiero que tú _____ (vivir) en París.

Stem-Changing Verbs

Stem-changing –er and –ir verbs have the same change in pattern in the present subjunctive as in the present indicative.

	(e, i)	(o, ue)
Infinitive	perder	volver
yo (indicative)	pierdo	vuelvo
yo (subjunctive)	pierda	vuelva
tú	pierdas	vuelvas
él	pierda	vuelva
nosotros	perdamos	volvamos
vosotros	perdáis	volváis
ellos	pierdan	vuelvan

No quiero que pierdas mi bolígrafo.
I do not want you to lose my pen.

Espero que no te pierdas en el camino.
I hope you do not get lost on the way.

Mi tío quiere que nosotros volvamos a su casa.
My uncle wants us to return to his home.

No deseo que vuelvas a ese restaurante.
I don't want you to return to that restaurant.

Test Yourself: 7) Complete the following sentences with the appropriate form of the present subjunctive.

1. Juan desea que yo _____ (volver) temprano.
2. Mis abuelos quieren que nosotros _____ (volver).
3. Ella prefiere que tú no _____ (volver).
4. Ellos no desean que él _____ (perder) el partido.

5. Nosotros deseamos que ellos _____ (volver).
6. Yo no quiero que vosotros _____ (perder) las llaves.
7. Tú prefieres que ella _____ (poder) asistir.
8. Vosotros queréis que José _____ (volver) mañana.
9. María quiere que yo _____ (poder) ir al cine.
10. Ellos mandan que nosotros no _____ (volver).

Stem-changing **–ir** verbs have the same changes in the present subjunctive as in the present indicative. In the **nosotros** and **vosotros** the stem vowel **e** changes to **i**, and the stem vowel **o** changes to **u:**

	(e, ie)	(e, i)	(o, ue)
Infinitive	sentir	pedir	dormir
yo (indicative)	siento	pido	duermo
yo (subjunctive)	sienta	pida	duerma
tú	sientas	pidas	duermas
él	sienta	pida	duerma
nosotros	sintamos	pidamos	durmamos
vosotros	sintáis	pidáis	durmáis
ellos	sientan	pidan	duerman

Ramón quiere que ellos sientan la calidad del material.
Raymond wants them to feel the quality of the material.

Ellos dudan que tú lo sientas.
They doubt that you regret it.

La policía no quiere que las personas pidan dinero.
The police do not want people to ask for money.

Esperamos que duerman bien.
We hope you sleep well.

Test Yourself: 8) Complete the following verbs by using the appropriate form of the presente subjunctive.
1. Mi mamá espera que yo no _____ (sentir) frío.
2. Espero que ellos _____ (sentir) calor.
3. Es necesario que nosotros _____ (dormir) bien.
4. Deseamos que tú _____ (dormir) en tu propia habitación.
5. Prefiero que ella _____ (pedir) café con leche.
6. Esperamos que Felipe se _____ (sentir) bien.
7. Él quiere que nosotros _____ (pedir) limosna para los pobres.
8. Prefiero que Pepe _____ (pedir) por mí.
9. Es mejor que Paco _____ (dormir) en el próximo turno.
10. Prefiero que vosotros _____ (pedir) ayuda.

Irregular –er and –ir Verbs

The verbs **haber, saber, ser** and **ir** are irregular in the present subjunctive.

Infinitive	haber	saber	ser	ir
yo	haya	sepa	sea	vaya
tú	hayas	sepas	seas	vayas
él	haya	sepa	sea	vaya
nosotros	hayamos	sepamos	seamos	vayamos
vosotros	hayáis	sepáis	seáis	vayáis
ellos	hayan	sepan	sean	vayan

Esperamos que ellos hayan hecho la tarea.
We hope that they have done their homework.

Ellos dudan que sea cierto.
They doubt that it is true.

Mi amiga desea que yo vaya a su fiesta de cumpleaños.
My friend wants me to go to her birthday party.

For the present subjunctive to be used, the verb in the main clause must be in the present, present perfect, or future of the indicative mood, or in the imperative mood.

Yo prohibo que él salga esta noche.
I forbid that he go out tonight.

Yo no he prohibido que él salga esta noche.
I have not forbidden that he go out tonight.

Yo no prohibiré que él salga esta noche.
I will not forbid that he go out tonight.

No prohiba usted que él salga esta noche.
Do not forbid that he go out tonight.

Test Yourself: 9) Complete the following sentences by using the appropriate form of the present subjunctive.
1. Yo quiero que ella _____ (decir) la verdad.
2. Ellos desean que él _____ (decir) lo que piensa.
3. Federico espera que ustedes _____ (hacer) la tarea.
4. Tú necesitas que yo _____ (venir) temprano.
5. Él quiere que ustedes _____ (construir) el edificio.
6. Marta prefiere que tú _____ (traer) los regalos.
7. Todos deseamos que vosotros _____ (oír) el anuncio.
8. Yo no creo que el coche _____ (valer) tanto dinero.
9. Rafael y Pablo quieren que yo me _____ (poner) el vestido.
10. Ella prefiere que ustedes _____ (conducir).

Test Yourself: 10) Rewrite the following sentences according to the model using the present subjunctive.
modelo: **Ellos preparan los regalos.**
Esperamos que ...
Esperamos que ellos preparen los regalos.
1. Él hace su trabajo.
2. Ella oye la música.
3. Yo tengo dinero para ir de compras.
4. Ellos van al cine.
5. Ustedes lo traducen al inglés.
6. María tiene tiempo.
7. Vosotros conocéis al artista.
8. Tú dices la respuesta correcta.
9. Ellas ponen música clásica.
10. Armando y Plácido construyen el modelo.

Imperfect Subjunctive

The imperfect subjunctive of all verbs is formed by dropping the **–ron** ending of the third person plural form of the preterite indicative and adding the endings **–ra, –ras, –ra, –ramos, –rais, –ran** or **–se, –ses, –se, –semos, –seis,** or **–sen.** Both of these conjugations are acceptable.

Infinitive	**hablar**	
ellos (preterite indicative)	**hablaron**	
yo	**hablara**	**hablase**
tú	**hablaras**	**hablases**
él	**hablara**	**hablase**
nosotros	**habláramos**	**hablásemos**
vosotros	**hablarais**	**hablaseis**
ellos	**hablaran**	**hablasen**

Infinitive	**comer**	
ellos (preterite indicative)	**comieron**	
yo	**comiera**	**comiese**
tú	**comieras**	**comieses**
él	**comiera**	**comiese**
nosotros	**comiéramos**	**comiésemos**
vosotros	**comierais**	**comieseis**
ellos	**comieran**	**comiesen**

Infinitive	**decir**	
ellos (preterite indicative)	**dijeron**	
yo	**dijera**	**dijese**
tú	**dijeras**	**dijeses**
él	**dijera**	**dijese**
nosotros	**dijéramos**	**dijésemos**
vosotros	**dijerais**	**dijeseis**
ellos	**dijeran**	**dijesen**

Juan quería que su hermano hiciera la tarea.
John wanted his brother to do the homework.

Él pidió que Andrés lo hiciera.
He asked Andrew to do it.

Ellos querían que todos hablásemos español.
They wanted everyone to speak Spanish.

El profesor quería que sus estudiantes contestaran.
The professor wanted his students to answer.

Mi padre deseaba que yo bebiese sangría.
My father wanted me to drink sangria.

For the imperfect subjunctive to be used, the verb in the main clause must be in the imperfect, preterite, conditional, or pluperfect of the indicative mood.

Él deseaba que ella viniera (viniese) a la fiesta.
He was wishing that she would come to the party.

Él deseó que ella viniera (viniese) a la fiesta.
He wished that she would come to the party.

Él desearía que ella viniera (viniese) a la fiesta.
He would wish that she would come to the party.

Él había deseado que ella viniera (viniese) a la fiesta.
He had wished that she would come to the party.

Test Yourself: 11) Complete the following sentences with the appropriate –**ra** form of the imperfect subjunctive.
1. Ellos querían que los alumnos _____ (estudiar).
2. Nosotros queríamos que ustedes _____ (aprender) español.
3. Pedro deseaba que yo _____ (trabajar) por la noche.
4. Andrés quería que él _____ (comer) con nosotros.
5. La policía prohibió que ellos _____ (vender) en la calle.
6. Mi padre decidió que nosotros _____ (empezar) a construir una casa en el campo.
7. Yo insistí en que tú _____ (viajar) por Suramérica.
8. El jefe pidió que nosotros _____ (salir) temprano.
9. La gente quería que vosotros _____ (cantar).
10. Mi tío insistía en que ellos _____ (vender) los libros.

Test Yourself: 12) Complete the following sentences with the appropriate –**se** form of the imperfect subjunctive.
1. Ellos deseaban que yo _____ (aprender).
2. Tú querías que ellos _____ (volver) mañana.
3. Marta deseaba que tú _____ (nadar) en la competencia.
4. El doctor insistía en que nosotros _____ (descansar).
5. El director mandó que él _____ (hacer) el trabajo.
6. José insistió en que vosotros _____ (estudiar) la lección.
7. Tú preferiste que yo _____ (hablar) español.
8. El cocinero quiso que ellas _____ (comer) arroz.
9. Yo mandé que tú _____ (cerrar) la tienda.
10. Usted pidió que yo _____ (vender) la mercancía.

Test Yourself: 13) Rewrite the following sentences by changing the main verb to the preterite.
1. Ella espera que yo lo conozca.
2. Ellos insisten en que nosotros aprendamos español.
3. Nosotros mandamos que los niños no fumen.
4. Prefiero que tú compres esta casa.
5. Ustedes quieren que él devuelva el libro.
6. Marta prefiere que vosotros comáis comida venezolana.
7. El profesor desea que sus estudiantes aprendan español.
8. El gerente pide que nosotros salgamos temprano.
9. Ella espera que podamos hacer el viaje.
10. Insisten en que nosotros vayamos a la universidad.

Present Perfect Subjunctive

The present perfect subjunctive of all verbs is formed by using the present subjunctive of the auxiliary verb **haber** plus the past participle.

Infinitive	**hablar**
yo	**haya hablado**
tú	**hayas hablado**

él	**haya hablado**
nosotros	**hayamos hablado**
vosotros	**hayáis hablado**
ellos	**hayan hablado**
Infinitive	**comer**
yo	**haya comido**
tú	**hayas comido**
él	**haya comido**
nosotros	**hayamos comido**
vosotros	**hayáis comido**
ellos	**hayan comido**
Infinitive	**ir**
yo	**haya ido**
tú	**hayas ido**
él	**haya ido**
nosotros	**hayamos ido**
vosotros	**hayáis ido**
ellos	**hayan ido**

The present perfect subjunctive is used when a present or future verb in the main clause refers to a subjunctive verb in the dependent clause that refers to a past action.

No pienso que ellos hayan hecho la tarea.
I do not think that they have done their homework.

El doctor duda que el accidente haya causado tanto daño.
The doctor doubts that the accident has caused so much harm.

Es posible que ellos hayan llegado a tiempo.
It is possible that they have arrived on time.

Dudo que Luis haya sacado la basura.
I doubt that Louis has taken out the garbage.

Él esperará hasta que los estudiantes hayan terminado.
He will wait until the students have finished.

Test Yourself: 14) Complete the following sentences with the appropriate form of the present perfect subjunctive.

1. Él no piensa que nosotros _____ (caminar) tanto.
2. Es necesario que ustedes _____ (comer) antes de salir.
3. Esperamos que ella _____ (mirar) el programa.
4. Es imposible que tú _____ (dormir) tantas horas.
5. Espero que ellas _____ (vender) muchas cosas.

Pluperfect Subjunctive

The pluperfect subjunctive is formed with the imperfect subjunctive of the auxiliary verb **haber** plus a past participle.

Infinitive	**hablar**	
yo	**hubiera hablado**	**hubiese hablado**
tú	**hubieras hablado**	**hubieses hablado**
él	**hubiera hablado**	**hubiese hablado**
nosotros	**hubiéramos hablado**	**hubiésemos hablado**
vosotros	**hubierais hablado**	**hubieseis hablado**
ellos	**hubieran hablado**	**hubiesen hablado**

Infinitive	comer	
yo	hubiera comido	hubiese comido
tú	hubieras comido	hubieses comido
él	hubiera comido	hubiese comido
nosotros	hubiéramos comido	hubiésemos comido
vosotros	hubierais comido	hubieseis comido
ellos	hubieran comido	hubiesen comido
Infinitive	vivir	
yo	hubiera vivido	hubiese vivido
tú	hubieras vivido	hubieses vivido
él	hubiera vivido	hubiese vivido
nosotros	hubiéramos vivido	hubiésemos vivido
vosotros	hubierais vivido	hubieseis vivido
ellos	hubieran vivido	hubiesen vivido

The pluperfect subjunctive is used in clauses when the verb in the main clause is in the preterite, imperfect, conditional, or pluperfect tense of the indicative mood and the action of the verb of the dependent clause was completed prior to that of the verb in the main clause.

Ellos no creyeron que él hubiera terminado la obra.
They did not believe that he had finished the work.

Marta deseaba que tú hubieses traído tu guitarra.
Martha was wishing that you had brought your guitar.

Tú deseabas que él hubiera estudiado antes del examen.
You wished he had studied before the examination.

THE SUBJUNCTIVE MOOD AND DEPENDENT CLAUSES

The subjunctive is used in dependent clauses when the verb in the main clause denotes an idea or opinion. The subjunctive in the dependent clause is introduced by the relative pronoun **que.** Also notice that in order to use the subjunctive, (1) a verb is required in the main clause that denotes subjectivity, (2) the word **que** is needed to introduce the clause, and (3) two different subjects must appear in the sentence: one in the main clause and a different one in the dependent clause.

Some of the verbs that denote ideas, opinions, or feelings (and are considered verbs of influence or emotion) are:

aconsejar	*to advise*
decir	*to say; to tell*
dejar	*to allow*
desear	*to wish*
esperar	*to hope*
insistir en	*to insist*
mandar	*to order*
pedir	*to ask; to request*
preferir	*to prefer*
querer	*to want*
rogar	*to beg*
sentir	*to feel; to regret*
sugerir	*to suggest*
suplicar	*to plead*
temer	*to fear*

Yo le aconsejo que vaya al doctor.
I advise him (her) to go to the doctor.

Fernando desea que nosotros trabajemos el domingo.
Ferdinand wishes that we work on Sunday.

Ellos esperarán que tú hagas el trabajo.
They will hope that you do the work.

El presidente prefiere que ellos estudien el reporte.
The president prefers that they study the report.

Nosotros sentíamos que Juan viajase en burro.
We were sorry that John had to travel by donkey.

Mi madre insiste en que yo limpie la habitación antes de salir.
My mother insists that I clean my room before going out.

Test Yourself: 15) Form sentences with the following words using the present tense.
1. Yo / desear / tú / estudiar / mucho.
2. Ellos / querer / ir / cine.
3. Tú / querer / hablar / español.
4. Jorge / insistir / Julio / limpiar / habitación.
5. Nosotros / mandar / limpiar / coche.
6. Ella / esperar / nosotros / traer / guitarra.
7. Él / temer / ellos / estar / ciudad.
8. Yo / querer / ir / viaje.
9. Vosotros / creer / información.
10. Nosotros / preferir / ellos / salir.

The subjunctive mood is also used after verbs or expressions that denote doubt, disbelief, or denial:

dudar	*to doubt*
es dudoso	*it is doubtful*
es incierto	*it is uncertain*
negar	*to deny*
no creer	*to disbelieve*
no es cierto	*it is not certain*
no estar seguro	*not to be sure*
no saber	*not to know*

Dudo que vaya al viaje.
I doubt that he will go on the trip.

No creemos que vengan a ayudarnos.
We do not believe that they will come to help us.

Dudan que la noticia sea importante.
They doubt that the news is important.

Notice that the opposite expressions denote certainty; therefore, the indicative mood is used:

Creo que él viene.
I believe that he is coming.

Sabemos que ellos vendrán.
We know they will come.

No dudo que ella vendrá.
I do not doubt that she will come.

Test Yourself: 16) Rewrite the following sentences by using the expression **dudar** according to the model.

modelo: **Yo vivo en la calle cinco.**
Dudo que vivas en la calle cinco.

1. Yo conozco a Camilo José Cela.
2. Ella estudia en la universidad.
3. Nosotros hablamos francés.
4. Tú vendes equipos electrónicos.
5. Él corre todas las mañanas.

Test Yourself: 17) Rewrite the following sentences by using the expression **no creer** according to the model.

modelo: **Ella hace la tarea.**
No creo que ella haga la tarea.

1. Usted bebe vino.
2. Ellos estudian en la biblioteca.
3. Tú corres en el estadio.
4. Nosotros trabajamos esta noche.
5. Tú conoces a Luis.

Test Yourself: 18) Complete the following sentence with the appropriate form of the present indicative or the present subjunctive.

1. Es dudoso que ella _____ (vivir) en Tejas.
2. No dudo que ella _____ (vivir) en Tejas.
3. Creo que ellos _____ (ser) buenas personas.
4. No creo que tú _____ (estar) mintiendo.
5. Es cierto que tú _____ (llegar) temprano.
6. No hay duda que nosotros _____ (pasar) el examen.
7. No es cierto que ellos _____ (venir).
8. Dudo que él _____ (saber) la verdad.
9. Es cierto que yo _____ (ir) de viaje.
10. No creo que ustedes _____ (trabajar) esta noche.

IMPERSONAL EXPRESSIONS

The subjunctive mood is required after impersonal expressions that voice an element of subjectivity such as *possibility, probability, doubt, uncertainty, necessity, emotion,* and *importance:*

es bueno	*it is good*
es difícil	*it is difficult*
es fácil	*it is easy*
es importante	*it is important*
es imposible	*it is impossible*
es interesante	*it is interesting*
es (una) lástima	*it is a pity*
es malo	*it is bad*
es mejor	*it is better*
es necesario	*it is necessary*
es peor	*it is worse*

es posible	*it is possible*
es preciso	*it is necessary*
es probable	*it is probable*
es raro	*it is rare*

Test Yourself: 19) Write sentences with the following words according to the model.

modelo: **Es necesario / yo / hacer / tarea.**

Es necesario que yo haga la tarea.

1. Es importante / tú / estudiar / mucho.
2. Es dudoso / ellos / trabajar / primavera.
3. Es posible / yo / beber / vino / argentino.
4. Es mejor / vosotros / estudiar / español.
5. Es preciso / nosotros / servir / comida.
6. Es raro / ella / terminar / temprano.
7. Es interesante / tú / viajar / Oriente.
8. Es malo / ellos / perder / empleos.
9. Es una lástima / yo / vivir / lejos.
10. Es preciso / él / asistir / doctor.

Indefinite Expressions

All words that end in **. . . quiera** are followed by the subjunctive.

dondequiera	*wherever*
cualquiera (sing.)	*whatever*
cualesquiera (pl.)	*whatever*
quienquiera (sing.)	*whoever*
quienesquiera (pl.)	*whoever*
cuando quiera	*whenever*
como quiera	*however*

Quienquiera que sea, no debe llamar a esta hora.
Whoever it may be should not call at this time.

Dondequiera que vayas, debes siempre tener cuidado.
Wherever you may go, you should always be careful.

Como quiera que sea, debemos terminar el trabajo a la una.
However it may be, we must finish the job at one.

Test Yourself: 20) Complete the following sentences by using the appropriate form of the present subjunctive of the verbs in parentheses.

1. Quienquiera que _____ (ser), debe llamar a la puerta.
2. Dondequiera que ellos _____ (ir), nos escribirán.
3. Como quiera que tú _____ (venir), lo sabremos.
4. Quienquiera que lo _____ (saber), nos lo dirá.
5. Como quiera que lo _____ (hacer), te ayudaré.
6. Cualquiera que _____ (ser), lo sabremos.
7. Cuando quiera que él _____ (volver), me avisa.
8. Como quiera que nosotros _____ (ayudar), es apreciado.
9. Quienquiera que vosotros _____ (ayudar), deben informar al supervisor.
10. Cualquiera que ellos _____ (traer), está bien.

Adjective Clauses

The subjunctive is used when the antecedent does not exist or it is unknown whether it exists or not. If the object in the main clause is definite, the indicative mood is used. The personal **a** is omitted when the object is indefinite.

Yo conozco a un cantante que canta zarzuelas.
I know a singer who sings zarzuelas.

Yo necesito un cantante que cante zarzuelas.
I need a singer who sings zarzuelas.

In the first sentence, a definite person is known who can accomplish the task. In the second sentence, a specific person who can sing zarzuela is not known; therefore, the subjunctive mood is used in the relative clause.

Ellos tienen un libro que explica las ecuaciones.
They have a book that explains the equations.

Ellos quieren un libro que explique las ecuaciones.
They want a book that explains the equations.

Test Yourself: 21) Write sentences with the following words according to the model.
modelo: **(nosotros) tres habitaciones**
Queríamos una casa que tuviera tres habitaciones.

1. (yo) un sótano
2. (ella) dos garages
3. (tú) una piscina
4. (ellos) un jardín enorme
5. (usted) dos cocinas
6. (nosotros) un sauna
7. (vosotros) siete alcobas
8. (ellos) un sistema de seguridad
9. (nosotros) una cancha de baloncesto
10. (José) tres pisos

Test Yourself: 22) Complete the following exercise with the correct form of the indicative or subjunctive moods.

1. Conozco a un ingeniero que _____ (escribir) en español.
2. Conozco a un pintor que _____ (pintar) obras impresionistas.
3. Conozco a una secretaria que _____ (saber) taquigrafía.
4. Busco un arquitecto que _____ (hablar) español.
5. Busco un artista que _____ (bailar) flamenco.
6. Buscamos un secretario que _____ (escribir) rápido.
7. Necesitamos una persona que _____ (resolver) este problema.
8. Necesitáis un chico que _____ (comprar) la comida.
9. Veo a un doctor que _____ (conocer) su profesión.
10. Tengo a un amigo que _____ (saber) programación.

Another use of adjective clauses is with double negatives. The combination of two negatives like **no** and **nadie**, or **no** and **ninguno** with the word **que** will require the use of a subjunctive. If the verb between the two negatives is in the present indicative, a present subjunctive verb is used. If the verb between two negatives is in one of the past tenses, a past subjunctive verb is used.

No hay nada que puedas hacer por mi.
There isn't anything that you can do for me.

No había nadie que quisiera ir al cine conmigo.
There wasn't anyone that wanted to go to the movie with me.

Test Yourself: 23) Complete the following sentences with the correct form of the verb in parentheses.
1. No quiero comer nada que (tener) _____ sal.
2. No conocía a nadie que (saber) _____ la respuesta.
3. No hay nadie que (conocer) _____ a ese hombre.
4. No tienen ninguna cosa que me (interesar) _____ en esa tienda.
5. No había ninguna persona que (poder) _____ resolver el problema.

The subjunctive is used in relative clauses, and it modifies a superlative expression that is considered an exaggeration. If the superlative expressions are considered true, the indicative is used instead.

Es la peor cosa que ellos pueden decir.
It is the worst thing that they can say.

Es la peor cosa que ellos puedan decir.
It is the worst thing that they could say.

Test Yourself: 24) Complete the following sentence with the correct form of the verb in parentheses.
1. Es la peor obra que yo _____ (conocer).
2. Es la ciudad más grande que _____ (existir).
3. Es la mejor universidad que _____ (visitar).
4. Es la peor comida que ellos _____ (poder) hacer.
5. Jorge es la persona más amable que _____ (trabajar) en esta compañía.

The subjunctive mood is used after adjective and adverbial expressions that are introduced by the preposition **por** because they imply uncertainty.

Por bueno que sea no lo debes comprar.
No matter how good it is, you should not buy it.

Por mucho trabajo que ella haga no le aumentarán el salario.
No matter how much work she does, they will not raise her salary.

Test Yourself: 25) Complete the following exercise with the appropriate form of the verb in parentheses.
1. Por bueno que _____ (ser), no debes comprarlo.
2. Por malo que _____ (estar), debes ayudarlo.
3. Por mucho trabajo que _____ (tener), debes visitar a tus padres.
4. Por mejor que _____ (estar), no debes salir.
5. Por barato que _____ (obtener) el coche, no debes comprarlo.

Adverbial Clauses
The subjunctive mood is used with adverbial clauses that express *uncertainty, doubt, purpose,* and *anticipation.* Such clauses are usually introduced by conjunctions such as:

a fin de que	in order that
a menos que	unless
a pesar de que	in spite of
antes de que	before
antes que	before
aunque	although
con tal que	provided that
cuando	when
de manera que	so that

de modo que	*so that*
después de que	*after*
en caso de que	*in case that*
en cuanto	*as soon as*
hasta que	*until*
luego que	*as soon as*
mientras	*while*
para que	*in order that*
sin que	*without*
tan pronto como	*as soon as*

Adverbial clauses provide information about the verb such as what, how, when, where, and why or any other interrogative questions.

Terminaremos el trabajo a menos que algo imprevisto ocurra.
We will finish the job unless something unforeseen happens.

Juan llegará antes de que Miguel llegue.
John will arrive before Michael arrives.

Toma esta medicina en caso de que la necesites.
Take this medicine in case you need it.

However, if certainty is implied, the indicative mood is used:

Rosario estudió hasta que se aprendió las fórmulas.
Rosario studied until she learned the formulas.

Sometimes, the speaker determines whether or not to use the subjunctive. This depends on the idea the speaker wishes to convey.

Ellos no lo comprarán aunque son ricos.
They will not buy it although they are rich.

Ellos no lo comprarán aunque sean ricos.
They will not buy it although they may be rich.

Test Yourself: 26) Answer the following questions according to the model.
modelo: **¿Saludaste a Marta? (sin que)**
No, se marchó sin que yo la saludara.
1. ¿Viste a Julio?
2. ¿Invitaste a los señores Bache?
3. ¿Le pagaste a Raúl?
4. ¿Le mostraste tu obra a los invitados?
5. ¿Vieron la exposición?

Test Yourself: 27) Answer the following questions according to the model.
modelo: **¿Se marchan hoy?**
Sí, se marchan antes de que sea tarde.
1. ¿Vuelven mañana? (a pesar de que)
2. ¿Regresan después? (a menos que)
3. ¿Vienen esta noche? (con tal de que no)
4. ¿Regresa? (después de que)
5. ¿Vuelve? (a pesar de que)

Adverbial Expressions

There are expressions that can use the indicative mood or the subjunctive mood according to the degree of doubt the speaker wants to convey. If the subjunctive mood is used with these adverbs, the degree of doubt is increased. If the indicative mood is used, the degree of certainty is increased.

a lo mejor	*perhaps*
acaso	*perhaps*
quizá	*perhaps*
quizás	*perhaps*
tal vez	*perhaps*

Test Yourself: 28) Rewrite the following sentences according to the model.

modelo: **Salgo con Marta.**

Quizás salga con Marta.

1. Vuelvo pronto.
2. Hago la tarea ahora.
3. Traigo las cosas.
4. Trabajo hasta las ocho.
5. Escribo una carta a Pedro.
6. Estudio filosofía.
7. Maneja hasta la capital.
8. Voy a ver una película de Buñuel.
9. Escucha la radio.
10. Construyo una casa para mis abuelos.

If Clauses

There are several types of *if* clauses. To express a possible event in the present time use: future tense + **si** + present indicative. *If* clauses are also used to express contrary-to-fact conditions.

Present time:

Future tense + **si** + present indicative

Terminaremos el trabajo hoy, si tenemos tiempo.
We will finish the job today, if we have time.

Past time:

Conditional tense + **si** + imperfect subjunctive
Conditional perfect + **si** + pluperfect subjunctive
Pluperfect subjunctive + **si** + pluperfect subjunctive

Haríamos el viaje, si tuviéramos dinero.
We would make the trip, if we had money.

Habrías visto la película, si hubieras llegado a tiempo.
You would have seen the movie, if you had arrived on time.

Hubiera hecho la tarea, si lo hubiera sabido.
I would have done the homework, if I had known it.

Test Yourself: 29) Complete the following sentences by using the appropriate form of the subjunctive according to the verb in parentheses.

1. Comería contigo si _____ (tener) tiempo.
2. Obtendrías mejores notas si _____ (estudiar) más.
3. Haría un viaje si _____ (tener) dinero.
4. Tendrías mejores notas si _____ (prestar) mejor atención.
5. Habrías llegado a tiempo si _____ (tomar) el tren a tiempo.
6. Hubieras terminado temprano si _____ (obtener) asistencia.
7. Tendrías mucho dinero si _____ (ahorrar) un poco cada semana.
8. Te ayudaría si _____ (poder).
9. Ganaría mucho dinero si _____ (trabajar) más.
10. Hubiera visto la función si _____ (llamar) al administrador.

Test Yourself Answers

1)
1. hable
2. trabajéis
3. cantes
4. terminen
5. baile
6. estudie
7. pase
8. caminen
9. hablen
10. pinte

2)
1. Yo espero que tú hables con Miguel.
2. Ella desea que nosotros trabajemos en el proyecto.
3. El profesor insiste en que los alumnos canten.
4. María manda que su hijo arregle la alcoba.
5. Nosotros preferimos que ellos estudien hoy.

3)
1. siente
2. cuente
3. contéis
4. cuente
5. siente
6. cerremos
7. pienses
8. sentemos
9. cuente
10. siente

4)
1. toques
2. busque
3. alcance
4. busque
5. llegue
6. pague
7. entregue
8. comencemos
9. paguéis
10. llegues

5)
1. dé
2. estén
3. dé
4. estemos
5. estés
6. esté
7. dé
8. den
9. estén
10. dé

6)
1. coman
2. coma
3. salgas
4. coman
5. vivamos
6. salga
7. escriban
8. leáis
9. coja
10. vivas

7)
1. vuelva
2. volvamos
3. vuelvas
4. pierda
5. vuelvan
6. perdáis
7. pueda
8. vuelva
9. pueda
10. volvamos

8)
1. sienta
2. sientan
3. durmamos
4. duermas
5. pida
6. sienta
7. pidamos
8. pida
9. duerma
10. pidáis

9)
1. diga
2. diga
3. hagan
4. venga
5. construyan
6. traigas
7. oigáis
8. valga
9. ponga
10. conduzcan

10)
1. Esperamos que él haga su trabajo.
2. Esperamos que ella oiga la música.
3. Esperamos que yo tenga dinero para ir de compras.
4. Esperamos que ellos vayan al cine.
5. Esperamos que ustedes lo traduzcan al inglés.
6. Esperamos que María tenga tiempo.
7. Esperamos que vosotros conozcaís al artista.
8. Esperamos que tú digas la respuesta correcta.
9. Esperamos que ellas pongan música clásica.
10. Esperamos que Armando y Plácido construyan el modelo.

11)
1. estudiaran
2. aprendieran
3. trabajara
4. comiera
5. vendieran
6. empezáramos
7. viajaras
8. saliéramos
9. cantarais
10. vendieran

12)
1. aprendiese
2. volviesen
3. nadases
4. descansásemos
5. hiciese
6. estudiáseis
7. hablase
8. comiesen
9. cerrases
10. vendiese

13)
1. Ella esperó que yo lo conociera.
2. Ellos insistieron en que nosotros aprendiéramos español.
3. Nosotros mandamos que los niños no fumaran.
4. Preferí que tú compraras esta casa.
5. Ustedes quisieron que él devolviera el libro.
6. Marta prefirió que vosotros comiérais comida venezolana.
7. El profesor deseó que sus estudiantes aprendieran español.
8. El gerente pidió que nosotros saliéramos temprano.
9. Ella esperó que pudiéramos hacer el viaje.
10. Insistieron en que nosotros fuéramos a la universidad.

14)
1. hayamos caminado
2. hayan comido
3. haya mirado
4. hayas dormido
5. hayan vendido

15)
1. Yo deseo que tú estudies mucho.
2. Ellos quieren ir al cine.
3. Tú quieres hablar español.
4. Jorge insiste en que Julio limpie la habitación
5. Nosotros mandamos limpiar el coche.
6. Ella espera que nosotros traigamos la guitarra.
7. Él teme que ellos estén en la ciudad.
8. Yo quiero ir de viaje.
9. Vosotros creéis la información.
10. Nosotros preferimos que ellos salgan.

16)
1. Dudo que conozcas a Camilo José Cela.
2. Dudo que ella estudie en la universidad.
3. Dudo que nosotros hablemos francés.
4. Dudo que vendas equipos electrónicos.
5. Dudo que él corra todas las mañanas.

17)
1. No creo que usted beba vino.
2. No creo que ellos estudien en la biblioteca.
3. No creo que tú corras en el estadio.
4. No creo que nosotros trabajemos esta noche.
5. No creo que tú conozcas a Luis.

18)
1. viva
2. vive
3. son
4. estés
5. llegas
6. pasamos
7. vengan
8. sepa
9. voy
10. trabajen

19)
1. Es importante que tú estudies mucho.
2. Es dudoso que ellos trabajen en la primavera.
3. Es posible que yo beba vino argentino.
4. Es mejor que vosotros estudiéis español.
5. Es preciso que nosotros sirvamos comida.
6. Es raro que ella termine temprano.
7. Es interesante que tú viajes al Oriente.
8. Es malo que ellos pierdan los empleos.

9. Es una lástima que yo viva lejos.

10. Es preciso que él asista al doctor.

20)
1. sea
2. vayan
3. vengas
4. sepa
5. hagas
6. sea
7. vuelva
8. ayudemos
9. ayudéis
10. traigan

21)
1. Quería una casa que tuviera un sótano.
2. Quería una casa que tuviera dos garajes.
3. Querías una casa que tuviera una piscina.
4. Querían una casa que tuviera un jardín enorme.
5. Quería una casa que tuviera dos cocinas.
6. Queríamos una casa que tuviera una sauna.
7. Queríais una casa que tuviera siete alcobas.
8. Querían una casa que tuviera un sistema de seguridad.
9. Queríamos una casa que tuviera una cancha de baloncesto.
10. José quería una casa que tuviera tres pisos.

22)
1. escribe
2. pinta
3. sabe
4. hable
5. baile
6. escriba
7. resuelva
8. compre
9. conoce
10. sabe

23)
1. tenga
2. supiera
3. conozca
4. interese
5. pudiera

24)
1. conozco (ind.)/conozca (subj.)
2. existe (ind.) / exista (subj.)
3. visito (ind.) / visite (subj.)
4. pueden (ind.) / puedan (subj.)
5. trabaja (ind.) / trabaje (subj.)

25)
1. sea
2. estés
3. tengas
4. estés
5. obtengas

26)
1. No, se marchó sin que lo viera.
2. No, se marcharon sin que los invitara.
3. No, se marchó sin que le pagara.
4. No, se marcharon sin que les mostrara la obra.
5. No, se marcharon sin que la vieran.

27)
1. Sí, vuelven a pesar de que sea tarde.
2. Sí, regresan a menos que sea tarde.
3. Sí, vienen con tal de que no sea tarde.
4. Sí, regresa después que sea tarde.
5. Sí, vuelve a pesar de que sea tarde.

28)
1. Quizás vuelva pronto.
2. Quizás haga la tarea ahora.
3. Quizás traiga las cosas.
4. Quizás trabaje hasta las ocho.
5. Quizás escriba una carta a Pedro.
6. Quizás estudie filosofía.
7. Quizás maneje hasta la capital.
8. Quizás vaya a ver una película de Buñuel.
9. Quizás escuche la radio.
10. Quizás construya una casa para mis abuelos.

29)
1. tuviera
2. estudiaras
3. tuviera
4. prestaras
5. hubieras tomado
6. hubieras obtenido
7. ahorraras
8. pudiera
9. trabajara
10. hubiera llamado

The Imperative Mood

The imperative mood is only used when one wants to give a command, whether it be formally or informally.

FORMAL COMMANDS

Formal commands are used when addressing the person using "Usted" (Ud.) or the "Ustedes" (Uds.) forms. Formal commands are formed by using the third person singular and plural of the present subjunctive.

Infinitive		
hablar	**hable Ud.**	**hablen Uds.**
	no hable Ud.	**no hablen Uds.**
comer	**coma Ud.**	**coman Uds.**
	no coma Ud.	**no coman Uds.**
vivir	**viva Ud.**	**vivan Uds.**
	no viva Ud.	**no vivan Uds.**

Test Yourself: 1) Answer affirmatively the following questions with formal commands.

1. ¿Nado?
2. ¿Trabajo en el proyecto?
3. ¿Bailamos salsa?
4. ¿Estudio ahora?
5. ¿Traemos el libro?
6. ¿Compro la hamburguesa?
7. ¿Construimos el edificio?
8. ¿Fabrico el modelo?
9. ¿Pienso?
10. ¿Analizamos el problema?
11. ¿Busco a María?
12. ¿Limpio la habitación?
13. ¿Servimos la cena?
14. ¿Como el almuerzo?
15. ¿Repito la pregunta?
16. ¿Calculamos la fórmula?
17. ¿Prendo el televisor?
18. ¿Escuchamos la música?
19. ¿Mando la carta?
20. ¿Voy a la exposición?

Test Yourself: 2) Answer the following questions negatively with formal commands.

1. ¿Escucho el radio?
2. ¿Vemos la película?
3. ¿Compro la revista?
4. ¿Tiramos los libros?
5. ¿Hago el desayuno?
6. ¿Vamos a la fiesta?
7. ¿Nado en la piscina?
8. ¿Rompemos los platos?

9. ¿Duermo en la sala?
10. ¿Digo una mentira?
11. ¿Quitamos la mesa?
12. ¿Lavo los platos?
13. ¿Planchamos la camisa?
14. ¿Limpio el coche?

15. ¿Apagamos la luz?
16. ¿Cierro la tienda?
17. ¿Quemamos la basura?
18. ¿Voy al concierto?
19. ¿Regalo el suéter?
20. ¿Tocamos la puerta?

Test Yourself: 3) Complete the following sentences with the correct formal singular command of the verbs indicated in parentheses. Use the negative command with the sentences that have the word "No" beside them.

1. la camisa (planchar) No
2. los zapatos (limpiar)
3. el cinturón (buscar)
4. el traje ahí (poner) No
5. los calcetines (traer)
6. la caja (abrir) No
7. su cabello (peinar)
8. la silla (traer) No
9. la luz (encender)
10. de la casa (salir)

With reflexive verbs, the reflexive pronoun is attached to the affirmative command. With negative commands, the reflexive pronoun precedes the verb.

Infinitive	Affirmative	Negative
levantarse	**levántese Ud.**	**no se levante Ud.**
	levántense Uds.	**no se levanten Uds.**
detenerse	**deténgase Ud.**	**no se detenga Ud.**
	deténganse Uds.	**no se detengan Uds.**
dormirse	**duérmase Ud.**	**no se duerma Ud.**
	duérmanse Uds.	**no se duerman Uds.**

Test Yourself: 4) Change the following formal commands to their opposite form; that is, from negative to positive, and vice versa.

1. No se ponga ese traje.
2. Levántese ahora.
3. Cepíllense los dientes.
4. No se duerma tarde.
5. Prepárese para la fiesta.

6. No abran los ojos.
7. Despiértese temprano.
8. Vístase pronto.
9. Deténgase Ud.
10. No se duerman Uds.

Test Yourself: 5) Answer the following questions positively with formal commands.

1. ¿Me levanto?
2. ¿Me acuesto?
3. ¿Nos vestimos?
4. ¿Nos vamos?
5. ¿Me visto?

6. ¿Me despido?
7. ¿Nos lavamos?
8. ¿Nos tomamos el café?
9. ¿Me lavo la cara?
10. ¿Nos saludamos?

FAMILIAR COMMANDS

The familiar singular (**tú**) command is the same as the third person singular (**Ud.**) of the present indicative form of the verb.

Infinitive	Singular Command	Infinitive	Singular Command
bailar	**baila tú**	**pedir**	**pide tú**
beber	**bebe tú**	**reunir**	**reúne tú**
cantar	**canta tú**	**servir**	**sirve tú**
comer	**come tú**	**tomar**	**toma tú**
decidir	**decide tú**	**trabajar**	**trabaja tú**
escribir	**escribe tú**	**traer**	**trae tú**
hablar	**habla tú**	**volver**	**vuelve tú**
meter	**mete tú**		

The only irregular commands occur in the familiar affirmative singular (**tú**) form. All other commands are regular. The following verbs have irregular forms in the familiar singular form:

Infinitive	Affirmative	Infinitive	Affirmative
decir	**di tú**	**salir**	**sal tú**
hacer	**haz tú**	**ser**	**sé tú**
ir	**ve tú**	**tener**	**ten tú**
poner	**pon tú**	**venir**	**ven tú**

The plural (**vosotros**) familiar command is formed by dropping the –**r** ending of the infinitive and replacing it with –**d**.

Infinitive	Plural Command	Infinitive	Plural Command
bailar	**bailad vosotros**	**pedir**	**pedid vosotros**
beber	**bebed vosotros**	**reunir**	**reunid vosotros**
cantar	**cantad vosotros**	**servir**	**servid vosotros**
comer	**comed vosotros**	**tomar**	**tomad vosotros**
decidir	**decidid vosotros**	**trabajar**	**trabajad vosotros**
escribir	**escribid vosotros**	**traer**	**traed vosotros**
hablar	**hablad vosotros**	**volver**	**volved vosotros**
meter	**meted vosotros**		

Test Yourself: 6) Answer the following questions positively with the familiar commands.

1. ¿Nado?
2. ¿Trabajo en el proyecto?
3. ¿Bailamos salsa?
4. ¿Estudio ahora?
5. ¿Traemos el libro?
6. ¿Compro la hamburguesa?
7. ¿Construimos el edificio?
8. ¿Fabrico el modelo?
9. ¿Pensamos en eso?
10. ¿Analizamos el problema?
11. ¿Busco a María?
12. ¿Limpio la habitación?
13. ¿Servimos la cena?
14. ¿Como el almuerzo?
15. ¿Repito la pregunta?
16. ¿Calculamos la fórmula?
17. ¿Prendo el televisor?
18. ¿Escuchamos la música?
19. ¿Mando la carta?
20. ¿Voy a la exposición?

Like the formal negative command, the familiar negative command is also formed by using the present subjunctive.

Infinitive	Negative	
bailar	**no bailes tú**	**no bailéis vosotros**
beber	**no bebas tú**	**no bebáis vosotros**
cantar	**no cantes tú**	**no cantéis vosotros**
comer	**no comas tú**	**no comáis vosotros**
hablar	**no hables tú**	**no habléis vosotros**
meter	**no metas tú**	**no metáis vosotros**
tomar	**no tomes tú**	**no toméis vosotros**
trabajar	**no trabajes tú**	**no trabajéis vosotros**
traer	**no traigas tú**	**no traigáis vosotros**
volver	**no vuelvas tú**	**no volváis vosotros**

Test Yourself: 7) Answer the following questions negatively by using familiar commands.

1. ¿Escucho la radio?
2. ¿Vemos la película?
3. ¿Compro la revista?
4. ¿Tiramos los libros?
5. ¿Hago el desayuno?
6. ¿Vamos a la fiesta?
7. ¿Nado en la piscina?
8. ¿Rompemos los platos?
9. ¿Duermo en la sala?
10. ¿Digo una mentira?
11. ¿Quitamos la mesa?
12. ¿Lavo los platos?
13. ¿Planchamos la camisa?
14. ¿Limpio el coche?
15. ¿Apagamos la luz?
16. ¿Cierro la tienda?
17. ¿Quemamos la basura?
18. ¿Voy al concierto?
19. ¿Regalo mi suéter?
20. ¿Tocamos la puerta?

Test Yourself: 8) Make the following familiar commands positive or negative according to the model.
modelo: **Cubre la cama.**

No cubras la cama.

1. Limpia la cocina.
2. Trae los libros.
3. No busquéis las llaves.
4. Apagad las luces.
5. No tiréis la basura.
6. Arregla tus cosas.
7. Mirad el programa.
8. No abráis la botella.
9. Apaga la música.
10. Abre la puerta.

Test Yourself: 9) Answer the following questions by using the irregular forms of the familiar commands according to the model.
modelo: **¿Tengo hambre?**
Ten hambre.

1. ¿Pongo la cena?
2. ¿Salgo temprano?
3. ¿Hago el trabajo?
4. ¿Digo la verdad?
5. ¿Voy al cine?

Test Yourself: 10) Rewrite the following familiar commands in the negative.

1. Habla
2. Hablad
3. Canta
4. Cantad
5. Mira
6. Mirad
7. Duerme
8. Dormid
9. Come
10. Comed
11. Sirve
12. Servid
13. Trabaja
14. Trabajad
15. Ven
16. Venid
17. Ten
18. Tened
19. Sal
20. Salid

INDIRECT COMMANDS

Indirect commands are expressed by the present subjunctive and are normally introduced by **que:**

Que hable él en espaúol.
Let him speak in Spanish.

Que coma ella antes de salir.
Have her eat before leaving.

Que escriban la tarea.
Let them write the homework.

To express the idea of *let's*, the first person plural form of the subjunctive is used.

Cantemos una canción navideña.
Let's sing a Christmas song.

Hablemos sobre el problema.
Let's talk about the problem.

Escribamos una carta a nuestros amigos.
Let's write a letter to our friends.

Let us go is expressed by **vamos** instead of the subjunctive. In the negative, the regular subjunctive is used.

Vamos a la playa.
Let's go to the beach.

No vayamos a la playa.
Let us not go to the beach.

Test Yourself: 11) Make sentences with the following words by using indirect commands according to the model.

modelo: **No quiero limpiar la habitaci6n.**
Que la limpie tu hermano.

1. No quiero hacer la tarea.
2. No quiero limpiar la casa.
3. No quiero probar la comida.
4. No deseo ir a la ópera.
5. No deseo poner la mesa.

Test Yourself: 12) Make sentences with the following words by using indirect commands according to the model.

modelo: **Juan / estudiar español.**
Que Juan estudie español.

1. Roberto / trabajar esta noche.
2. Marta y María / diseñar el edificio.
3. Ellos / recoger las entradas.
4. Jorge y Daniel / tocar el violín
5. El / abrir la puerta

Test Yourself: 13) Make sentences with the following words according to the model.

modelo: **Llevar un regalo**
Llevemos un regalo.
Vamos a llevar un regalo.

1. Comprar un reloj
2. Abrir el regalo
3. Traer los libros
4. Esperar a Carlos
5. Ir al teatro

Test Yourself Answers

1)
1. Nade.
2. Trabaje en el proyecto.
3. Bailen salsa.
4. Estudie.
5. Traigan el libro.
6. Compre la hamburguesa.
7. Construyan el edificio.
8. Fabrique el modelo.
9. Piense.
10. Analicen el problema.
11. Busque a María.
12. Limpie la habitación.
13. Sirvan la cena.
14. Coma el almuerzo.
15. Repita la pregunta.
16. Calculen la fórmula.
17. Prenda el televisor.
18. Escuchen la música.
19. Mande la carta.
20. Vaya a la exposición.

2)
1. No escuche el radio.
2. No vean la película.
3. No compre la revista.
4. No tiren los libros.
5. No haga el desayuno.
6. No vayan a la fiesta.
7. No nade en la piscina.
8. No rompan los platos.
9. No duerma en la sala.
10. No diga ninguna mentira.
11. No quiten la mesa.
12. No lave los platos.
13. No planchen las camisas.
14. No limpie el coche.
15. No apaguen la luz.
16. No cierre la tienda.
17. No quemen la basura.
18. No vaya al concierto.
19. No regale el suéter.
20. No toquen la puerta.

3)
1. No planche la camisa.
2. Limpie los zapatos.
3. Busque el cinturón.
4. No ponga el traje ahí.
5. Traiga los calcetines.
6. No abra la caja.
7. Peine su cabello.
8. No traiga la silla.
9. Encienda la luz.
10. Salga de la casa.

4)
1. Póngase ese traje.
2. No se levante ahora.
3. No se cepillen los dientes.
4. Duérmase tarde.
5. No se prepare para la fiesta.
6. Abran los ojos.
7. No se despierte temprano.
8. No se vista pronto.
9. No se detenga usted.
10. Duérmanse ustedes.

5)
1. Levántese.
2. Acuéstese.
3. Vístanse.
4. Váyanse.
5. Vístase.
6. Despídase.
7. Lávense.
8. Tómense el café.
9. Lávese la cara.
10. Salúdense.

6)
1. Nada.
2. Trabaja en el proyecto.
3. Bailad salsa.
4. Estudia ahora.
5. Traed el libro.

6. Compra la hamburguesa.
7. Construíd el edificio.
8. Fabrica el modelo.
9. Pensad en eso.
10. Analizad el problema.
11. Busca a María.
12. Limpia la habitación.
13. Servid la cena.
14. Come el almuerzo.
15. Repite la pregunta.
16. Calculad la fórmula.
17. Prende el televisor.
18. Escuchad la música.
19. Manda la carta.
20. Ve a la exposición.

7) 1. No escuches la radio.
2. No veáis la película.
3. No compres la revista.
4. No tiréis los libros.
5. No hagas el desayuno.
6. No vayáis a la fiesta.
7. No nades en la piscina.
8. No rompáis los platos.
9. No duermas en la sala.
10. No digas ninguna mentira.
11. No quitéis la mesa.
12. No laves los platos.
13. No planchéis la camisa.
14. No limpies el coche.
15. No apaguéis la luz.
16. No cierres la tienda.
17. No queméis la basura.
18. No vayas al concierto.
19. No regales tu suéter.
20. No toquéis la puerta.

8) 1. No limpies la cocina.
2. No traigas los libros.
3. Buscad las llaves.

4. No apaguéis las luces.
5. Tirad la basura.
6. No arregles tus cosas.
7. No miréis el programa.
8. Abrid la botella.
9. No apagues la música.
10. No abras la puerta.

9) 1. Pon la cena.
2. Sal temprano.
3. Haz el trabajo.
4. Di la verdad.
5. Ve al cine.

10) 1. No hables.
2. No habléis.
3. No cantes.
4. No cantéis.
5. No mires.
6. No miréis.
7. No duermas.
8. No durmáis.
9. No comas.
10. No comáis.
11. No sirvas.
12. No sirváis.
13. No trabajes.
14. No trabajéis.
15. No vengas.
16. No vengáis.
17. No tengas.
18. No tengáis.
19. No salgas.
20. No salgáis.

11) 1. Que la haga tu hermano.
2. Que la limpie tu hermano.
3. Que la pruebe tu hermano.
4. Que vaya tu hermano.
5. Que la ponga tu hermano.

12) 1. Que Roberto trabaje esta noche.

2. Que Marta y María diseñen el edificio.

3. Que ellos recojan las entradas.

4. Que Jorge y Daniel toquen el violín.

5. Que él abra la puerta.

13) 1. Compremos un reloj. Vamos a comprar un reloj.

2. Abramos el regalo. Vamos a abrir el regalo.

3. Traigamos los libros. Vamos a traer los libros.

4. Esperemos a Carlos. Vamos a esperar a Carlos.

5. Vamos al teatro. Vamos a ir al teatro.

Passive Voice

The passive voice is simply a different way of expressing a thought. The order of the words is changed so that what used to receive the action now becomes the new subject. .

José compró una pintura de Picasso.
Joseph purchased a painting of Picasso.

La pintura de Picasso fue comprada por José.
Picasso's painting was purchased by Joseph.

In the active voice, the subject normally performs an action. In the passive voice, the subject is acted upon. When the passive voice is used, its formation is similar to that in English: subject + form of **ser** + past participle + **por** + doer

Este edificio fue construido por Luis Rodríguez.
This building was constructed by Louis Rodríguez.

Estas personas fueron invitadas por Juan.
These people were invited by John.

La fiesta será celebrada por los miembros del club.
This party will be celebrated by the members of the club.

La tienda es abierta por el administrador.
This store is opened by the administrator.

Test Yourself: 1) Change the following sentences from the active voice to the passive voice.
1. Juan abre la tienda.
2. Lorca escribió *Bodas de sangre*.
3. El mejor diseñador hizo este modelo.
4. El incendio destruyó la ciudad.
5. Todos aplaudieron a los artistas.

In the passive voice, the past participle is used as an adjective and agrees with the subject in gender and number.

> **La tarea fue hecha por Jorge.**
> *The homework was done by Jorge.*

> **Los regalos fueron traídos por él.**
> *The gifts were brought by him.*

The doer of the action is preceded by the preposition **por;** however, if the past participle expresses feeling or emotion, **por** may be substituted with **de:**

> **La ópera Carmen es la preferida de nosotros.**
> *The opera Carmen is preferred by us.*

PASSIVE VOICE WITH –se

When the doer by whom the action is performed is not mentioned or implied, and the subject is a thing, the reflexive pronoun **se** is used with the third person singular or plural form of the verb.

> **Se habla español aquí.**
> *Spanish is spoken here.*

In this sentence, we know someone speaks Spanish but we do not have any information regarding the subject. The subject is indefinite.

> **Se perdió el libro.**
> *The book was lost.*

> **Se dice que la conferencia será a las cuatro.**
> *It is said that the lecture will be at three.*

> **Se necesitan empleados en esta tienda.**
> *Employees are needed at this store.*

Test Yourself: 2) Rewrite the following sentences by using the **se** construction in the present tense.
1. Hablar español en el bufete.
2. Cerrar las tiendas a las once.
3. Vender esta casa.
4. Comprar oro.
5. Dar información.

The forms **dicen, creen,** and **saben** are used without the reflexive pronoun **se:**

> **Dicen que nevará esta tarde.**
> *It is said that it will snow tonight.*

Many times, the active third person plural is used instead of the indefinite **se:**

Los capturaron en el acto.
They captured them in the act.

Las engañaron en la tienda.
They were fooled at the store. (indefinite)

SPECIAL USE OF CERTAIN VERBS

There are some verbs in Spanish that are difficult to learn for English-speaking students. The reason for this is mainly that two verbs in Spanish have one single meaning in English, and you must learn to differentiate between them. The following are some of these verbs. Study in detail how they are used.

Ser and Estar

The verbs **ser** and **estar** have one single meaning in English: *to be.* In general, the verb **ser** denotes permanent or inherent qualities or characteristics. The verb **estar** expresses states, conditions, or events. However, there are other rules to consider.

Uses of Ser

Ser is used:

A) To express an inherent quality or characteristic of a subject:

Este anillo es de oro.
This ring is made of gold.

Esta casa es de madera.
This house is made of wood.

La pintura es blanca.
The painting is white.

Las uvas son dulces.
The grapes are sweet.

Test Yourself: 3) Complete the following sentences by describing the quality or characteristic of the subject.

1. La casa _____ blanca.
2. El reloj _____ de oro.
3. Juan _____ amable.
4. Las frutas _____ dulces.
5. Los chicos _____ buenos.
6. El vino _____ español.
7. El edificio _____ de concreto.
8. El profesor _____ inteligente.
9. Julia _____ una chica disciplinada.
10. El plato _____ de plata.

B) To describe or identify a subject:

El hombre es alto.
The man is tall.

La mujer es hermosa.
The woman is beautiful.

La ciudad es enorme.
The city is enormous.

Test Yourself: 4) Complete the following sentences by describing or identifying the subject.

1. Carmen _____ alta.
2. La ciudad _____ enorme.
3. Mi primo _____ médico.
4. Ellos _____ millonarios.
5. ¿Quién _____ tú?
6. El automóvil _____ moderno.
7. El joven _____ esbelto.
8. El río _____ caudaloso.
9. El cielo _____ azul.
10. Ellas _____ abogadas.

C) To express origin, the place where someone or something is from:
Beatriz es de Paraguay.
Beatriz is from Paraguay.

Ellos son de San Juan.
They are from San Juan.

El vino Concha y Toro es de Chile.
The wine Concha y Toro is from Chile.

D) To express ownership:
Este coche es mío.
This car is mine.

Éste es mi reloj.
This is my watch.

E) To express time, dates, and to express where something is taking place
¿Qué hora es?
What time is it?

Son las cuatro de la tarde.
It is four o'clock in the afternoon.

¿Cuál es la fecha de hoy?
What is today's date?

¿Dónde es la obra de teatro?
Where is the play?

Hoy es el doce de octubre de 1991.
Today is October twelfth, 1991.

La obra de teatro es en el Repertorio Español.
The play is at the Spanish Repertory Theatre.

F) With impersonal expressions:
Es importante estudiar español.
It is important to study Spanish.

Es necesario que estudies todos los días.
It is necessary that you study every day.

G) In the passive voice with the past participle:
Los estudiantes fueron examinados por el profesorado.
The students were tested by the faculty.

El teléfono es contestado por la recepcionista.
The telephone is answered by the receptionist.

Test Yourself: 5) Write sentences with the following words.
1. Jorge / ser / profesor.
2. Portugal / ser / país / europeo.
3. Caballo / ser / animal / cuadrúpedo.
4. Bogotá / ser / capital / Colombia.
5. Platino / ser / metal / valioso.
6. Nosotros / ser / ingeniero.

7. Ser / importante / aprender / idiomas.
8. ¿Qué / hora / ser?
9. Concierto / ser / hoy.
10. Yo / ser / guatemalteco.

Test Yourself: 6) Complete the following paragraph with the appropriate form of the verb **ser.**

¡Hola! Yo _____ (1) Pedro Estrada. _____ (2) un estudiante universitario. Yo vivo en Nueva York aunque no _____ (3) norteamericano. Yo _____ (4) venezolano. Yo vivo aquí porque estudio en la Universidad de Fordham. La universidad _____ (5) muy bella y la educación que recibo _____ (6) la mejor. Mis profesores _____ (7) inteligentes y desean que nosotros _____ (8) buenos alumnos. Te escribo porque deseo saber cómo _____ (9) tu ciudad, y cómo _____ (10) las personas de tu pueblo.

Escríbeme pronto. Saludos.

Uses of Estar

Estar is used to:

A) To express the location, position, or situation of the subject:

Yo estoy en la universidad.
I am at the university.

Lima está en Perú.
Lima is in Peru.

Felipe está en el cuarto piso.
Philip is on the fourth floor.

La Universidad Complutense está en Madrid.
The Complutense University is in Madrid.

Test Yourself: 7) Complete the following sentences with the appropriate form of the verb **estar.**

1. La capital _____ en el centro del país.
2. Yo _____ en la calle doce.
3. Octavio _____ en la cocina.
4. Nosotros _____ en el balcón.
5. La biblioteca _____ detrás del laboratorio.
6. Ellos _____ en casa.
7. Vosotros _____ sentados en el sofá.
8. Tú _____ en la plaza.
9. Ellas _____ en el museo.
10. Yo _____ aquí.

B) To indicate a state or condition of the subject:

Juan está enfermo.
John is ill.

El automóvil está listo.
The car is ready.

El paciente está mejorando.
The patient is getting better.

El té está caliente.
The tea is hot.

Test Yourself: 8) Complete the following sentences with the appropriate form of the verb **estar.**

1. Julia _____ cansada.
2. Nosotros _____ alegres.
3. Ella _____ enferma.
4. El automóvil _____ sucio.
5. La camisa _____ planchada.

6. La sopa _____ caliente.
7. El día _____ frío.
8. La tienda _____ cerrada.
9. El perro _____ ladrando.
10. Las frutas _____ agrias.

C) To form the progressive tense with the present participle:

Felipe está divirtiéndose en la fiesta.

Philip is enjoying himself at the party.

Ellos están jugando al fútbol.

They are playing soccer.

Los estudiantes están estudiando para el examen final.

The students are studying for the final examination.

Test Yourself: 9) Complete the following sentences with the appropriate form of the verb **ser** or **estar** according to the meaning expressed in the sentence.

1. La ciudad _____ al norte del país.
2. Nosotros _____ cansados.
3. Juan _____ dentista.
4. La luz _____ fuerte.
5. Ellos _____ cantando.
6. La comida _____ buena.
7. El té _____ frío.
8. Mi hermana _____ alta.
9. _____ importante hablar varios idiomas.
10. Lima _____ la capital de Perú.
11. El Señor Rodríguez _____ contento.
12. Él _____ de mal humor.
13. Él _____ amable.
14. Julio _____ rico.
15. ¿Qué hora _____ ?
16. Las niñas _____ estudiando.
17. María _____ hermosa.
18. ¿Dónde _____ Luis?
19. Todos _____ aquí. (ellos)
20. Mi hermano _____ honrado.

Changes of Meaning

Certain words change their meaning depending whether **ser** or **estar** is used. The following is a list of those words:

	Ser	**Estar**
aburrido	*boring*	*bored*
bueno	*good (characteristic)*	*good (condition)*
enfermo	*sickly*	*sick*
listo	*clever*	*ready*
pálido	*pale (complexion)*	*pale (condition)*
seguro	*safe*	*sure*
vivo	*sharp; quick*	*alive*

Test Yourself: 10) Complete the following sentences with the appropriate form of **ser** or **estar** according to the meaning expressed.

1. Yo _____ aburrido. No sé que hacer hoy.
2. La comida _____ buena. Siempre me gusta.
3. Ella _____ enferma. Hizo mucho frío ayer.
4. Él _____ un hombre listo sabe, muchas, cosas.
5. Ella _____ lista para salir. La fiesta es a las once.

Saber and Conocer

Saber and **conocer** also have the same meaning in English, which is *to know.* However, they are used differently in Spanish. **Saber** means to know a fact, a reason, or a learned subject. **Conocer,** on the other hand, means to know a person, a geographic area, or a literature.

Ellos saben la verdad.
They know the truth.

Vosotros sabéis español.
You know Spanish.

El señor Jiménez sabe mátematicas.
Mr. Jimenez knows mathematics.

Conozco a los invitados.
I know the guests.

Conocemos Bogotá muy bien.
We know Bogota very well.

¿Conoces las obras principales de la literatura china?
Do you know the main works of Chinese Literature?

In addition, the expression **sabe a** means to taste.

Esto sabe a mango.
This tastes like mango.

No sabe a nada.
It has no taste.

Test Yourself: 11) Complete the following sentences with the appropriate present indicative form of **saber** or **conocer.**

1. María _____ a Miguel.
2. Yo _____ la verdad sobre lo que pasó.
3. Ellos no _____ la ciudad.
4. Ella _____ español.
5. Pedro y Juan _____ mucho sobre ese tema.
6. Tú _____ la respuesta.
7. Vosotros _____ la literatura española.
8. Tú _____ la condición del paciente.
9. Tú _____ muy bien este restaurante.
10. Nosotros _____ matemáticas.

Pedir and Preguntar

These two verbs have the same meaning in the English language, which is *to ask.* **Pedir** means to ask for something or to request. **Preguntar** means *to ask a question.*

Pídeles una copia del contrato.
Ask him (her) for a copy of the contract.

Pregúntale al profesor la diferencia entre ser y estar.
Ask the professor the difference between ser and estar.

Test Yourself: 12) Complete the following sentences with the appropriate form of the verb **pedir** or **preguntar.**

1. Voy a _____ un taxi.
2. Él _____ una hamburguesa.
3. Nosotros _____ por Miguel.
4. El hombre _____ una limosna.
5. Ellos _____ la respuesta.
6. Yo _____ la comida.
7. Tú _____ un libro en la biblioteca.
8. El profesor _____ ayuda.
9. El maestro _____ por ti.
10. Yo le _____ dinero a mi esposa.

Jugar and Tocar

Both of these verbs mean to play; however, they are used differently. **Jugar** means to play a sport, game, or to gamble. **Tocar** means to play a musical instrument or to touch.

El equipo Real Madrid juega fútbol.
The team Real Madrid plays soccer.

Andrés Segovia tocaba muy bien la guitarra.
Andrés Segovia used to play the guitar very well.

A Antonio le gusta jugar a la brisca.
Anthony likes to play brisca.

Test Yourself: 13) Complete the following exercises with the appropriate form of the verb **jugar** or **tocar.**

1. Nosotros _____ el piano.
2. Ellos _____ al fútbol.
3. Mercedes _____ la flauta.
4. Tú _____ a la puerta.
5. Ella _____ el violoncelo.
6. Él _____ la trompeta.
7. Usted _____ bien al baloncesto.
8. Vosotros _____ al béisbol.
9. Marta _____ contigo en el casino.
10. Yo _____ a las cartas.

Volver and Devolver

Volver means to return from a place. **Devolver** means to give back something.

Ellos vuelven de Sur América.
They return from South America.

Juan vuelve de Puerto Rico.
John returns from Puerto Rico.

Tengo que devolver este libro antes de que cierre la biblioteca.
I have to return this book before the library closes.

As an expression **volver a** means to repeat an action or to do again.

Nosotros volvemos a repasar los verbos irregulares.
We review the irregular verbs again.

Julia vuelve a leer el libro.
Julia reads the book again.

Test Yourself: 14) Complete the following sentences with the appropriate form of the verb **volver** or **devolver.**

1. Yo _____ a casa tarde.
2. Ellos _____ al club.
3. Nosotros _____ las cartas.
4. Ellos _____ las herramientas.
5. Tú _____ de la fiesta.
6. Vosotros _____ la máquina.
7. Él _____ temprano.
8. Carlos _____ mañana.
9. Todos _____ a bailar.
10. Ella _____ el lápiz.

Test Yourself Answers

1)
1. La tienda es abierta por Juan.
2. *Bodas de sangre* fue escrita por Lorca.
3. Este modelo fue hecho por el mejor diseñador.
4. La ciudad fue destruída por el incendio.
5. Los artistas fueron aplaudidos por todos.

2)
1. Se habla español en el bufete.
2. Se cierran las tiendas a las once.
3. Se vende esta casa.
4. Se compra oro.
5. Se da información.

3)
1. es
2. es
3. es
4. son
5. son
6. es
7. es
8. es
9. es
10. es

4)
1. es
2. es
3. es
4. son
5. eres
6. es
7. es
8. es
9. es
10. son

5)
1. Jorge es profesor.
2. Portugal es un país europeo.
3. El caballo es un animal cuadrúpedo.
4. Bogotá es la capital de Colombia.
5. El platino es un metal valioso.
6. Nosotros somos ingenieros.
7. Es importante aprender idiomas.
8. ¿Qué hora es?
9. El concierto es hoy.
10. Yo soy guatemateico.

6)
1. soy
2. Soy
3. soy
4. soy
5. es
6. es

7 (continued from col 1)
7. son
8. seamos
9. es
10. son

7)
1. está
2. estoy
3. está
4. estamos
5. está
6. están
7. estáis
8. estás
9. están
10. estoy

8)
1. está
2. estamos
3. está
4. está
5. está
6. está
7. está
8. está
9. está
10. están

9)
1. está
2. estamos
3. es
4. es
5. están
6. es
7. está
8. es
9. Es
10. es
11. está
12. está
13. es
14. es
15. es
16. están
17. es
18. está
19. están
20. es

10)
1. estoy
2. es
3. está
4. es
5. está

11)
1. conoce
2. sé
3. conocen
4. sabe
5. saben
6. sabes
7. conocéis
8. sabes
9. conoces
10. sabemos

12)
1. pedir
2. pide
3. preguntamos
4. pide
5. piden
6. pido
7. pides
8. pide
9. pregunta
10. pido

13)
1. tocamos
2. juegan
3. toca
4. tocas
5. toca
6. toca
7. juega
8. jugáis
9. juega
10. juego

14)
1. vuelvo
2. vuelven
3. devolvemos
4. devuelven
5. vuelves
6. devolvéis
7. vuelve
8. vuelve
9. vuelven
10. devuelve

Pronouns

Pronouns are a way of indicating who is the subject, by using subject pronouns or who is receiving the action, by using direct and indirect object pronouns.

SUBJECT PRONOUNS

Subject pronouns indicate who is the subject. They include: I, you, he, she, we, they.

Yo estudio español.
I study Spanish.

Tú eres el amigo de Juan.
You (singular familiar) are John's friend.

¿Fue él al almuerzo?
Did he go to the luncheon?

Ella es rubia.
She is blond.

¿Cómo está Ud?
How are you (singular formal)?

Nosotros vamos al cine.
We go to the movies.

Vosotros tenéis razón.
You (plural familiar) are right.

¿Tienen ellos buenas notas?
Do they have good grades?

¿Quieren ellas ir a nadar?
Do they want to go swimming?

¿Conocen Uds. a Fulgencio?
Do you (plural formal) know Fulgencio?

In Spanish there are four ways of saying *you*. **Tú** is the familiar form used to address friends, family, small children, and animals. The familiar plural form of **tú** is **vosotros(as)**. **Vosotros(as)** is rarely used today except in Spain.

Usted (Ud.) is the formal form of address. The formal plural, Ustedes (Uds.), has replaced vosotros(as) in Latin America, especially in nonliterary use, and is used for both formal and informal addresses when speaking to two or more people. Usted (Ud.) takes the third person, both in the singular and plural forms.

The subject pronouns in Spanish are:

Singular		Plural	
yo	*I*	nosotros (as)	*we*
tú	*you*	vosotros (as)	*you* (familiar)
él	*he*	ellos	*they* (masculine)
ella	*she*	ellas	*they* (feminine)
usted (Ud.)	*you*	ustedes (Uds.)	*you*

In Spanish, subject pronouns indicate the gender and number of the subject. The pronouns él, nosotros, vosotros, and ellos have their feminine counterparts: ella, nosotras, vosotras, and ellas. Usted and Ustedes are neuter pronouns and can apply to feminine or masculine subjects as well as mixed groups. The form ending in –os is also used to indicate both feminine and masculine subjects grouped together.

Test Yourself: 1) Complete the following sentences with the correct subject pronoun according to the model.

modelo: **Carlos y Maria tienen 10 años.**
Ellos tienen la misma edad.

1. _____ soy de Nueva York.
2. _____ somos de Francia.
3. Olga es la hermana de Andrés. _____ tiene diez y siete años.
4. Luz y Maribel son primas. _____ son de Bogotá..
5. Marta quiere ir a España. ¿Quieres ir _____ también?
6. Señor Gómez, ¿es _____ el profesor de inglés?
7. Miguel quiere viajar por avión, pero _____ no tiene pasaporte.
8. _____ (feminine) vivimos con Pilar.
9. _____ (formal) tiene mucho dinero.
10. Eduardo y Anita, ¿de dónde sois _____?
11. _____ soy cubana.
12. _____ (masculine) es puertorriqueño.
13. ¿Cuántos estudiantes tienen ustedes? _____ tenemos treinta estudiantes.

Test Yourself: 2) Substitute the subject with the correct pronoun according to the model.

modelo: **María y Pedro, ¿vienen con nosotros a Madrid?**
¿ Ustedes vienen con nosotros a Madrid?

1. Sara vive en San Juan.
2. Carlos y yo vamos a cenar.
3. ¿Cómo está señor Jiménez?
4. Sandra y Enrique son graduados de la universidad.
5. ¿Dónde juega Pablo al tenis?

DIRECT AND INDIRECT OBJECT PRONOUNS

Object Pronouns are used to tell who or what is receiving the action of the verb. Examples of object pronouns would be "me, you, him, her, us, them". In the following sections these object pronouns will be covered in more depth.

Yo te veo.
I see you

Tú me ves.
You see me.

Él nos ve.
He sees us.

Ella nos ve.
She sees us.

Notice that the pronouns **me, te, nos** and **os** can function as either direct or indirect objects. These direct or indirect pronouns normally precede the verb.

María te ve.
Maria sees you.

El policía nos habla.
The policeman speaks to us.

Test Yourself: 3) Complete the following sentences with the appropriate object pronoun: **me, te,** or **nos.**
1. ¿Por qué ____ (us) molestan ?
2. Él ____ (you) busca.
3. ¿Cuánto ____ (me) cuesta?
4. Carmelita ____ (us) hace reír.
5. Mi abuela ____ (you) cose el vestido.
6. El panadero ____ (me) conoce,
7. Uds. ____ (us) buscan
8. ¿Quién ____ (me) llama?
9. Andrés ____ (you) busca.
10. Ellos ____ (us) llaman.

Direct Object Pronouns

Direct object pronouns can refer to people or things and indicate the gender and number of the object. The direct object of a sentence receives the action of the subject, and is found by asking the question *what* to the verb in the main clause.

María quiere el coche.
Maria wants the car.

María lo quiere.
Maria wants it.

Él tiene los marcos.
He has the frames.

El los tiene.
He has them.

In Spanish, the direct object pronouns are:

Singular		Plural	
me	*me*	**nos**	*us*
te	*you* (familiar)	**os**	*you* (familiar)
lo	*you, him, it*	**los**	*you, them*
la	*you, her, it*	**las**	*you, them*

Lo and **los** are masculine pronouns; **lo** is the singular form and **los** is the plural form. **La** and **las** are feminine pronouns, singular and plural, respectively.

Direct object pronouns normally precede the conjugated form of the verb and are placed after the negative.

Yo preparo las mesas.
I set the tables.

Yo las preparo.
I set them.

Ellos no llaman a María.
They do not call Mary.

Ellos no la llaman.
They do not call her.

Test Yourself: 4) Substitute the direct object with the appropriate direct object pronoun according to the model.

modelo: **Tú buscas la cámara.**
You look for the camera.

Tú la buscas.
You look for it.

1. La maestra recoge los exámenes.
2. Juan ve al muchacho.
3. Yo compré el vestido.
4. Nosotros tenemos las respuestas.
5. ¿Usted quiere la manzana?
6. Ellos miran los letreros.
7. La madre recoge la mesa.
8. Tomás ve a Ángel.
9. Yo quiero a mis hijos.
10. ¿Ustedes quieren el perro?

Test Yourself: 5) Complete the sentences with the appropriate direct object pronoun according to the model.

modelo: **Yo perdí los boletos.**
Yo los perdí.

1. Mario compró la cartera. Él ____ compró.
2. El cocinero preparó el almuerzo. Él ____ preparó.
3. Marco e Isabel vieron al padre. Ellos ____ vieron.
4. Las mariposas buscan las flores. Ellas ____ buscan.
5. El profesor nos dio la tarea. Él nos ____ dio.
6. Yo lavé las frutas. Yo ____ lavé.
7. ¿Comiste tú el pimiento? No, yo no ____ comí.
8. Juan compró un regalo. Juan ____ compró.
9. Ellos buscaron los libros. Ellos ____ buscaron.
10. Ellos no hicieron la tarea. Ellos no ____ hicieron.

Test Yourself: 6) Answer the following questions using the appropriate direct object pronouns according to the model.

modelo: **¿Compraste los libros?**

Sí, los compré.

1. ¿Viste a Fernando y a Carlos?
2. ¿Vieron las noticias de la tarde?
3. ¿Invitamos a Beatriz a cenar?
4. ¿Quién pintó el muro?
5. ¿Vas a ver la película en el cine?
6. ¿Ayudaste al empleado con el trabajo?
7. ¿Quieres comprar los pendientes?
8. ¿Van a ver la cantante ustedes?
9. ¿Preparan las comidas ellos?
10. ¿Comprará usted el vino?

When a direct object pronoun is used with an infinitive, a gerund, or an affirmative command, the object pronoun may be placed before the auxiliary verb or attached to the infinitive, the gerund, or the affirmative command.

Quiero comprarlo.
I want to buy it.

Lo quiero comprar.
I want to buy it.

Estoy grabándola.
I am taping her.

La estoy grabando.
I am taping her.

Tómelo Ud.
Take it.

No lo tome Ud.
Don't take it.

Test Yourself: 7) Rewrite the following sentences by attaching the appropriate direct object pronoun to the verb.

1. Compra la grabadora.
2. Lleven los niños.
3. Dame el dinero.
4. Cuelga la ropa.
5. Abre el sobre.
6. Mira los pájaros.
7. Vende las flores.
8. Termina el trabajo.
9. Haz la tarea.
10. No escribas las notas.

Indirect Object Pronouns

Indirect object pronouns refer to people and animals. The indirect object of a sentence is found by asking the question "who is it being done to?" (or *for whom?*) to the verb in the main clause. Indirect object pronouns normally precede the conjugated form of the verb and are placed after the negative.

Tú le cantas a él.
You sing to him.

Él le canta a ella.
He sings to her.

Yo le canto a Ud.
I sing to you.

Tú me cantas la canción a mí.
You sing the song to me.

Él nos canta la canción a nosotros.
He sings the song to us.

Yo les canto la canción a Uds.
I sing the song to them.

In Spanish, the indirect object pronouns are:

Singular		Plural	
me	*me*	**nos**	*us*
te	*you* (familiar)	**os**	*you* (familiar)
le	*you, him* (masculine)	**les**	*you, them*

The third person indirect object pronouns are **le** in the singular and **les** in the plural. In the case of **le** and **les,** gender is not differentiated, only the number is indicated. To clarify the gender, a prepositional phrase often accompanies indirect object pronouns.

Yo les hablo a ellas.
I speak to them

Le mandé la ropa a Juan.
I sent the clothes to Jon

Ella les recogió los libros a los estudiantes.
She picked up the books for the students

Test Yourself: 8) Complete the following exercise with the appropriate third person indirect object pronoun (**le, les**).

1. Tú ___ hablas a Miguel.
2. Él ___ mandó las cartas a ella.
3. Cristóbal ___ dijo la verdad a ellas.
4. María ___ cantó una canción a él.
5. Ustedes ___ contaron la historia a ellos.
6. La profesora no ___ explicó bien a Fernando la respuesta.
7. Carlos ___ escribió a ella.
8. Yo ___ pedí una respuesta a ellos.
9. A ellas ___ mandaron los paquetes.
10. Miriam no ___ llevó un regalo a ellas.

Test Yourself: 9) Fill in the appropriate direct or indirect object pronoun according to the model.
modelo: **Antonio llamó a los curas.**
Antonio los llamó.

1. Yo sabía las respuestas. Yo ___ sabía.
2. María ___ dijo una mentira a su mamá.
3. El carpintero ___ dio el martillo a los jefes.
4. Francisco necesita el maletín. Francisco ___ necesita.
5. ¿Recogiste tú las plumas? Yo ___ recogí.
6. El jardinero saludó al señor Celestín. El jardinero ___ saludó.
7. La universidad no quiere a los maleducados. La universidad no ___ quiere.
8. El conductor dejó subir a la enferma. El conductor ___ dejó subir.
9. Él compró un regalo. Él ___ compró.
10. Mateo ___ dio un regalo a su hermano.

The verbs **encantar** *(to enchant, to delight)*, **enfurecer** *(to infuriate)*, **asustar** *(to scare)*, **sorprender** *(to surprise)*, **gustar** *(to like)*, **doler** *(to hurt)*, **faltar** *(to lack)* and **molestar** *(to annoy)* are always used with the indirect object.

Gustar and **faltar** (**hacer falta**) are two verbs commonly used with indirect object pronouns. **Gustar** can be translated in English as *to like* but actually means *to be pleasing to*. **Faltar** (hacer **falta**) can be translated in English as *to need* but it actually means *to be lacking*.

¿Te sorprenden mis ideas políticas?
Do my political ideas surprise you?

Los ruidos de la noche lo asustaron.
The night sounds scared him.

Nos sorprendió la cantidad de estudiantes.
The number of students surprised us.

A Marisol le molesta la humedad.
The humidity annoys Marisol.

A José le gusta jugar.
Joseph likes to play.

A José le gustan los juegos.
Joseph likes games.

Me hace falta la sopa.
I'm missing the soup.

Me faltan los condimentos.
I'm lacking the spices.

Nos gusta la ropa.
We like the clothing.

Nos gustan las prendas.
We like the jewelry.

Les falta el cepillo.
They are lacking the brush.

Les faltan los peines.
They are lacking the combs.

Test Yourself: 10) Fill in the following sentences with the appropriate indirect object pronoun and verb ending according to the model.

modelo: **A Máximo le gusta bailar.**

1. A mí _____ asustan los aviones.
2. A ellas _____ sorprende la música.
3. A Juan _____ encantan las flores.
4. A ti _____ hace falta aquel maestro.
5. A nosotros _____ enfurece el noticiero.
6. A ellos no _____ molesta nada.
7. A mí _____ hacen falta los retratos.
8. A Olga _____ gusta aquel carro.
9. A nosotros _____ encanta la película.
10. A ti no _____ asustan los gritos.

Notice that the verb is conjugated only in the third person singular or the third person plural. This is because the verb agrees with what is being "liked" (in the case of gustar), instead of the subject.

Test Yourself: 11) Rewrite the following sentences by using the verbs **encantar, molestar, asustar, enfurecer, sorprender, enojar, gustar,** or **faltar**. Make sure the verb is conjugated only in the third person singular or the third person plural, depending on what is being *liked* or *missed* or *surprised by*.

1. A Uds. / asustar / los tiburones.
2. A mí / gustar / la leche.
3. A Raúl / faltar / las medicinas.
4. A nosotros / enojar / el profesor.
5. A ti / sorprender / las campanas.
6. A Carmen / hacer / faltar / la secadora.
7. A ellos no / enfurecer / el error.
8. A usted / gustar/ los mariscos.
9. A mí / faltar / el pan.
10. A nosotros / molestar / las abejas.

DOUBLE OBJECT PRONOUNS

Many times, both a direct and an indirect object pronoun will appear in the same sentence. This is a double object pronoun, with the indirect pronoun always preceding the direct object pronoun.

Fernando me los dio.
Fernando gave them to me.

La maestra te lo enseñó.
The teacher taught it to you.

María nos lo dio.
Mary gave it to us.

Me lo	**Te lo**	**Nos lo**	masculine, singular
Me los	**Te los**	**Nos los**	masculine, plural
Me la	**Te la**	**Nos la**	feminine, singular
Me las	**Te las**	**Nos las**	feminine, plural

Test Yourself: 12) Rewrite the following sentences, substituting the direct object with an object pronoun according to the model.

modelo: **Carmen me vendió las flores.**

Carmen me las vendió.

1. Él nos enseñó la lectura.
2. ¿Quién te compró las medias?
3. Luis me dio el regalo.
4. Ellos te devolvieron el billete.
5. ¿No me dieron las respuestas?
6. Ella nos regaló el reloj.
7. Usted me explicó bien la pregunta.
8. Patricia nos mandó las cartas.
9. Miguel te preparó la comida.
10. Ellas me cambiaron los paquetes.

The indirect object pronouns **le** and **les** become **se** when they are placed in front of the direct object pronouns **lo, los, la,** or **las.** The pronoun **se** can imply many different meanings and is, therefore, often clarified by the use of a prepositional phrase.

Juan se lo manda a Carmen.
Juan sends it to Carmen.

Nosotros se lo explicamos a Ud.
We explain it to you.

Test Yourself: 13) Substitute the following direct and indirect objects for the appropriate object pronouns according to the model,

modelo: **Nosotros les pagamos el dinero.**

Nosotros se lo pagamos.

1. Pepe le pidió las respuestas a Patricia.
2. El jefe les dio la orden a sus empleados.
3. La lavandera le lavó la ropa al marido.
4. Yo le compré el pantalón a Luis.
5. Carmen le enseñó las cartas a Pilar.
6. El maestro les explicó la clase a sus estudiantes.
7. La madre mandó el regalo para Isabel.
8. Nosotros les regalamos la pintura a nuestros hijos.
9. Marcos le cuenta la historia a Marta.
10. La costurera les cosió los pantalones a los jugadores.
11. Ella le vendió el terreno a sus abuelos.
12. Olga les pintó el cuadro a las niñas.

With Conjugated Verbs

Object pronouns always precede the conjugated form of the verb. If a sentence is negative, the negative word precedes the object pronouns. In the case of compound tenses, the object pronouns precede the auxiliary verb.

negative + indirect obj. pron. + direct obj. pron. + verb

La cocinera me enseñó la receta.
The cook showed me the recipe

Ella no te lo ha explicado bien.
She hasn't explained it to you well.

Usted nos lo compró.
You bought it for us.

Test Yourself: 14) Substitute the direct and indirect objects with the appropriate object pronouns according to the model.

modelo: **Rosa no nos dio las respuetas.**

Rosa no nos las dió.

1. Marta ha vestido las muñecas.
2. Yo vi a mi vecino ayer.
3. Ella contó la historia.
4. Tú no has leído el manual.
5. Usted le dio las respuestas a Lázaro.
6. Rodolfo conoce a la maestra.
7. Él ha terminado el examen.
8. Ellos no nos aceptaron la solicitud.
9. Pilar me dio la solución.
10. Ustedes me mandaron el dinero.

With Infinitives

Object pronouns can be attached to the infinitive or precede the auxiliary verb. Often, two pronouns can be attached to the infinitive.

Roberto me lo quiere regalar.
Roberto quiere regalármelo.
Roberto wants to give it to me (a gift).

Ellas te lo quieren mandar.
Ellas quieren mandártelo.
They want to send it to you.

Elena nos va a despertar.
Elena va a despertarnos.
Elena is going to wake us.

Yo te quiero escribir una carta.
Yo quiero escribírtela.
I want to write you a letter.

Martín nos lo prefiere pagar por cheque.
Martin prefers to pay it to us by check

Martín prefiere pagárnoslo por cheque.
Martin prefers to pay it to us by check.

Test Yourself: 15) Rewrite the following sentences by placing the object pronouns before the auxiliary verb.

1. Marisa va a decírtelo.
2. Yo quiero mandársela a usted.
3. Ellos prefieren comprárnoslas.
4. El pintor desea mostrarlos.
5. Felipe quería explicármelo.
6. Mi abuela va a enviárnosla.

Test Yourself: 16) Rewrite the sentences by adding two pronouns to the infinitive.

1. La cantante me quiso dedicar la canción.
2. Máximo no te deseó explicar el problema.
3. Ellos me van a regalar los camarones.
4. Ustedes nos quieren enviar las blusas.
5. Yo te deseo mandar los juguetes.
6. El carnicero me quería picar la carne.

Test Yourself: 17) Rewrite the following sentences according to the model.

modelo: **Carmen quiere escribir la carta a Luis.**

Carmen se la quiere escribir.

Carmen quiere escribírsela.

1. Yo quiero enseñarle el cuarto.
2. Ustedes desean regalar los caramelos.
3. Patricia quiere pedirnos el dinero.
4. Ellos pueden darnos la muestra.
5. Adolfo quiere mostrarle las maletas.
6. Deseamos renovar el edificio.
7. La maestra prefiere enseñarnos los verbos.
8. Van a pedirle el mensaje a la secretaria.
9. Ustedes van a devolverme los calcetines.
10. El jefe quiere dar las órdenes.

With Present Participles

In the case of progressive tenses, object pronouns can either precede the auxiliary verb **estar** (**seguir, ir, andar**) or be attached to the present participle.

Rocío sigue arreglando la computadora.
Rocio continues to fix the computer

Rocío la sigue arreglando.
Rocio continues to fix it.

Rocío sigue arreglándola.
Rocio continues to fix it.

Usted le está respondiendo las preguntas a las madres.
You are answering the questions to the mothers

Usted se las está respondiendo.
You are answering them to them.

Usted está respondiéndoselas.
You are answering them to them.

Test Yourself: 18) Replace the direct and/or indirect object with the appropriate object pronouns. If it is possible to place them in two different positions, attach them to the correct verb.

1. La maestra está buscando su licencia.
2. Uds. van a devolver el automóvil al propietario.
3. Luis está atendiendo al paciente.
4. Los empleados le garantizan el precio.
5. El padre está regañando a los niños.
6. La operadora quiere saber su número de teléfono.
7. Olga está apuntando la dirección.
8. Él quiere comprar los boletos.
9. Ellos están discutiendo los planes.
10. Él acaba de pedirle la respuesta a la maestra.
11. Carlos está mandando los paquetes.
12. Yo quiero vender la plancha.

Test Yourself: 19) Rewrite the following sentences according to the model.

modelo: **Andrés está devolviéndonos los documentos.**

Andrés nos los está devolviendo.

1. Patricia sigue mandándote dinero.
2. Yo prefiero comprarme una prenda.
3. Ellos quieren enviarle a Ud. las cartas.
4. El cantante acaba de dedicarte la canción.
5. Los muchachos quieren pedirnos los juegos.

Test Yourself: 20) Complete the following exercise by attaching the object pronouns to the present participle.

1. Ella nos lo está preguntando ahora.
2. Carmen te la estaba cantando.
3. Yo los estaba ayudando.
4. Nosotros lo estábamos explicando.
5. Fernando te las estaba comprando.
6. Elena lo estaba molestando.

With Commands

Object pronouns are always placed after and attached to affirmative commands, and they always precede the negative commands.

Cómpramelo tú.
You buy it for me.

No me lo compres tú.
Don't you buy it for me.

Cómpralo tú.
You buy it.

No lo compres tú.
Don't you buy it.

Test Yourself: 21) Rewrite the following sentences in the negative form.

1. Cómpremelos.
2. Cómalo.
3. Pásamelo.
4. Dámelas.
5. Enséñenmelo.
6. Sírvamelos, señora Lorca.
7. Llévamela.
8. Pregúnteselo a ella.
9. Póngalos Ud. dondequiera.
10. Ayúdenme Uds.

Test Yourself: 22) Rewrite the following commands in the affirmative form.

1. No me lo pidan Uds.
2. No nos ayudes.
3. No lo prepare Ud.
4. No se la compre.
5. No me lo manden Uds.

6. No se lo diga.
7. No nos la compre Ud.
8. No nos lo sirvas tú.
9. No lo deje Ud.
10. No la ofrezcas tú.

Test Yourself: 23) Substitute the following direct or indirect objects with the appropriate object pronouns according to the model.

modelo: **Préstenme Uds. el manual.**

Préstenmelo Uds.

1. Llama el gato.
2. No comas caramelos en la clase.
3. Cánteme Ud. la canción.
4. No venda Ud. el perfume.
5. Sube tú el piano eléctrico.
6. No pague Ud. la cuenta al muchacho.
7. Prepárame el desayuno.
8. No quite Ud. las sillas.
9. Ponga Ud. los platos.
10. Véndeme la computadora.

First Person Plural (Let's)

The object pronoun is attached, in affirmative expressions, to the participle, and it precedes the verb when the sentence is negative.

In the case of reflexive verbs, the final –s of the verb is dropped with the pronouns **nos** and **se.**

Levantémonos.
Let's get up.

Vistámonos.
Let's get dressed.

Acostémonos.
Let's lay down.

Sentémonos.
Let's sit down.

Arrastrémoslo.
Let's drag it.

Llevémosla.
Let's take her.

No los arrastremos.
Let's not drag them.

No los llevemos.
Let's not take them.

Test Yourself: 24) Rewrite the following sentences in the affirmative according to the model.
 modelo: **No lo hagamos.**
 Hagámoslo.
1. No lo llevemos.
2. No se los mandemos.
3. No la vendamos.
4. No lo digamos.
5. No las ayudemos.

Test Yourself: 25) Rewrite the following sentences in the negative according to the model.
 modelo: **Arreglémoslo.**
 No lo arreglemos.
1. Mandémosla.
2. Borrémoslo.
3. Acostémonos.
4. Visitémosla.
5. Comprémoslos.

REFLEXIVE PRONOUNS

Reflexive pronouns are used when the action in the sentence is both executed and received by the subject.

No me llames.
Do not call me.

Ella nos llama.
She calls us.

Él se lava las manos.
He washes his hands.

Ellos se lavan las manos.
They wash their hands.

In Spanish, the reflexive pronouns are:

Singular	Plural
me	**nos**
te	**os**
se	**se**

Test Yourself: 26) Fill in the blanks with the appropriate reflexive pronoun.
1. _____ baño primero.
2. ¿Por qué no _____ acuesta ella?
3. _____ levantamos temprano.
4. Yo _____ peino el pelo.
5. Ellos _____ visten para salir esta noche.
6. Él _____ lava el cabello.
7. Nosotros _____ marchamos en seguida.
8. Ella _____ levanta tarde.
9. ¿A qué hora _____ vas a vestir?
10. Ellos _____ preparan con tiempo.

In Spanish, involuntary or unexpected actions are expressed in a sentence by using the reflexive pronoun along with the indirect object pronoun.

A Pedro se 1e perdió el dinero.
Peter lost the money.

A Maribel se le perdieron los zapatos.
Maribel lost her shoes.

Se te perdió la cartera.
You lost your wallet.

Se me perdieron las entradas.
I lost the tickets.

Test Yourself: 27) Complete the following sentences with the appropriate reflexive and indirect object pronouns.

1. A Fernando _____ cayó el vaso.
2. A mí _____ olvidaron las flores.
3. A Uds. _____ perdieron las llaves.
4. A papá _____ fue el conocimiento.
5. A ti _____ rompió el cuadro.
6. A las muchachas _____ escaparon los perros.
7. Al niño _____ cayó el reloj.
8. A nosotros _____ salían las lágrimas.
9. A María _____ olvidó la respuesta.
10. A ellos _____ notó cierta curiosidad.

PREPOSITIONAL PRONOUNS

Prepositional pronouns are pronouns that follow a preposition. Prepositional pronouns are the same as subject pronouns with the exception of **yo** and **tú,** which change to **mí** and **ti.**

The prepositional pronoun **mí** takes an accent (**ti** does not) to distinguish it from the possesive adjective **mi,** which does not carry an accent.

Patricia y Jorge están pensando en mí.
Patricia and Jorge are thinking about me

Ella quiere hablar con Ignacio.
She wants to talk to Ignacio

Yo vivo cerca de ellos.
I live close to them

Pablo está hablando de nosotros.
Pablo is talking about us

In Spanish, the prepositional pronouns are:

Singular		Plural	
mí	*me*	**nosotros(as)**	*us*
ti	*you*	**vosotros(as)**	*you*
Ud.	*you*	**Uds.**	*you*
él	*him, it*	**ellos**	*them*
ella	*her, it*	**ellas**	*them*
sí	*yourself, himself*	**sí**	*yourselves, herself, itself, themselves*

Prepositional pronouns **mí, ti,** and **sí** are the only prepositional pronouns that can be added to the word **con** (with) forming a contraction. The ending **–igo** must always be added.

conmigo **contigo** **consigo**

El quiere salir conmigo.
He wants to go out with me.

Nosotros queremos salir contigo.
We want to go out with you.

Test Yourself: 28) Complete the following sentences with the appropriate prepositional pronoun according to the model.

modelo: **Ellos quieren ir con ustedes.** (you, pl.)
1. Ella está pensando en _____. (them, m.)
2. Juan vive cerca de _____. (me)
3. ¿Por qué no se ríe Marta con _____? (you, informal)
4. Nosotros no hablamos de _____. (her)
5. Para _____ no era importante. (us, f.)
6. El maestro quiere hablar con _____. (him)
7. ¿Fuiste sin _____? (them, f.)
8. El carro es para _____. (you)
9. Los niños quieren salir sin _____. (you, pl.)
10. ¿Quién quiere salir con _____? (us, m.)

Test Yourself: 29) Complete the following exercise according to the model.

modelo: **Tú llegaste con ellas.**
Ellas llegaron contigo.
1. Yo me fui con el carnicero.
2. Tú te perdiste con Marta.
3. Tú lloraste con él.
4. Tú volviste con ellas.
5. Yo me mudé con Luis.
6. Yo lo discutí con mis padres.
7. Tú saliste con el muchacho.
8. Yo me fui con mis amigos.
9. Yo hablé con los maestros.
10. Yo salí con mi padre.

POSSESSIVE PRONOUNS

Possessive pronouns are used to replace a noun modified by a possessive adjective. The possessive pronoun must agree with the noun it replaces, and it must be accompanied by the appropriate definite article.

Tú tienes tu libro, no el suyo.
You have your book, not his / hers / yours (Ud.).

Carmen tiene su silla y la mía.
Carmen has her chair and mine.

Aquí tienes tus libros. ¿Dónde están los nuestros?
Here are your books. Where are ours?

Yo tengo mi carta pero no la suya.
I have my letter, but not his / hers / yours (Ud.).

Possessive Adjective	Possessive Pronouns
mi, mis	**el mío, la mía, los míos, las mías**
tu, tus	**el tuyo, la tuya, los tuyos, las tuyas**
su, sus	**el suyo, la suya, los suyos, las suyas**
nuestro, nuestra	**el nuestro, la nuestra**
nuestros, nuestras	**los nuestros, las nuestras**
vuestro, vuestra	**el vuestro, la vuestra**
vuestros, vuestras	**los vuestros, las vuestras**
su, sus	**el suyo, la suya, los suyos, las suyas**

In sentences in which the verb **ser** is used, the definite article is omitted.

Aquella maleta es tuya.
That suitcase is yours.

Aquellos libros son nuestros.
Those books are ours.

Esas sillas son suyas.
Those chairs are theirs.

Aquel boleto es mío.
That ticket is mine.

Often, the definite article is used with the verb **ser** to add emphasis.

¿Esa casa? Es la mía, no la tuya.
That house? It's mine, not yours.

Prepositional phrases are often used with pronouns like **el suyo, la suya**, and so on to clarify the meaning of the pronoun.

el de él	**la de él**	**los de él**	**las de él**
el de ella	**la de ella**	**los de ella**	**las de ella**
el de Ud.	**la de Ud.**	**los de Ud.**	**las de Ud.**

Test Yourself: 30) Rewrite the following sentences with the appropriate possessive pronoun.
Patricia busca sus zapatos y mis zapatos.
Patricia busca los suyos y los míos.
Patricia busca los nuestros.
1. Mi padre es más inteligente que tu padre.
2. Nuestras primas no están con tus primas.
3. He vendido mis entradas y tu entrada.
4. Tu ropa es más elegante que mi ropa.
5. Estos son mis cuadros. ¿Dónde están tus cuadros?
6. Pablo prefiere nuestra casa.
7. ¿Tiene Ud. su cartera o mi cartera?
8. Tengo tu pasaporte.
9. Yo tengo mis medias, pero Sara no encuentra sus medias.
10. Tu radio es mejor que mi radio.

DEMONSTRATIVE PRONOUNS

Demonstrative adjectives with their accompanying nouns can be substituted by demonstrative pronouns. These pronouns are differentiated from demonstrative adjectives by the accent marks placed on them.

Yo quiero ése.
I want that one there.

Pero me queda mejor éste.
But this one here fits me better.

Aunque aquél es el más cómodo.
Even though that one (over there) is the most comfortable one.

The demonstrative pronouns are:

Singular

éste	**ésta**	*this one (here)*
ése	**ésa**	*that one (there)*
aquél	**aquélla**	*that one (over there)*

Plural

éstos	**éstas**	*these (here)*
ésos	**ésas**	*those (there)*
aquéllos	**aquéllas**	*those (over there)*

Test Yourself: 31) Complete the following sentences with the appropriate demonstrative pronoun according to the model.

modelo: **El otro vestido tiene más brillo que éste (aquí).**

1. Estas casas son tan bonitas como _____ (allá).
2. Estos calamares son mejores que _____ (en la nevera).
3. De las tiendas donde he comprado prefiero _____ (donde compro ahora).
4. ¿Cuántos zapatos ? Me he puesto _____ (aquí), (que tiene Lorena) y _____ (que están allí).
5. Esta película es interesante pero prefiero _____ (que mira usted).
6. Esta computadora cuesta más que _____ (aquí).
7. Estas revistas son mejores que _____ (en la otra tienda).
8. El otro edificio tiene más apartamentos que _____ (aquí).

RELATIVE PRONOUNS

In many instances, relative pronouns are difficult for the English speaker because they are used in Spanish where they are often omitted in English. These pronouns are: what, who, whom, that, which, whose

La señora que habla ahora es cubana.
The lady that speaks now is Cuban.

El periódico que está en la cocina es el de la semana.
The newspaper that is in the kitchen is the weekly one.

Los muchachos que se van son de Bogotá.
The boys that are leaving are from Bogota.

La gente que visitamos el otro día son los dirigentes del partido.
The people that we visited the other day are the party leaders.

Que

Que is the relative pronoun used to introduce a clause that modifies a noun. **Que** can be used to replace either a person or a thing. The meaning of **que** can be *who, whom, what, which,* or *that.*

Las muchachas de que hablas son estudiantes.
The girls that you were talking about are students.

El libro con que estudian es nuevo.
The book with which you study is new.

When two simple sentences share a common element, it's possible to replace one of them with a relative pronoun to create one sentence.

Van a comprar el libro. El libro fue escrito por Octavio Paz.
They are going to buy the book. The book was written by Octavio Paz.

Van a comprar el libro que fue escrito por Octavio Paz.
They are going to buy the book that was written by Octavio Paz.

Test Yourself: 32) Combine both sentences into one single sentence by using the conjunction **que** according to the model.

modelo: **El profesor terminó la lección. Era difícil.**
La lección que terminó el profesor era difícil.

1. Tú tienes las respuestas. Las respuestas son largas.
2. Ella escribió la carta. La carta es interesante.
3. El señor entró. El señor es médico.
4. Olga compró los aretes. Los aretes eran largos.
5. Hicimos el viaje en el avión. El avión es nuevo.
6. Vimos los animales. Los animales eran raros.
7. La maestra es de Argentina. La maestra habla español.
8. Veo la película. La pelicula es cómica.
9. Tú acabaste la tarea. La tarea era fácil.
10. Los empleados son rubios. Los rubios son inteligentes.

Quien, Quienes

The pronoun **quien** is used when referring to a person. However, **quien** can be used only if it is preceded by a preposition or if it's used between two commas.

El médico con quien salí era colombiano.
The doctor with whom I went out, was Colombian

Jorge, quien sufre de alergias, está en el hospital.
Jorge, who suffers from allergies, is in the hospital.

If it doesn't follow these two rules, **quien** is not used. **Que** is used in place of **quien.**

Test Yourself: 33) Complete the following sentences with the appropriate pronoun using **que, quien,** or **quienes.**

El chico con quien hablo es de mi escuela.

1. La botella _____ está en el suelo es mía.
2. El profesor de _____ hablamos es español.
3. Los chicos con _____ bailé eran guapos.
4. La mesa en _____ comimos estaba sucia.
5. La maestra para _____ compré la blusa es buena.
6. Es un problema _____ no tiene solución.

7. La respuesta _____ ofreciste es la solución.
8. El muchacho con _____ hablaste era muy inteligente.
9. Las chicas con _____ te fuiste eran inteligentes.
10. Los pantalones _____ te probaste te quedan bien.

El Que, La Que, Los Que, Las Que

The pronouns **el que, la que, los que,** and **las que** can also be used as the subject or object of a clause, replacing either people or things. They can also replace **quien (quienes)** or **que** when the speaker wishes to be extremely specific or seeks emphasis. They can often be translated as "the one who" or "the ones who."

It is important to notice the agreement of the verb **ser.** In the case where present or future are used in the clause, present form of **ser** is used. When the preterite is used in the clause, the preterite of **ser** is used also.

El que llama no es mi hermano.
The one who calls is not my brother.

La que llamará es mi prima.
The one who will call is my cousin.

Los que llamaron fueron mis amigos.
The ones who called were my friends.

Las que llamaron fueron mis tías.
The ones who called were my aunts.

The pronouns **el cual, la cual, los cuales,** and **las cuales** can also be used to replace **el que, la que, los que,** and **las que.** However, they are not used frequently in everyday speech.

Test Yourself: 34) Rewrite the following sentences according to the model.
modelo: **Mi tía llamó anoche.**
La que llamó anoche fue mi tía.
 1. Federico me invitó a cenar en su casa.
 2. La señora Gómez ganará el premio.
 3. Mi hermano aprende a bailar.
 4. Los médicos resolvieron el problema.
 5. Don Juan habla con la señorita.
 6. El maestro pagará sus deudas.
 7. Mis abuelos estuvieron aquí.
 8. Mis primos llegan por avión.
 9. Las chicas irán al baile.
 10. El dueño llamó al inspector.

With Prepositions

The relative pronouns **el que, la que, los que, las que** are used after short prepositions such as **por, para, sin, de, en, con.** The pronouns **el cual, la cual, los cuales** and **las cuales** are used with longer prepositions (usually prepositions of more than one syllable) and also with compound prepositions such as **alrededor de, tras, hacia, durante, cerca de, a través de,** and **lejos de.**

La compañía para la que trabaja es muy buena.
The company for which he works is a very good one.

El hombre con el que salí anoche es muy interesante.
The man with whom I went out last night is very interesting.

El monumento, encima del cual dejaron la maleta, está en el Parque Central.
The monument on top of which they left the suitcase is in Central Park.

Las noches, durante las cuales no había calefacción, eran muy frías.
The nights during which there was no heat were very cold.

Test Yourself: 35) Complete the following sentences with the appropriate relative pronoun.
1. El río hacia _____ nos dirigimos es una belleza.
2. Los estigmas contra _____ luchamos eran ridículos.
3. La universidad detrás de _____ estudiamos es la mía.
4. Aquellos edificios alrededor de _____ estacionamos los coches son modernos.
5. La tienda enfrente de _____ está el museo es viejísima.
6. La casa detrás de _____ hicíeron una piscina era moderna.
7. Ese artista siempre regala los bolígrafos con _____ firma autógrafos.
8. La ventana por _____ entraron los ladrones era muy pequeña.
9. El problema a _____ se refiere, es el que discutimos ayer.
10. La fiesta para _____ nos vestimos tan elegantemente, fue cancelada.

Lo Que

Lo que is a neuter relative pronoun that is used to replace a general or abstract idea. Its function is similar to that of *what.*

No sé lo que quiere la niña.
I don't know what the little girl wants.

Lo que pensamos no importa.
What we think does not matter.

Test Yourself: 36) Arrange the following sentences so that they are introduced by **lo que.**
modelo: **Queremos otro carro.**
Lo que queremos es otro carro.
1. Me molesta su insolencia.
2. Dicen una mentira.
3. Necesitamos una mesa más grande.
4. Voy a comer la ensalada.
5. Quieren más comida.
6. Logramos ganar el partido.
7. Me sorprende su reacción.
8. Hace una injusticia.
9. Quiero escribir el libro.
10. Queremos cenar en nuestra casa.

Cuyo, Cuya, Cuyos, Cuyas

The relative pronouns **cuyo, cuya, cuyos,** and **cuyas** are equivalent to the English *whose,* and agree in gender and number with the noun it modifies.

El maestro cuya hija cenó conmigo es argentino.
The teacher whose daughter dined with me is Argentinian.

La pasajera cuyos boletos están aquí ya se fue.
The passenger whose tickets are here left already.

Test Yourself: 37) Complete the following sentences with the appropriate relative pronoun **cuyo, cuya, cuyos,** or **cuyas.**

1. El señor _____ maleta está en la puerta se va de viaje.
2. El muchacho _____ abuelo ganó la lotería es mi primo.
3. Me acuerdo de aquella casa _____ jardines eran tan bellos.
4. La casa _____ portal era de piedra es muy antigua.
5. Es un doctor _____ reputación es buenísima.
6. Los señores _____ cartas recibimos son abogados.
7. El gobernador _____ pensamientos están escritos en el libro, murió en 1908.

INTERROGATIVES

The following are the most commonly used interrogative words used to introduce a question. Note that all interrogative words carry an accent.

¿Qué?	*What?*	**¿A quién?**	*To whom?*
¿Quién?	*Who?*	**¿A quiénes?**	*To whom?*
¿Quiénes?	*Who?*	**¿Adónde?**	*To where?*
¿Cuándo?	*When?*	**¿Cuánto?**	*How much?*
¿Dónde?	*Where?*	**¿Cómo?**	*How?*

Note: Quien and quienes can also be preceded by the prepositions **de, con,** and **en.**

¿Qué quiere tu madre?
What does your mother want?

¿Cuándo se van?
When are you leaving?

¿Dónde está mi revista?
Where is my magazine?

¿A dónde fue mi amiga?
Where did my friend go to?

¿Cuánto cuesta el auto?
How much does the car cost?

¿Quién fue al baño?
Who went to the bathroom?

¿A quién visita usted?
Whom do you visit?

¿Cómo estaba el agua?
How was the water?

In Spanish, the subject and the verbs are frequently inverted in interrogative sentences.

Test Yourself: 38) Rewrite the following sentences by using interrogative pronouns according to the model. Do not repeat an interrogative pronoun twice in the same sentence.

modelo: **El médico no trabaja mañana.**

¿Quién no trabaja mañana?

1. Yo iré a Francia mañana en avión.
2. Yo iré a Francia mañana en avión.
3. Yo iré a Francia mañana en avión.
4. El pan está caliente.
5. El pan está caliente.
6. Ayer estaba María en mi casa.
7. Ayer estaba María en mi casa.
8. La escuela va de excursión en octubre.
9. La escuela va de excursión en octubre.
10. La escuela va de excursión en octubre en autobús.
11. El vestido cuesta treinta dólares,
12. El vestido cuesta treinta dólares.

Test Yourself: 39) Complete the following sentences with the appropriate interrogative pronoun.

1. Yo veo la película. ¿_____ ves tú?
2. Ellas van a la ciudad a comprar. ¿_____ van a comprar ellas?
3. Nosotros nos vamos hoy. ¿_____ se van ellos?
4. La maestra habla con el estudiante. ¿Con _____ habla la maestra?
5. Pablo nada en el río. ¿_____ nada Pablo?
6. Uds. hacen un viaje a Nueva York, ¿_____ hacen un viaje?
7. Ella tiene el libro. ¿_____ tiene ella?
8. El hospital es muy limpio. ¿_____ es el hospital?
9. El profesor le habla al estudiante. ¿_____ le habla el profesor?
10. El gorro me cuesta veinte euros, ¿_____ te cuesta el gorro?
11. El muchacho me habla. ¿_____ me habla?
12. Aurora vuelve a las tres. ¿_____ vuelve Aurora ?

Cuál, Cuáles

Cuál (cuáles) is the interrogative word equivalent to the English *which* or *which one (which, which ones).*

¿Cuál de los colores te queda mejor?
Which color looks best on you?

¿Cuál te queda mejor?
Which one looks best on you?

¿Cuáles de los libros son más interesantes?
Which of the books are most interesting?

¿Cuáles son más interesantes?
Which ones are more interesting?

Test Yourself: 40) Complete the following sentences with the correct interrogative **cuál** or **cuáles.**

1. ¿_____ son los zapatos que compraron?
2. ¿_____ es la mejor película que has visto?
3. ¿_____ de los maestros es el mejor?
4. Yo tengo tres vestidos. ¿_____ de los tres me pongo?
5. ¿_____ de las chicas es la más bonita?
6. ¿_____ es el peinado más bonito de los tres?

Cuál versus Qué

Both **cuál** and **qué** mean *what* in English. Often, many English-speaking students have difficulty distinguishing between these two interrogative pronouns when asking a question with the verb *to be*. In Spanish, **ser** is the most commonly used verb with **cuál.** The interrogative pronoun **qué** is used only with **ser** when the speaker is asking for a definition. **Cuál** is used when there is some kind of choice to be made.

¿Qué es el mar?
What is the ocean?

El mar es un cuerpo de agua.
The ocean is a body of water.

¿Cuáles son los países que tienen acceso al Pacífico?
Which countries have access to the Pacific?

¿Qué es esto?
What is this?

Esto es un coche.
This is a car.

Test Yourself: 41) Complete the following exercise with the interrogative pronoun: **que, cuál,** or **cuáles.**

1. ¿____ es la capital de Perú? Lima.
2. ¿____ es la respuesta? Falso.
3. ¿____ es Filadelfia? Una ciudad en Pennsylvania.
4. ¿____ es la fecha de nacimiento? El día en que uno nace.
5. ¿____ es la fecha de tu nacimiento? El 4 de noviembre.
6. ¿____ es un profesor? Cualquiera que trabaje en una universidad.
7. ¿____ es el desayuno? El desayuno es la primera comida del día.

Test Yourself Answers

1)
1. Yo
2. Nosotros
3. Ella
4. Ellas
5. tú
6. usted
7. él
8. Nosotras
9. Usted
10. vosotros
11. Yo
12. Él
13. Nosotros

2)
1. Ella vive en San Juan.
2. Nosotros vamos a cenar.
3. ¿Cómo está usted?
4. Ellos son graduados de la universidad.
5. ¿Dónde juega él tenis?

3)
1. nos
2. te
3. me
4. nos
5. te
6. me
7. nos
8. me
9. te
10. nos

4)
1. La maestra los recoge.
2. Juan lo ve.
3. Yo lo compré.
4. Nosotros las tenemos.
5. ¿Usted la quiere?
6. Ellos los miran.
7. La madre la recoge.
8. Tomás lo ve.
9. Yo los quiero.
10. ¿Ustedes lo quieren?

5)
1. la
2. lo
3. lo
4. las
5. la
6. las
7. lo
8. lo
9. los
10. la

6)
1. Sí, los vi.
2. Sí, las vieron; Sí, las vimos.
3. Sí, la invitamos a cenar.
4. Yo lo pinté.
5. Sí, la voy a ver.
6. Sí, lo ayudé.
7. Sí, los quiero comprar.
8. Sí, la vamos a ver.
9. Sí, las preparan.
10. Sí, lo compraré.

7)
1. Cómprala.
2. Llévenlos.
3. Dámelo.
4. Cuélgala.
5. Ábrelo.
6. Míralos.
7. Véndelas.
8. Termínalo.
9. Hazla.
10. No las escribas.

8)
1. le
2. le
3. les
4. le
5. les
6. le
7. le
8. les
9. les
10. les

9)
1. las
2. le
3. les
4. lo
5. las
6. lo
7. los
8. la
9. lo
10. le

10)
1. me
2. les
3. le
4. te
5. nos
6. les
7. me
8. le
9. nos
10. te

11)
1. A ustedes les asustan los tiburones.
2. A mí me gusta la leche.
3. A Raúl le faltan las medicinas.
4. A nosotros nos enoja el profesor.

5. A ti te sorprenden las campanas.

6. A Carmen le hace falta la secadora.

7. A ellos no les enfurece el error.

8. A usted le gustan los mariscos.

9. A mí me falta el pan.

10. A nosotros nos molestan las abejas.

12) 1. Él nos la enseñó.

2. ¿Quién te las compró?

3. Luis me lo dio.

4. Ellos te lo devolvieron.

5. ¿No me las dieron?

6. Ella nos lo regaló.

7. Usted me la explicó bien.

8. Patricia nos las mandó.

9. Miguel te la preparó.

10. Ellas me los cambiaron.

13) 1. Pepe se las pidió.

2. El jefe se la dio.

3. La lavandera se la lavó.

4. Yo se lo compré.

5. Carmen se las enseñó.

6. El maestro se la explicó.

7. La madre se lo mandó.

8. Nosotros se la regalamos.

9. Marcos se la cuenta.

10. La costurera se los cosió.

11. Ella se lo vendió.

12. Olga se lo pintó.

14) 1. Marta las ha vestido.

2. Yo lo vi ayer.

3. Ella la contó.

4. Tú no lo has leído.

5. Usted se las dio.

6. Rodolfo la conoce.

7. Él lo ha terminado.

8. Ellos no nos la aceptaron.

9. Pilar me la dio.

10. Ustedes me lo mandaron.

15) 1. Marisa te lo va a decir.

2. Yo se la quiero mandar a usted.

3. Ellos nos las prefieren comprar.

4. El pintor los desea mostrar.

5. Felipe me lo quería explicar.

6. Mi abuela nos la va a enviar.

16) 1. La cantante quiso dedicármela.

2. Máximo no deseó explicártelo.

3. Ellos van a regalármelos.

4. Ustedes quieren enviárnoslas.

5. Yo deseo mandártelos.

6. El carnicero quería picármela.

17) 1. Yo se lo quiero enseñar.
 Yo quiero enseñárselo.

2. Ustedes los desean regalar.
 Ustedes desean regalarlos.

3. Patricia nos lo quiere pedir.
 Patricia quiere pedírnoslo.

4. Ellos nos la pueden dar.
 Ellos pueden dárnosla.

5. Adolfo se las quiere mostrar.
 Adolfo quiere mostrárselas.

6. Lo deseamos renovar.
 Deseamos renovarlo.

7. La maestra nos los prefiere enseñar.
 La maestra prefiere enseñárnoslos.

8. Se lo van a pedir.
 Van a pedírselo.

9. Ustedes me los van a devolver.
 Ustedes van a devolvérmelos.

10. El jefe las quiere dar.
 El jefe quiere darlas.

18) 1. La maestra está buscándola.

2. Uds. van a devolvérselo.

3. Luis está atendiéndolo.

4. Los empleados se lo garantizan.

5. El padre está regañándolos.

6. La operadora quiere saberlo.

7. Olga está apuntándola.

8. Él quiere comprarlos.

9. Ellos están discutiéndolos.

10. Él acaba de pedírsela.

11. Carlos está mandándolos.

12. Yo quiero venderla.

19) 1. Patricia te lo sigue mandando.

2. Yo me la prefiero comprar.

3. Ellos se las quieren enviar.

4. El cantante te la acaba de dedicar.

5. Los muchachos nos los quieren pedir.

20) 1. Ella está preguntándonoslo ahora.

2. Carmen estaba cantándotela.

3. Yo estaba ayudándolos.

4. Nosotros estábamos explicándolo.

5. Fernando estaba comprándotelas.

6. Elena estaba molestándolo.

21) 1. No me los compre.

2. No lo coma

3. No me lo pases.

4. No me las des.

5. No me lo enseñen .

6. No me los sirva, señora Lorca.

7. No me la lleves.

8. No se lo pregunte a ella.

9. No los ponga Ud. dondequiera.

10. No me ayuden Uds.

22) 1. Pídanmelo Uds.

2. Ayúdanos.

3. Prepárelo Ud.

4. Cómpresela.

5. Mándenmelo Uds.

6. Dígaselo.

7. Cómprenosla Ud.

8. Sírvemelo tú.

9. Déjelo Ud.

10. Ofrécela tú.

23) 1. Llámalo.

2. No los comas en la clase.

3. Cántemela usted.

4. No lo venda Ud.

5. Súbelo tú.

6. No se la pague usted.

7. Prepáramelo.

8. No las quite Ud.

9. Póngalos Ud.

10. Véndemela.

24) 1. Llevémoslo.

2. Mandémoselos.

3. Vendámosla.

4. Digámoslo.

5. Ayudémoslas.

25) 1. No la mandemos.

2. No lo borremos.

3. No nos acostemos.

4. No la visitemos.

5. No los compremos.

26) 1. Me 6. se

2. se 7. nos

3. Nos 8. se

4. me 9. te

5. se 10. se

27) 1. se le 6. se les

2. se me 7. se le

3. se les 8. se nos

4. se le 9. se le

5. se te 10. se les

28) 1. ellos

2. mí

3. tigo

4. ella

5. nosotras

6. él

7. ellas

8. ti, usted

9. vosotros; ustedes

10. nosotros.

29)
1. El carnicero se fue conmigo.

2. Marta se perdió contigo.

3. El lloró contigo.

4. Ellas volvieron contigo.

5. Luis se mudó conmigo.

6. Mis padres lo discutieron conmigo.

7. El muchacho salió contigo.

8. Mis amigos se fueron conmigo.

9. Los maestros hablaron conmigo.

10. Mi padre salió conmigo.

30)
1. El mío es más inteligente que el tuyo.

2. Nuestras primas no están con las tuyas.

3. He vendido las mías y la tuya.
 He vendido las nuestras.

4. Tu ropa es más elegante que la mía.

5. Estos son los míos. ¿Dónde están los tuyos?

6. Pablo prefiere la nuestra.

7. ¿Tiene Ud. la suya o la mía?

8. Tengo el tuyo.

9. Yo tengo las mías, pero Sara no encuentra las suyas.

10. El tuyo es mejor que el mío.
 La tuya es mejor que la mía.

31)
1. aquéllas
2. ésos
3. ésta
4. éstos; ésos
5. ésa
6. ésta
7. aquéllas
8. éste

32)
1. Las respuestas que tú tienes son largas.

2. La carta que ella escribió es interesante.

3. El señor que entró es médico.

4. Los aretes que Olga compró eran largos.

5. Hicimos el viaje en un avión que es nuevo.

6. Los animales que vimos eran raros.

7. La maestra que habla español es de Argentina.

8. La película que veo es cómica.

9. La tarea que tú acabaste era fácil.

10. Los rubios que son empleados son inteligentes.

33)
1. que
2. quien
3. quienes
4. que
5. quien
6. que
7. que
8. quien
9. quienes
10. que

34)
1. El que me invitó a cenar en su casa fue Federico.

2. La que ganará el premio será la señora Gómez.

3. El que aprende a bailar es mi hermano.

4. Los que resolvieron el problema fueron los médicos.

5. El que habla con la señorita es don Juan.

6. El que pagará sus deudas será el maestro.

7. Los que estuvieron aquí fueron mis abuelos.

8. Los que llegan en avión son mis primos.

9. Las que irán al baile serán las chicas.

10. El que llamó al inspector fue el dueño.

35)
1. el cual
2. los cuales
3. la cual
4. los cuales
5. la cual
6. la cual
7. los que
8. la que
9. el que
10. la que

36)
1. Lo que me molesta es su insolencia.

2. Lo que dicen es una mentira.

3. Lo que necesitamos es una mesa más grande.

4. Lo que voy a comer es la ensalada.

5. Lo que quieren es más comida.

6. Lo que logramos ganar es el partido.

7. Lo que me sorprende es su reacción.

8. Lo que hace es una injusticia.

9. Lo que quiero escribir es el libro.

10. Lo que queremos es cenar en nuestra casa.

37)
1.	cuya	5.	cuya
2.	cuyo	6.	cuyas
3.	cuyos	7.	cuyos
4.	cuyo		

38)
1. ¿Quién irá a Francia mañana en avión?

2. ¿Adónde irá mañana en avión?

3. ¿Cómo irá a Francia mañana?

4. ¿Como está el pan?

5. ¿Qué está caliente?

6. ¿Cuándo estaba María en mi casa?

7. ¿Quién estaba en mi casa ayer?

8. ¿Adónde va la escuela en octubre?

9. ¿Cuándo va la escuela de excursión?

10. ¿Cómo va la escuela de excursión en octubre?

11. ¿Qué cuesta treinta dólares?

12. ¿Cuánto cuesta el vestido?

39)
1.	Qué	7.	Qué
2.	Qué	8.	Cómo
3.	Cuándo	9.	A quién
4.	quién	10.	Cuánto
5.	Dónde	11.	Quién
6.	Adónde	12.	Cuándo

40)
1.	Cuáles	4.	Cuál
2.	Cuál	5.	Cuál
3.	Cuál	6.	Cuál

41)
1.	Cuál	5.	Cuál
2.	Cuál	6.	Qué
3.	Qué	7.	Qué
4.	Qué		

Adverbs

To form adverbs in Spanish, the suffix **–mente** is added to the feminine singular form of the adjective. Remember that adjectives ending in **–e** (such as **dulce** or **firme**) are the same in the masculine or the feminine, so you simply add the **–mente** ending:

Adjective	Adverb
adecuado	**adecuadamente** *(adequately)*
cariñoso	**cariñosamente** *(tenderly)*
constante	**constantemente** *(constantly)*
dulce	**dulcemente** *(sweetly)*
feliz	**felizmente** *(happily)*
inteligente	**inteligentemente** *(intelligently)*
intencional	**intencionalmente** *(intentionally)*
rápido	**rápidamente** *(quickly)*

David se vistió rápidamente.
David dressed quickly.

Ludmila abrazó dulcemente a su mejor amiga.
Ludmila gently embraced her best friend.

Felipe ama profundamente a su novia.
Philip deeply loves his girlfriend.

Paco fue llevado inmediatamente al hospital.
Paco was taken immediately to the hospital.

Miguel condujo lentamente el coche.
Michael slowly drove the car.

Adjectives that end in a consonant (such as **difícil** or **feliz**) also attach the ending **–mente.** However, adjectives that end in **–dor, –an,** and **–on** form the feminine by adding an **–a** and then the **–mente.**

Note: Words with accents maintain those accents in the same place when **–mente** is added.

Test Yourself: 1) Change the following adjectives into adverbs.

1. intencional	4. normal	7. honorable	10. sincero
2. tradicional	5. estupendo	8. terrible	11. libre
3. natural	6. fabuloso	9. concreto	12. habitual

| 13. cortés | 15. verdadero | 17. bello | 19. superficial |
| 14. diario | 16. astuto | 18. inmediato | 20. lento |

If two adverbs ending in **–mente** are used, the first one doesn't use the ending **–mente** but it does change to the feminine adjective.

La mamá abrazó a su bebé cariñosa y dulcemente.
The mother hugged her baby tenderly and sweetly.

To form an adverbial phrase, place the word **con** *(with)* before a noun:

fácilmente	*easily*	**con facilidad**	*with ease*
rápidamente	*quickly*	**con rapidez**	*with speed*
cuidadosamente	*carefully*	**con cuidado**	*with care*
claramente	*clearly*	**con claridad**	*with clarity*
violentamente	*violently*	**con violencia**	*with violence*
hospitalariamente	*hospitably*	**con hospitalidad**	*with hospitality*
desesperadamente	*desperately*	**con desesperación**	*with desperation*
curiosamente	*curiously*	**con curiosidad**	*with curiosity*
frecuentemente	*frequently*	**con frecuencia**	*with frequency*
cortésmente	*courteously*	**con cortesía**	*with courtesy*

Test Yourself: 2) Complete the following sentences with the correct adverbial phrase of the given adverbs.

1. Elena habla por teléfono _____ (frecuentemente)
2. Pablo abrió la puerta _____ (cortésmente)
3. Mónica se fijó en el pelo de su amiga _____ (envidiosamente)
4. Verónica miró la cara de su novio _____ (desesperadamente)
5. Vivian escuchó la conversación _____ (atentamente)
6. Mauricio se asusta _____ (fácilmente)
7. Lucía levantó el cristal _____ (cuidadosamente)
8. Los boxeadores se peleaban _____ (violentamente)
9. Cuando tengo prisa hago las cosas _____ (rápidamente)
10. Ignacio cree que le pegaste _____ (intencionalmente)

By combining nouns, adjectives, verbs, and adverbs with prepositions, adverbial expressions can be formed.

The following is a list of commonly used adverbial expressions:

a menudo	*often*	**dentro de poco**	*in a little while*
a pesar de	*in spite of*	**en cualquier caso**	*in any case*
a solas	*alone*	**en la vida**	*in life*
al amanecer	*at daybreak*	**en otra parte**	*elsewhere*
al cabo	*in the end*	**en todas partes**	*everywhere*
al final	*in the end*	**mientras tanto**	*meanwhile*
al menos	*at least*	**por desgracia**	*unfortunately*
de memoria	*by heart*	**por escrito**	*in writing*
de ninguna manera	*not in any way*	**por fin**	*at last*
de noche	*at night*	**por lo visto**	*apparently*
de repente	*suddenly*	**sin duda**	*undoubtedly*
de verdad	*really*	**sin embargo**	*nevertheless*

Test Yourself: 3) Form sentences with the following adverbial expressions.
1. dentro de poco
2. en cualquier caso
3. a pesar de
4. en todas partes
5. por fin
6. por desgracia
7. sin embargo
8. de repente
9. por lo visto
10. de noche

Test Yourself: 4) Complete the following sentences by converting the words in parentheses into adverbs.
1. El sol salió _____. (lento)
2. Leah se marchó a España _____. (alegre)
3. El barco se hundía _____. (rápido)
4. Las amigas fueron a la playa _____. (ansioso)
5. Miguel Angel se murió, _____. (desafortunado)
6. El anillo desapareció _____. (misterioso)
7. La casa estaba adornada _____. (estupendo)
8. Pedro siempre hace sus diseños _____. (hábil)

Test Yourself: 5) Replace the adverbial phrase with adverbs.
1. Siempre hay que tratar a los amigos con hospitalidad.
2. Sacó las cuentas con error.
3. Bernarda Alba no miró a la mendiga con piedad.
4. Las madres cuidan a los hijos con cariño.
5. Un maestro tiene que explicar los temas con claridad.
6. Para ser amigos tenemos que comunicarnos con sinceridad.
7. Cecilia miró al asesino con curiosidad.
8. Sergio aceptó el regalo con alegría.

Test Yourself: 6) Complete the following paragraph with the appropriate Spanish adverbial expressions.

¡Nunca iré al cine _____ 1. (alone)! Tan pronto como llegué a mi asiento vino un hombre alto, flaco, calvo, y muy extraño que empezó a hablar conmigo. _____ 2. (In a little while) decidí cambiarme de asiento. No quería perderme la película. _____, 3. (Nevertheless) cuando giré para ver si el hombre me había seguido me di cuenta de que _____ 4. (everywhere) había hombres altos, flacos, y calvos. _____ 5. (In spite of) mi deseo de ver la película, empecé a correr hacia la puerta de salida. _____, 6. (Meanwhile) todos los hombres extraños me seguían. _____ 7. (Unfortunately) cuando salí a la calle ya era _____ 8. (at night) y había poca gente. _____ 9. (Finally) llegué a mi casa sano y salvo. _____, 10. (At daybreak) me di cuenta de que todo había sido una pesadilla. _____, 11. (In any case) no volveré al cine sin buena compañía.

Test Yourself: 7) Identify the adverbial expressions in the following sentences.

1. No salgan de ninguna manera.
2. Sin duda alguna, sé que te gustará el chocolate.
3. Mañana, a primera hora iremos al médico.
4. Por lo visto, Pepita está preparada para el viaje.
5. En la vida, he visto otra cosa semejante.
6. Al fin y al cabo sólo me quedan dos centavos.
7. Me sé todo el libro de memoria.
8. En cualquier caso estoy contento.
9. De repente Julio gritó.
10. Mientras tanto, yo prepararé la comida.

Test Yourself Answers

1)
1. **intencionalmente** *intentionally*
2. **tradicionalmente** *traditionally*
3. **naturalmente** *naturally*
4. **normalmente** *normally*
5. **estupendamente** *stupendously*
6. **fabulosamente** *fabulously*
7. **honorablemente** *honorably*
8. **terriblemente** *terribly*
9. **concretamente** *concretely*
10. **sinceramente** *sincerely*
11. **libremente** *freely*
12. **habitualmente** *habitually*
13. **cortésmente** *courteously*
14. **diariamente** *daily*
15. **verdaderamente** *truly*
16. **astutamente** *wisely*
17. **bellamente** *beautifully*
18. **inmediatamente** *immediately*
19. **superficialmente** *superficially*
20. **lentamente** *slowly*

2)
1. con frecuencia
2. con cortesía
3. con envidia
4. con desesperación
5. con atención
6. con facilidad
7. con cuidado
8. con violencia
9. con rapidez
10. con intención

3)
1. Dentro de poco será de noche.
2. En cualquier caso estudiaré mucho para el examen.
3. A pesar de tus notas pasarás el curso.
4. ¡Hay hormigas en todas partes de la cocina!
5. Por fin iremos a Suramérica de vacaciones.
6. Por desgracia mi profesor no puede ayudarme en el examen.
7. Sin embargo, iremos a la fiesta.
8. De repente vimos a un hombre salir del edificio corriendo
9. Por lo visto no has aprendido la lección.
10. De noche salen muchas estrellas.

4)
1. lentamente
2. alegremente
3. rápidamente
4. ansiosamente
5. desafortunadamente
6. misteriosamente
7. estupendamente
8. hábilmente

5)
1. hospitalariamente
2. erróneamente
3. piadosamente
4. cariñosamente
5. claramente
6. sinceramente
7. curiosamente
8. alegremente

6)
1. a solas
2. Dentro de poco
3. Sin embargo
4. en todas partes
5. A pesar de
6. Mientras tanto
7. Por desgracia
8. de noche
9. Por fin
10. Al amanecer
11. En cualquier caso

7)
1. De ninguna manera
2. Sin duda alguna
3. a primera hora
4. Por lo visto
5. En la vida
6. Al fin y al cabo
7. de memoria
8. En cualquier caso
9. De repente
10. Mientras tanto

Negatives

In Spanish, sentences can usually be negated with the word **no.** This word is placed before the conjugated verb that is being negated.

Pepe no desea ir a la escuela.
Joseph does not want to go to school.

Yo no dormí bien anoche.
I did not sleep well last night.

Nosotros no tenemos dinero.
We do not have money.

La función no empezó a tiempo.
The show did not start on time.

Trabajé mucho ayer.
I worked a lot yesterday.

No trabajé mucho ayer.
I did not work a lot yesterday.

Quiero ir de compras.
I want to go shopping.

No quiero ir de compras.
I do not want to go shopping.

Whenever object pronouns are involved in a sentence, the negative word **no** will be placed immediately before them.

María lo tiene.
Mary has it.

María no lo tiene.
Mary does not have it.

Ellos se lo dieron.
They gave it to him.

Ellos no se lo dieron.
They didn't give it to him.

Test Yourself: 1) Rewrite the following sentences in the negative.

1. Ricardo es simpático.
2. Tengo que ir a Guadalajara.
3. Me gusta el color de tu chaqueta.
4. Ella llegó temprano.
5. Se lo bebe con su desayuno.
6. Los niños están jugando.
7. Le gusta charlar por teléfono.
8. El profesor nos enseñó mucho.
9. Hemos estudiado para el examen de mañana.
10. Lo han traído para ella.

In addition to **no,** the following are the principal negatives in Spanish:

jamás	*never, not ever*
nada	*nothing, not anything*
nadie	*no one, nobody, not anyone*
ni . . . ni	*neither . . . nor, not . . . nor*
ninguno	*no one, none, not any*
nunca	*never, not ever*
tampoco	*neither, not either*

Note: The negative words **nadie** and **ninguno** (when referring to a person) must be preceded with a personal **a** when it is the object in a sentence.

Sentences in Spanish may contain more than one negative. When used alone, the negative simply precedes the verb, but when used with **no,** the second negative follows the verb, while the **no** comes before.

Ana nunca lo ha visto.
Ana has never seen it.

Ana no lo ha visto nunca.
Ana has not ever seen it.

Note that **no** can thus be combined with other negatives (such as **nada, ni, ninguno, nunca,** or **jamás**), which follow it and work to strengthen the negation.

Pablo no quiso ayuda.
Paul didn't want help.

Pablo nunca quiso ninguna ayuda de nadie.
Paul never wanted any help from anyone.

When used alone, **ni** means *nor,* and it can be used to join negative sentences, just as **y** joins affirmative ones. When repeated, it means *neither . . . nor* or *not . . . nor,* and like other negatives, it needs a **no** to come before the verb whenever its phrase follows the verb.

Ellos no han llegado, ni vendrá nadie.
They have not arrived, nor will anyone come.

No necesito ni dinero ni fama.
I need neither money nor fame.

Also, note that **alguno** can take the place of its opposite negative **ninguno,** when in connection with a noun, such that the new construction is still negative, and even more forceful. **Alguno** will follow the noun, unlike **ninguno,** which will precede it.

No he recibido ninguna carta de ellos.

No he recibido carta alguna de ellos.
I have not received any letters from them.

Realize that **ninguno** has both masculine (**ninguno**) and feminine (**ninguna**) forms, and that it becomes **ningún** when it is an adjective modifying a masculine noun coming right after it. It is not used in the plural form, because it means *not even one.*

Ramón no oyó ningún ruido.
Raymond didn't hear any noise.

Test Yourself: 2) Use one of the following negatives to complete the sentences. More than one answer might be possible.

no	nada	nunca	ninguno
ni	nadie	jamás	

1. _____ lo conoce como yo.
2. _____ recibió _____ regalo hoy, aunque recibió muchos ayer.
3. No tengo _____ que darte.
4. _____ en nuestra familia ha tenido que llevar anteojos.
5. El ciego no pudo ver a _____.
6. No le gusta _____ el helado _____ la torta.
7. ¿_____ has visto a ese hombre?
8. Víctor _____ tiene _____ libro de la biblioteca.
9. ¿ _____ ha escuchado esa canción?
10. En la clase, _____ estudiante hizo su tarea.

Test Yourself: 3) Write alternate forms of the following sentences, making them even more emphatic.

1. Nada veo.
2. José nunca estuvo allí.
3. Ni lápiz ni pluma tuvo.
4. ¿Se ha encontrado con un hombre más codicioso?
5. Anita jamás bebió una taza de café.
6. Desafortunadamente, ninguna palabra comprendí.
7. Nadie ha llegado.
8. Ni cantar ni bailar me gusta.
9. Aunque tenía mucha hambre, nada comí.
10. A ninguna persona conozco en la habitación.

Tampoco is the opposite negative of **también,** and it can either precede the verb alone or follow it, thereby needing **no** or **ni** to come before the verb.

Tampoco quería ir al cine con ellos.
I didn't want to go to the movies with them either.

Cuando yo no caminaba, el perro no caminaba tampoco.
When I didn't walk, the dog didn't walk either.

Test Yourself: 4) Use **tampoco** to negate the following sentences.
1. Miguel también recibe un cien en el examen.
2. Queremos ir también.
3. Catarina también tiene un gato.
4. La conozco a ella también.
5. Y yo estudio también.

Although **pero** and **sino** mean *but,* **pero** can be used in both positive and negative statements. In negative statements, **pero** means *however.* **Sino** is used only after negative statements and can basically be interpreted as *but rather.* **Sino** works to signal a contrast or contradiction between the components of a sentence.

> **Juan está cansado, pero todavía va a asistir a la fiesta.**
> *John is tired, but is still going to attend the party.*

> **Él no es de Chile, sino de la Argentina.**
> *He is not from Chile, but Argentina.*

Sino que replaces **sino** when there is a conjugated verb immediately following it:

> **Margarita no compró el coche, sino que lo alquiló.**
> *Margarita didn't buy the car, but rather rented it.*

Test Yourself: 5) Complete the following exercise with either **pero, sino,** or **sino que.**
1. La chica no tiene dieciocho años, _____ dieciséis.
2. No es tarde, _____ va a acostarse.
3. Ahora no quiero comer, _____ dormir.
4. El bebé no habla, _____ llora.
5. Su nombre no es Martín, _____ Luis.
6. Los dos están enamorados, _____ no van a casarse.
7. No estoy triste, _____ aburrido.
8. No miraré la televisión, _____ haré mi tarea.
9. Ella no es gorda, _____ no es flaca tampoco.
10. Carlos no lo trajo, _____ lo dejó en casa.

When placed after comparatives, negatives such as **nada, ni, ninguno, nunca,** and **jamás** can be used to express affirmative ideas.

> **Tú cantas mejor que nadie.**
> *You sing better than anyone.*

> **El niño quería tener un perro más que nada.**
> *The boy wanted to have a dog more than anything.*

The following are special negative expressions:

de ningún modo	*by no means*
de ninguna manera	*by no means*
ni siquiera	*not even*
no importa	*it does not matter*
todavía no	*not yet*
ya no	*no longer*

Finally, in using any negatives, remember that their placement is very important, and a misplaced **no** can easily change the meaning of a sentence.

Adela no sabe que Elena está en Europa.
Adela doesn't know that Elena is in Europe.

Adela sabe que Elena no está en Europa.
Adela knows that Elena is not in Europe.

Test Yourself: 6) Answer the following questions in the negative.
1. ¿Conoció a la familia de Isabel?
2. ¿Puede recordar el título del libro?
3. ¿Se ha divertido con Leonardo?
4. ¿Lo perdió?
5. ¿Lo han traído?
6. ¿Le gusta despertarse temprano?
7. ¿Hay alguien en la casa?
8. ¿Los ha lavado?
9. ¿Quiere comprar algo?
10. ¿Le da la muñeca a la niña?

Test Yourself: 7) Translate the following into Spanish.
1. We are not ready for the test.
2. Do not give it to her.
3. Can you not do it for me?
4. I did not bring anything.
5. That dog never barks at anyone.
6. There was no furniture in the room.
7. Her boyfriend brought neither candy nor flowers—only himself.
8. She wanted fame more than anything.
9. The weather is not good today either.
10. I do not have children, and do not need any.
11. That artist paints better than anyone.
12. Mary does not like to swim either.

Test Yourself: 8) Complete the following sentences by using either **pero, sino,** or **sino que.**
1. Mi color favorito no es el azul, _____ el verde.
2. Quiero ir contigo, _____ tengo que hacer este trabajo.
3. El gato no se queda en la casa, _____ sale por la ventana.
4. El marzapán no es una forma de pan, _____ un dulce.
5. El maestro no está castigando a un estudiante, _____ a todos en general.
6. Nosotros no cantaríamos, _____ bailaríamos.
7. A mí, no me gusta limpiar mi cuarto, _____ dormir en él.
8. No le gusta viajar por autobús, _____ por subterráneo.
9. Los niños no durmieron, _____ corrieron por todos lados.
10. Tú lo has perdonado, _____ no has olvidado lo que pasó.

Test Yourself: 9) Match the following expressions with their meanings.

1. de ninguna manera
2. todavía no
3. ni siquiera
4. no importa
5. ya no

a. it doesn't matter
b. no longer
c. not yet
d. by no means
e. not now
f. not even

Test Yourself: 10) Answer the following questions using one of the negative expressions.

1. ¿Todavía deseas pedir prestado algún libro?
2. ¿Ya has hablado con ella?
3. ¿Vas a reírte de mí?
4. ¿Te importan mucho las notas a ti?
5. ¿Vas a reprenderme también a mí?

Test Yourself Answers

1)
1. Ricardo no es simpático.
2. No tengo que ir a Guadalajara.
3. No me gusta el color de tu chaqueta.
4. Ella no llegó temprano.
5. No se lo bebe con su desayuno.
6. Los niños no están jugando.
7. No le gusta charlar por teléfono.
8. El profesor no nos enseñó mucho.
9. No hemos estudiado para el examen de mañana.
10. No lo han traído para ella.

2)
1. No
2. No; ningún
3. nada
4. Nadie
5. nadie
6. ni; ni
7. nunca/no
8. no; ningún
9. Nunca
10. ningún

3)
1. No veo nada.
2. Jose no estuvo nunca allí.
3. No tuvo ni lápiz ni pluma.
4. ¿No se han encontrado con ningún hombre más codicioso?
5. Anita no bebió jamás una taza de café.
6. Desafortunadamente, no comprendí ninguna palabra.
7. No ha llegado nadie.
8. No me gusta ni cantar ni bailar.
9. Aunque tenía mucha hambre, no comí nada.
10. No conozco a ninguna persona en la habitación.

4)
1. Miguel tampoco recibe un cien en el examen.
2. Tampoco queremos ir.
 No queremos ir tampoco.
3. Catarina tampoco tiene un gato.
 Catarina no tiene un gato tampoco.
4. Tampoco la conozco a ella.
 No la conozco tampoco a ella.
5. Y tampoco yo estudio.
 Y no estudio tampoco.

5)
1. sino	6. pero
2. pero	7. sino
3. sino	8. sino que
4. sino que	9. pero
5. sino	10. sino que

6)
1. No conocí a la familia de Isabel.
2. No puedo recordar el título del libro.
3. No me he divertido con Leonardo.
4. No lo perdí.
5. No lo han traído.
6. No me gusta despertarme temprano.
7. No hay nadie en la casa.
8. No los ha lavado.
9. No quiere comprar nada.
10. No le da la muñeca a la niña.

7)
1. No estamos listos para el examen.
2. No se lo des a ella.
3. ¿No lo puedes hacer por mí?
4. No traje nada.
5. Ese perro nunca le ladra a nadie.
6. No había ningún mueble en la habitación.
7. Su novio no trajo ni dulces ni flores—solamente él mismo.
8. Ella deseaba fama más que nada.

9. No hace buen tiempo tampoco hoy.

10. No tengo hijos, y no necesito ninguno.

11. Ese artista pinta mejor que nadie.

12. A María tampoco le gusta nadar.

8) 1. sino 6. sino que

 2. pero 7. sino

 3. sino que 8. sino

 4. sino 9. sino que

 5. sino 10. pero

9) 1. d 4. a

 2. c 5. b

 3. f

10) 1. Ya no deseo pedir prestado ningún libro.

 2. Todavía no he hablado con ella.

 3. No voy a reírme de tí.

 4. No me importan nada las notas a mí.

 5. No voy a reprenderte a ti tampoco.

Prepositions

A preposition is a word that connects words, and according to the thought expressed in the sentence, it serves to indicate the relation between these words.

CATEGORIES OF PREPOSITIONS

In general, prepositions in Spanish are used in the following categories:

A) Preposition + noun: **con Julio**
 Marta va al parque con Juan.
 Martha goes to the park with John.

B) Preposition + pronoun: **de él**
 Este libro es de él.
 This book is his.

C) Preposition + infinitive verb: **sin hablar**
 Ellos trabajan sin hablar.
 They work without talking.

D) Verb + preposition: **amenaza con**
 El huracán amenaza con pasar por la ciudad.
 The hurricane threatens to pass through the city.

Common prepositions are:

a	*at; to*	**en**	*in*
ante	*before; in the presence of*	**entre**	*among; between*
		hacia	*toward*
bajo	*underneath*	**hasta**	*until*
con	*with*	**para**	*for; in order to*
contra	*against*	**por**	*by; for*
de	*of; from*	**según**	*according to*
delante	*in front of*	**sin**	*without*
desde	*from; since*	**sobre**	*on; upon; above*
durante	*during*	**tras**	*after; behind*

María va con su madre al mercado.
Mary goes with her mother to the market.

La motocicleta negra es de él.
The black motorcycle is his.

Los estudiantes deben tomar el examen sin hablar.
The students should take the test without talking.

Mi profesor me amenazó con no graduarme.
My professor threatened to not allow me to graduate.

Voy contra la corriente.
I go against the current.

PREPOSITIONAL MODIFIERS

In the following section you will learn the rules for uses of prepositions, whether they are used in conjunction with other nouns to make adjectives or whether they are used to modify a verb.

A) Prepositional adjective: the union of a preposition and a noun that modifies another noun.
 noun preposition + noun = adjective
 una camisa de algodón
 a shirt of cotton

 una silla de madera
 a wooden chair

 un reloj de oro
 a gold watch

 una estrella de papel
 a paper star

B) Prepositional adverb: the union of a preposition and a noun that modifies a verb.
 verb preposition + noun = adverb
 corre con rapidez
 he runs fast

VERBS FOLLOWING PREPOSITIONS

The use of verbs with prepositions can be difficult for English speakers because many times the tense used is different than what is used in Spanish. For example, in many cases a verb after a preposition in English, uses a gerund. *You shouldn't do that without asking first.* However, in Spanish, all verbs that follow a preposition are always used in the infinitive.

Prepositions Used with Infinitives

In Spanish, the infinitive is the only verb form that can follow a preposition.

Comenzó a llover.
It began to rain.

Acaba de llegar.
He has just arrived.

Regresa de trabajar.
She returns from working.

Debemos pensar antes de actuar.
We should think before acting.

No aprenderá sin estudiar.
He will not learn without studying.

Specific Verb/Preposition Rules

Some verbs are always followed by the preposition **a**:

acercarse a	*to approach*	**dedicarse a**	*to devote oneself to*
acostumbrarse a	*to become accustomed to*	**empezar a**	*to begin to*
		enseñar a	*to teach to*
aprender a	*to learn to*	**entrar a**	*to enter*
apresurarse a	*to hurry to*	**ir a**	*to go to*
aspirar a	*to aspire to*	**llegar a**	*to arrive; to become*
atreverse a	*to dare to*	**obligar a**	*to force to*
ayudar a	*to help to*	**ponerse a**	*to begin to*
comenzar a	*to begin to*	**prepararse a**	*to prepare oneself to*
dar a	*to open out on; look out over*	**salir a**	*to go out*
		venir a	*to come to*
decidirse a	*to decide to*	**volver a**	*to return to*

La maestra enseña a leer a sus alumnos.
The teacher teaches her students to read.

Ellos se dedican a reparar computadoras.
They dedicate themselves to repair computers.

Tenemos que apresurarnos a terminar el examen.
We must hurry to finish the examination.

Voy a empezar a comer.
I am going to begin to eat.

Other verbs require the preposition **de**:

acabar de	*to finish*	**disfrutar de**	*to enjoy*
acordarse de	*to remember*	**enamorarse de**	*to fall in love with*
alegrarse de	*to be glad*	**encargarse de**	*to take charge of*
cesar de	*to stop*	**gozar de**	*to enjoy*
darse cuenta de	*to realize*	**pensar de***	*to think of*
dejar de	*to stop*	**salir de**	*to get out of*
depender de	*to depend on*	**tratar de**	*to try to*

¿Qué piensas del presidente?
What do you think of the president

*****Pensar de** is used when one is asking for an opinion. **Pensar en** is used when one is reflecting on something. One can also use the verb pensar without a preposition.

¿En qué piensas?
What are you thinking about?

Pienso trabajar toda la noche.
I'm planning (thinking about) working all night.

Some verbs require the preposition **con:**

amenazar con	*to threaten to*	**dar con**	*to stumble upon*
casarse con	*to marry*	**soñar con**	*to dream of*
contar con	*to count on*	**tropezar con**	*to stumble upon*
cumplir con	*to carry out; to obey*		

María sueña con ser una actriz.
Mary dreams of being an actress.

Other verbs require the preposition **en:**

confiar en	*to trust*	**entrar en**	*to enter into*
consentir en	*to consent to*	**insistir en**	*to insist on*
consistir en	*to consist of*	**pensar en**	*to think about*
convenir en	*to agree to*	**tardar en**	*to delay in*
empeñarse en	*to insist on*		

Yo insisto en pagar la cuenta.
I insist on paying the bill.

Other common prepositions used before an infinitive are as follows:

a	*to; at*	**en lugar de**	*in place of*
al + infinitive	*upon; on* + gerund	**en vez de**	*instead of*
antes de	*before*	**en**	*in; on; of*
con	*with*	**hasta**	*until*
de	*of; to*	**sin**	*without*
después	*after*		

Al regresar vio a su esposa.
Upon entering, he saw his wife.

Se fue sin despedirse.
He left without saying goodbye.

Test Yourself: 1) Write full sentences in the future tense of the indicative mood with the word given, and add the respective prepositions according to the model.

modelo: **El bailarín / alegrarse / visitar / Viena.**

El bailarín se alegrará de visitar Viena.

1. Ella / dejar / ir / conciertos / todos los fines de semana.
2. María / consentir / hacer / quehacer.
3. Su madre / enseñarle / tocar / piano.
4. Después de artista / él / aspirar / ser / doctor.
5. Juan / empezar / cerrar / tienda / a las 9 de la noche.
6. Avión / tardar / aterrizar.
7. Juan / insistir / ir / biblioteca.
8. Miguel / tratar / ver / actor.
9. Nosotros / contar / él.
10. Tú / encargarse / arreglar / habitación.

Test Yourself: 2) Complete the following paragraph with the appropriate prepositions, when needed.
Unos niños se disponían _____ 1. jugar _____ 2. el parque, cuando un hombre _____
3, unas pistolas empezó _____ 4. disparar por todas partes. Yo pensaba _____ 5.ayudar pero
era demasiado peligroso. Algunas personas quedaron heridas y el malhechor huyó ame-
nazando _____ 6. la gente. Este hombre debe _____ 7. ser un loco. Cuando la policía llegó y
me iba _____ 8. interrogar, yo traté _____ 9. ayudarlos, pero me desmayé _____ 10. el
susto.

Test Yourself: 3) Match each verb with the prepositions **a, con, de,** or **en.**

1. acabar
2. tratar
3. insistir
4. amenazar
5. empezar

6. obligar
7. cesar
8. enamorarse
9. contar
10. tardar

Test Yourself: 4) Answer the following questions in full sentences.
1. ¿A quién esperas en el parque? (Luis)
2. ¿Qué quehaceres debes hacer después de la cena? (lavar los platos)
3. ¿Cuándo piensas comenzar tu tarea? (en la tarde)
4. ¿Qué instrumento musical puedes tocar? (violoncelo)
5. ¿Con quién sueñas? (novio)

MOST COMMONLY USED PREPOSITIONS

The most commonly used prepositions that cause some difficulty are *por*, *para*, and *de*. The fol-
lowing section will distinguish the differences in their uses.

The Preposition de

The preposition **de,** with certain words (most of them adverbs), generally changes that part of speech
to a preposition.

además de	*in addition to; besides*	**detrás de**	*behind*
		en contra de	*against*
alrededor de	*around*	**en lugar de**	*instead of*
antes de	*before*	**en medio de**	*in the middle of*
cerca de	*near*	**en vez de**	*instead of*
debajo de	*underneath*	**encima de**	*on top of; upon*
delante de	*in front of*	**enfrente de**	*opposite to*
dentro de	*within; inside of*	**fuera de**	*outside of*
después de	*after*	**lejos de**	*far from*

PREPOSITIONS PARA AND POR

Para and **por** are generally translated as *for.* Observe the variations in translation and the differences between the two.

Para expresses:

A) Destination:
Mañana salgo para Japón.
Tomorrow, I am leaving for Japan.

B) A purpose or goal:
Estudio para ser científico.
I am studying to be a scientist.

C) The special use of an object:
Este vaso es para café.
This glass is for coffee.

D) A time or date in the future or a due date:
Esta lección es para mañana.
This lesson is due tomorrow.

E) A comparison when it is something not very common:
Para ser norteamericano, habla español muy bien.
For an American, he speaks Spanish well.

F) To mean *to* or *for himself* (*herself, themselves,* and so on) when used with the reflexive pronoun **sí:**
Lo quieren todo para sí.
They want everything for themselves.

G) *In order to,* when followed by an infinitive:
Necesito gafas para leer.
I need glasses in order to read.

Por is used to:

A) Express *in exchange for:*
¿Cuánto dinero me dará por mi trabajo?
How much money will you pay me for my work?

B) Indicate a length of time or the duration of an action:
Me quedé en casa por tres días.
I stayed home for three days.

C) Introduce the agent in a passive construction *(by):*
Este libro fue escrito por García Lorca.
This book was written by Garcia Lorca.

D) To mean *along, through, by,* and *around* after a verb of motion:
Pasaron por el parque.
They passed through the park.

E) To indicate an indefinite time:
Por la noche estudio.
I study at night.

F) To mean for the sake of and on behalf of:
La madre habló por la asociación de padres.
The mother spoke on behalf of the Parent's Association.

G) To mean *for* as used after the verbs **enviar, ir, luchar, regresar,** and so on:

Yolanda regresó por su muñeca.

Yolanda returned for her doll.

H) To express manner or means:

Llegaron por barco.

They arrived by boat.

I) To express frequency *(per):*

Los alumnos asisten a la escuela cinco veces por semana.

The students attend school five times per week.

J) To express a reason or motive:

Lo castigaron por robarse el dinero.

They punished him for stealing the money.

K) To express opinion or estimation; this is equivalent to the English *for* or *as:*

Se le conocía por Pepe Menteseca.

He was known as Pepe Menteseca.

L) To express certain adverbial expressions:

por eso	*that is why*
por lo común	*generally*
por lo general	*generally*
por lo visto	*apparently*
por supuesto	*naturally*

M) **Por** when it is followed by an infinitive and expresses what remains to be done:

Queda mucho por hacer.

Much remains to be done

Test Yourself: 5) Complete the following sentences with **por** or **para.**

1. Carlos trabaja _____ sostener a su familia.
2. Las entradas son _____ la obra teatral.
3. El tren de juguete es _____ el niño huérfano.
4. Mis amigos salieron _____ el campo. (destination)
5. García Lorca es famoso _____ su trilogía dramática.
6. Nuestra clase de español quiere viajar _____ Cancún.
7. Los árabes vinieron a España _____ conquistarla.
8. ¿ _____ quién es la pluma de oro?
9. Vamos a pagar trescientos dólares _____ el viaje a la Florida.
10. El barco va _____ las orillas del mar del Norte.
11. Ellos van _____ Guatemala. (through)
12. Esto es _____ ti.
13. El regalo es _____ mi madre.
14. Hago estas cosas _____ ti.
15. _____ lo visto, ellos no llegarán a tiempo.
16. Trabajo sesenta horas _____ semana.
17. Obtuvo el empleo _____ sus excelentes calificaciones.
18. Marta llegó _____ taxi.
19. Necesito mis gafas _____ leer.
20. La tarea es _____ mañana.

Test Yourself: 6) Complete the following sentences by using the prepositions **por** or **para**.

1. Es muy inteligente _____ ser tan joven.
2. Yo pagué cuarenta dólares _____ este libro.
3. Estudio _____ aprender.
4. Ellos salieron _____ la universidad.
5. Ellos habrán llegado _____ las tres.
6. _____ lo visto, ustedes no comprendieron lo que dije.
7. Ella estudia _____ abogada.
8. Mi hermana habló _____ teléfono.
9. _____ favor envíelo _____ fax.
10. Esta computadora no es _____ jugar.

Test Yourself: 7) Complete the following paragraph by using the prepositions **por** or **para**.

Yo tuve que salir _____ 1. comprar un libro que necesito _____ 2. el examen mañana. Tengo que comprar también verduras _____ 3. la cena. Estaré fuera _____ 4. una hora aproxi-madamente, pues debo tomar el autobus al centro del pueblo. ¡Oh! Casi lo olvido, también voy _____ 5. el regalo de papá _____ 6. su cumpleaños.

The Personal a

The personal **a** is a difficult concept for English speakers because it has no translation at all. One must simply memorize the rules for its uses since there is no equivalent in English.

In Spanish, the **a** is used before the direct object of a verb if the direct object is:

A) A person or persons:
Conozco a su tía Elena.
I know his aunt Helen.

B) A domesticated animal when personified:
Yo quiero a mi gatito.
I love my kitten.

C) A pronoun when it refers to a person:
Laura está visitando a alguien.
Laura is visiting someone.

Other pronouns commonly used are as follows:

alguien	*someone*
él	*he*
ella	*she*
nadie	*no one*
ninguno	*none*
quien	*whom*

D) The personal **a** is not generally used with the verb **tener** when it means *to have:*
Tengo dos hermanas.
I have two sisters.

However, when **tener** means *to hold*, the personal **a** is used.

La enfermera tiene a un niño en sus brazos.
The nurse has a child in her arms.

Test Yourself: 8) Complete the following exercise with the personal **a**, where appropriate.

Mis padres compraron _____ 1. un perrito. Me lo dieron _____ 2. mí como regalo de Navidad. Hace solamente unos días que lo he tenido, pero ya quiero mucho _____ 3. mi perrito. El primer día, yo tuve _____ 4. mi perrito en los brazos constantemente. Mi perrito no quiere _____ 5. nadie más que a mí. Yo le dí _____ 6. mis padres un gran abrazo. Éste es posiblemente el mejor regalo que me han dado _____ 7. mí.

Test Yourself: 9) Complete the sentences with the preposition **a,** if necessary.

1. Mis padres van a visitar _____ mi tía.
2. Voy a visitar _____ Colombia.
3. Mi hermano llama _____ mamá una vez a la semana.
4. Muchos jóvenes en la calle piensan que _____ nadie le importa su bienestar.
5. Mi primo conoce _____ la presidenta de las Filipinas.
6. Vamos _____ Santo Domingo.
7. Veo _____ un tigre.
8. Tenemos _____ cinco perros en mi casa.
9. Marta tiene _____ un gatito en sus brazos.
10. Conozco _____ Luis.

Test Yourself Answers

1)
1. Ella dejará de ir a conciertos todos los fines de semana.
2. María consentirá en hacer los quehaceres.
3. Su madre le enseñará a tocar el piano.
4. Después de artista, él aspirará a ser doctor.
5. Juan empezará a cerrar la tienda a las 9 de la noche.
6. El avión tardará en aterrizar.
7. Juan insistirá en ir a la biblioteca.
8. Miguel tratará de ver un actor.
9. Nosotros contaremos con él.
10. Tú te encargarás de arreglar la habitación.

2)
1. a
2. en
3. con
4. a
5. en
6. a
7. —
8. a
9. de
10. por

3)
1. de
2. de
3. en
4. a
5. a
6. a
7. de
8. de
9. con
10. en

4)
1. Yo espero a Luis.
2. Yo debo lavar los platos después de la cena.
3. Pienso comenzar mi tarea en la tarde.
4. Puedo tocar el violoncelo.
5. Sueño con mi novio.

5)
1. para
2. para
3. para
4. para
5. por
6. para
7. para
8. Para
9. por
10. por
11. por
12. para
13. para
14. por/para
15. Por
16. por
17. por
18. por
19. para
20. para

6)
1. para
2. por
3. para
4. para
5. para
6. Por
7. para
8. por
9. Por/por
10. para

7)
1. para
2. para
3. para
4. por
5. por
6. para

8)
1. —
2. a
3. a
4. a
5. a
6. a
7. a

9)
1. a
2. —
3. a
4. a
5. a
6. a
7. —
8. —
9. a
10. a

Idioms and Proverbs

Although one can learn the grammatical structures of a language, it is of great importance to also learn idiomatic expressions of languages. These make the language come alive and help the student understand not only the language used by native speakers, but also part of the culture as well.

IDIOMS

Idiomatic expressions are an important part of learning the intricate ways a language is used. In Spanish, verbs and nouns are the most commonly used form of these expressions.

With Nouns

The following is a list of some of these idiomatic expressions with nouns:

a causa de	on account of	a tientas	gropingly
a cuestas	on one's back	a veces	sometimes
a eso de	at about	ahora mismo	right now
a fines de	at the end of	al aire libre	in the open air
a fondo	thoroughly	al alcance de	within reach
a hurtadillas	furtively	al amanecer	at dawn
a la vista	at sight	al anochecer	at nightfall
a lo alto	at the top	al azar	at random
a lo lejos	at a distance	al cabo	after
a manos llenas	abundantly	al día siguiente	on the next day
a media voz	in a whisper	al encuentro de	to meet
a menudo	often	al fiado	on credit
¡anda!	go ahead!	al fin y al cabo	anyway
a pesar de	in spite of	al fin	at last
a pie	on foot	al lado de	beside
a poco	soon after	al menos	at least
a principios de	at the beginning of	al parecer	apparently
¿a qué hora?	at what time?	al por mayor	wholesale
a solas	alone	al por menor	retail
a tiempo	on time	al principio	at the beginning

alguna vez	*sometime*	de sol a sol	*from sunrise to sunset*
ante todo	*above all*	de todos	*at any rate*
antes bien	*on the contrary*	modos	
buenas noches	*good night*	de verdad	*in truth*
buenos días	*good morning*	de vez en	*from time to time*
¡cómo no!	*certainly!*	cuando	
¿cómo se dice	*how do you say . . . ?*	del todo	*entirely*
. . . ?		dentro de	*in a little while*
con ahinco	*earnestly*	poco	
con excepción	*with the exception*	desde entonces	*since then*
con mucho	*with great pleasure*	de veras	*truly*
gusto		el año pasado	*last year*
con permiso	*excuse me*	el día menos	*when least expected*
cosa de	*a matter of*	pensado	
cuanto antes	*as soon as possible*	en cambio	*on the other hand*
¿cuántos años	*how old are you?*	en casa	*at home*
tienes?		en cuanto	*as soon as*
cumplir . . .	*to become . . .*	en cuclillas	*crouching*
años	*years old.*	en el extranjero	*abroad*
de antemano	*beforehand*	en fin	*anyway*
de buena	*gladly (unwillingly)*	en general	*generally*
(mala) gana		en las afueras	*on the outskirts*
de costumbre	*usually*	en lugar de	*instead of*
de día	*by day*	en medio de	*in the middle of*
de esta manera	*in this way*	en ninguna	*nowhere*
de este modo	*in this way*	parte	
de hoy en	*from now on*	en pos de	*in pursuit of*
adelante		en punto	*sharp (time)*
de la mañana	*in the morning*	en seguida	*immediately*
de la noche	*in the evening*	en un santi-	*in a flash*
de la tarde	*in the afternoon*	amén	
de memoria	*by heart*	en vano	*in vain*
de moda	*in fashion*	en vísperas	*on the eve of*
de nada	*you are welcome*	de	
de ninguna	*in no way*	en voz alta	*aloud*
manera		en voz baja	*in a low voice*
de noche	*at night*	entrado en	*advanced in years*
de nuevo	*again*	años	
de par en par	*wide open*	eso es	*that is it*
de pie	*standing*	gracias a	*thanks to*
de prisa	*quickly*	hace mucho	*a long time ago*
de pronto	*suddenly*	tiempo	
¿de qué color	*what color is . . . ?*	hacia abajo	*towards the bottom;*
es . . . ?			*below*
de segunda	*second hand; used*	hacia arriba	*towards the top;*
mano			*above*

hasta la vista	*until we meet again*	por la noche	*at night*
hasta luego	*good bye*	por la tarde	*in the afternoon*
hasta mañana	*until tomorrow*	por lo común	*usually*
(la noche)	*(this evening)*	por lo general	*generally*
hombre de bien	*good man*	por lo menos	*at least*
hoy día	*nowadays*	por lo tanto	*therefore*
hoy mismo	*this very day*	por lo visto	*apparently*
la mayor parte de	*most of*	por otra parte	*on the other hand*
lo más pronto	*as quickly as*	por supuesto	*of course*
posible	*possible*	por todas partes	*everywhere*
lo mismo	*the same*	¿qué hora es?	*what time is it?*
los (las) dos	*both*	¿qué pasa?	*what is the matter?*
mañana por la	*tomorrow morning*	¿qué tal?	*how are you?*
mañana		¿qué tiempo	*how is the weather?*
más allá de	*beyond*	hace?	
más bien	*rather*	¿qué tienes tú?	*what is the matter*
más que nunca	*more then ever*		*with you?*
más vale	*better*	quince días	*two weeks*
mientras tanto	*meanwhile*	rara vez	*rarely*
muchas gracias	*thank you*	sin duda	*undoubtedly*
muchas veces	*many times*	sin embargo	*however*
mucho tiempo	*a long time*	sin novedad	*as usual*
muy de mañana	*very early*	sin querer	*accidentally*
ni siquiera	*not even*	sin tregua	*relentlessly*
ni yo tampoco	*me either*	sobrarle algo	*to have something*
no hay de que	*you are welcome*		*left over*
no obstante	*nevertheless*	sobre todo	*above all*
no tener pie ni	*to have neither*	tal vez	*perhaps*
cabeza	*rhyme nor reason*	tanto como	*as much as*
ocho días	*a week*	tanto por ciento	*such a percent*
otra cosa	*furthermore*	todavía no	*not yet*
otra vez	*again*	todo el día	*all day*
¿para qué?	*what for?*	todo el mundo	*everybody*
para siempre	*forever and ever*	todos los días	*every day*
jamás		un día sí y otro no	*every other day*
poco a poco	*little by little*	un poco de	*a little of*
por ahí	*that way*	un sin fin de	*a countless*
por allí	*that way*		*number of*
por aquí	*this way*	una vez	*once*
por cierto	*truly*	unas veces	*sometimes*
por dentro	*on the inside*	unos cuantos	*a few*
por entonces	*at that time*	¡ya lo creo!	*I should think so!*
por eso	*therefore*	ya no	*no longer*
por esto	*for this reason*	¡ya se acabó!	*it is all over!, it is*
por fin	*finally*		*finished*
por la mañana	*in the morning*	yo no	*not I*
		yo tampoco	*me neither*

Test Yourself: 1) Write the corresponding idiom in Spanish.

1. from sunrise to sunset
2. at any rate
3. last year
4. when least expected
5. on the other hand
6. on the outskirts
7. in pursuit of
8. in a flash
9. on the eve of
10. this very day
11. as quickly as possible
12. more than ever
13. not even
14. everybody
15. forever and ever
16. finally
17. on the other hand
18. therefore
19. two weeks
20. relentlessly

Test Yourself: 2) Complete the following sentences with the appropriate idiom.

1. _____ (At the end of) junio, iremos a España.
2. _____ (At the distance), veo la ciudad.
3. Ellos jugaban al tenis _____ (often).
4. Juan lo hizo _____ (alone).
5. Había uvas _____ (abundantly).
6. El avión llegó _____ (on time).
7. Saldréis de viaje _____ (at dawn).
8. Tú escogiste el ganador _____ (at random).
9. _____ (At last) llegamos.
10. Llama a tu madre _____ (tomorrow morning).
11. _____ (go ahead!) El agua no es profunda.
12. _____ (above all), deben hablar español.
13. Se marcharon _____ (quickly).
14. Todos pasaron la prueba _____ (except) él.
15. _____ (excuse me). Necesito pasar.
16. Vamos al cine como _____ (usually).
17. _____ (In this way) se escucha mejor.
18. Obtuve mi información con _____ (a countless number of) de problemas.
19. _____ (At night), deben tener ciudado al caminar.
20. _____ (Suddenly), empezó a nevar.

Test Yourself: 3) Translate the following idioms into Spanish.

1. I should think so!
2. It is all over!
3. What is the matter?
4. How is the weather?

5. What is the matter with you?
6. Good morning.
7. What time is it?
8. What is the color of the book?
9. A second-hand car.
10. How old are you?

With Verbs

The following is a list of some of these idiomatic expressions with verbs:

acabar de	*to have just*	**dar la mano**	*to shake hands*
acabar por	*to finally . . . ; to end up*	**dar las buenas noches**	*to say good night*
acerca de	*concerning*	**dar las gracias**	*to thank*
acercarse a	*to approach*	**dar los buenos días**	*to say good day*
acordarse de	*to remember*		
alegrarse de	*to be glad*	**dar miedo**	*to frighten*
aprender a	*to learn*	**dar un paseo**	*to take a walk*
apretar el paso	*to quicken one's pace*	**dar una vuelta**	*to take a walk*
		darse cuenta de	*to realize*
aproximarse a	*to approach*	**decir que sí (no)**	*to say yes (no)*
armar un escándalo	*to start an argument*	**dedicarse a**	*to devote oneself to*
		dejar caer	*to drop*
asistir a	*to attend*	**dejar de**	*to fail to*
asombrarse de	*to be astonished*	**despedirse de**	*to say good-bye to*
atreverse a	*to dare*	**dirigirse a**	*to address; to go to*
bajar de	*to come down from*	**disponerse a**	*to get ready to*
caer de bruces	*to fall headlong*	**dormir la siesta**	*to take a nap*
caer en cuenta	*to realize*	**echar a pique**	*to sink*
cambiarse de ropa	*to change clothing*	**echar al correo**	*to mail*
		echar de menos	*to miss; to long for*
cesar	*to stop*	**echar en el buzón**	*to mail*
con (mucho) gusto	*with (great) pleasure*	**echar la culpa**	*to blame*
		echar suerte	*to draw lots*
conforme a	*according to*	**echarse a**	*to begin*
consistir en	*to consist of*	**empezar a**	*to begin*
consta que	*it is evident that*	**enamorarse de**	*to fall in love with*
constar de	*to consist of*	**encaminarse a**	*to take the road to*
contar con	*to rely on*	**encontrarse**	*to find oneself*
creer que sí (no)	*to think so (not)*	**enseñar a**	*to teach*
dar a conocer	*to make known*	**equivocarse**	*to be mistaken*
dar a	*to look out upon*	**es decir**	*that is to say*
dar con	*to come upon*	**está bien**	*it is all right*
dar crédito a	*to believe*	**estar a punto**	*to be about to*
dar de comer	*to feed*	**estar bien (de salud)**	*to be in good health*
dar ganas de	*to make one feel like*		
dar gritos	*to shout*	**estar conforme**	*to agree*
dar la hora	*to strike the hour*	**estar de vuelta**	*to be back*

estar malo	to be ill	llover a cántaros	to rain cats and dogs
estar para	to be about to		
estar por	to be in favor of; to be about to	meter bulla	to make noise
		meterse de por medio	to meddle
faltar a una cita	to miss an appointment		
		mirar de reojo	to look askance
frente a	opposite	negarse a	to refuse to
fruncir las cejas	to frown	no faltaba más	that is the limit
gozar de	to enjoy	ocuparse de	to take care of
guardar silencio	to keep silent	parecer mentira	to seem unbelievable
guardarse de	to guard against		
hace buen (mal) tiempo	the weather is good (bad)	parecerle a uno	to seem
		pasar un buen rato	to have a good time
hace calor	it is warm		
hace frío	it is cold	pensar + infinitive	to intend
hace poco	a little while ago		
hace sol	it is sunny	pensar de	to think about
hace un mes que + present ind.	It's been a month since	pensar en	to think of
		perder ciudado	not to worry
hacer caso de	to pay attention to	perder de vista	to lose sight of
hacer cola	to stand in line	poner al corriente	to inform
hacer el papel de	to play the role of	ponerse + adjective	to become
hacer la vista gorda	to overlook intentionally	ponerse a + infinitive	to begin
hacer las maletas	to pack the suitcases	ponerse de acuerdo	to agree
		ponerse en pie	to stand up
hacer saber	to inform	ponerse	to put on
hacer un viaje	to take a trip	prepararse para	to get ready
hacer una pregunta	to ask a question	pronunciar un discurso	to make a speech
hacer una visita	to pay a visit		
hacerse tarde	to become late	¿qué hay?	what is the matter?
hágame el favor de	please, do me the favor of	reírse de	to laugh at
		rendir culto a	to worship
hallarse	to find oneself	saber a	to taste like
hay neblina	it is foggy	salir bien	to be successful
hay que + infinitive	it is necessary	salir de	to get ride of; to leave
hay sol	it is sunny		
ir a buscar	to look for	salir mal	to be unsuccessful
ir a pie	to walk	salirse con la suya	to have one's way
ir a	to go to	saltar a la vista	to be obvious
ir de puntillas	to walk on tip-toe	se pone el sol	the sun sets
ir en coche	to drive	se ve	it is clear
llegar a ser	to become	servir de	to serve as
llegar a	to arrive at	servir para	to be used for
llegar al grano	to come to the point	soñar con	to dream of
		tardar en + infinitive	to delay in
llevar a cabo	to carry out		
llevar aquí un mes	to be here a month	temblar de	to tremble with

tener (mucha) hambre	*to be (very) hungry*	tener prisa	*to be in a hurry*
		tener razón	*to be right*
tener calor	*to be warm*	tener sed	*to be thirsty*
tener cuidado	*to to be careful*	tener sueño	*to be sleepy*
tener derecho	*to have the right to*	tirar de	*to pull*
tener dolor de cabeza	*to have a headache*	tocarle a uno + infinitive	*to be one's turn*
tener en cuenta	*to take into consideration*	tomar a pecho	*to take to heart*
		tomar el desayuno	*to have breakfast*
tener frío	*to be cold*	trasnochar	*to keep late hours*
tener ganas	*to feel like*	tratar de	*to try to*
tener gusto en + infinitive	*to be glad to*	valerse de	*to take advantage of*
		¡vamos a ver!	*let's see*
tener la culpa	*to be guilty of*	vamos	*let's go*
tener lugar	*to take place*	¡vaya!	*come on!*
tener mucho que	*to have a great deal to*	volver a + infinitive	*again*
tener por + adjective	*to consider*	volver en sí	*to regain consciousness*
tener presente	*to keep in mind*	volverse + adjective	*to become*

Test Yourself: 4) Write the corresponding idiom in Spanish.

1. to approach
2. to realize
3. to consist of
4. to make known
5. to say goodbye to
6. to take the road to
7. to be in good health
8. it is warm
9. to play the role of
10. to become late
11. to carry out
12. to make noise
13. the sun sets
14. to be sleepy

Test Yourself: 5) Complete the following sentences in Spanish with the corresponding idioms.

1. Yo deseo _____ (to have breakfast).
2. Juan _____ (informs me).
3. El presidente necesita _____ (to make a speech).
4. Ellos _____ (had their way).
5. Nosotros _____ (were successfull) en la escuela.
6. Yo _____ (am sleepy).
7. _____ (opposite) la tienda está la casa.
8. Ella _____ (laughs at) del comediante.
9. No _____ (meddle) en el asunto.
10. _____ (to become late), debes marcharte.

Test Yourself: 6) Translate into Spanish the following idioms.
1. It is all right.
2. The weather is good.
3. I feel like traveling.
4. It is foggy.
5. What is the matter?
6. Let's see.

PROVERBS

Proverbs are short sayings that generally have a moralizing intent or a historical content; their beginnings can be traced either to a scholastic or popular origin. They are common in many countries and cultures, with a mainly didactic purpose.

In Latin America, proverbs are interjected by speakers into normal conversation to support their point of view and to give their argument or action a greater sense of wisdom and truth.

Some of the most popular Spanish proverbs are as follows:

A buen hambre, no hay pan duro.
Hunger is the best sauce.

A caballo dado, no se le ven los dientes.
Beggars cannot be choosers.

A Dios rogando, y con el mazo dando.
Speak softly and carry a big stick.

A palabras necias, oídos sordos.
Turn a deaf ear to ill advice.

A tal pregunta, tal respuesta.
Ask a dumb question, get a dumb answer.

Al buen amigo, le prueba el peligro.
A friend in need is a friend indeed.

Al pan pan, y al vino vino.
Stop beating around the bush.

Al que le sirva que se lo ponga.
If the shoes fits, wear it.

Algo que torcido creció, nunca se enderezó.
Once a thief, always a thief.

Aquí hay gato encerrado.
Something is fishy or I smell a rat.

Aunque el lobo pierde sus dientes, no pierde sus inclinaciones.
Once a thief, always a thief.

Ayudate que Dios te ayudará.
God helps those that help themselves.

Barriga llena, corazón contento.
To a full belly, a happy heart.

Cada loco con su tema.
Every man to his taste. (Or, to each his own).

Camarón que se duerme se lo lleva la corriente.
You snooze, you lose.

Colgarle a uno el muerto.
To pass the buck.

Como anillo al dedo.
It fits like a glove.

Con la cuchara que elijas, con esa comerás.
You have made your bed, now lie in it.

Contra viento y marea.
Come rain or shine.

Cual te veo tal te creo.
I will believe it when I see it.

Cuando la gata anda en amores, tiempo para los ratones.
When the cat is away, the mice will play.

Darle al clavo en la cabeza.
To hit the nail on the head.

De mal en peor.
From bad to worse.

De tal palo tal astilla.
Like father like son.

Del dicho al hecho, hay mucho trecho.
Deeds speak louder than words.

Despacio que voy de prisa.
Haste makes waste.

Desprecia a tu enemigo y serás vencido.
Do not underestimate your enemies.

Dime con quien andas y te diré quien eres.
Birds of a feather flock together.

Divide y vencerás.
Divide and you shall conquer.

Donde quiera que fueres, haz como vieres.
When in Rome, do as the Romans.

E1 que da lo suyo, a pedir se queda.
You cannot give what you do not have.

El que en mentira es cogido, cuando dice la verdad no es creído.
Do not cry wolf.

El que ríe al último, ríe mejor.
He who laughs last, laughs best.

El que se va para la villa, pierde su silla.
Finders keepers, loosers weepers.

El tiempo es oro.
Time is gold.

El uso trae el abuso.
Familiarity breeds contempt.

En lo que canta un gallo.
Quick as a wink.

Engañar al engañador, no es deshonor.
There is no honor between thieves.

Entre la espada y la pared.
Between a rock and a hard place.

Estar en las nubes.
To be up in the clouds.

Grano a grano llena la gallina el buche.
A penny saved is a penny earned.

Guárdate y Dios te guardará.
Take care of yourself, and God will take care of you

Hacer castillos en el aire.
To build castles in the air.

Ir de la hoya al fuego.
Out of the frying pan and into the fire.

La ociosidad es la madre de todos los vicios.
Laziness is the mother of all vices.

Le patina el coco.
To have a screw loose.

Leer entre líneas.
To read between the lines.

Llorar a lágrimas sueltas.
To cry like a baby.

Lo que nada nos cuesta, hagámoslo fiesta.
Easy come, easy go.

Lo que no quieras para ti, no lo desees para mí.
Do not do onto others what you do not want to be done onto you.

Más fuerte es la pluma que la espada.
The pen is mightier than the sword.

Más vale dar que recibir.
It is better to give than to receive.

Más vale precaver que tener que lamentar.
A stitch in time saves nine.

Más vale prevenir que lamentar.
An ounce of prevention is worth a pound of cure.

Más vale rodear que rodar.
If you cannot beat them join them.

Más vale tarde que nunca.
It is better late than never.

Matar dos pájaros de un tiro.
Kill two birds with one stone.

Mientras hay vida hay esperanza.
Hope springs eternal.

Nadie por más sucia diga: De esta agua no beberé.
Never say never.

No cantes victoria antes de tiempo.
Do not count your chickens before they hatch.

No dar el brazo a torcer.
To stick to one's guns.

No dejes para mañana, lo que puedas hacer hoy.
Do not leave for tomorrow what you can do today.

No hay mal que dure cien años, ni hombre que lo resista.
Nothing lasts forever.

No se ganó Zamora en una hora.
Rome was not built in a day.

No tener pelos en la lengua.
Not to mince words.

No todo lo que brilla es oro.
Things are not always what they seem.

Palabras sin obras, guitarra sin cuerdas.
Actions speak louder than words.

Para el gusto, se hicieron los colores.
Every man to his taste.

Parar en seco.
To put your foot down.

Pegar el grito al cielo.
To hit the ceiling.

Plato de segunda mesa.
Second fiddle.

Por sus frutos, se conoce el árbol.
By their deeds you shall know them.

Por un gustazo, un trancazo.
No pain, no gain.

Querer es poder.
Where there is a will, there is a way.

Quien la hizo una vez, la hará ciento diez.
Once a fool, always a fool.

Quien más sabe más vale.
Knowledge is power.

Quien practicando no aprende, poco talento tiene.
Practice makes perfect.

Tiempo perdido, no se recupera jamás.
Time lost is time wasted.

Tomar las de Villadiego.
To high-tail it.

Un lobo vestido de oveja.
A wolf in sheepskin.

Un loco hace ciento, y un tonto un regimiento.
A bad apple spoils the bunch.

Usando hazte diestro, y saldrás buen maestro.
Practice makes perfect.

Ver para creer.
Seeing is believing.

Test Yourself: 7) Complete the following proverbs with the appropriate words.
1. No me digas que no puedes hacerlo. _____ es poder.
2. Comiste mejor que Sancho Panza. A barriga llena _____
3. Dime con quien andas y _____
4. Me invitaron a la fiesta al último momento, me siento como plato de _____
5. No creas todo lo que él dice. Del dicho al _____.
6. No me gusta el pastel que me regalaron, sin embargo a caballo dado no _____
7. ¡Qué bueno! Esto me cae como _____ al dedo.
8. Tengo demasiados problemas. Estoy entre la espada y _____.
9. José llegó a las nueve, cuando debía llegar a las ocho. Pero, más vale tarde que _____.
10. ¡Qué extraño! Aquí hay _____.
11. Algunas personas son excéntricas. Cada loco _____.
12. Más vale precaver que _____.
13. Ten paciencia. Grano a grano _____.
14. Yo siempre te digo que el uso trae _____.
15. No te descuides de tu competencia porque camarón que _____.
16. Mi abuela siempre me decía: "Guárdate y _____".

17. Ten ciudado con los amigos que elijas, porque un loco hace ciento y un

18. Hay que luchar contra viento y _____

19. Ten paciencia. Recuerda que quien practicando no aprende _____

20. ¡Qué hombre más deshonesto! Tiene ochenta años y todavía engaña a la gente. Claro aunque el lobo pierda sus dientes, _____

Test Yourself: 8) Write the equivalent Spanish proverb for the English proverbs given.

1. To kill two birds with one stone.
2. Once a fool, always a fool.
3. The pen is mightier than the sword.
4. To stick to one's guns.
5. Do not count your chickens before they hatch.
6. Hunger is the best sauce.
7. Come rain or shine.
8. Seeing is believing.
9. Stop beating around the bush.
10. Every man to his taste.

Test Yourself Answers

1)
1. de sol a sol
2. de todos modos
3. el año pasado
4. el día menos pensado
5. en cambio
6. en las afueras
7. en pos de
8. en un santiamén
9. en vísperas de
10. hoy mismo
11. tan pronto posible
12. más que nunca
13. ni siquiera
14. todo el mundo
15. para siempre jamás
16. por fin
17. en cambio
18. por eso
19. quince días
20. sin tregua.

2)
1. A fines de
2. A lo lejos
3. a menudo
4. a solas
5. a manos llenas
6. a tiempo
7. en la madrugada
8. al azar
9. Al fin
10. mañana por la mañana
11. ¡Anda!
12. Sobretodo
13. de prisa
14. con excepción de
15. Con permiso
16. de costumbre
17. De esta manera
18. un sinfin

19. Por la noche
20. De repente

3)
1. ¡Ya lo creo!
2. ¡Ya se acabó!
3. ¿Qué pasa?
4. ¿Qué tiempo hace?
5. ¿Qué tienes tú?
6. Buenos días
7. ¿Qué hora es?
8. ¿De qué color es el libro?
9. Un automóvil de segunda mano.
10. ¿Cuántos años tienes?

4)
1. acercarse a
2. darse cuenta de
3. consistir en
4. dar a conocer
5. despedirse de
6. encaminarse a
7. estar bien
8. hace calor
9. hacer el papel de
10. hacerse tarde
11. llevar a cabo
12. hacer bulla
13. se pone el sol
14. tener sueño

5)
1. desayunar
2. me pone al corriente; me hace saber
3. pronunciar un discurso
4. se salieron con la suya.
5. salimos bien
6. tengo sueño.
7. Frente a
8. se ríe
9. te metas de por medio
10. Se hace tarde

6)
1. Está bien.
2. Hace buen tiempo.

3. Tengo ganas de viajar.

4. Hace neblina.

5. ¿Qué pasa?

6. Vamos a ver.

7) 1. Querer

2. corazón contento

3. te diré quien eres

4. segunda mesa

5. hecho hay mucho trecho

6. se le ven los dientes

7. anillo

8. la pared

9. nunca

10. gato encerrado

11. con su tema

12. que tener que lamentar

13. llena la gallina el buche

14. el abuso

15. se duerme se lo lleva la corriente

16. Dios te guardará

17. tonto un regimiento

18. marea

19. poco talento tiene

20. no pierde sus inclinaciones

8) 1. Matar dos pájaros de un tiro.

2. Quien la hizo una vez, la hará ciento diez.

3. Más fuerte es la pluma que la espada.

4. No dar el brazo a torcer.

5. No cantes victoria antes de tiempo.

6. A buen hambre, no hay pan duro.

7. Contra viento y marea.

8. Ver para creer.

9. Al pan pan, y al vino vino.

10. Cada loco con su tema.

Rules of Accentuation

In Spanish, there are two types of accents, one is the phonetic accent, and the other is the written accent. All words have a phonetic accent; therefore, all words in the Spanish language have a syllable that is stressed more than others. For example, in the word **español,** the syllable /**ñol**/ is stressed more than the syllables /**es**/ and /**pa**/.

In general, there is a natural tendency in Spanish to phonetically stress the last syllable of words that end in a consonant (except consonants **n** or **s**). For example, all verbs in the infinitive have the phonetic accent on the last syllable because they end in a consonant: /**ha**/ /**blar; /co**/ /**mer**/; /**vi**/ /**vir**/. In the same manner, there is a natural tendency in Spanish to phonetically stress the next to the last syllable of words that end in a vowel (**a, e, i, o, u**) and **n** or **s.** For example: /**ca**/ /**sa**/; /**me**/ /**sa**/; /**si**/ /**lla**/; / **si**/ /**llas**/.

When these normal and natural rules of pronunciation are broken, the reader must know that the word is an exception. For this reason, written accents were instituted. A written accent mark is a visual signal to the reader that a particular word has an altered pronunciation. Written accents are always placed on the same syllable where the phonetic accent is found.

Words that have a written accent are divided into the following categories.

PALABRAS AGUDAS

When a word has the phonetic accent on the last syllable and it ends in a vowel, an **n** or **s,** it takes a written accent. The written accent is placed over the vowel that is phonetically accentuated. For example: In the word /**pe**/ /**ón**/, the phonetic stress is on the last syllable /**ón**/; also this word ends in the consonant **n,** therefore, it takes a written accent over the vowel **o.** The word /**Pa**/ /**rís**/ has the phonetic stress on the last syllable /**rís**/, also this word ends in the consonant **s;** therefore, it takes a written accent over the vowel **i.**

PALABRAS GRAVES O LLANAS

When a word has the phonetic accent on the next-to-last syllable and it does not end in a vowel, an **n,** or an **s,** it takes a written accent. For example, in the word /**lá**/ /**piz**/, the phonetic accent is on the syllable before last /**lá**/; also this word does not end in a vowel, an **n,** or an **s,** so it takes a written accent over the vowel **a.**

PALABRAS ESDRÚJULAS AND SOBREESDRÚJULAS

When a word has a phonetic accent on the third or fourth syllable before the last, it automatically takes a written accent on that syllable. For example, in the word /sí//la//ba/, the phonetic accent is on the third syllable before last /sí/; therefore, it takes a written accent over the vowel **i**. In the word /rá/ /pi/ /da/ /men/ /te/, the phonetic stress is on the fourth syllable before last /rá/; therefore, it takes a written accent over the vowel **a.**

Another important factor that determines whether a word takes a written accent is the diphthong. In Spanish, vowels are divided into strong vowels and weak vowels according to the strength of pronunciation. The strong vowels are **a, e,** and **o.** The weak vowels are **i** and **u.** A diphthong occurs when there is a strong and a weak vowel, or two weak vowels together in one word. When this occurs, there is a natural tendency of placing the phonetic accent on the strong vowels. For example: In the word /jau//la/, the phonetic stress is on the vowel a on the syllable /jau/.

When the phonetic stress is on a weak vowel (**i** or **u**), a written accent is placed over that vowel in order to increase its strength and to let the reader know that the word has an altered pronunciation. For example, in the name /Ma/ /rí/ /a/, the phonetic stress is on the vowel **i**; therefore, a written accent is placed over this vowel. When a written accent is placed over a weak vowel, the diphthong is broken and the syllable becomes two separate syllables. For example, in the word /diá/ /lo/ /go/, the syllable /dia/ is a single syllable because the vowel **a** is a strong vowel and it takes over the weak vowel **i.** When a weak vowel is stressed as in the word /dí/ /a/, a written accent is placed on the weak vowel—the diphthong is broken and the syllable is divided in two.

A diphthong also occurs when there are two weak vowels together on a word. If the phonetic accent is placed on one of these syllables, that vowel behaves like a strong vowel that would not modify the way the word is divided into syllables. For example, in the word /cui//da/, the phonetic accent in on the vowel **i,** and the diphthong is not broken.

If the letter **h** divides a strong and a weak vowel or two weak vowels, the diphthong remains because the **h** is mute in Spanish.

In the case of adverbs, they take a written accent only if the adjectives from which they are formed are also accentuated. For example, the adverb /rá/ /pi/ /da/ /men/ /te/ takes a written accent because the adjective **rápido** also takes one. The adverb **lentamente** does not take a written accent because the adjective **lento,** from where it is formed, does not take an accent.

Other words take written accents not because of phonetic rules, but to differentiate them from similar words with a different function. You might have noticed that many pronouns have written accents to differentiate them from articles, adjectives, or verbs with a similar spelling; for example, **esta casa** (adjective); **ésta es roja** (pronoun); **Juan está en su casa** (verb).

Test Yourself: 1) Circle the syllable where the phonetic accent is found in the following words.

1. a-mi-go
2. des-ti-no
3. i-dio-ma
4. per-so-na
5. pa-dre
6. es-tu-dian-te
7. te-le-vi-sor
8. ca-mi-nar
9. ac-ción
10. com-pu-ta-do-ra
11. va-ca-cio-nes
12. te-a-tro
13. za-pa-to
14. lá-piz
15. i-dio-ma
16. bon-dad
17. al-fom-brar
18. can-de-la-bro
19. men-sa-je-ro
20. tí-tu-lo

Test Yourself: 2) Put a written accent on the following words.

1. ca-mion
2. a-vion
3. des-pues
4. a-cua-ti-co
5. an-ti-pa-ti-co
6. a-no-ni-mo
7. ca-ma-ra
8. ca-pi-tu-lo
9. car-bon
10. ces-ped
11. cin-tu-ron
12. di-ver-sion
13. e-jer-ci-to
14. e-xi-to
15. fi-lo-so-fo
16. ge-ne-ro
17. nu-me-ro
18. ju-gue-ton
19. ma-qui-na
20. mas-ca-ra

Test Yourself: 3) Circle the diphthongs found in the following words. Note that not all the words have diphthongs.

1. diario
2. criado
3. diálogo
4. ciudad
5. teología
6. aduana
7. país
8. hielo
9. huérfano
10. oído
11. airado
12. peine
13. distribuir
14. deleitable
15. huerto
16. día
17. policía
18. huir
19. teníamos
20. aeropuerto

Test Yourself: 4) Put a written accent on the following words when needed.

1. calle
2. felicidad
3. automovil
4. armario
5. opera
6. satelite
7. lampara
8. arbol
9. dia
10. paisaje
11. montaña
12. nevera
13. diversion
14. noticia
15. periodico
16. tarea
17. autopista
18. electricidad
19. platano
20. publico

Test Yourself: 5) Put a written accent on the following adverbs when needed.

1. lentamente
2. automaticamente
3. rapidamente
4. sinceramente
5. habilmente
6. bondadosamente
7. inteligentemente
8. intimamente
9. proximamente
10. ultimamente

Test Yourself: 6) Read the following paragraph and place a written accent where needed.

Durante los proximos tres dias, la policia de carreteras tratara de instruir al publico sobre la necesidad de obedecer la ley de transito. Estas leyes existen con el proposito de proteger vidas y salvaguardar el orden publico. Es importante abrocharse el cinturon de seguridad cuando se anda en un automovil. Esta accion les puede salvar la vida al conductor y a sus pasajeros en caso de un accidente. Es necesario manejar a una velocidad adecuada como manda la ley. Y sobre todo, no se debe conducir embriagado. Su vida y la vida de otras personas corren peligro. Estos seran algunos de los temas que la policia de carreteras explicara a los miles de automovilistas en esta ciudad en los proximos dias.

Test Yourself Answers

1)

1. mi	11. cio		
2. ti	12. a		
3. dio	13. pa		
4. so	14. lá		
5. pa	15. dio		
6. dian	16. dad		
7. sor	17. brar		
8. nar	18. la		
9. ción	19. je		
10. do	20. tí		

2)

1. camión	11. cinturón
2. avión	12. diversión
3. después	13. ejército
4. acuático	14. éxito
5. antipático	15. filósofo
6. anónimo	16. género
7. cámara	17. número
8. capítulo	18. juguetón
9. carbón	19. máquina
10. césped	20. máscara

3)

1. ia; io	11. ai
2. ia	12. ei
3. —	13. ui
4. iu	14. ei
5. —	15. ue
6. ua	16. —
7. —	17. —
8. ie	18. ui
9. ue	19. —
10. —	20. ue

4)

1. —	11. —
2. —	12. —
3. automóvil	13. diversión
4. —	14. —
5. ópera	15. periódico
6. satélite	16. —
7. lámpara	17. —
8. árbol	18. —
9. día	19. plátano
10. —	20. público

5)

1. —	6. —
2. automáticamente	7. —
3. rápidamente	8. íntimamente
4. —	9. próximamente
5. hábilmente	10. últimamente

6) Durante los próximos tres días, la policía de carreteras tratará de instruir al público sobre la necesidad de obedecer la ley de tránsito. Estas leyes existen con el propósito de proteger vidas y salvaguardar el orden público. Es importante abrocharse el cinturón de seguridad cuando se anda en un automóvil. Esta acción les puede salvar la vida al conductor y a sus pasajeros en caso de un accidente. Es necesario manejar a una velocidad adecuada como manda la ley. Y sobre todo, no se debe conducir embriagado. Su vida y la vida de otras personas corren peligro. Estos serán algunos de los temas que la policía de carreteras explicará a los miles de automovilistas en esta ciudad en los próximos días.

Vocabulary

The vocabulary words listed in this section have been put together to include words not found elsewhere in this grammar book so that you may develop a broader Spanish vocabulary. Some basic terms learned in lower-level Spanish courses have been excluded.

SPANISH-ENGLISH

A

amanecer to dawn; dawn
abandonado abandoned
abarcar to take up; encompass; include
abertura opening
abierto open; opened
abismo abyss; gulf
abogado lawyer
aborrecer to detest; to hate
abrazar to embrace; to hug
abrigar to cover up; to bundle up
abrochar to fasten
aburrido to be bored; boring
aburrir to bore
acabar to finish
acampar to camp out
aceite oil
aceituna olive
acelerador accelerator; gas pedal
acera sidewalk
acerca de about
acercarse to go near
acero steel
acertar to guess correctly
acompañar to accompany
aconsejar to advise

acordarse to remember
acostar to lie down
acostumbrarse to get used to
actual current; present
actuar to act
acuático aquatic
acudir to go to; to come to
acuerdo agreement
adelantar to advance
además besides
adivinar to guess
adornar to decorate
adorno decoration
adquirir to acquire
aduana customs
adversario opponent; adversary
advertencia warning
advertir to warn; to notify
afeitar to shave
aficionado amateur; fan
afrontar to confront
afuera outside
afueras outskirts
agarrar to grab
agitado to be agitated

agitar to stir; to agitate
agradable pleasant
agradar to please
agregar to add to
aguantar to hold; to bear
ahogar to drown
ahora now
ahorrar to save
aire air
aislado isolated
ajedrez chess
ajeno foreign; somebody else's
ajustar to adjust
ala wing
alabar to praise
alargar to lengthen
alcalde mayor
alcanzar to reach
alcoba bedroom
alcohol alcohol
aldea village
alegrarse to cheer up
alegría happiness
alemán German
aleta fin
alfiler pin
alfombra carpet
alga seaweed
algodón cotton
alguien somebody
alguno some
alimento food
alma soul
almacén shop; grocery store
almendra almond
almohada pillow
almorzar to lunch
almuerzo lunch
alojamiento lodgings
alojar to lodge
alquilar to rent
alquiler rent
alrededor de around
altura height
alzar to raise; to lift
amar to love, to be fond of
amargar to make bitter
ambos both
amenazar to threaten

amistad friendship
amo master
analfabetismo illiteracy
ancho wide
anchura width
anciano old man
andar to walk; to go
andén platform
angosto narrow
angustia anguish; distress
anillo ring
animado lively
animar to encourage
anoche last night
anochecer nightfall; dusk
anónimo anonymous
ante before; in the presence of
anteojos eyeglasses
antepasados ancestors
anterior previous
antes before
antiguo old; ancient
antipático disagreeable
anuncio announcement; advertisement
añadir to add
aparecer to appear
apatía apathy
apenarse to grieve; to be ashamed
apenas hardly; scarcely
aplicado studious; industrious
apoyo support
aprender to learn
apretar to tighten; to squeeze
aprovecharse to take advantage of
apuntar to write down
apunte note
archivar to file
arco bow; arch
arena sand
arete earring
arma firearm
armario closet; wardrobe
arquero archer
arquitectura architecture
arrancar to pull out; to snatch
arreglar to arrange
arrepentirse to regret
arroyo stream
arroz rice

arruga wrinkle
arruinado ruined
arruinar to ruin
artesano craftsman
ascendencia ancestry; origin
ascender to ascend
ascensor elevator
asegurar to assure
aseo cleanliness
asequible within grasp; available
asilo asylum
asistir to attend
asombrarse to be astonished; to be amazed
aspiradora vacuum cleaner
aspirar to aspire
asunto matter; subject
asustado frightened
asustar to frighten
asustarse to be frightened
atacar to attack
atención attention
atender to serve; to look after
atentamente attentively; thoughtfully

aterrador frightening; terrifying
aterrizar to land
atraer to attract
atrapar to trap
atravesar to cross; to pass through
atrevido daring; bold
auge period of prosperity
aumentar to increase
aún even
aunque although; even though
auricular receiver; earpiece
ausente absent
avanzar to advance
ave bird
averiguar to find out; to investigate
aviso notice; warning
ayuda help; assitance
ayudante helper; assistant
ayuno fasting
azafrán saffron
azúcar sugar
azufre sulphur
azulejo tile

B

bahía bay
bajar to lower
bajo short
balanza scale
banco bank
bandera flag
banquero banker
bañar to bathe
bañarse to take a bath
barato cheap; inexpensive
barco boat
barrer to sweep
barrera barrier; obstacle
barro clay; mud
bastante enough; sufficient
bastar to suffice
basura garbage; waste
bata robe
baúl trunk
belleza beauty
billete ticket
blando soft
bocina loudspeaker; horn

boda wedding
bodega warehouse
boleto ticket
boliche bowling
bolsa bag; purse
bolso bag; purse
bombero fireman
bombilla light bulb
bondadoso kind
bosque forest
bostezar to yawn
bota boot
boticario pharmacist; druggist
bravo angry; brave
breve brief
brillar to shine
broma joke; prank
bruja witch
burlarse trick; to deceive; make fun of
burro donkey; ass
busca search
buscar to look for
buzón mailbox

C

cabello hair
caber to fit
cabo end; cape
cabra goat
cacique Indian chief
cadena chain
caer to fall
caja box
cajero cashier
calabaza pumpkin
calcetín sock
calidad quality
calificación grade; mark
calificar to grade
callarse to keep quiet
calumnia slander
cámara camera; chamber
camarera waitress; chambermaid
cambiar to change
campamento camp
campaña campaign
campeón champion
campeonato championship
campesino peasant
campo countryside
canal channel
canasta basket
cancha court
cansado tired; weary
cantante singer
cantidad quantity
canto song
capítulo chapter
caprichoso whimsical; willful
captar to win; to secure
cara face
carbón coal
carcajada loud laugh
cárcel jail
carecer to lack; to be in need of
cargado laden; loaded
cargo load; cargo
caridad charity
cariño affection
carnicería butcher shop
caro expensive
carpintero carpenter

carrera race; career
carretera road
carril lane
cartel poster
cartera wallet
casarse to marry
cascada cascade; waterfall
caseta booth
casi almost
caso case
castañuelas castanets
castigar to punish
castigo punishment
castillo castle
cataratas waterfalls
catre cot
causa cause
cautivo captive
cebolla onion
cegar to blind
célebre famous
celoso jealous
cena dinner; supper
centro center
cepillar to brush
cepillo brush
cercano near
cereza cherry
certidumbre certainty
cesar to cease; to stop
césped grass; lawn
ciego blind
cielo sky
ciencia science
cine movie theater
cinta ribbon; tape
cintura waist
ciudadano citizen
clima climate
cobrar to charge; to collect
cocinar to cook
cofre chest
coger to seize; to take
cohete rocket
cola tail
coleccionar to collect
colgar to hang up

colina hill
colocar to place
colorado red
colorido colorful
comedia comedy
comedor dining room
comentar to comment on
comenzar to begin; to start
comestible foodstuff
cómodo comfortable
compañía company.
compartir to share
competir to compete
complejo complex
componer to compose; to repair
compra purchase
comprador buyer
comprensión comprehension
comprometido engaged
compromiso commitment; engagement
común common
concluir to conclude; to finish
concurso contest
condenar to condemn
conducir to drive
conductor driver
confesar to confess
confianza trust
confiar to confide in
congelar to freeze
conmover to affect
conocer to know
conocido known
conseguir to get; to obtain
consejero advisor; counselor
consentir to consent; to allow
consistir en to consist of
construir to construct
consultar to consult with
consultorio doctor's office
consumo consumption
contar to count
contener to contain
contestar to answer
contra against
contrario opposed
contrastar to contrast
contribuir to contribute
convencer to convince

conversar to converse
convertir to convert
convidar to invite
copa cup
copia copy
cordillera mountain range
coro chorus
corona crown
corregir to correct
correo mail
corriente current
cortar to cut
corte court
cortesía courtesy
cortina curtain
corto short
cosecha harvest
coser to sew
costar to cost
costumbre custom; habit
creador creator
crecer to grow
creer to believe
cría breeding
criado servant
cruz cross
cruzar to cross
cuadra street block
cuadro painting; frame
cualquier any
cuarto room; fourth
cubrir to cover
cuchillo knife
cuenta bill
cuentista storywriter
cuento story
cuerda rope
cuidado care
cuidadoso careful
cuidar to take care
culpa blame
cumbre top; mountain top
cumplir to fulfill
cuna cradle
cura priest; cure
curar to cure; heal; recover
curiosidad curiosity
curioso curious; odd
cuyo whose

CH

chal shawl
champú shampoo
chaqueta jacket
chica girl
chico boy
chimenea fireplace

chiste joke
chistoso funny
chivo goat
chocar to crash
chofer chauffeur; driver

D

dama lady
dañar to damage; to hurt
daño damage; hurt
dar to give
dato fact
debajo de under
deber ought to; should
debido a because of; due to
débil weak
decir to say
decisión decision
declaración statement
decorar to decorate
dedicar to dedicate
dedo finger
defectuoso defective
defender to defend
delgado thin
demás the rest
demasiado excessive; too much
demorarse to delay
dentro de inside of; within
deportivo sporting
derecha right hand; right side
derecho straight
derrota defeat
desaparecer to hide; to disappear
desarrollo development
desayunar to have breakfast
descansar to rest
descolgar to take down
desconocer not to know
descortés impolite
descubierto discovered
descubrir to discover
desde from; since
desear to wish
desembocar to flow into; empty into

desenvolvimiento unfolding; development
desesperar to despair
desfilar to parade; to march
desfile parade
desgraciadamente unfortunately
deshacer to undo
deslizarse to slip; to slide; to glide
desmayarse to faint
despacho office; study
despacio slowly
despedirse to say goodbye
despertador alarm clock
despertar to awaken
después after; later
destacado standing out
destinado destined
destruir to destroy
detalle detail
detener to detain
detrás behind
devolver to give back
día day
diablo devil
dibujar to draw
dictadura dictatorship
dieta diet
dios god
dirigir to direct
disciplina discipline
disculparse to excuse oneself
diseñador designer
diseño design
disfraz disguise; mask
disfrutar to enjoy
disparo shot
distinguir to distinguish
distinto different
distraído absent-minded

distribuir to distribute
diversión amusement
divertirse to enjoy oneself
doblar to bend
docena dozen
doler to hurt
dolor pain
domicilio home, domicile
dominar to dominate
dominio control

dondequiera wherever
dormitorio bedroom
dramaturgo playwriter
dudar to doubt
dueño owner
dulce sweet
dulzura sweetness
durar to last
duro hard

E

echar to expel; to throw out
economía economy
edad age
educar to educate
eficaz effective; efficient
ejemplo example
ejercer to exert; to practice
ejército army
elaborar to elaborate
elegir to choose
embarcar to embark
emisora radio station
emocionante exciting; thrilling
empeñarse en to insist on; to be determined to
empezar to begin; to start
empleado employee
emplear to employ; to use
emprender to undertake
empresa company
enamorado in love
encantado delighted; enchanted
encarcelado imprisoned; jailed
encargar to entrust; to put in charge
encender to light; to ignite
encerrar to lock up
encima de on top of; above
encogerse to shrink
encontrar to find; to meet
encuesta survey; poll
energía energy
enfermarse to become ill
enfrente de in front of
engañar to deceive
enojar to anger
enriquecer to enrich
enterarse to find out; about

enterrar to bury
entonces then
entrada entrance
entregar to hand over; to give in
entretener to entertain
entrevista interview
enviar to send
envidiar to envy; to desire
envolver to wrap
época epoch; age; period
equipo equipment; team
equivalente equivalent
equivocarse to make a mistake
escalera stairs; ladder
escapar to escape
escasez scarcity
escenario stage
escoger to choose
esconder to hide
escrito written
escritorio desk
escuchar to listen
escultor sculptor
esfuerzo effort
eso that
espacio space
espada sword
especie kind of; species
esperar to wait
espeso thick
esquina corner
establecerse to establish oneself; to settle
estación season; station
estadio stadium
estado state; condition
estallar to break out; to burst

estante shelf
estatua statue
estilizar to stylize
estilo style
estirarse to stretch
estrecho narrow; tight; intimate
estreno first use; first performance
excelencia excellence
exigir to demand

éxito success
experimentar to experiment
expulsar to expel
extensión extension; length; range
extinguir to extinguish
extranjero foreign
extrañar to miss
extraño strange; odd

F

fábrica factory
fabricar to manufacture
facultad faculty
falda skirt
falta fault; mistake
fama fame
fantasma ghost
fascinar to fascinate; to captivate
fe faith
felicitar to congratulate
feliz happy
feria fair
feroz fierce
ferretería hardware store
fiarse to trust
fiebre fever
figura figure
fijarse to notice
filoso sharp
fin end
fingir to pretend

firmar to sign
florecer to flourish
folleto brochure; pamphlet
fomentar to promote; to encourage
fondo bottom; background; fund
fortaleza fortress
fotografía picture; photograph
fracasar to fail
frecuencia frecuency
freno brake
frente forehead
fresa strawberry
fresco fresh; cool
frontera frontier
fuego fire
fuera outside
fuerte strong
fuerza strength
fumar to smoke
fundar to found; to establish
fusilar to shoot; to execute

G

gafas glasses
galleta cookie
ganas desire; will
ganar to win
ganga sale; bargain
garbanzo chickpea
garganta throat
gastar to spend
gemelo twin
género gender; kind
gente people
gerente manager; director
gigantesco gigantic

girar to revolve
gitano gypsy
globo balloon
gloria glory
gobierno government
goma rubber; gum
gorra cap
gota drop
gozar to enjoy
grabadora recorder
grabar to record
graduarse to graduate
granja farm

grano grain
grito scream
grueso thick; bulky
gruñir to growl; to grunt
guapo attractive; handsome

guardar to keep
guardia guard
guerra war
guía guide
gusto pleasure; taste

H

hábil skillful; able
hablador talkative
hacer to do
hacha ax
hacia towards
hada fairy
hamaca hammock
hambre hunger
harina flour
hasta until; as far as
hazaña deed; exploit
hecho act; fact
helar to freeze
heredado inherited
herido hurt; wounded
hermoso beautiful
hervir to boil

hielo ice
hierba weeds
hierro steel
hilo thread
historia history
hoja leaf
hombro shoulder
horario schedule
horno oven
hostal inn
hubo there was
huelga strike
huerta orchard
huésped guest
huir to flee
humedad humidity
humilde humble

I

identidad identity
idioma language
iglesia church
igual the same
ilustre illustrious; famous
imagen image; figure
impedir to prevent; to obstruct
impermeable raincoat
imponer to impose
importar to matter; to be important
importe amount; cost
impreso printed
imprimir to print
impuesto tax
incluir to include
incómodo uncomfortable
inconformista nonconformist
indeciso indecisive
indicar to indicate; to suggest

indígena indigenous; native
indio Indian
influir to influence
ingeniero engineer
iniciar to initiate
inmenso immense
inmigración immigration
innumerable countless
inolvidable unforgettable
inscribirse to register; to enroll
intercambio exchange
inundar to flood
inútil useless
invitado guest
inyección injection; shot
ir to go
ira anger; rage
isla island
izquierdo left

J

jabón soap
jamás never
jamón ham
jarabe cough syrup
jardín garden
jarro jug; pitcher
jefe boss; chief
jinete horseman
joyería jewelry
judío Jew

juez judge
jugador player
jugar to play
juguetería toy store
juguetón playful
juicio judgement
juntar to join; to unite
junto together
jurado jury; panel
juventud youth

L

locutor announcer
lograr to achieve
lado side
ladrillo brick
ladrón thief
lago lake
laguna lagoon
lamentar to lament; to regret
lana wool
lanzar to throw
largo long
lástima pity
lastimarse to hurt oneself
lavandería laundry
lavaplatos dishwasher
lavar to wash
leal faithful
lechería dairy store
lechuga lettuce
lectura reading
legumbre vegetable
lejano distant
lejos far
lengua tongue
lenguaje language
lente lens, glass
lento slow
leña firewood
letra letter

letrero sign
levantarse to get up
ley law
leyenda legend
libertad freedom
libra pound
libre free
librería bookstore
ligero light
limitar con to border with
limosna alms; charity
limpiar to clean
limpio clean
linterna lantern; flashlight
lío mess
listo ready; intelligent
localidad location
lodo mud
lucha fight; struggle
luego then; afterwards
lugar place
lujoso luxurious
luna moon
lunático having fits of madness
lupa magnifying glass
lustrar to polish
luto mourning
luz light

LL

llama llama
llamada call

llano flat; level; plain
llanto weeping; crying

llanura plain
llave key
llegada arrival
llegar to arrive

llenar to fill
llevar to carry
llover to rain

M

madera wood
madrugar to get up early
maestría mastery; skill
maíz corn
maleta suitcase
malgastar to waste
mancha stain
mandado order; errand
mandar to send; to order
manejar to drive
manera way; manner
manga sleeve
mantel tablecloth
mantener to maintain
mantequilla butter
manto cloak; mantle
máquina machine
marca brand
marcharse to leave; to go away
marido husband
marisco shellfish
marrón brown
mascar to chew
masticar to chew
materia subject
materno maternal
matricularse to enroll
mayor greater
media stocking
médico doctor
medio half
mediodía noon
medir to measure
mejor better
menester need
menor younger; minor
menos less
mentir to lie

mentira lie
merecer to deserve
merienda afternoon snack; supper
mesero waiter
meter to put in; to fit in
metro meter, subway
mezcla mixture
mezclar to mix
mientras during
milagro miracle
milla mile
miseria misery
mismo same
misterio mystery
mitad half
moda fashion
modismo idiom
modo manner, way
molido grounded; crushed
moneda coin
montaña mountain
monte hill
morado purple; violet
morder to bite
morir to die
mostrador counter
mostrar to show
mover to move
muchedumbre crowd
mueble furniture
muerte death
muerto dead
multa fine; penalty
multar to fine
multitud multitude; crowd
mundial worldwide
mundo world
muñeca doll; wrist

N

nacer to be born
nada nothing

nadador swimmer
nadar to swim

nadie no one
natación swimming
naturaleza nature
nave vessel; ship
neblina fog
necesitado needy
negar deny
negocio business
nieta granddaughter
nieto grandson

ninguno nobody
nivel level
noche night
nota note; grade
noticia news
noticiero newscast
novedad novelty
nube cloud
nudo knot
nunca never

O

obedecer to obey
obligar to force
obra work
obrero worker
obtener to obtain
ocaso sunset
occidental western
ocupado occupied; busy
ocurrir to happen; to occur
odiar to hate
ofrecer to offer
oír to hear
oler to smell

oliva olive
olla pot
olvidar to forget
onda wave
oponerse to be opposed to
opuesto opposite
oración sentence
orgulloso proud
orilla shore; edge
oscuro dark
otorgar to grant; to award
oveja sheep

P

paisaje lansdcape
paja straw
pájaro bird
palma palm tree
palo stick
panadería bakery
pantano swamp
pañuelo handkerchief
papelería paper store
par pair
parada stop
paraguas umbrella
parecer to seem
parecido similar
pareja couple
pariente relative
párrafo paragraph
partido game; match
partir to depart; to start

pasado past
pasajero passenger
pasar to pass
paseo stroll; outing
pasillo aisle
paso step
pastel cake
paterno paternal
patinar to skate
patria fatherland; motherland
patrulla patrol
pedazo piece
pedir to ask for
peinar to comb
pelear to fight
película film; movie
peligroso dangerous
peluquería barbershop
peluquero hairdresser

pena pity
pensamiento thought
pensar to think
peor worse
perder to lose
permanecer to remain; to stay
permiso permission
personaje character
pertenecer to belong to
pesca fishing
pescado fish
pez fish
pícaro mischievous; sly
pie foot
piedra stone; rock
piel skin
píldora pill
pintar to paint
piña pineapple
pisar to step on
piscina swimming pool
piso floor
pista clue
placer pleasure
plano flat; level
plata silver
playa beach
plomo lead
población population
pobre poor
poco little
poder to be able to
poesía poem
policía police
polvo dust
poner to put; to place
portarse to behave
porvenir future

poseer to own; to possess
potencia potential
precio price
precioso precious; lovely
preciso precise
precursor forerunner
preferir to prefer
premio prize
preparar to prepare
preparativo preparation
presidir to preside
preso prisoner
préstamo loan
prestar to lend
prevenir to prevent
primaria elementary school
primario primary
primo cousin
principio beginning
prisa hurry; haste
probar to prove
producir to produce
prometer to promise
pronto soon
propina tip
propio proper
proponer to propose
protagonista main character
proteger to protect
próximo next
prueba test
publicar to publish
público public
pueblo town
puente bridge
pulga flea
punto point
pureza purity

Q

quebrar to break; to smash
quedar to remain; to have left
quehacer chore
quejarse to complain
quemar to burn
querer to want; to wish; to love
querido dear

queso cheese
quiebra break; crack; fissure
quienquiera whoever
quietud quietness; tranquility
química chemistry
quitar to take off; remove
quizás perhaps

R

radicar to take root; to be situated
raíz root
ramo branch; bunch
rana frog
rápido fast
raqueta racquet
raza race
razón reason
realizar to achieve a goal
rebajado reduced
rebozo wrap; shawl
recado message
receta recipe
rechazar to reject
recibir to receive
recoger to gather; to pick up
reconocer to recognize
recordar to remember
recorrer to travel; to tour
recuerdo remembrance
recurso resource
red net
redondo circular; round
refresco refreshment
regalar to give
regalo gift
regar to water
regla ruler; rule
regresar to return
rehusar to refuse
reina queen
reino kingdom

reirse to laugh
relámpago lighting
rellenar to stuff; to fill
relleno stuffing; filling
remar to row
remendar to patch; to mend
rendir to produce; to yield
renovar to renew; to restore
reñir to quarrel
repartir to distribute
replicar to argue; to answer back
resfriarse to catch a cold
resfrío cold
resolver to resolve
respirar to breathe
restos remains
retrato portrait
reunión meeting; gathering
reunirse to reunite
rezar to pray
riego irrigation
rincón corner
riqueza wealth; riches
risa laugh
robo theft; robbery
rodear to surround
rogar to beg
rompecabezas puzzle
romper to break; to tear up
roto broken
ruido noise
rumor murmur; rumor

S

saber to know
sabio wise person
sabor taste; flavor
sabroso delicious; tasty
sacar to take out
sacerdote priest
saco jacket
sacrificar to sacrifice
sagrado sacred
sala living room
salida exit
salir to come out; to leave

saltar to jump
salto jump; leap
salud health
saludable healthy
saludar to greet
salvo safe
sangre blood
sano healthy; fit
santo saint
secadora dryer
seco dry
secundaria high school

seda silk
seguido continuous
según according to
seguridad security; safety
seguro safe; secure; certain
sello stamp
selva jungle
semáforo traffic light
sembrar to seed; to sow
sencillez simplicity
sentido sense; meaning
señal signal
servilleta napkin
servir to serve
siglo century
significado meaning
significar to mean
siguiente following; next
sillón chair
simpático likeable
sirena siren
sitio place; site
sobrar to exceed
sobre envelope; on; over; above
sobrevivir to survive
sobrio sober
socio partner; member
soga rope
soldado soldier
solicitud application
solo alone

soltar to let go of
sombra shade; shadow
sometido subjected
sonar to sound
sonreír to smile
soñar to dream of
sopa soup
soplar to blow
sordo deaf
sorprenderse to be surprised at
sorpresa surprise
sostener to hold; to support
sótano basement
subir to raise; to go up
subrayado underlined
suceder to happen; to succeed
suceso event; happening
sucio dirty
sueldo salary
suelo ground; floor
sueño dream
sufrir to suffer
sugerencia suggestion
superficie surface
suplicar to beg for; to implore
suprimir to suppress
sur south
surgir to arise; to emerge
suspirar to sigh
suspiro sigh
sustituir to substitute; to replace

T

tabla board; plank
taller workshop
tamaño size
tampoco neither
tapa lid; cover; snack(Spain)
tapiz tapestry
tardanza delay
tardar to delay; to be late
tarde late
tarea assigment; chore
tarjeta card
techo roof
tela cloth
teléfono telephone

televisor television
televisión television
tema theme; topic
temblar to tremble
temer to fear
templado temperate
tenedor fork
tener to have
terminar to finish
terraza terrace; balcony
terremoto earthquake
terreno terrain; land
tertulia social gathering; group
tesoro treasure

testigo witness
tiempo time
tienda store
tijeras scissors
tipo type; kind
título title
toalla towel
tocar to touch
todavía still; yet
todo all
tontería foolishness
torcer to twist
tormenta storm
torre tower
torta cake
tos cough

trabajador worker
traducir to translate
traer to bring
traje suit
tranquilo tranquil; peaceful; calm
trás after
tratar to treat
travesura prank
trigo wheat
tristeza sadness
tropezar to stumble; to trip
trozo piece
trueno thunder
tumba tomb; grave
turno turn, shift

U

único only; unique
unidad unit; unity
unido united

uña nail; fingernail; toenail
útil useful
uva grape

V

vaca cow
vacilar to hesitate
vacío empty
valioso valuable
valor valuable
vapor steam
vaquero cowboy
variar to vary
varios several
vaso glass
vecino neighbor
vela candle
veloz swift; quick
vencer to conquer
vender to sell
vengar to avenge
verdad truth

vestuario wardrobe; costumes
vez time
vicio vice
vidrio glass
vino wine
víspera eve; day before
vista view
viuda widow
viudo widower
vivo alive; lively
volar to fly
volcar to overturn; to spill
volver to return
voz voice
vuelo flight
vuelta turn

Z

zapatería shoe store

ENGLISH – SPANISH

A

abandoned abandonado
abduction rapto
able hábil
about acerca de
above encima de; sobre
absent ausente
absent-minded despistado
abyss abismo
accompany acompañar
according to según
achieve lograr; realizar
acquire adquirir
act actuar
add agregar; añadir
adjust ajustar
advance adelantar; avanzar
adversary adversario
advertisement anuncio
advice aconsejar
advisor consejero
affect afectar
affection cariño
after después; trás
afterwards luego
against contra
age edad; época
agitated agitado
agreement acuerdo
air aire
aisle pasillo
alarm clock despertador
alcohol alcohol
alive vivo
all todo
allow consentir
alm limosna
almond almendra
almost casi
alone solo
although aunque
amount cantidad
amusement diversión

ancestors antepasados
ancient antiguo
anger enojar; ira
angry enojado
anguish angustia
announcement anuncio
announcer locutor
anonymous anónimo
answer contestar
answer back replicar
any cualquier
apathy apatía
appear aparecer
application solicitud
aquatic acuático
arch arco
archer arquero
architecture arquitectura
army ejército
around alrededor de
arrange arreglar
arrival llegada
arrive llegar
as far as hasta
ask for pedir
aspire aspirar
assignment tarea
assistant ayudante
assistance ayuda
astonished asombrarse
asylum asilo
at least siquiera
attack atacar
attend asistir
attention atención
attentively atentamente
attract atraer
attractive guapo
avenge vengar
awaken despertar
award otorgar
axe hacha

B

background fondo
bag bolsa; bolso
bakery panadería
balcony terraza
balloon globo
bank banco
banker banquero
barber peluquero
barber shop peluquería
bargain ganga
barrier barrera
basement sótano
basket canasta
basketball baloncesto
bathe bañar
bay bahía
be able to poder
be determined to empeñarse en
be born nacer
be opposed oponerse
be ser; estar
be late tardar
be frighten asustarse
be bored aburrido
be amazed asombrarse
be surprised at sorprenderse
beach playa
bear aguantar
beautiful hermoso
beauty belleza
because of debido a
become ill enfermarse
bedroom alcoba; dormitorio; recámara
before ante; antes
beg for suplicar
beg rogar
begin comenzar; empezar
beginning principio
behave comportarse
behind detrás
believe creer
belong to pertenecer
beloved amado
bend doblar
besides además
better mejor

bird ave; pájaro
bite morder
bitter amargo
blame culpa
blanket manta; cobija
blind cegar; ciego
blood sangre
blow soplar
board tabla
boat barco
boil hervir
bold atrevido
bookstore librería
boot bota
booth caseta
border with limitar con
bore aburrir
boring aburrido
boss jefe
both ambos
bottom fondo
bow arco
bowling boliche
box caja
boy chico
brake freno
branch rama
brand marca
brave bravo
break out estallar
breathe respirar
brick ladrillo
brown marrón
brush cepillar; cepillo
bulky grueso
bundle up abrigar
burn arder; quemar
burst estallar
bury enterrar
business negocio
busy ocupado
butcher shop carnicería
butter mantequilla
buyer comprador
buzz rumor

C

cheese queso

cake pastel; torta

call llamar; llamada

calm tranquilo

camera cámara

camp campamento

camp out acampar

campaign campaña

candle vela

cap gorra

cape cabo

captivate fascinar

captive cautivo

card tarjeta

care cuidado

career carrera

careful cuidadoso

carpenter carpintero

carpet alfombra

carry cargar

cascade cascada

case caso

cash efectivo

cashier cajero

castanets castañuelas

castle castillo

catch a cold resfriarse

cause causa

cease cesar

center centro

century siglo

certain seguro

certainty certidumbre

chain cadena

chair sillón

chamber cámara

chambermaid camarera

champion campeón

championship campeonato

change cambiar

channel canal

chapter capítulo

character personaje

charge cobrar

charity caridad; limosna

chat charlar

chauffeur chofer

cheap barato

check cheque

cheer up alegrarse

chemistry química

cherry cereza

chess ajedrez

chew mascar; masticar

chief jefe

choose elegir; escoger

chore quehacer; tarea

chorus coro

church iglesia

circular redondo

citizen ciudadano

clay barro

clean limpiar; limpio

cleanliness aseo

climate clima

cloak manto

closet armario

cloth tela

cloud nube

clue pista

coal carbón

coin moneda

cold resfrío

collect coleccionar

collect cobrar

colorful colorido

comb peinar

come out salir

comedy comedia

comfortable cómodo

comment on comentar

commitment compromiso

common común

company compañía

compel obligar

compete competir

complain quejarse

compose componer

comprehension comprensión

conclude concluir

condemn condenar

condition estado

confess confesar
confide in confiar
congratulate felicitar
conquer vencer
consent consentir
consist of consistir en
construct construir
consult with consultar
consumption consumo
contain contener
contest concurso
continuous seguido
contribute contribuir
converse conversar
convert convertir
convince convencer
cook cocinar
cool fresco
copy copia
corn maíz
corner esquina; rincón
correct corregir
cost costar
costumes vestuario; disfraces
cot catre
cotton algodón
cough tos
cough syrup jarabe
counselor consejero

count contar
counter mostrador
countless innumerable
countryside campo
couple pareja
court cancha; corte
courtesy cortesía
cousin primo; prima
cover up abrigar
cover cubrir, tapar
cow vaca
cowboy vaquero
cradle cuna
craftsman artesano
crash into chocar
creator creador
cross atravesar; cruzar
crowd muchedumbre; multitud
crown corona
crushed molido
cup copa
cure cura
curiosity curiosidad
curious curioso
current actual; corriente
curtain cortina
custom costumbre
customs aduana
cut cortar

D

dairy store lechería
damage dañar; daño
dangerous peligroso
daring atrevido
dark oscuro
dawn amanecer
day before víspera
dead muerto
deaf sordo
dear querido
death muerte
deceive burlarse
decision decisión
decorate adomar; decorar
decoration adorno
dedicate dedicar
deed hazaña

defeat derrota
defective defectuoso
defend defender
delay demorarse; tardar
delicious sabroso
delighted encantado
demand exigir
deny negar
depart partir
descend descender
deserve merecer
design diseño
designer diseñador
desire desear
desk escritorio
despair desesperar
destined destinado

destiny destino
destroy destruir
detail detalle
detain detener
detest aborrecer
development desarrollo
devil diablo
dictatorship dictadura
die morir
diet dieta
different distinto
dining room comedor
dinner cena
direct dirigir
dirty sucio
disagreeable antipático
disappear desaparecer
discipline disciplina
discover descubrir
discovered descubierto
disguise disfraz
dishwasher lavaplatos

distant lejano; distante
distinguish distinguir
distress angustia
distribute distribuir
do hacer
doctor médico
doll muñeca
dominate dominar
doubt dudar
dozen docena
draw dibujar
dream of soñar
dream sueño
drive conducir; manejar
drop gota
drown ahogar
dry seco
dryer secadora
due to debido a
during mientras
dusk anochecer
dust polvo

E

earring arete
earthquake terremoto
economy economía
edge orilla
educate educar
effective eficaz
efficient eficiente
effort esfuerzo
elementary school primaria
elevator ascensor
embark embarcar
embrace abrazar
emerge surgir
employ emplear
employee empleado
emptiness vacío
enchanted encantado
encompass abarcar
encourage animar
end fin
energy energía
enfold envolver
engaged comprometido
engagement compromiso

engineer ingeniero
enjoy disfrutar; gozar
enjoy oneself divertirse
enough suficiente
enrich enriquecer
enroll inscribirse; matricularse
entertain entretener
entrance entrada
entrust encargar
envelope sobre
envy envidiar
epoch época
equipment equipo
equivalent equivalente
errand mandado
escape escapar
establish oneself establecerse
establish fundar
eve vispera
even though aunque
even aún
event suceso
example ejemplo
excellence excelencia

excessive demasiado

exchange intercambio

excite agitar

exciting emocionante

excuse oneself disculparse

execute fusilar; ejecutar

exert ejercer

exit salida

expel echar; expulsar

expensive caro

experiment experimentar

extension extensión

extinguish extinguir

eyeglasses anteojos

F

face cara

face up afrontar

fact hecho

factory fábrica

faculty facultad

fail fracasar

faint desmayarse

fair feria

fairy hada

faith fe

faithful leal

fall caer

fame fama

famous famoso; célebre; ilustre

fan aficionado

far lejos

farm granja

fascinate fascinar

fashion moda

fast rápido

fasten abrochar

fasting ayuno

fatherland patria

fault falta

fear temer

fever fiebre

fierce feroz

fight lucha; pelea

figure figura; imagen

file archivar

fill llenar; rellenar

filling relleno

film película

fin aleta

find to meet encontrar

find out about enterarse

find out averiguar

fine multa; multar

finger dedo

finish terminar

finish acabar; concluir

fire fuego

firearm arma

fireman bombero

fireplace chimenea

firewood leña

first use estreno

first performance estreno

fish pescado; pez; pescar

fishing pesca

fit in meter

fit caber

flag bandera

flashlight linterna

flat llano; plano

flavor sabor

flea pulga

flee huir

flood inundar

floor piso; suelo

flour harina

flourish florecer

flow into desembocar

fly volar

fog neblina

following siguiente

food alimento

foodstuff comestible

foolishness tontería

foot pie

force obligar

forehead frente

foreign ajeno; extranjero

forerunner precursor

forest bosque
forget olvidar
fork tenedor
fortress fortaleza
fourth cuarto
free libre
freedom libertad
freeze congelar; helar
frequency frecuencia
fresh fresco
friendship amistad

frighten asustar
frightened asustado
frightening aterrador
frog rana
from desde
frontier frontera
fulfill cumplir
fund fondo
funny chistoso
furniture mueble
future porvenir

G

game partido; juego
garbage basura
garden jardín
gas pedal acelerador
gather recoger
gathering reunión
gender género
German alemán
get used to acostumbrarse
get up early madrugar
get conseguir
get up levantarse
ghost fantasma
gift regalo
gigantic gigantesco
girl chica
give dar; regalar
give back devolver
given dado
glass vaso; vidrio
glasses gafas
glide deslizarse
glory gloria
go near acercarse
go away marcharse
go ir
go up subir

goat cabra; chivo
God Dios
government gobierno
grab agarrar
grade calificación; calificar
graduate graduarse
grain grano
granddaughter nieta
grandson nieto
grant otorgar
grape uva
grapefruit toronja
grass césped
grave tumba
greater mayor
greet saludar
ground suelo
ground molido
grow crecer
growl gruñir
grunt gruñir
guard guardia
guess correctly acertar
guess adivinar
guest huésped; invitado
guide guía
gypsy gitano

H

habit costumbre
hair cabello
half medio; mitad

ham jamón
hammock hamaca
hand over entregar

handkerchief pañuelo
hang up colgar
happen ocurrir; suceder
happening suceso
happiness alegría
happy feliz
hardly apenas
hardware store ferretería
harvest cosecha
haste prisa
hate aborrecer; odiar
have tener
have breakfast desayunar
health salud
healthy saludable; sano
hear oír
height altura

help ayuda
helper ayudante
hesitate vacilar
hide esconder
high school secundaria
hill colina
history historia
hold up demorarse
hold aguantar; sostener
horn bocina
hug abrazar
humble humilde
humidity humedad
hunger hambre
hurry prisa
hurt oneself lastimarse
husband marido

I

ice hielo
identity identidad
idiom modismo
ignite encender
illiteracy analfabetismo
illustrious ilustre
image imagen
immense inmenso
immigration inmigración
implore suplicar
impolite descortés
important importante
impose imponer
imprisoned encarcelado
in front of enfrente de
include incluir
increase aumentar
indecisive indeciso
index índice

Indian indio
Indian chief cacique
indicate indicar
indigenous indígena
industrious aplicado
inexpensive barato
influence influir
inherited heredado
initiate iniciar
injection inyección
inside of dentro de
insist on empeñarse en
interview entrevista
investigate investigar; averiguar
invite invitar
irrigation riego
island isla
isolate aislado

J

jacket chaqueta; saco
jail cárcel
jailed encarcelado
jealous celoso
Jew judío
jewelry joyería
join juntar

joke broma; chiste
judge juez
judgment juicio
jug jarro
jump saltar; salto
jungle selva
jury jurado

K

keep guardar
keep quiet callarse
key llave
kind bondadoso; especie; género
kingdom reino

knife cuchillo
knot nudo
know conocer; saber
known conocido

L

lack carecer
ladder escalera
laden cargado
lady dama
lagoon laguna
lake lago
lament lamentar
land aterrizar; terreno
landlord proprietario, dueño
lane carril
language idioma; lenguaje
landscape paisaje
lantern lintcrna
last night anoche
last durar
late tarde
later después
laugh reirse; risa
lawn césped
lawyer abogado
lead plomo
leaf hoja
leap salto
learn aprender
leave; departure marcharse
leave; to go out salir
left izquierdo
legend leyenda
lend prestar
length extensión
lengthen alargar
less menos
let go of soltar
letter letra; carta

lettuce lechuga
level llano; nivel; plano
lid tapa
lie down acostarse
lie mentir; mentira
lift alzar
light bulb bombilla
light encender; luz
lightning relámpago
likeable simpático
link enlazar
listen escuchar
little poco
lively animado; vivo
living room sala
load cargo
loaded cargado
loan préstamo
location localidad; lugar
lock up encerrar
lodge alojar
lodgings alojamiento
log leña
long largo
look for buscar
lose perder
loud laugh carcajada
loudspeaker bocina; altavoz
love querer
lovely precioso
lower bajar
lunch almorzar; almuerzo
luxurious lujoso

M

machine máquina
mail correo
mailbox buzón

main character protagonista
maintain mantener
make bitter amargar

manager gerente
manner manera; modo
mantle manto
manufacture fabricar
march desfilar; marchar
mark marcar
marry casarse
mask disfraz
mastery maestría
match partido
maternal materno
matter asunto; importar
mayor alcalde
mean significar
meaning sentido; significado
measure medir
meeting reunión
member miembro
mend remendar
merit merecer
mess lío
message recado
meter metro

mile milla
minor menor
miracle milagro
misery miseria
mischievous pícaro
miss extrañar
mistake error
mix mezclar
mixture mezcla
moon luna
motherland patria
mountain top cumbre
mountain range cordillera
mountain montaña
mountainous montañoso
move mover
movie theater cine
movie película
mud barro; lodo
multitude multitud
murmur rumor
mystery misterio

N

nail uña; clavo
nap siesta
napkin servilleta
narrow angosto
native indígena
nature naturaleza
near cercano
neat limpio; ordenado
neck cuello
needle aguja
neglect abandonar; descuidar
neighbor vecino
neither tampoco
never jamás; nunca
news noticias

newscast noticiero
next próximo; siguiente
night noche
nightfall anochecer
no one nadie
nobody ninguno
noon mediodía
note apunte; nota
note down apuntar
nothing nada
notice aviso; fijarse
notify advertir; notificar
novelty novedad
now ahora

O

obey obedecer
obstacle barrera
obstruct impedir
obtain conseguir; obtener
occupied ocupado

occur ocurrir
odd curioso; extraño
offer ofrecer; oferta
office despacho; oficina
oil aceite; petróleo

old viejo
old man anciano
olive aceituna
on sobre; encima de
onion cebolla
only único
open abierto
opened abierto
opening abertura
opponent adversario
opposite opuesto
orchard huerta

order mandar
origin origen
ought to deber
outing paseo
outside afuera; fuera
outskirts afueras
oven horno
over sobre
overturn volcar
owe deber
own poseer
owner dueño

P

pain dolor
paint pintar
painting cuadro; pintura
pair par
palm tree palma
pamphlet folleto
parade desfilar; desfile
paragraph párrafo
partner socio
pass through atravesar
pass pasar
passenger pasajero
past pasado
patch remendar
paternal paterno
patrol patrulla
peaceful tranquilo
peasant campesino
people gente
perhaps quizás
period época
permission permiso
photograph fotografía
picture fotografía
piece pedazo; trozo
pill píldora
pillow almohada
pin alfiler
pineapple piña
pitcher jarro
pity lástima; pena
place colocar; lugar; sitio

plain llano; llanura
plank tabla
platform andén
play jugar
player jugador
playful juguetón
playwrite dramaturgo
pleasant agradable
please agradar; por favor
pleasure gusto; placer
poem poesía
point punto
police policía
poll encuesta
poor pobre
population población
portrait retrato
portray retratar
possess poseer
poster cartel
pot olla
potential potencial
pound libra
praise alabar
prank broma; travesura
pray rezar
precious precioso
precise preciso
prefer preferir
preparation preparativo
prepare preparar
present actual

preside presidir
pretend fingir
prevent impedir; prevenir
previous anterior
price precio
priest cura; sacerdote
primary primario
print imprimir
printed impreso
prisoner preso
prize premio
produce producir; rendir
promise prometer
promote fomentar
proper propio
propose proponer

protect proteger
proud orgulloso
prove probar
public público
publish publicar
pull out arrancar
pumpkin calabaza
punish castigar
punishment castigo
purchase compra
purity pureza
purple morado
purse bolsa
put poner
put in meter
puzzle rompecabeza

Q

quality calidad
quantity cantidad
quarrel reñir

queen reina
quick veloz; rápido
quickly rápidamente

R

race carrera; raza
racquet raqueta
radio station emisora
rage ira
railroad ferrocarril
raincoat impermeable
raise alzar; subir
reach alcanzar
reading lectura
ready listo
reason razón
receive recibir
recipe receta
recognize reconocer
record grabar
recorder grabadora
red colorado; rojo
reduced rebajado
refuse rehusar
register inscribirse
regret arrepentirse; lamentar
reject rechazar
relative pariente

remain permanecer; quedarse
remains restos
remember acordarse; recordar
remembrance recuerdo
remove quitar
renew renovar
rent alquilar; alquiler
repair reparar
replace sustituir
resist resistir
resolve resolver
resource recurso
rest descansar
restore renovar
return regresar; volver
reunite reunirse
rice arroz
right derecha; correcto
ring anillo
road carretera
robbery robo
robe bata
rock piedra

rocket cohete
roof techo
room cuarto
root raíz
rope cuerda; soga
round redondo

row remar
rubber goma
ruin arruinar
ruined arruinado
ruler regla

S

sacred sagrado
sacrifice sacrificar
sadness tristeza
safe salvo; seguro
safety seguridad
saffron azafrán
saint santo
salary sueldo
sale venta
same mismo
sand arena
save up ahorrar
say decir
say goodbye despedirse
scale balanza
scarcely apenas
scarcity escasez
schedule horario
science ciencia
scissors tijeras
scream grito
sculptor escultor
search buscar
season estación
seaweed alga
secure seguro
security seguridad
seed semilla; sembrar
seem parecer
send enviar; mandar
sense sentido
sentence oración
servant criado
serve atender; servir
settle establecerse
several varios
sew coser
shade sombra
shampoo champú

share compartir
sharp filoso
shave afeitar
shawl chal
sheep oveja
shelf estante
shellfish marisco
shine brillar
ship nave; barco
shoe store zapatería
shoot fusilar; disparar
shop tienda
shore orilla
short bajo
shot disparo; inyección
should deber
shoulder hombro
show mostrar
shrink encogerse
side lado
sidewalk acera
sigh suspirar; suspiro
sign firmar; letrero
signal señal
silk seda
silver plata
similar parecido a
simplicity sencillez
since desde
singer cantante
siren sirena
site sitio
size tamaño
skate patinar
skillful hábil
skin piel
skirt falda
sky cielo
slander calumnia

sleeve manga
slide deslizarse
slow lento
slowly despacio
sly pícaro
smash quebrar
smell oler
smile sonreír
smoke fumar
snatch arrancar
soap jabón
sober sobrio
sock calcetín
soft blando
soldier soldado
some alguno
somebody alguien
song canción
soon pronto
soul alma
sound sonar; sonido
soup sopa
south sur
space espacio
species especie
spend gastar
sporting deportivo
squeeze apretar
stadium estadio
stage escenario
stain mancha
stairs escalera
stamp sello; timbre
stand out destacar
start comenzar; empezar
state estado
statement declaración
station estación
stationary store papelería
statue estatua
stay permanecer
steam vapor
steel acero; hierro
step on pisar
steward sobre cargo
stick palo
still todavía
sting arder
stocking media

stone piedra
stop cesar; parada; dejar de
store tienda
storm tormenta
story cuento
storywriter cuentista
straight derecho
strange extraño
straw paja
strawberry fresa
stream arroyo
street block cuadra
strength fuerza
stretch estirarse
strict estricto
strike huelga
stroll paseo
strong fuerte
studious aplicado
stuff rellenar
stuffing relleno
stumble tropezar
style estilo
stylize estilizar
subject asunto; materia
subjected sometido
substitute sustituir
subway metro; subterráneo
succeed tener éxito
success éxito
suffer sufrir
suffice bastar
sufficient suficiente
sugar azúcar
suggest sugerir
suggestion sugerencia
suit traje
suitcase maleta
sulphur azufre
supper cena
support apoyo
suppress suprimir
surface superficie
surprise sorpresa; sorprender
surround rodear
survey encuesta
survive sobrevivir
swamp pantano
sweet dulce

sweetness dulzura
swift veloz
swim nadar
swimmer nadador

swimming natación
swimming pool piscina
sword espada

T

tablecloth mantel
tail cola
take advantage of aprovecharse
take off quitar; quitarse
take out sacar
take care cuidar
take up abarcar
take tomar
take down descolgar
take a bath bañarse
talkative hablador
tape cinta
tapestry tapiz
taste gusto; sabor
tasty sabroso
tax impuesto
tear up romper
telephone teléfono
television televisor; televisión
terrace terraza
terrain terreno
terrifying aterrador
test prueba
that eso; que
the rest lo demás
theft robo
theme tema
then entonces; luego
there was hubo; había
thick espeso; grueso
thief ladrón
thin delgado
think pensar
thought pensamiento
threaten amenazar
thrilling emocionante
throat garganta
throw lanzar

throw out echar
thunder trueno
ticket billete; boleto
tight apretado
tighten apretar
tile azulejo
time tiempo; vez
tip propina
tired cansado
title título
together junto
tomb tumba
tongue lengua
too much demasiado
top cumbre
topic tema
touch tocar
tough fuerte; duro
towards hacia
towel toalla
tower torre
town pueblo
toy store juguetería
traffic light semáforo
tranquil tranquilo
translate traducir
trap atrapar
travel viajar
treasure tesoro
treat tratar
trip tropezar
trunk baúl
truth verdad
turn girar; dar vuelta
twin gemelo
twist torcer
type tipo

U

umbrella paraguas
uncomfortable incómodo
under debajo de

underlined subrayado
undertake emprender
undo deshacer

unfolding desenvolvimiento
unforgettable inolvidable
unfortunately desafortunadamente
unique único
unit unidad
unite juntar

united unido
unity unidad
until hasta
usage trato; tratamiento
useful útil
useless inútil

V

vacant vacío
vacuum cleaner aspiradora
valuable valioso
vary variar
vegetable legumbre
vessel nave

vice vicio
view vista
village aldea
violet morado
voice voz

W

waist cintura
wait esperar
waiter mesero; mozo
waitress camarera
walk caminar
want querer
war guerra
warn advertir
warning advertencia
waste basura; malgastar
waterfall cascada
wave onda; ola
way modo; manera
weak débil
wealth riqueza
weary cansado
wedding boda
wheat trigo
wherever dondequiera
whimsical caprichoso
whoever quienquiera
whose cuyo
wide ancho
widow viuda
widower viudo

width anchura
will voluntad
willful caprichoso
win ganar
wine vino
wing ala
wish desear; querer; deseo
witch bruja
within grasp asequible
within dentro de
witness testigo
wood madera
wool lana
work on elaborar
work obra; trabajar
worker obrero
workshop taller
world mundo
worldwide mundial
worse peor
wounded herido
wrap envolver
wrinkle arruga
wrist muñeca
written escrito

Y

yawn bostezar
yell grito
yet todavía

yield rendir
younger menor
youth juventud

Index

A
above, 24, 183, 194
abstract noun, *see* nouns, abstract
acabar, 185, 187, 197
accentuation, rules of, 209–211
 palabras agudas, 209
 palabras graves o llanas, 209
 palabras esdrújulas and sobrees-
 drújulas, 210
acerca de, 66, 90, 197
aconsejar, 106
acostumbrarse, 185
además, 187, 213
adjectives, 3, 19–31, 33, 35–37, 83,
 110, 128, 153–156, 169, 170,
 177, 184, 198, 199, 210
 adverbs, and, 169
 clauses, 110
 color, of, 24
 comparative and superlative,
 27–31
 absolute superlative, 30, 31
 irregular comparative form, 28
 regular comparison of equality,
 31
 comparisons, in, 26, 27
 demonstrative, 37, 156
 feminine, 19, 20
 formation of nouns from, 35
 gender and number, change of, 19
 interrogative, 160
 masculine, 19
 nationality, of, 22, 23
 participles as, 128
 position of, 25
 possessive, 3, 36, 37, 83,
 153–155
 possessive pronoun, and, 154,
 155
 + prepositions, 184
 reflexive verbs, with, 83
 types of, 19
adverbs, 26, 111–113, 169–173,
 184, 187, 189, 210, 211
 adjectives, and, 169
 clauses, adverbial, 111, 112
 expressions, adverbial, 113,
 170–172, 189
 phrase, adverbial, 170, 171
 prepositional, 184
 + prepositions, 170
affirmative expression, *see* expres-
 sions, affirmative
ahora, 42, 66, 72, 77, 97, 113, 117,
 119–121, 124, 150, 156, 165,
 178, 193
allow, 106
along, 188
alguno, 25, 177
alrededor de, 66, 158, 159, 187
although, 111
-ando (adding of), 71
ante, 183, 194, 214
antes, 8, 44, 79, 105–107, 111, 112,
 123, 135, 185–187, 194, 203,
 207
any, 2
-ar verbs, *see* verbs, *-ar*
articles, 1–9, 11, 14, 27, 29, 35–37,
 83, 154, 155, 210

comparative adjectives, and, 29
definite, 1–6, 14, 27, 29, 35–37,
 83, 154, 155
 feminine (la, las), 1
 masculine (el, los), 1
 indefinite (un, una, unos, unas), 1,
 6–9, 11
 feminine (una, unas)
 masculine (un, unos)
 reflexive verbs, with, 83
as, 31, 112
 as…as in comparisons, 31
 as much as/as many as, 31
 as soon as, 112
ask, 54, 106, 134, 198, 224
 a question, 134, 198
 for something, 224
 indirect requests, in, 134
asunto, 199
at, 64
 time, 64
aunque, 11, 14, 111, 112, 131, 156,
 177, 181, 200, 205
auxiliary verbs, 74, 79, 104, 105,
 143, 147–149
 see also be, have, need, used, will

B
be, 48, 58, 59, 67, 68, 129, 162
 auxiliary verb, *see* auxiliary verbs
 forms of, 129
 + infinitive for orders etc., 48,
 58, 59
 irregular verbs, 67, 68
before, 111
by, 188, 189
 agent of passive verb, with, 188
 manner or means, for, 189
 movement, for, 188

C
calidad, 101
cambiar, 43, 56
cantidad, 14, 145
-car (verbs ending in), 57, 98
cardinal numbers, *see* numbers, car-
 dinal
categories of preposition, *see* prepo-
 sitions, categories of
causa, 193
cesar, 185, 187, 197
clauses, 76, 95, 96, 102, 103, 105,
 106, 110–113, 141, 144, 157,
 158
 adjective clause, 110
 adverbial clause, 111, 112
 dependent, 95, 96, 105, 106
 'if' clause, 76, 113
 main, 96, 102, 103, 105, 106,
 110, 141, 144
 relative clause, 110, 111
 subjunctive mood, and, 106
comenzar, 45, 57, 69, 98, 185, 187,
 192
commands, 42, 119–123, 143, 150
 affirmative, 143, 150
 familiar, 121, 122
 formal, 119, 120
 imperative mood, 119
 indicative mood, 42

indirect, 123
irregular, 121
negative, 120, 122, 150
plural, 121
regular, 121
singular, 121
comparison, 26, 27, 31
 adjectives, of, 26, 27, 31
 equality, 31
compound preposition, *see* preposi-
 tions, compound preposition
compound verb, *see* verbs, com-
 pound
con (with), 154, 170, 183, 186
concluir, 55
conditional verb, *see* verbs, condi-
 tional
conjugated verb, *see* verbs, conju-
 gated
conjunctions, 33, 76, 95, 111, 157,
 184
conocer, 47, 60, 69, 110, 133, 197,
 206
 see also saber
conocido, 7, 28, 39
consistir en, 186, 197, 206
contractions, 5, 154
 a + el (al), 5
 de + el (del), 5
cualquier, 37, 170–173
cuidar, 43
cuyo, 159, 160, 167

D
dado, 191, 200, 204
dar, 44, 58–60, 99, 128, 149, 164,
 185, 186, 197, 202, 203, 206,
 207
dates and days, 8, 10, 11, 130, 188,
 200, 202
debajo de, 187
decir, 52, 60, 63, 67–70, 72, 77–80,
 102, 103, 106, 111, 121, 164,
 197
definite article, *see* article, definite
dejar de, 185, 197
demasiado, 187
demonstrative pronoun, *see* pro-
 nouns, demonstrative
dentro de, 170, 171, 173, 187, 194
desde, 183, 194
desear, 44, 97, 106, 107
despacio, 201
después, 24, 44, 56, 59, 61, 65, 67,
 90, 112, 117, 186, 187, 192,
 212
devolver, 50, 135, 149, 164
 see also volver
Dios, 14, 36, 200, 202, 207
direct objects, 139–143, 146, 147,
 190
dirigir, 24, 42
dondequiera, 109, 150, 165
dudar, 107, 108

E
each, 2
each other, *see* verb, reciprocal verb,
 for each other
edad, 30, 32, 140

indirect, 123
él (infinitive), 43–55, 57–59, 61–63,
 66, 69, 78–80, 96–101, 103,
 105, 106, 140, 153, 155, 190
ellos (infinitive), 42–55, 57–59,
 61–63, 66, 69, 78–80, 96–101,
 103, 105, 106, 140, 153
empezar, 45, 56, 57, 104, 185–187,
 197
encima de, 187
entonces, 79, 194, 195
enviar, 148, 164, 165, 189
-er verbs, *see* verbs, *-er*
escuchar, 43, 71
eso, 8, 25, 121, 125, 189, 193–195,
 206
estado, 92
estar, 11, 24, 44, 58–61, 66, 69, 71,
 74, 76, 77, 99, 107, 108, 111,
 129, 131–134, 149, 197, 198,
 202, 206
ever, 176, 196
exclamations, 7
expressions, 7–9, 11, 96, 108, 109,
 111, 113, 130, 151, 170–172,
 178, 180, 189, 193, 197
 adverbial, 111, 113, 170–172,
 189
 affirmative, 151
 idiomatic, 193, 197
 impersonal, 96, 108, 130
 indefinite, 109
 negative, 7, 178, 180
 special, 178
 superlative, 111
 weather, 8, 11

F
falta, 145, 146, 164
feminine pronoun, *see* pronouns,
 feminine
for, 188, 189
 para, 188
 comparison, 188
 destination, 188
 in order to, 188
 purpose, 188
 with reflexive pronoun, 188
 special use of an object, 188
 time and date in the future, 188
 por, 188, 189
 after a verb of motion, 188
 agent in passive construction,
 188
 express frequency, 189
 express manner or means, 189
 express opinion or estimation,
 189
 express reason or motives, 189
 for the sake of, 188
 indefinite time, 188
 in exchange for, 188
 length of time, 188
from, 130, 135
 for travel and movement or ori-
 gin, 130, 135
fuerte, 27, 38, 50, 132, 202, 207
future expressed by, 197, 198
 be about to, 197, 198
 see also will
future tenses, *see* tenses, future

G

-gar (verbs ending in), 57, 98
gender of nouns, 1, 12, 13, 19,
 24–27, 30, 32, 36, 37, 128,
 140, 141, 144, 159
 adjectives, use of, 19, 24–26, 30,
 36, 37, 128
 articles, use of, 1, 27
 with prepositional phrase, 144
 pronoun, use of, 140, 141, 144,
 159
género, 212
gente, 13, 65, 70, 91, 104, 156, 171,
 187, 205
gerund, *see* participles, present par-
 ticiple

H

haber, 48, 60, 63, 66, 78–80, 101,
 104, 105
 + past participle, 78–80, 105
hacer, 11, 46–48, 60, 62, 63,
 67–71, 75, 77–80, 91, 102,
 104, 109–111, 116, 121, 123,
 133, 145, 146, 179, 181, 186,
 187, 189, 192, 198, 202, 203,
 206
has *see* have
hasta, 56, 97, 105, 112, 113, 117,
 183, 186, 195
have, 76–80
 conditional perfect, 80
 future perfect, 79
 for obligations: *see* have to
 forming past participle, 76
 present perfect, 78
he, him, his, her, hers, *see* pronouns,
 personal
hecho, 48, 77, 79, 92, 93, 102, 105,
 113, 136, 201, 207
herself, himself, *see* pronouns,
 prepositional
how, 160
 interrogatives, 160
hubo, 60

I

idiomatic expression, *see* expres-
 sions, idiomatic
idioms, 193–200, 206, 207
 with nouns, 193–195
 with verbs, 197–199
-iendo (adding of), 71
'if' clauses, 76, 80, 113
 conditional perfect tenses, in,
 80
 conditional progressive tenses, in,
 76
 contrary to fact condition, 113
 past time, 113
 present time, 113
imperative, *see* mood, imperative
impersonal expression, *see* expres-
 sions, impersonal
in case, 112
incluir, 55, 73
indefinite article, *see* article, indefi-
 nite
indefinite expression, *see* expres-
 sions, indefinite
indicative mood, *see* mood, indica-
 tive
indicative verb, *see* verbs, indicative
indirect objects, 139–141, 144–149,
 151, 153
influir, 55
in front of, 183, 187, 219, 236

in order + infinitive of purpose, 111,
 112, 183, 188
in spite of/despite, 111, 170, 171,
 193
infinitive, 41–55, 57–59, 61–63, 66,
 69, 71, 78–80, 82, 83, 96–101,
 103, 104, 106, 119–122, 143,
 148, 183, 184, 186, 188, 189,
 198, 199, 209
 future tense, 66
 gerund, 71
 imperfect tense, in, 61, 62
 imperative mood, in, 119–122
 familiar command, in, 121,
 122
 formal command, in, 119
 negative command, in, 120
 imperfect subjunctive, 103
 perfect, 78–80, 104, 105, 106
 conditional, 80
 future, 79
 pluperfect, 79, 105
 pluperfect subjunctive, 105,
 106
 present, 78, 104, 105
 present perfect subjunctive,
 104, 105
 preposition +, 183, 184, 186
 pronoun, with, 143, 148
 reflexive pronoun, 83
 verbs, 41, 46, 50–52, 55, 57–59,
 63, 69, 82, 83, 96–101
 irregular, in, 63, 83, 99, 101
 reflexive, 82
 regular, in, 69, 96, 99
 stem changing verb, in, 50, 53,
 54, 83, 97, 100, 101
interrogative, 112, 160–162
 adverbial clauses, 112
 pronouns, 161, 162
 sentence, 160
 see also auxiliary verbs and
 tenses
-ir verbs, *see* verbs, *-ir*
irregular verb, *see* verbs, irregular

J

jamás, 176–178, 181, 195, 204, 206
jefe, 51; 96, 97, 99, 104, 147, 149,
 164
jugar, 41, 50, 57, 58, 61, 67, 71, 86,
 134, 145, 187, 190
 see also tocar

L

largo, 6, 14, 27, 28, 38, 39
lejos, 51, 87, 109, 117, 158, 187,
 193, 206
length of time/duration, 188
lento, 170, 171, 210
let/let's, 123, 151
 commands, in, 123
levantarse, 81, 82, 120
limpiar, 43, 69, 71, 107, 116, 120,
 123, 179
limpio, 119–122, 161
llamada, 53
luego, 24, 44, 56, 59, 65, 67, 112,
 195
lugar, 35, 50, 75, 186, 187, 194, 199

M

mandar, 41, 43, 77, 97, 106, 107,
 148, 164
many, 2, 31
 articles, use of, 2
 comparison of, 31

marcharse, 82, 83
masculine pronoun, *see* pronouns,
 masculine
mind, state of, 63, 65
mine, 36, 155
months, 10, 64, 65, 198
mood,, 42, 66, 119
 imperative, 119
 indicative, 42, 66
 subjunctive, *see* subjunctive
 mood
mostrar, 45, 164
motive, 189
mover, 50, 66
much, more, most, 26, 27, 31, 61,
 111, 160, 189
 for comparison of, 26, 27, 31
 interrogative, 160
must, 70, 109
 conditional, 70

N

nadie, 110, 111, 176–178, 181, 182,
 190, 191, 203
near, 37
 adjective, 37
need, 145, 176
negar, 45, 107
negatives, 7, 110, 119, 120, 122,
 123, 142, 144, 147, 150–152,
 175–181
 after comparatives, 178
 auxiliaries and simple tenses, of,
 147
 command, 120, 122, 150
 familiar, 122
 formal, 122
 indirect, 123
 double negatives, 110
 adjective clause, with, 110
 negative expressions, *see* expres-
 sions, negative
 object pronouns, 142, 144, 147,
 150, 175
 direct object pronoun, 142
 indirect object pronoun, 144
 sentence, 176
 special negative expressions, 178.
neither, 176, 179
 neither...nor, 176
never, 176, 179, 203
ninguno, 25, 26, 110, 176–178, 182,
 190
nosotros (infinitive), 42–55, 57–59,
 61–63, 66, 69, 78–80, 96–101,
 103, 105, 106, 140, 153
nouns, 1–17, 19, 24–27, 30, 31,
 33–37, 177, 183, 184, 193
 abstract, 2
 feminine, 1, 6, 12, 13, 25, 26,
 33
 formation from adjective, 35
 gender, 1, 13, 27, 30
 general, 2
 idioms, in, 193
 masculine, 1, 6, 12, 13, 25, 26,
 33, 35
 number, 1, 27, 30
 plural forms, 12
 preposition +, 183, 184
 singular form, 12, 33, 35
numbers, 32, 33, 35
 cardinal, 32
 feminine, 33
 ordinal, 35
nunca, 171, 176–178, 181, 195, 200,
 203, 206, 207

O

obedecer, 47, 211, 212
ocupado, 58
ocurrir, 51
offers, 47
opposite, 107, 120, 177, 187
ordinal numbers, *see* numbers, ordi-
 nal
other, others, 85

P

participles, 71, 72, 74, 76–80, 104,
 105, 127, 128, 130, 132,
 149–151
 gerund, *see* participles, present
 participle
 past participle, 76–80, 104, 105,
 127, 128, 130
 conjunction with the verb
 'have', in, 76
 irregular, 77
 passive voice, in, 127, 128,
 130
 past perfect tense (pluperfect),
 with, 79
 pluperfect tense, with, 78
 present perfect tense, with, 78
 present participle, 71, 72, 74, 132,
 149, 150
 progressive tense, in, 74, 132,
 149
 verbs in motion, with, 72
pasado, 24, 60, 64, 65, 194, 206
pasar, 43, 53, 56, 66, 85, 97, 108,
 183, 196, 198
passive voice, *see* voice, passive
past tense, *see* tenses, past
pedir, 54, 63, 72, 101, 106, 121,
 134, 136, 164, 165, 180, 182,
 201
 see also preguntar
personal pronouns, *see* pronouns,
 personal
pertenecer, 47
pluperfect tenses, *see* tenses, perfect,
 pluperfect
poco, 11, 77, 114, 170, 171, 173,
 193–195, 198, 204, 207
poder, 50, 60, 66–70, 72, 101, 111,
 114, 204
poner, 42, 47, 48, 60, 66, 67, 69–71,
 77, 78, 84–86, 102, 120, 121,
 123, 198
possession, 36, 37
 ese, with, 37
 este, with, 37
possessive adjectives, *see* adjectives,
 possessive
possessive pronouns, *see* pronouns,
 possessive
possibility, 108
preguntar, 134
 see also pedir
prepositions, 3, 5, 27, 37, 41, 111,
 128, 144, 147, 153–155, 157,
 158, 160, 170, 183–191
 categories of, 183
 commonly used prepositions,
 187
 compound preposition, 158
 contraction with, 5
 de, 3, 5, 27, 28, 65, 111, 112,
 128, 155, 158, 183, 185,
 187
 para, 9, 158, 183, 187, 188, 190
 por, 64, 111, 127, 128, 187, 188,
 190

prepositional adjective, 184
prepositional modifier, 184
prepositional phrase, 144, 147, 155
prepositional pronoun, 153, 154
prepositions used with infinitives, 184
specific verb/preposition rules, 185
used with infinitives, 184
verbs following prepositions, 184
prepositional pronoun, *see* pronouns, prepositional
present tense, *see* tenses, present
preterite tense, *see* tenses, preterite
progressive tense, *see* tenses, progressive
pronouns, 31, 37, 41, 43, 81, 83, 84, 95, 106, 120, 128, 139–167, 175, 183, 188, 190, 210
command, with, 150
demonstrative, 37, 156
feminine, 142
interrogative, 160, 161, 162
masculine, 142
object pronoun, 139–151, 153, 175
auxiliary verb, with, 149
conjugated verb, with, 147
direct and indirect, 139–146, 153
double, 146
infinitives, with, 148
present participle, with, 149
personal, 41, 43
possessive, 154, 155
prepositional, 153, 154
que, 157
reflexive, 81, 83, 84, 120, 128, 152, 153, 188
relative, 95, 106, 156–160
neuter, 159
prepositions, with, 158
subject, 139, 140, 153
pronto, 67, 80, 112, 113, 117, 120, 124, 131, 171, 194, 195, 206
proper names, 10
proverbs, 193, 200–207
provided (that), 111
purpose, 1, 25, 59, 111, 188
adverbial clauses, with, 111
phonetic, for, 1, 59
spelling change, 59
preposition, 188
stylistic, 25
adjectives places before noun, 25

Q
quantitative adjectives and pronouns, 2
any, 2
each, 2
many, 2
some, 2
que, 2, 6, 7, 8, 11, 14, 20, 26–30, 37–39, 42, 44, 46, 48–50, 52, 53, 56, 60, 63, 65–70, 75, 87, 95–112, 115–117, 123, 125, 126, 128, 130, 131, 133, 135, 155–159, 162, 166, 167, 171, 172, 176–179, 181, 182, 185, 190, 191, 195, 197–207, 211, 212
querer, 49, 50, 60, 63, 67, 68, 70, 106, 107, 195, 204, 207

questions, 112, 134, 141, 144, 160, 162
adverbial clauses, 112
what, how, when where, why, 112
see also adjectives, interrogative; and pronouns, interrogative
quienquiera, 109
quitarse, 82, 83
quizás, 113, 117

R
rápidamente, 58, 82, 88, 93, 169, 170, 173, 212
rápido, 27, 98, 110, 169, 171, 210
rather, 178
razón, 37, 139, 199
reason, 189
reciprocal verb, *see* verbs, reciprocal
reflexive pronoun, *see* pronouns, reflexive
reflexive verb, *see* verbs, reflexive
regalar, 43, 148, 149, 164
regular verb, *see* verbs, regular
relative clauses, 110, 111
relative pronouns, *see* pronoun, relative
requests, 95, 106, 134

S
saber, 42, 47, 48, 60, 63, 66–68, 70, 71, 76, 77, 86, 101, 107–111, 131, 133, 149, 198, 206
see also conocer
sacar, 43, 57, 78
seguido, 171
ser, 4, 7, 8, 14, 22, 28, 48, 59, 60, 63, 66, 67, 70, 77, 101, 108, 109, 111, 121, 127, 129–134, 155, 158, 162, 171, 186–188, 190, 192, 198
since, 169, 183
siguiente, 24, 193
siquiera, 178, 180, 195, 206
sobre, 48, 51, 68, 78, 87, 91, 123, 133, 143, 183, 195, 211, 212
some, 2, 6
indefinite article, 6
vague quantity, 2
somebody, someone, something, 96, 130, 134, 135, 185, 188
sostener, 49, 189
so that... + clause of result, 111, 112
specific verb/preposition rules, *see* prepositions, specific verb/preposition rules
spelling, 33, 59, 98, 210
change, 59, 98
subjunctive mood, 42, 95–117, 119, 122, 123
adverbial clauses, in, 111, 113
dependent clauses, and, 106
formal commands, in, 119, 122
imperfect, 103–105, 113
impersonal expressions, and, 108
indefinite expressions, and, 109
indirect commands, in, 123
past subjunctive, 110
pluperfect, 105, 106, 113
present subjunctive, 96–102, 104, 105, 108–110, 123
present perfect, 104, 105
regular, 123
relative clauses, in, 111
suficiente, 48, 76, 91

superlatives, *see* adjectives, comparatives and superlatives
see also comparison
superlative expression, *see* expressions, superlative

T
tan...como, *see* as...as in comparisons
tardar, 186, 187, 198
temer, 106, 107
tener, 8, 42, 49, 60, 62, 68, 70, 71, 109, 111, 114, 121, 178, 190, 195, 196, 199, 203, 206, 207
tenses, 41, 42, 44, 46–49, 51–53, 55–57, 59–70, 74–76, 78–82, 96, 98, 106, 107, 110, 113, 128, 132, 147, 149, 184, 186
compound, 78–80, 147
conditional, 69, 70, 76, 78, 80, 81, 106, 113
perfect, 78, 80, 113
conditional, 76
future, 66–69, 75, 78, 79, 81, 82, 113, 186
perfect, 78, 79, 81
progressive, 75
imperfect, 61–65, 79, 81, 82
progressive, 75
versus preterite tense, 64
past, 61–65, 79, 81, 82, 106, 110
imperfect, 61–65, 75, 79, 81, 82, 106
perfect, 79
perfect tenses, 76, 78–81, 102, 104, 105
conditional, 78
future perfect, 78–81
past perfect, 79
pluperfect, 78, 79, 81, 82, 106, 113
subjunctive, 113
present perfect, 78, 81, 102, 104, 105
subjunctive, 104, 105
present, 42, 44, 46–49, 51–53, 74, 78, 81, 82, 107, 128
first person singular, 47, 52
perfect, 78
progressive, 73, 74
subjunctive, 96
preterite, 55–57, 59, 60, 64, 65, 74, 81, 82, 98, 106
first person singular, 57
perfect, 78
versus imperfect tense, 64
progressive, 74–76, 132, 149
conditional, 76
imperfect, 75
future, 75
present, 73, 74
preterite, 74
than in comparisons, 26–30, 33, 178, 179, 196, 201–203
that, 156, 157
relative pronoun, 156
them, 12
themselves, 74
tiempo, 11, 12, 14, 48, 58, 61, 69, 70, 72, 80, 88, 89, 96, 99, 102, 105, 113–115, 152, 175, 182, 189, 193–195, 198, 201–204, 206, 207
time, 4, 8–10, 12, 61, 63, 64, 74, 130, 188
prepositions of time, 188

tocar, 57, 98, 123, 134, 186, 187, 192
see also jugar
todo, 48, 56, 82, 90, 171, 172, 188, 194, 195, 203, 204, 206, 211, 212
tomar, 11, 41, 44, 56, 61, 65, 67, 69, 76, 114, 121, 122, 184, 190, 199, 204
tú (infinitive), 42–55, 57–59, 61–63, 66, 69, 78–80, 96–101, 103–106, 108, 140

U
unless, 111, 112
until, 112, 183, 186
used, used to, 61–63, 65, 134
útil, 14, 28, 39

V
veloz, 22, 31
verbs, 9, 11, 26, 41–107, 109–112, 114, 120, 121, 128, 129, 131, 132, 134, 140–149, 151, 155, 160, 162, 183–190, 197
-*ar*, 41–44, 50, 61, 66, 69, 71, 96, 99
gerund, 71
irregular, 44, 99
regular, 42, 55, 61, 66, 69, 96
stem-changing, 44, 97
auxiliary, 74, 79, 104, 105, 143, 147–149
-*er*, 42, 46–49, 58, 59, 62, 66, 69, 71, 76, 99–101
gerund, 71
irregular, 47, 101
regular, 46, 62, 66, 69, 76, 99
past participle, 76
stem-changing, 49, 100
compound, 68
conditional, 69
conjugated, 84, 98, 142, 144, 146, 147
idioms, with, 197
indicative, 41–81, 121
infinitive, in, 41
-*ir*, 42, 51–53, 58, 59, 62, 66, 69, 71, 76, 99–101
gerund, 71
irregular, 52, 101
regular, 51, 62, 66, 69, 76, 99
past participle, 76
stem-changing, 53, 100, 101
irregular, 57, 58, 63, 67–69, 83
preposition, and, 183–187
proverbs, with, 197
reciprocal, 85
for each other, 85
reflexive, 81–85, 120, 151
adjectives with, 83
articles with, 83
regular, 57
singular form, 9
special use, 128, 129
subjunctive, 105, 109, 110
tenses: *see* tense: conditional, future, past, present and perfect tenses; imperative and subjunctive; passive voice
verbs following prepositions, *see* prepositions, verbs following prepositions
weather expression, 11
vez, 63, 64, 90, 113, 186, 187, 191, 194, 195, 204, 207

viejo, 35
voice, 108, 127–137
 active, 127
 passive, 127–137
volver, 50, 59, 62, 71, 77, 79, 100,
 101, 104, 109, 121, 122, 135,
 185, 199
 see also devolver
vosotros (infinitive), 42–55, 57–59,
 61–63, 66, 69, 78–80,
 96–101, 103, 105, 106, 140,
 153

W

want + (object +) infinitive, 41

was, 61
weather expression, *see* expressions,
 weather
weight, 5
what, 7–11, 112, 141, 156, 157, 159,
 160, 162
 exclamation, in, 7
 interrogatives, 112, 160
 relative pronoun, 156
 asking to know the time, date, or
 weather, 8–11
when, 112, 160
 interrogatives, 160
where, 112, 160
 interrogatives, 160

which, 156–159, 161
 interrogatives, 161
 preposition, with, 158, 159
 relative pronoun, 156
while, 112, 170
who, whom, 156, 157, 160
 interrogatives, 160
 relative pronouns, 156
whose, 156, 159
 relative pronoun, 156, 159
why, 112, 189
 adverbial clause, in, 112, 189
will, 66, 68, 69, 74
 what will happen, 66, 69
 what would happen, 69

with (*con*), 154, 170, 183,
 186
would, 70, 80
 conditional sentences, in, 70,
 80

Y

year, 10, 64, 65
yet, 178
yo (infinite), 42–55, 57–59, 61–63,
 66, 69, 78–80, 96–101,
 103–106, 140

Z

-zar (verbs ending in), 57, 98

Collins College OUTLINES

Fully Revised and Updated

Written by professors, teachers, and experts in various fields, the titles in the Collins College Outlines series provide students with a fast, easy, and simplified approach to the curricula of important introductory courses, and also provide a perfect preparation for AP exams. Each title contains a full index and a "Test Yourself" section with full explanations for each chapter.

BASIC MATHEMATICS
Lawrence A. Trivieri
ISBN 0-06-088146-1 (paperback)

INTRODUCTION TO CALCULUS
Joan Van Glabek
ISBN 0-06-088150-X (paperback)

INTRODUCTION TO AMERICAN GOVERNMENT
Larry Elowitz
ISBN 0-06-088151-8 (paperback)

INTRODUCTION TO PSYCHOLOGY
Joseph Johnson and Ann L. Weber
ISBN 0-06-088152-6 (paperback)

MODERN EUROPEAN HISTORY
John R. Barber
ISBN 0-06-088153-4 (paperback)

ORGANIC CHEMISTRY
Michael Smith
ISBN 0-06-088154-2 (paperback)

UNITED STATES HISTORY TO 1877
Light Cummins and Arnold M. Rice
ISBN 0-06-088159-3 (paperback)

WESTERN CIVILIZATION TO 1500
John Chuchiak and Walter Kirchner
ISBN 0-06-088162-3 (paperback)

ABNORMAL PSYCHOLOGY
(coming in 2007)
Sarah Sifers
ISBN 0-06-088145-3 (paperback)

UNITED STATES HISTORY FROM 1865
(coming in 2007)
John Baick and Arnold M. Rice
ISBN 0-06-088158-5 (paperback)

ELEMENTARY ALGEBRA
(coming in 2007)
Joan Van Glabek
ISBN 0-06-088148-8 (paperback)

SPANISH GRAMMAR
(coming in 2007)
Ana Fairchild and Juan Mendez
ISBN 0-06-088157-7 (paperback)